D1469480

Digital V ls

TK 6680..5 .S28 2003
DIGITAL VIDEO ESSENTIALS

Sadum, Erica

DATE	ISSUED TO

TK 6680..5 .S28 2003
DIGITAL VIDEO ESSENTIALS

Sadum, Erica

Digital Video Essentials™:
Shoot, Transfer, Edit, Share

ERICA SADUN

SAN FRANCISCO | LONDON

SYBEX®

Associate Publisher: Dan Brodnitz
Acquisitions Editor: Bonnie Bills
Developmental Editor: James A. Compton
Editor: Marilyn Smith
Production Editor: Kylie Johnston
Technical Editor: Eric Bell
Graphic Illustrator: Caryl Gorska
Electronic Publishing Specialists: Maureen Forys, Kate Kaminski, Happenstance Type-O-Rama
CD Coordinator: Dan Mummert
CD Technician: Kevin Ly
Proofreaders: Amey Garber, Emily Hsuan, Dave Nash, Laurie O'Connell, Nancy Riddiough
Indexer: Ted Laux
Book Designer: Caryl Gorska
Cover Designer: John Nedwidek, Emdesign
Cover Illustrator/Photographer: John Nedwidek, Emdesign

An earlier version of this book was published under the title *Digital Video! I Didn't Know You Could Do That...* © 2001 SYBEX Inc.

LIBRARY OF CONGRESS CARD NUMBER: 2002113845

ISBN: 0-7821-4198-6

SYBEX and the SYBEX logo are either registered trademarks or trademarks of SYBEX Inc. in the United States and/or other countries.

Essentials is a trademark of SYBEX Inc.

Screen reproductions produced with FullShot 99. FullShot 99 © 1991–1999 Inbit Incorporated. All rights reserved.
FullShot is a trademark of Inbit Incorporated.

The CD interface was created using Macromedia Flash, COPYRIGHT 1994, 1997–2003 Macromedia Inc. For more information on Macromedia and Macromedia Flash, visit www.macromedia.com.

TRADEMARKS: SYBEX has attempted throughout this book to distinguish proprietary trademarks from descriptive terms by following the capitalization style used by the manufacturer.

The author and publisher have made their best efforts to prepare this book, and the content is based upon final release software whenever possible. Portions of the manuscript may be based upon pre-release versions supplied by software manufacturer(s). The author and the publisher make no representation or warranties of any kind with regard to the completeness or accuracy of the contents herein and accept no liability of any kind including but not limited to performance, merchantability, fitness for any particular purpose, or any losses or damages of any kind caused or alleged to be caused directly or indirectly from this book.

MANUFACTURED IN THE UNITED STATES OF AMERICA

10 9 8 7 6 5 4 3 2 1

Dear Reader,

Thank you for choosing *Digital Video Essentials: Shoot, Transfer, Edit, Share*. This book is part of a new wave of Sybex graphics books, all written by outstanding authors—artists and professional teachers who really know their stuff, and have a clear vision of the audience they're writing for.

At Sybex, we're committed to producing a full line of quality digital imaging books. With each title, we're working hard to set a new standard for the industry. From the paper we print on, to the designers we work with, to the visual examples our authors provide, our goal is to bring you the best graphics and digital video books available.

I hope you see all that reflected in these pages. I'd be very interested in hearing your feedback on how we're doing. To let us know what you think about this or any other Sybex book, please visit us at www.sybex.com. Once there, go to the product page, click on Submit a Review, and fill out the questionnaire. Your input is greatly appreciated.

Best regards,

Daniel A. Brodnitz
Associate Publisher, Graphics
Sybex Inc.

Dedication

For Tamara, who held things together when we could not, with our
family's gratitude

Acknowledgments

Unlike mythical Greek figures, books do not spring fully formed from the heads of their creators. Many others have helped contribute to this work. I find myself the recipient of the skills, generosity, and kindness of many people. I could not have written this book without their assistance, and I sincerely and profoundly thank everyone who has offered advice, help, information, and time. And let me ask forgiveness in advance from anyone I've overlooked in these acknowledgments. ■ First, let me thank the wonderful team at Sybex who made this possible. Bonnie Bills, Kylie Johnston, Jim Compton, the magnificent Marilyn Smith, Maureen Forys, Kate Kaminski, Chris Gillespie, Caryl Gorska, and Ted Laux helped make this a wonderful and fulfilling project. Thank you. A special thank you as well to Eric Bell, my technical editor, whose warmth and insight always adds to his knowledgeable assistance. Several of the best anecdotes scattered throughout this book, particularly the note about *Schindler's List* in Chapter 5, are his contributions. ■ Second, I want to thank all of the companies that have graciously offered review hardware and software. This book could not have been written without these items. I very much appreciate your generosity and timeliness. ■ Third, I offer my thanks to those people whose outstanding knowledge, insight, and courtesy helped this process enormously. These include Shelly Sofer of MGI; Jill Ryan of McLean Public Relations; Michelle Gallina, Pamela Swartwood, and Travis White of Ulead; the marvelous Michael Bartosh and Bo Turney of Apple; Jason Taylor of Beatnik; Jenny Menhart of Ahead; Steve Kilisky and Craig Snyder of Adobe; Robert Altmann of ForMac; Jeff Bakeman and Rebecca Elder of PowerR; Daniel Ziegler, Monkey Wrangler and Artiste Extraordinaire; Dr. Alberto Sadun, Brad Busley, and Dr. Randy Tagg of the University of Colorado at Denver; Rob Uhrina and Dave Chaimson of Sonic Foundry; Jeff Klinedinst of Tracer Technologies; David Cox of Micro Technology Unlimited; Elena Min of Raz Public Relations; Bruce Gee of GeeThree.com; Christopher Knight of Eskape Labs (a Division of Hauppauge Digital Incorporated); Kari Day and Steve McMillen of RealNetworks; Dirk Peters, Kimberly Blackledge, and David Seo of SCM Micro (the Dazzle people); Amy Mattern of the T&O Group; Mark Shapiro of *Camcorder Magazine*; Bill LaCommarre of MovieWorks.com; Kostya Vasilyev of Single Reel; Barry Sulpor, Phillip Djwa, and Nwan Kwo of POPcast; Blythe Robertson of VideoShare; Lisa Hirschman of iClips; Jeff Kletsky, John Walsh, and Rick Mitchell of

SpotLife; Rebecca Young of ImageStation; Sharon Morgan of Sonic Desktop Software, Inc.; Jack Waldenmaier of The Music Bakery; Georges Jaroslaw of Arboretum, Inc.; Simone Souza of Roxio; Jo Ann Guear and Kristine Zeichner of New Directions; Tamara Strauser and Francis Tan of Terapin Technologies; Victor Nemechek of ElGato; Ryuhei Yoshii of Pegasys, Inc; Alison Pitura of eZedia; Christopher Ryan and Nathan Ryan of Virtix; Kaveh Kardan of Stupendous Software; and Ed Swicegood and Gene Shin of Playstream. ■ Fourth, I would like to thank everyone who helped out on the home front. I could not have gotten through this process without the help, cheerfulness, and camaraderie of Hayden Starr. Thanks go to Jim, Kate, Erin, and Jamie Molloy. One cannot find better or more inspiring models. Thanks, too, to all of my family members who agreed to be videotaped and photographed for this book. ■ Finally, let me thank Barbara Mulitz and Pat Bates, for general inspiration, which can arrive in a wide variety of forms and shapes.

CONTENTS AT A GLANCE

Introduction ■ **xv**

Chapter 1 ■ Why Digital Video? **1**

Chapter 2 ■ Compose, Light, and Shoot **23**

Chapter 3 ■ Video Tech Talk **61**

Chapter 4 ■ Transfer Video to Your Computer **81**

Chapter 5 ■ Video-Editing Techniques **99**

Chapter 6 ■ iMovie Simplified **121**

Chapter 7 ■ VideoStudio Skills **143**

Chapter 8 ■ Burn Your Movies to DVD and VCD **159**

Chapter 9 ■ Share Your Movies with Streaming Video **185**

Chapter 10 ■ Export Your Movies to TV, Tape, and More **195**

Chapter 11 ■ Digital Video Fun **205**

Glossary ■ **233**

Index ■ **244**

Contents

Introduction xv

Chapter 1 ▪ Why Digital Video? **1**

Digital versus Analog Camcorders 2

Benefits of Desktop Video 4

Digital Video Equipment 5

Plan Your Video 9

Shoot Your Video 13

Set Your Focus 15

In This Chapter... 21

Chapter 2 ▪ Compose, Light, and Shoot **23**

An Introduction to Camera Shots 24

Advanced Shooting Techniques 33

Video Composition Tips 38

Techniques for Filming People 44

Microphone Choices 47

Video Lighting Tips 51

Build a Home Studio 56

Dress Your Set 58

In This Chapter... 59

Chapter 3 ▪ Video Tech Talk **61**

TV Basics 62

Video Quality 67

Digital Video Basics 73

Video Storage Media 76

In This Chapter... 79

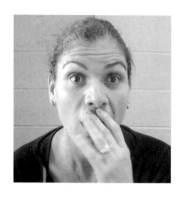

Chapter 4 ▪ Transfer Video to Your Computer **81**

Prepare Your Digital Video Camera
 for Transfer 82

Prepare to Transfer from an Analog Source 85

Prepare to Transfer Analog Video with a
 Non-1394 Digitizer 90

Bring Over Your Data 93

Avoid Dropped Frames 94

In This Chapter... 96

Chapter 5 ▪ Video-Editing Techniques **99**

Split and Trim Clips 100

Assemble a Rough Cut 102

Add Effects to Enhance the Story 107

Add a Soundtrack 114

In This Chapter... 119

Chapter 6 ▪ iMovie Simplified **121**

The iMovie Interface 122

Manage Your Projects 125

Import Video and Pictures 125

Manage Your Clips 127

Manage Your Video's Sound 129

Add Wipes and Other Special Effects 131

Add Titles to Your Footage 137

Export Your Movie 139

In This Chapter... 141

Chapter 7 ▪ VideoStudio Skills **143**

The VideoStudio Interface 144

Manage Your Projects 145

Import Video and Pictures 147

Manage Your Clips 150

Manage Your Video's Sound 152

Add Special Effects 153

Overlay Text or Pictures 155

Create Your Movie 157

In This Chapter... 158

Chapter 8 ▪ Burn Your Movies to DVD and VCD 159

DVD and Video-on-CD Technologies 160

Burn a DVD or VCD 162

VCD Compatibility Issues 164

Focus on DVD and VCD Production with
 Ulead VideoStudio 6 166

Focus on Nero 5.5 and TMPGEnc 172

Focus on iDVD 176

Focus on Toast Titanium 182

In This Chapter... 184

**Chapter 9 ▪ Share Your Movies with
 Streaming Video 185**

Why Choose Streaming Video? 186

Streaming Basics 186

Streaming Video Considerations 189

Create Streaming Video 190

Find a Streaming Host Site 192

In This Chapter... 194

**Chapter 10 ▪ Export Your Movies to TV,
 Tape, and More 195**

Export through Your Camera 196

Export through a Converter Box 197

Record Using TV-Out 198

Save to Alternative Media 200

PAL Format versus NTSC Format 203

In This Chapter... 204

Chapter 11 ■ **Digital Video Fun** **205**

Stage a Disappearing Act 206

Create a Montage 211

Create Animations 211

Shake, Rattle, and Roll—
 Create Your Own Earthquake 216

Create Time-Reverse Effects 218

Produce Mind Teasers 222

Use Focus Effects 226

Use Sound Creatively 227

In This Chapter... 231

Glossary **233**

Index 244

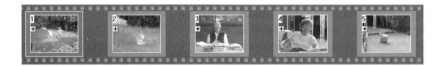

Introduction

I fell in love with moviemaking when I took my first film course back in 1981.
At that time, I shot my movies using Super-8 film. I would mail the reels to the processing
lab and wait in breathless anticipation for them to come back. It usually took about two
weeks. When they arrived, I would cut and splice the footage by hand. This took a very long
time and required a manual adeptness that I never really seemed to master, even though I
thoroughly enjoyed the process. I remember sitting over the viewing, cutting, and splicing
equipment and thinking that there had to be a better and easier way to do things.

By the mid-1980s, things got better. I started working at a lab where I had access to
video-production equipment. In 1984, I produced my first video (SigGraph 1985 Video
Review, "Mr. Yorick Skull Gets Ahead in Life"). Videotape certainly made movie production
a lot better and easier. I didn't need to wait for the processing lab. My footage was ready to
use the instant I shot it. I didn't need to cut film—and sometimes my fingertips—apart, and
I didn't need to use splicing tape anymore. Still, it took hours and hours, as I sat between a
couple of hot, heavy, and expensive tape decks and carefully assembled each segment in
order. When I messed up, which happened a little more often than I care to admit, I needed
to go back and reassemble the bits I destroyed—usually the entire video. I knew there still
had to be a better and easier way to do things.

Throughout the 1990s, things continued to improve. By the mid-1990s, I used interactive
editing boards and rudimentary computer programs to sequence and title my videos. But
things didn't really come together until the turn of the millennium. It was then that personal
video production leapt forward because of an amazing innovation: the IEEE 1394 standard.

IEEE 1394, better known as FireWire or I-LINK, was developed by a large consortium of
video camera manufacturers. This standard introduced a computer-controllable camera that
produced very high-quality digital movies. It meant that you could easily connect your com-
puter and interactively access and edit that high-quality video. All that was missing was the
affordable editing suite—the computer software to make everything fall together.

At first, Apple's iMovie dominated the scene, taking advantage of the 1394 power with a
straightforward and elegant program design. It threw the doors of video editing wide open
for consumers. Soon the magic spread to the PC. Influenced by iMovie's user-friendliness,

manufacturers of video-editing software began to rethink their interfaces. They provided easier-to-use suites that simplified movie production without sacrificing power.

And the magic didn't stop there. Affordable converter cards and converter boxes soon opened the door for those people with older (non-1394) camcorders who wanted in on the revolution. Anyone who wanted to could now bring their old home videos into the digital world.

Today, digital video is there for the asking. Whether you're producing home movies or business videos, on videotape or DVD, on a PC or Macintosh, this technology has fully entered the consumer market. Nothing more stands in the way of the aspiring moviemaker.

How This Book Is Organized

Digital Video Essentials: Shoot, Transfer, Edit, Share (which is updated from *Digital Video! I Didn't Know You Could Do That...*) offers a complete introduction to video filming and production. Topics range from filming high-quality videos, to transferring your footage to a computer, to editing with sense and creativity, and to publishing your video on disc, tape, and the Web. If you want to know how to shoot, transfer, edit, and produce video, this book will guide you through the most important and vital steps, while providing interesting and diverting options.

Here's a chapter-by-chapter summary of what you'll find in this book:

Chapter 1, "Why Digital Video?" Learn the difference between analog and digital video cameras and how you can use either one to create digital video on your computer. Get some tips on the different ways that you can use digital video in your home, business, or school. Learn how to efficiently plan and execute your video shoots. Discover what you need to bring along when you hit the road to shoot your movie. Finally, explore some focusing techniques.

Chapter 2, "Compose, Light, and Shoot" Learn the techniques that lie behind the video. Discover which shots (such as close-ups and establishing shots) and camera moves you can use to put together an interesting movie. Learn how to compose, light, and frame your subjects. Understand the role of sound and microphones in your productions. Find out what you need to set up a home studio, and learn how to encourage your subjects to relax while you film them.

Chapter 3, "Video Tech Talk" Expand your knowledge of the technology that drives digital video. Learn about TVs, country systems, video quality, and compression. Round this out with an overview of video cameras and output formats.

Chapter 4, "Transfer Video to Your Computer" Discover how to hook up your camera to your computer and transfer your footage. Step-by-step instructions guide you through all aspects of transferring analog or digital video.

Chapter 5, "Video-Editing Techniques" Learn how to transform your raw footage into a finished, professional production. Discover how to trim and order video and audio clips, as well as how to add special effects and soundtracks to your movies.

Chapter 6, "iMovie Simplified" Learn how to use iMovie to edit your videos in this hands-on overview of the Apple product. This coverage includes many details and tricks associated with this superb video-editing software.

Chapter 7, "VideoStudio Skills" Start creating movies with VideoStudio. Learn many of the tips and tricks involved with using this Ulead software title. Discover how to import, edit, and customize your video.

Chapter 8, "Burn Your Movies to DVD and VCD" Learn how to design and burn your own DVDs and video CDs so you can share your video work with others. Discover the difference between DVD and Video-on-CD technologies and learn how you can jump on the bandwagon and start creating your own video discs. Explore your software options, including the Ulead DVD Plug-in (part of VideoStudio), iDVD, Nero 5.5, and Toast Titanium.

Chapter 9, "Share your Movies with Streaming Video" Find out how you can transmit your videos over the Internet. Learn the steps involved in shooting, compressing, and hosting your movies on the Web. Discover some of the most popular kinds of video-hosting solutions available today.

Chapter 10, "Export your Movies to TV, Tape, and More" Learn how to transfer your digital movie to videotape. Understand video format conversion, which may be necessary if you are sharing your videos with people in different countries. Explore some of the new stand-alone disc recording solutions that work like VCRs.

Chapter 11, "Digital Video Fun" Follow step-by-step instructions to add magical effects to your videos without needing special equipment or high-end software. Discover how you can make someone disappear, teach a candle to light itself, animate common objects, and use many more special effects to fool the eye. And you can watch videos that show these magical effects. There are sample videos for all of these projects on the CD that comes with this book.

In addition, you'll find a glossary at the back of this book. If you're unfamiliar with any of the terms you see in this book, check the glossary for the definition.

What's on the Accompanying CD?

The CD-ROM that accompanies *Digital Video Essentials: Shoot, Transfer, Edit, Share* is packed with demos and shareware that you can use with your digital video. Looking for a video editor? You'll find a full 30-day trial version of Ulead VideoStudio 6 editing package. Since this book offers introductory tutorials for both VideoStudio and iMovie (which comes bundled with new Macintosh computers), you'll quickly get up to speed editing your videos, whether you're using Windows or a Macintosh.

You'll also find time-limited and demo versions of the top encoding and CD-burning software. We've included Nero and TMPGEnc tools. Use these software packages to create and burn video on CDs with the CD-RW equipment you already own.

If you want to create streaming video, the CD has tools for that as well. We've included RealNetwork's HelixProducer and the QuickTime player. These packages allow you to encode and view streaming movies in every major format available today.

And that's not all. Your CD contains even more software to help you play, share, edit, and enhance your videos. Enjoy all the packages on your CD, but please be aware of each type of software found here.

Commercial demos These time-limited programs offer full functionality, but will work for only a specified period, typically 30 days. After this time, you may purchase a serial number that allows you to continue using the software indefinitely. Contact the software manufacturer for details.

Shareware Shareware packages are not free. They allow you to try the product before you buy it. Shareware works only when people take personal responsibility and pay for the software they actually use. Be responsible. If you like the software, send the requested fee to the developer. This helps keep shareware alive and available for the rest of us.

Freeware Yes, Virginia, you can get something for nothing. Some developers release certain software titles as freeware. You may use this software freely and owe nothing further to the developer. Still, nothing pleases freeware developers more than encouraging and grateful letters. It means a lot to them. If you use the software, why not spend a few minutes and write a thank you letter. It will make their day.

The CD also contains all the videos you will read about in Chapter 11, "Digital Video Fun." Watch them to see how you can have fun learning, using, and playing with special effects.

Why Digital Video?

Until recently, digital video belonged to the exclusive domain of film profes-sionals. Within the last few years, digital video equipment prices dropped, quality increased, and consumer-grade software appeared. With these changes, digital video leapt out of the unobtainable heights and landed on our desktops. Today, anyone with any sort of video camera can easily join the digital revolution. Affordable equipment and user-friendly editing suites provide the necessary tools to transform your computer into a digital-editing studio. All it takes is a bit of know-how and the desire to create videos. There's never been a better time to join in and learn exactly how you can plan, shoot, transfer, edit, and produce your video work.

This chapter covers the following topics:

- **Digital versus analog camcorders**
- **Benefits of desktop video**
- **Digital video equipment**
- **Plan your video**
- **Shoot your video**
- **Set your focus**

Digital versus Analog Camcorders

Today's digital video studios can capture footage from almost any type of video camera. Whether you use a traditional analog camcorder or one of the newer digital units, you'll be able to transform your footage to capture digital data and make movies. With the proper setup, you can transfer video to your computer from a low-end camcorder almost as easily as you can transfer it from a high-end camcorder. Once your video is transferred into your computer, the video camera difference disappears—digital data is digital data, no matter how it started out. When your video is in your computer, you can edit it to produce a wide range of video products.

If your video camera belongs to an earlier generation, you can easily digitize your traditional nondigital videos with a converter. Then your movies will be stored as data on your computer, ready to enhance, edit, and produce. Figure 1.1 illustrates how analog and digital camcorders work as a video source.

Digital Video Camera Features

As you would expect, the newer digital video technology has a lot to offer. Digital video (DV) cameras, or camcorders, have superb picture quality, as well as a lot of bells and whistles that you cannot find on older cameras. Keep the following factors in mind when you decide whether to upgrade your camera:

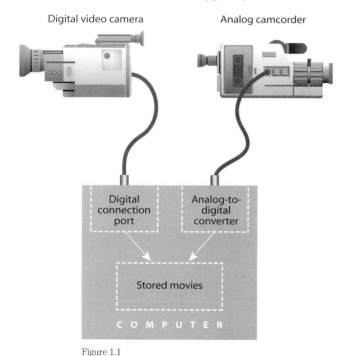

Figure 1.1

Set up your own digital studio with a digital video camera or a traditional analog camcorder.

Transfer quality When you transfer digital data within the digital domain, the copy you produce is identical to the original. Digital video never degrades between copies. Every copy is as perfect (or imperfect!) as the first.

Camera control Have you heard of FireWire or I-LINK? These trademarks (of Apple and Sony, respectively) refer to a single standard officially named IEEE 1394, a specification for a real-time, high-bandwidth connection between computers and electronics products. This standard allows your digital video camera to communicate with your computer at very high speeds. Now you can control your camera directly from your favorite movie-editing program. You can use your computer to play, fast forward, rewind, or pause your digital videotape to get to just the spot from which you want to record. You won't find this functionality on analog cameras.

Technological advances Technology always leaps forward. Newer digital cameras often contain higher-

quality optics and sensors than their predecessors. The better these features, the better the pictures you shoot. While this isn't strictly a matter of digital versus analog, you should be aware that newer, usually digital, equipment produces better footage than older, usually analog, cameras.

Resolution Resolution refers to the degree of detail you can capture with your camera. As picture resolution increases, the camera captures more and more information. The higher the resolution, the better the image quality you'll record. Digital video cameras can produce pictures with about double the resolution that you can capture on a traditional analog video system. Read more about resolution in Chapter 3, "Video Tech Talk."

Sound Digital video cameras capture CD-quality sound, which is two channels of sound (stereo) sampled with 16-bit resolution at 44.1 kilohertz (KHz). In fact, most digital video cameras capture sound at better-than-CD quality.

Size Digital video cameras are generally much smaller and lighter than older camcorders. You can literally stick some of the newer models into a shirt pocket. This feature alone makes new digital video systems extremely attractive to travelers, businesspeople, or others who value advanced technology in a small package.

All of these features provide power and flexibility to the digital video camera owner. You won't find these features on older, analog units.

Analog Camera Features

Unlike the data captured with a digital video camera, analog video quality does not hold up well between transfers. With analog data, you lose information every time you make a copy. You've probably seen this when you've made a copy of a copy of a copy of a videotape. This outcome is called the *generation effect*. Each new copy becomes fuzzier and less watchable.

Another thing that adversely affects analog video is the digitization process itself. When you use an analog-to-digital converter (ADC), also known as a *digitizer*, to transfer your traditional movies to digital format, you invariably introduce random and unintended changes to your video. These changes are called *noise*, and like the generation effect, they tend to blur your pictures to some extent. Of course, once you've converted your video to digital format, you won't lose any more quality with subsequent copies. Still, you should be aware that the conversion process degrades your video.

But the news is not all bad. Analog camcorders do offer some advantages:

Camera cost Analog camcorders cost much less than digital video cameras. You can find a wide selection of analog cameras for less than $400. You would be hard-pressed to find a decent digital setup for that price.

Tape cost and length Cassettes for digital video cameras are both expensive and short. In general, you can record 60 to 90 minutes on a digital videotape, which costs from $5 to $10. Tapes for analog camcorders cost less and record several hours of footage. You can buy a VHS-C cassette for less than $5.

Convenience You're likely to find batteries and tapes for your analog camcorder at a convenience store, drugstore, or supermarket, many of which are open late at night. For a high-tech digital video setup, you may need to shop at more specialized stores. Don't underestimate the value of easy access to important supplies.

TV viewing Surprisingly enough, an ADC for your home computer can cost about the same as an IEEE 1394 setup for connecting a digital video camcorder. (These setups are discussed in the "Digital Video Equipment" section later in this chapter.) You won't get the same quality, but you gain one useful feature: Many of these converter cards also let you watch TV on your desktop.

Benefits of Desktop Video

Digital video arrives on your desktop in either of two ways: A digital video camera can transfer the data directly, or a digitizer (ADC) can convert from analog to digital. It doesn't matter which approach you use. Once your digital video is transferred to your computer, you're all set to massage, tweak, edit, and transform that footage into a quality production.

Given the power and flexibility of today's PCs, your desktop can become your own personal video-editing studio, where you can produce videos for all sorts of needs and projects. Here are just a few ideas:

Capture the moment and the event Whether you record weddings, birthdays, parties, or trips, a video camera allows you to turn a fleeting moment into a lasting record of an important time. Use your video camera to capture those sights and sounds so you can experience them over and over again.

Build memories Your family grows and changes far too fast. Grab hold of the present. Spend time taping your children, relatives, and pets. You'll build a precious collection of memories and a record of changing times. See Figure 1.2 for some examples.

Share your family With today's global society, we're so spread out that it is hard to stay connected. Family videos, especially well-edited videos that are short enough to encourage viewing, can help us stay in virtual touch with friends and family. When grandparents retire to Florida or a cousin gets posted overseas, a video can help maintain that loving connection.

Figure 1.2

A video camera captures special family moments in a way that still pictures can never match.

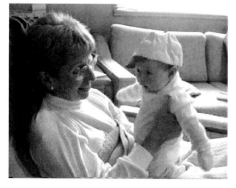

Expand your business More and more companies are employing digital video in their day-to-day operations. Use video to help sell your product line, educate your customers, and train your employees. Design your own Internet- or TV-based advertisements. Introduce online how-to videos to supplement customer support. Create permanent records of important meetings, especially brainstorming sessions. The possibilities are endless.

Create a school project If a picture is worth a thousand words, then a video must be worth at least ten thousand. Video provides the perfect accompaniment to any science fair project—just use your camcorder to help record data. Create a skit for your language class. Gather the neighborhood kids to demonstrate exactly how statistics really work. If you have a concept that you want to demonstrate, there is probably a way you can use video to get your point across.

Introduce an online curriculum Desktop video allows you to record, edit, and rebroadcast lectures with surprising ease. Make digital video the centerpiece of your online courses or an ancillary to your classroom courses.

Edit and preserve archives Every year, we lose so many memories to time and entropy. Transfer your old analog archives to digital format to ensure their preservation. At the same time, you can add narration and other annotation to help bring living memory and recorded memory together for all time.

Make your own feature film How about making your own movie or documentary? Today's software offers enough sophistication to make this feasible. Creating your own feature can be challenging, fun, and a great learning experience.

Digital Video Equipment

To get started in digital video, you need only three things: a video camera, a computer, and a connection between the two. Once you create this link and can transfer your images to your computer, you're well on your way. As you might expect, the technology available for digital video varies widely, particularly in terms of price, features, and quality. You can put your video studio together cheaply, or you can choose to go upscale. This section describes three kinds of setups: medium to high-end, analog, and low-budget. Keep in mind that no matter which approach you choose, the endpoint remains the same: You get digitized footage that you can edit, enhance, and distribute.

A Medium to High-End Setup

If you're ready to spend some money, you can take advantage of cutting-edge technology. Today's basic digital studio centers on the IEEE 1394 standard, which makes it possible for your computer and your camera to communicate, and for you to perform high-quality video transfers. In the U.S., this standard is often called FireWire (but strictly speaking, FireWire is a trademark of Apple Computer). Another name for 1394 is Sony's I-LINK (which is more popular in Japan).

To take advantage of FireWire or I-LINK, you must own a 1394-enabled digital video camera and a computer equipped with a 1394 port. Most Macintosh computers, particularly iMacs, ship with FireWire ports. Many PCs do not come with a 1394 port, but it's usually simple and inexpensive to add one. You can purchase a good-quality 1394 PCI card for your PC for about $50-$80.

> You'll need a fairly modern operating system for 1394. Windows 98 Second Edition, Windows Millennium Edition (Me), Windows 2000, and Windows XP support IEEE 1394. Earlier PC operating systems do not support 1394.

Along with the 1394 video camera and port, here are the elements of a medium to high-end setup for digital video:

Digital video camera Digital video camcorders can be pricey. Expect your camcorder to cost $500 to $700—possibly more (sometimes a lot more). As with most things, you get what you pay for. For example, a budget JVC model has few features. In particular, it does not have a microphone-in port (for hooking up an external microphone, as described in Chapter 2, "Compose, Light, and Shoot"). On the other hand, it takes excellent videos, so it might suit your needs. Unsurprisingly, higher-end digital video cameras provide more features and better optics.

Incidentals Expect to spend money on incidentals: tapes, cables, batteries, and so on. Digital videotapes, such as MiniDV or Sony's Digital8, can cost $5 to $10 each. 1394 cables are moderately expensive. Manufacturer-specific spare batteries can be costly.

> The Sony Digital8 line offers some exciting advantages to the aspiring videographer. Not only do these camcorders provide analog input and output, but they also play Hi8 tapes. Hook up to a 1394 connection, and the camera automatically digitizes the Hi8 tape to digital video format.

A video-capable computer Nothing eats up megabytes quite like digital video. Each minute of standard digital video footage takes up about 200 megabytes (MB). Yes, you read that right—*200MB per minute*! A 5-minute video will easily occupy a gigabyte (GB) of disk space. Your computer needs at least a 40GB hard drive; an 80GB, 120GB, or larger hard drive is better. Having several large disks works very well. Digital video is memory-intensive, so the more memory you install, the better off you'll be. Yes, you can get by with 128MB of RAM, but 256MB are a lot better, and 512MB will make your life much easier. Finally, you'll want a decent-sized monitor. Whenever you sit down to edit your videos, you'll find that your screen gets cluttered quickly. A nice large screen, 17 inches or bigger, can help keep your projects under control (at least visually).

> A speedier computer really does make a huge difference in the world of digital video. I regularly feel I've stepped back a couple of decades as I go find something else to do while my system crunches through a compression or special effect.

Support equipment Good equipment can include lighting accessories, sound system items, and so on. For example, you might want to invest in a high-quality set of silver-coated reflectors, or you might pick up a wireless lavalier microphone. Just stop by any camera and video shop to browse through the huge selection of accessories.

A typical setup can run between $1,000 and $3,000. Before you collapse from sticker shock, keep in mind that prices for digital video equipment and computers continue to drop. Also, you might consider purchasing a "bundle" computer or a used system. A bundle computer is a complete system that targets the digital video audience, such an iMac or one of the new "studio" systems from Dell and Compaq. This allows you to save money by purchasing a complete setup rather than assembling your order à la carte. Or, if you're willing to consider a used or refurbished system, you'll find that last year's technology offers this year's bargains. Look for systems with distinguished brand names and reputable warranties.

An Analog Setup

Do you own an analog camcorder? Do you want to work with older or archival videotapes or with TV footage? You'll find that a 1394-based desktop still offers the highest-quality editing and production tools, even with analog data. FireWire converter boxes allow you to transform your analog video into a standard digital video stream. However, don't expect digital video camera quality. When you use an analog camcorder to record your footage, that sets the quality of the video you stream into your computer.

For your analog setup, you'll need to buy or borrow a converter box that produces video output as well as video input. For a few hundred dollars, you can purchase a converter unit, such as Canopus's ADVC-100, Dazzle's Hollywood DV-Bridge, and Miglia's Director's Cut (shown in Figure 1.3), to bridge the gap between analog and 1394. To transfer video to your computer, hook your converter box into a 1394 port, connect your video source, and you can treat the video stream just like any other digital video data. To export your video from your computer to your VCR, just hook the output to your VCR's input jacks, switch from Capture mode to Export mode, and press the Record button on the VCR. Chapter 4, "Transfer Video to Your Computer," and Chapter 10, "Export Your Movies to TV and Tape," explain how to use converter boxes.

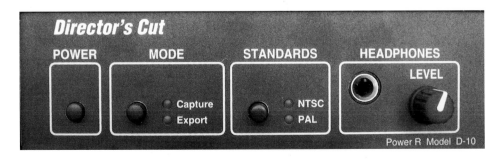

Figure 1.3

An external converter box allows you to import analog footage into your computer and export digital footage to your TV or VCR.

With an analog setup, be prepared for the lack of camera control. If you're spoiled by the instant feedback and control available with digital video camcorders, you'll miss it here. For example, when you click the Rewind button on your computer screen, the analog signal won't rewind.

A Low-Budget Setup

FireWire does not provide the only route to desktop video. Video solutions have been around for quite a while. You can find video-capture devices, including digitizing cards and capture boxes, to work with your older computer and older camcorder. Although these devices won't match the high quality, speed, and convenience of a 1394-based system, you'll still be able to import, edit, and work with video. Here are some of your choices:

USB video-capture devices Literally dozens of products now allow you to capture video through a Universal Serial Bus (USB) port. If your computer supports USB, you can pick up one of these video-capture boxes for less than $150 (and often for under $50). Like any other type of digitizer, a video-capture device converts analog video to digital. In this case, it uses the USB connection to transfer the video to your hard disk. For a Mac or PC with USB support, look for these features at a minimum: 300 megahertz (MHz) clock speed, 96MB of RAM, and 1GB hard disk. (Some experts would recommend at least a 3GB to 5GB hard disk; 1GB is the minimum.)

Newer USB-2 connections and video devices work far better than the original USB ones. They approach 1394 quality in some instances.

Parallel port video-capture devices Parallel port capture provides another video alternative. This solution is aimed strictly at Windows PC users. These units plug into your PC's parallel port and provide a link that transfers the digitized video. If your computer does not support USB, or if you're looking for an alternative to USB digitizers, a parallel port solution may work for you. Be aware that most parallel port digitizers use fairly low frame rates; that is, they capture fewer picture frames per second than other digitizers do. (See Chapter 3 for information about frame rates.)

Some parallel port video-capture units do not capture sound. Many rely on your computer's sound card to do so. This can cause problems when you're trying to synchronize video and sound.

TV tuner cards Many TV tuner cards lead double lives as video-capture devices. For example, an old ixTV card can work in a vintage (pre-USB, PowerPC) Macintosh. It will let you watch TV on your computer desktop and allow you to digitize video (albeit badly—it produces noisy, low-quality video). These cards can provide inexpensive, quick, and convenient video-capture

solutions. They usually cost under $75, or even less than $30 with rebates. Most require a spare PCI slot.

These digitizers work with analog and digital camcorders, as well as TV signals and VCRs. When you bypass FireWire in favor of simple digitizers, you can use practically any type of analog video input. This allows you to digitize archival materials such as family videos and bring them into the Internet age.

With an analog setup, your storage needs and equipment demands are lower than those for the digital version. You can use older computers with less RAM, processor speed, and hard disk storage. The non-FireWire digitizers do not demand anything like FireWire's extraordinary 200MB of disk space per minute of footage. Instead, you can expect to consume about 1MB to 10MB per minute (the amount varies with frame size and the quality of the video you capture). This allows you to work with older, more budget-minded resources.

> Contrary to what you might expect, low-quality video occupies more hard disk space at the same frame rate and frame size. As the signal quality decreases, the amount of noise increases. This makes video harder to compress and produces larger files.

A possible downside to an analog setup is that the resolution of your video will be lower than with a digital setup. *Resolution* refers to the number of pixels, or picture elements, that occupy a single video frame. As the resolution increases, so does the image quality. Most of the devices for digitizing video are optimized to capture at 160×120 or 320×240 pixels per frame. (See Chapter 3 for more information about resolution.) That's just a fraction of the resolution you can obtain with FireWire, but it's perfect for streaming media (sending video across the Internet). Many consumer-grade digitizers capture directly to AVI or QuickTime formats, which convert easily and quickly to streaming media. (See Chapter 9, "Share Your Movies with Streaming Video," for details on streaming media.)

Plan Your Video

The key to a successful video project is planning before you start shooting. The more you prepare, the more likely you are to capture the scene or event in the way that you intend. Before you pick up your camcorder, ask yourself the following questions.

Why are you doing this? Decide what you're trying to accomplish by making this video. Select a single goal. Are you trying to bring about more than one end? If so, stop and rethink. A video should serve a single purpose.

Who will see your video? Think about your audience members and their needs. Will your audience be elderly, needing clear and distinct audio? Will your audience be very young, needing simple exposition? Will your audience be professional, understanding technical jargon? Will your audience include students, mandating a clear and logical tutorial approach? Target your video to your particular audience.

In what context will your video be seen? Will you have a "captive" audience, sitting down and, ideally, glued to your presentation? Or will your video need to grab attention and play to a more distracted crowd? Allow context to shape and direct your video.

How long should your video last? Good videos should leave your audiences wanting more. Viewers shouldn't sneak away, covering their yawns and making polite excuses. Determine the amount of material to cover and the nature of your audience, and find a balance between the two. A video should never outstay its welcome.

How polished and professional must your video be? For some purposes, quick-and-dirty does the job. Any time and effort beyond that are wasted. For other purposes, a clean, elegant, and professional production creates an image that reflects back on you. Small flourishes and attention to fine detail will pay for themselves. Most efforts fall somewhere between quick-and-dirty and professional. Decide the quality level that meets your needs and strive toward it. Any effort above that will prove pointless. Any less will prove costly.

How will you distribute your video? Digital video allows you to share your movies both in old ways, like videotape, and new ways, like DVD and Internet streaming video. Today's technology offers a variety of production methods that allow flexibility and diversity in distribution. When possible, think about distribution before you begin filming. The medium you use to distribute your video affects the way you plan and record. Lush and detailed backgrounds that reproduce excellently on video or DVD will be lost in streaming media, or they may simply prove confusing and ugly. (See Chapter 3 for details on the various types of distribution media.)

Make a Script and Storyboard

The suggestion that you should "script and storyboard" a home video might make you burst out in laughter. These are home movies, right? You pick up the camera and shoot some footage. Memories captured and job done—right? Wrong. Some preparation can make the difference between a good video and a bad one.

Scripting and storyboarding do not mean that you spend hours planning the perfect shots for an Oscar-winning featurette. Scripting and storyboarding can mean that you spend a few minutes (or even seconds) thinking, making notes to yourself, and perhaps writing down some ideas and creating a game plan. These techniques can transform your video projects—whether large or small—from chaos to order.

Scripting

As an example, say that you're going to tape your grandmother during a family reunion. Get out a piece of paper and write down some topics to talk about. Perhaps you want to ask her about her memories of the war, or maybe you want to know what mom was like growing up (inevitable answer: "She was a handful!"). By listing topics and questions, you go into the

taping session prepared. You have things to talk about and ideas to pursue. This may not seem like much, but this is scripting, and it allows you to plan and structure your video's subject matter.

Scripting can range from some basic notes to a fully specified screenplay. The level of scripting you need depends on the purpose of your video and how much control you need over its content. Home videos generally need very little scripting—just a few well-thought notes can do the job. Business and instructional videos often follow precise scripts. Choose the approach that works best for you. Just remember that even informal videos will benefit from a little scripting. Scripts can aid you in several ways:

- Remember key points and questions.
- Maintain structure and direction, so you don't end up with a video that meanders through topics.
- Fill your time with quality material and a minimum of ers, ahs, and blank looks.

Storyboarding

Just as scripting helps you plan the content of your video, storyboarding specifies visual elements. Storyboarding allows you to think about, plan, and allocate time to shoot your material. If you think that storyboarding won't help you with informal videos, think again. Storyboarding prevents you from missing visual details that will enhance your story, such as stage-setting shots and transitional scenes.

Traditionally, a storyboard looks like a small cartoon, where you sketch the look of your scenes, with a brief description of each scene's action, as shown in Figure 1.4.

Your storyboards do not need to be as formal as the example in Figure 1.4. Even the roughest sketch will do. If you simply cannot draw, a list of shots will serve just as well. Figure 1.5 shows an example of a very informal, list-style storyboard for an interview. As long as you focus on visual planning, any quality of storyboard will help.

The informal list in Figure 1.5 demonstrates some of the videographer's staples:

- A wide-angle shot that establishes the location of your video shoot. (Exterior shots work particularly well.)

Establishing shot of sign

I am Marc the Magician and I will perform acts of wonder and delight

Behold! (hand enters and leaves cleanly)

I shall knock this tower down!

(Tower falls)

Now I shall wave my magic wand

Abracadabra! I command you to…

Reassemble! (run the falling footage backwards)

Ta-da!!! (and applause)

Figure 1.4

A storyboard with small pictures helps you plan the look and flow of your video. Each picture shows the approximate camera angle and composition for that shot.

- Shots of parts of the room that you wouldn't normally see during an interview. Shoot footage of furniture, bureaus, shelves, and so forth. These shots help establish the feel and setting of a room.

- Shots of possessions that help define the person you're profiling. Consider shots of a changing table for a baby, a cluttered desk for a businessman, the bride and groom's gift and cake tables, a scrub sink for a doctor, and so forth.

Ideally, your storyboard will provide you with an ordered presentation that mimics the final video. In the real world, even if you're not sure in advance how you will use additional shots, it's worth anticipating them by making a list. Chapter 2 introduces some shots that you can use to build your storyboards.

Understand the Event

Figure 1.5

A simple, list-style storyboard can help you plan your shots.

Whenever you videotape an event of any sort, spend time understanding its structure. Many events—even informal ones—have some sort of schedule. At the family picnic, everyone might hang around for a while before the big Frisbee game. When you know a schedule, you can anticipate events and prepare to capture them on video.

The more structured the event, the better you'll be able to plan. Always allow time for preparation and setup. Let the schedule guide and assist you, rather than work against you. By studying the timeline, you can prepare your shooting agenda and stay on top of things during busy and confusing affairs. Planning and timing go hand in hand.

1. Exterior shot of Nellie's house to be used to introduce the piece, with Nellie's voice-over.

2. Footage of Nellie during interview, interspersed with the following footage:

 - Her hand as she talks. Get some extra footage of this. She makes very elegant hand gestures

 - Her knickknack collection, particularly the mini-busts of great composers

 - Nellie playing the piano, herself

 - If possible, Nellie instructing a student during a lesson

 - Shots of shelves with all her music

 - Nellie walking down a street in her neighborhood

3. Footage of interviewer—on site—asking each of the key questions (see list). Try to get some shots over Nellie's shoulder to get a point of view effect.

4. For closing, Nellie saying goodbye to interviewer at door.

Scout Your Locations

Always keep your eyes open for good shooting locations. Whether you're already on location to shoot a particular event or just driving around during your own time, learn to see the world like a videographer. Be curious and explore so that you can find new places.

Learn to ask yourself what it would take to make a location work. Think about different camera angles, props, light, and the time of day. Collect great locations, including those that you can use right away and those that you can save for future video shoots.

Shoot Your Video

All the planning in the world comes to naught if you don't actually go out and shoot some video. The following sections will get you started with some suggestions for supplies and some shooting tips. Chapter 2 provides more details on shooting techniques.

Supplies for Shooting Video

When you're packing up for your video shoot, don't forget to bring a fully charged battery (and perhaps a spare battery), tape to record on, and, of course, your video camera itself. Also consider bringing the following supplies:

- Take a tripod to steady your camera. Consider your tripod as one of the most important pieces of your video equipment. (See the next section for details.)

- You may want to take a soft lens cloth to clean your lens and/or liquid crystal display (LCD).

- Pack up any sound and light equipment you'll be using and bring it along. Don't forget the microphones, reflectors, extra bulbs, and other accessories that you might need.

- Don't forget the duct tape—you never know when it will come in handy. For example, you can use duct tape to hang backdrops, fix your camera case, reattach a loose lens cap to the string, and hold branches out of the way.

- Bring any optional lenses and attachments you'll be using with your video camera.

- Pack an AC adapter cord if you plan to shoot for extended periods indoors or near outdoor electrical outlets.

- If your camera has an external battery charger, carry it with you.

- Take your camera's operation manual. Most manuals are small and sized to fit into a camera bag. You never know when some instructions will come in handy.

Set Up the Tripod

You can vastly improve your video footage simply by using a tripod. No matter how superb the auto-focus and stabilization system, unsteadiness will ruin your shot. Tripods steady your camera to help avoid that shaky, hard-to-watch look.

Nearly every digital video camera comes equipped with a tripod-compliant screw hole at the bottom. To mount your video camera on most tripods, do the following:

1. Remove the mounting screw from your tripod. Often this involves turning a release latch.

2. Fasten the screw to the hole at the bottom of your camera. Twist the mount until it has a firm seating and will not wiggle.

3. Place the video camera on the tripod, inserting the mounting mechanism into the appropriate opening.

4. Tighten the mount to provide a steady grip on your video camera.

Be careful if you occasionally leave the mounting screw on your camera after you're finished with the tripod. While this is convenient when you're going back and forth between editing and shooting, it can prove hazardous as well. The mount prevents you from laying you camera down properly on a table or desk. This introduces a knocking-over hazard that can be potentially tragic for your camera.

If your tripod offers horizontal and vertical rotation, practice using these features before attempting to pan or tilt. Learn how to perform these actions smoothly. If your tripod jerks or hesitates during this motion, you might want to adjust and/or oil the mechanism so that the tripod travels more smoothly.

Standard TV versus Wide-Screen Format

Many digital video cameras now have a feature that lets you shoot in either standard TV or wide-screen format, which means that you can choose between two aspect ratios. An *aspect ratio* refers to the proportion between the width and height of the image you record. For standard TV, this ratio is 4:3. For wide screen, it is 16:9. Either way, the camera stores the data as standard-sized frames on your digital videotape.

In the case of wide-screen format, one of two things occurs. In the first, more frequent case, these frames are somewhat squashed horizontally during recording and stored in their squashed form. In the second case, black bands are added to the top and bottom. The actual video occupies less of the frame. This is called *letterbox* format.

On output, video cameras will restore the wide-screen frames. To do so, they either stretch the frame to restore the original aspect ratio or crop the black bands to fit the screen. When viewed on a standard TV, these wide-screen presentations will generally display in letterbox format. However, some digital video cameras may display the full-screen squashed look instead. Avoid using wide-screen settings (16:9 aspect ratio) when you plan to output your video to a standard TV.

Shooting Tips

Here are a few tips that should help you when you get ready to go out and shoot your video.

Don't skimp on the footage Brevity and conciseness provide excellent goals for edited video, but while you're onsite, it's a good idea to shoot extra footage. Allow extra time to pad your shots, both before and after, to avoid abrupt transitions during editing. When shooting backgrounds, scenery, establishing shots, and so on, spend a little extra time recording more footage. At a minimum, shoot for at least 10 seconds.

Keep your picture quality high Always use your camera's best settings. Some digital video cameras allow you to choose from a variety of options. Set the highest image resolution possible. By starting with the best settings, you begin with the best raw material.

Keep your sound quality high Record your best-quality sound. Most digital video cameras allow you to record using 16-bit CD-quality stereo sound. This recording level places almost no additional demands on your camera. If sound is particularly important to what you are shooting (a piano recital, for example) use high-quality, externally mounted microphones where possible.

> Pay special attention to sound. Always use the best microphone you can, properly set up with high enough levels and no distortion. Poorly captured sound cannot be fixed "in the mix" when you're ready to edit your footage. See Chapter 2 for more information about microphones.

Avoid built-in special effects Many digital video cameras proudly announce a wide variety of special effects as selling points. In general, you should skip them. You can always add similar or better special effects during the editing process. Don't destroy precious moments by introducing wacky special effects that you'll regret later.

Seize the moment When something happens, pick up your camera and start it rolling. Imagine you are witnessing a bank robbery in progress or your child's first smile. The sooner you get your camera in action, the better the chance that you'll capture important events. When you worry too much and too long about focus, exposure, and so on, you might end up with a perfectly lit, composed, and focused shot of an empty alley or a sleeping child.

Set Your Focus

While your video camera's auto-focus mechanism can simplify shooting, it can introduce problems, too. In general, auto-focus allows you to shoot your videos without needing to think about setting your focus. This lets you concentrate on the content of your pictures without worrying about the optics.

Auto-focus typically works by shooting out a sonar beam and measuring how long it takes to bounce back. This lets your video camera know the distance to your subject and, therefore, how to set the lenses to create an in-focus photo. Some video cameras use infrared (IR) technology to achieve the same effect. Most video cameras use a "focus detection zone," usually located at the center of your picture. The range finder targets this zone to stay in focus. Unfortunately, auto-focus doesn't always work the way it should. Here are some problems you may encounter:

- An off-center subject can fool your range finder into picking the wrong focus settings.

- A moving subject in an otherwise still frame can confuse your auto-focus mechanism. As the subject passes through the focus detection zone, the video camera must readjust.

- A fast subject can often move faster than auto-focus can adjust. You see this most pointedly when a child runs directly toward the video camera. The focus often cannot keep up.

- Multiple subjects can throw off auto-focus, especially when they appear at different distances.

- Low illumination introduces a particular focusing hazard. In low-light conditions, your video camera's iris must dilate widely to admit enough light to produce video images. This limits the depth of field (as explained in the next section) and makes precise focus a more difficult goal.

For all these reasons, it's best to learn to how to set your video camera's manual focus. By switching from automatic to manual focus, you gain better control over your video camera and avoid those constant focus changes that disrupt your video footage. Consult your manual for focusing details that pertain to your video camera model.

Manual focus works best during interviews or other "set" shots where your subject stays at a fixed distance. It can come in handy in other ways, too. For example, suppose that you want to film some establishing shots at a local mall. When you use manual settings to focus on the entrance to a store, people passing by will not introduce constant refocusing as they move through your focus zone.

Understand Depth of Field

To better understand focus, you need to learn about depth of field. *Depth of field* refers to the zone in which all elements appear in focus. Any objects in this range look sharp and clear in your video. Objects outside this range appear fuzzy and out of focus. Figure 1.6 shows an example. Notice how the first flower, falling within the proper range, remains in focus, while the second flower looks blurry.

Using zoom or wide-angle settings can affect your depth of field. Telephoto greatly reduces the range in which objects stay in focus. With zoom, maintaining correct focus becomes more exacting. When you move the video camera, even a little, your subject may appear out of focus because of the limited depth of field. In contrast, wide-angle settings offer a much larger in-focus range, as shown in Figure 1.7. This makes your video camera much more tolerant of small camera movements and shakes. Also, your subjects can move in a larger range closer to or away from the video camera before the camera must refocus.

The distance that your focal point is located from the camera can also affect the depth of field, as illustrated in Figure 1.8. The nearer the focal point, the smaller the depth of field. More distant focal points offer larger ranges in which objects remain in focus. You obtain the greatest depth of field by focusing on objects in the far distance, such as clouds or mountains.

While a distant focal point offers a very large depth of field, nearby subjects will still appear out of focus. Don't assume that the "greatest depth of field" means that all distances fall within your field of focus.

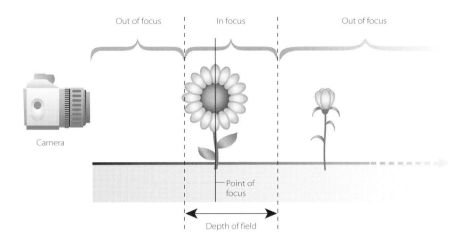

Out of focus In focus Out of focus

Camera

Point of focus

Depth of field

Figure 1.6

Your video camera's depth of field and point of focus determine which visual elements appear in focus.

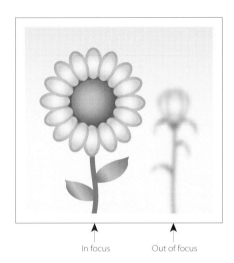

In focus Out of focus

The aperture levels on your video camera also affect the depth of field, as illustrated in Figure 1.9. The iris on your camera opens and closes to let in various amounts of light. This works just like the iris in your eye, dilating to adjust for light levels. The wider the opening, called the *aperture*, the more light flows through to your video camera's detectors. Smaller apertures let in less light. The smaller the aperture, the larger the depth of field; the larger the aperture, the smaller the depth of field. Even inexpensive video cameras, like an old analog camcorder or a low-end digital model, may allow you to set these aperture levels manually. Closing down the aperture works much like squinting your eyes.

Figure 1.7

Wide-angle settings produce larger and deeper depth of field than telephoto shots.

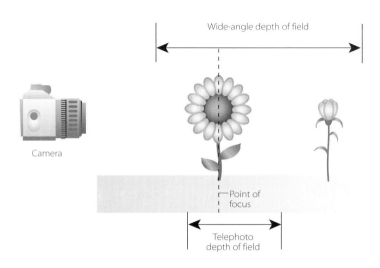

Wide-angle depth of field

Camera

Point of focus

Telephoto depth of field

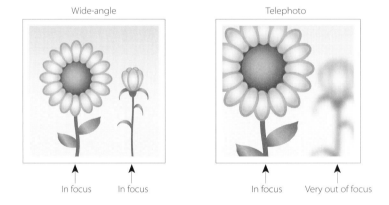

Wide-angle

Telephoto

In focus In focus

In focus Very out of focus

Figure 1.8

The distance to your point of focus will change the depth of field.

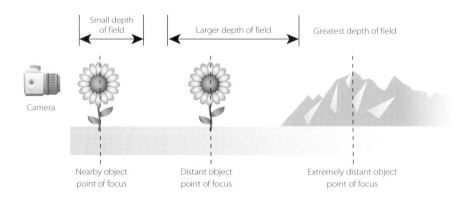

Small depth of field

Larger depth of field

Greatest depth of field

Camera

Nearby object point of focus

Distant object point of focus

Extremely distant object point of focus

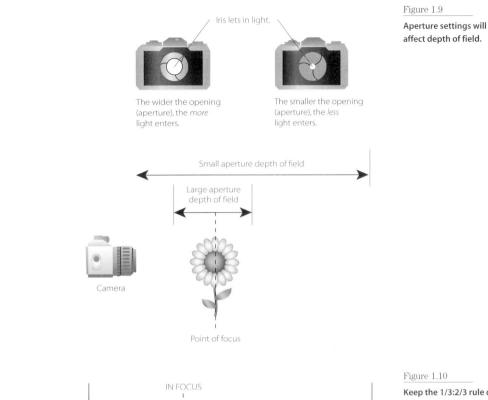

Figure 1.9

Aperture settings will affect depth of field.

Iris lets in light.

The wider the opening (aperture), the *more* light enters.

The smaller the opening (aperture), the *less* light enters.

Small aperture depth of field

Large aperture depth of field

Camera

Point of focus

Figure 1.10

Keep the 1/3:2/3 rule of focus in mind when choosing a focal point.

IN FOCUS

Camera

Approximately 1/3 of depth of field

Approximately 2/3 of depth of field

Point of focus

As illustrated in Figure 1.10, the range of the depth of field in front of and behind the focal point is not equal. The range of focus behind your focal point is always larger than the range in front of it. Keep this fact in mind whenever you set your focus and arrange your subjects. As a rule of thumb, about two-thirds of your field of focus lies behind and about one-third in front. When in doubt, always focus a little closer than farther away.

Focusing Tips

Here are some useful focusing techniques that can help you with your own projects:

Focus before the action When you plan to show a person entering your scene and sitting down, set your manual focus before shooting. Have the person sit down and make your focal adjustments. Once your focus is set, the subject can leave and then reenter while you shoot. As your subject sits again, your focus will be just right.

Focus before the zoom Set your focus for the end of a zoom. Here's how: First zoom in and adjust the focus for the zoomed picture, and then zoom out without changing any focal settings. Only then begin to record your shot.

Consider rack focus A special technique called *rack focus* offers a way to transfer attention between two elements in your scene. Pick two objects at different distances. Focus on the first so the second is out of focus. Then with the camera rolling, readjust the focus to bring the second object into clear view while defocusing the first. Rack focus introduces a dramatic visual transition. You'll see rack focus at work in Chapter 11, "Digital Video Fun."

Always keeps in mind that wide-angle settings offer better focus than telephoto. When you use a wide-angle setting, most of what you record will be sharp. When you zoom in to use telephoto, the depth of field shrinks. With zoomed-in shots, correct focus becomes much more critical, and small changes in camera position can cause big problems with focus.

WHITE BALANCE

White balance, also called *color temperature*, allows your video camera to set the sensitivity of its charge couple device (CCD) sensors to match the incoming light. This helps the camera adjust for color casts and overall contrast in a variety of lighting situations. As with focus, your camera can set the white balance automatically, or you can make manual white balance adjustments.

When working with special effects, such as those detailed in Chapter 11, you'll probably want to set your white balance manually. Several of the tricks described in that chapter rely on video techniques where a subject appears in just some of the shots. Manual white balance ensures that the contrast remains consistent between these shots.

If you wish to learn more about white balance, color temperature, and the entire field of photometry (the science of light and its properties), visit your library and pick up a book on basic photographic techniques. Kodak's Digital Learning Center provides an excellent how-to site at www.kodak.com/US/en/digital/dlc/index.jhtml.

In This Chapter...

This chapter covered many topics related to selecting your camcorder, planning your video, and shooting it. Here are a few important points you should keep in mind:

- Data is data. It doesn't matter whether your video originated as analog or digital. Once it's transferred to your computer, your video is digital information that you can use to build your movies.

- The IEEE-1394 standard provides superior-quality video fidelity and control. If you can afford to buy a digital camcorder and 1394 setup on your computer, go ahead and do so. You won't regret it.

- Nothing serves your video making better than foresight and thought. A well-planned video usually proves superior to an extemporaneous one. Scripting and storyboarding will help this process immensely.

- Learn about your video camera before you use it to shoot an important project. Your equipment comes with user manuals for a good reason.

- Probably the most important skill to master before you shoot is focusing. Know how to focus manually and learn how depth of field will affect your shots.

Compose, Light, and Shoot

In any type of video production, art plays as much of a role as technology. Shots, composition, sound, and light contribute to video excellence. How you set the camera, how you compose the view within your viewfinder, and how you capture sound and light all affect your video. Fortunately, there are a number of solid and useful rules that help you capture the best footage possible. In this chapter, you'll learn these rules and explore the visual language of video. You'll see how to apply this knowledge to your own video production work and discover why these techniques prove important to your final results.

This chapter covers the following topics:

- An introduction to camera shots
- Advanced shooting techniques
- Video composition tips
- Techniques for filming people
- Microphone choices
- Video lighting tips
- Build a home studio
- Dress your set

An Introduction to Camera Shots

Each time you start your camera rolling, you record a *shot*—an uninterrupted segment during which the camera does not stop. Press the record button, and you begin your shot. Press the button again, and you end your shot. Shots are the most basic and fundamental building blocks of videos.

Film and video pioneers have coined an entire language of shots. Each shot style performs a different function. Some shots help establish the mood and setting of your video; others bring you up close and personal with your subject; and some allow you to portray the interaction between several subjects. It's worth the time to become familiar with the most popular and useful of types of shots, so that you can incorporate them into your own videos. By learning the visual vocabulary of film and video, you will create more interesting and dynamic productions.

The Basic Shots

Three shots—close-up, medium, and wide—compose the most basic set of shots. As their names imply, these shots describe a relationship between the video camera and the apparent distance from the subject matter being recorded. The details for these shots are not fixed. It's up to you to combine distance and your video camera's zoom to set the exact way that you will fill your camera's frame.

You've certainly seen all three of these shots in action. Consider the filming of a televised talk show. A wide shot shows the entire stage, the interviewer, and the guest. It might even include parts of the audience. It introduces the atmosphere and the setting without narrowing in on any particular subject. A medium shot allows you to see just the interviewer and the guest. It brings you into the action at a comfortable distance, emulating the view from the better seats in the audience. A close-up on the face of the guest as she speaks establishes a direct connection with that person, so you feel like you are sitting in the other chair on the set.

Close-ups

A *close-up* focuses intensely on a particular subject. Close-ups take you right into the action. If you're filming a person, a close-up fills the field of view with that person's face. For your viewers, close-ups form the tightest relationship with your subject, as you can see in Figure 2.1.

There are a few caveats to consider when you're shooting close-ups. When you use your video camera's zoom to frame a close-up, you may encounter some geometric distortion. At extreme zoom, faces may seem to spread out with exaggerated features. Consider moving the camera closer instead of using a very high zoom. In addition, movements to and away from the video camera may appear slower than usual. Small changes in camera position appear more dramatic, so always use a tripod at high zoom to avoid shaky footage.

Wide Shots

A *wide shot* pulls away from your subjects to show them within a larger setting, as in Figure 2.2. Wide shots can portray a crowd, an event, or an entire landscape. A wide shot in a restaurant might depict groups of people eating at tables. A wide shot at the Grand Canyon might offer a panoramic view of the famous landmark. In general, wide shots give an overview and take you away from the mundane and particular.

When you use your video camera's wide-angle features, you'll notice better image stability. Wide-angle settings tend to hide shaking, making hand-held videos more stable. However, this setting also has side effects. People may appear to move faster than they really do, and facial features may tend to flatten out. Also, wide-angle shooting can exaggerate depth. It might make objects at different distances from the video camera seem farther apart than they really are. For example, if you've ever seen Alfred Hitchcock's *Psycho*, you may be surprised to know that the house is only a short distance from the Bates motel. Watch it again and count the steps as someone walks from the house.

Medium Shots

The *medium shot* falls between the close-up and the wide shot. Medium shots bring your subjects into clear view but without the close-up's intimacy. A medium shot typically includes your subject's face, shoulders, and torso. A common type of medium shot is the *fifty-fifty*, or *two-shot*, which is a camera angle that shows equal views of two subjects at once. Figure 2.3 is an example of a fifty-fifty medium shot.

Figure 2.1

A close-up generally shows the subject's shoulders and face. Close-ups create an intimate connection with your subject.

Figure 2.2

A wide shot shows the surrounding environment without placing emphasis on an individual person.

The POV Shots

A *point of view (POV) shot* allows the video camera to step into your subject's viewpoint and see the world the way your subject sees it—whether looking down at a keyboard, as in Figure 2.4, or into a cup of steaming coffee.

Consider the way that a newly walking toddler sees the world. To the toddler, tables loom large and are seen more often from the bottom than the top. Chair legs and adult feet are jungle gyms, and it's a joyous moment when arms swoop down to pick baby up to adult height.

Let your imagination and the POV technique take you and your video camera into the world-views of other people, pets, and things. Think about hiding in a mailbox, just as the day's delivery arrives. Consider how a pet cat sees the world—usually from the top of the refrigerator. Imagine how you would look to a camera hiding within your computer. The possibilities are endless.

Three variations of POV shots are follow shots, over-the-shoulder shots, and moving shots.

Follow Shots

If you've ever watched a reality TV show, you've probably seen a *follow shot*. These shots follow the action, usually on the shoulder of a cameraman trailing the journalist. Rather than showing the world strictly from your subject's viewpoint, a follow shot also includes a lot of the back of the subject's head and shoulders. This can be good or bad, depending on the effect you're trying to create. This kind of shot has become something of a cliché of modern "personality" journalism.

To capture this shot, just let your video camera tag along, recording the happenings as they occur. Be aware that you'll likely end up with shaky footage, a natural hazard of the process. Still, this is a powerful visual technique when used sparingly.

Figure 2.3

This fifty-fifty medium shot includes faces, shoulders, and torsos.

Figure 2.4

A POV shot shows the world the way your subject sees it.

Over-the-Shoulder Shots

Over-the-shoulder shots provide a stationary analog to follow shots. In this shot, you use your subject's shoulder and head to frame a scene. This provides a not-quite-POV shot, wherein you see what your subject sees, but your viewers will see at least part of your subject as well.

Moving Shots

Moving shots provide the point of view of traveling within or on a vehicle. These shots help set the feeling of speed, motion, and distance. A moving shot usually shows the landscape going by, and it may be framed by a window, car hood, or other visual indication of the mode of transport. You can use a moving shot to establish a scene within a car or to indicate the passage of time and location between scenes.

Angle Shots

Angle shots allow you to establish a mood by changing the angle at which you film. Low and high shots form the two variations of this shot. As their names suggest, you place the video camera either higher or lower than normal, shooting up or down to achieve the effect desired.

Changing the video camera angle affects the way people react emotionally to the shot. When the camera rests higher, looking down, you feel as if you're taller, looking down with it. When the camera moves lower, you perceive that you're smaller as you gaze upward. As the angle changes, so does your relationship to the subject.

Angle Shots of Subjects

When your shot looks up toward a subject, it mimics the emotionality of a child's eye view. Even as adults, we react to a taller person as possessing more authority and strength. A lower camera enhances your subject's importance and power (not to mention his chin). You see this camera angle appear in many political ads, lending clout to the candidate. Figure 2.5 shows a typical low-angle shot.

In contrast, a downward angle de-emphasizes your subjects. It makes them appear smaller, weaker, and less important. The visual focus on the subject's forehead and cheeks, and the reduction in prominence of the chin, creates a more childlike appearance. A downward angle can make a young girl appear more demure, a pet less threatening, and an employee more humble. Figure 2.6 illustrates the look of a downward angle.

Figure 2.5

A low-angle shot emphasizes power and authority.

Figure 2.6

A high-angle shot makes your subject appear more vulnerable.

Figure 2.7

A neutral shot provides an equal footing between your audience and your subject.

Finally, a *neutral shot*—shooting neither up nor down—allows you to create an equal footing between your subject and your audience. It introduces parity, offering a visual bond that emphasizes similarity. Figure 2.7 is an example of a neutral shot.

Angle Shots for Location

Your use of angle shots is not limited to people. When you change camera angles, you influence the way that your viewers react to locations. High, low, and neutral angles create different moods and settings.

Shooting downward tends to close off your pictures. As the horizon moves higher, you introduce a sense of boundaries, closure, and completeness. A downward angle minimizes the sky and emphasizes the more mundane aspects of life, including streets, cars, fire hydrants, and so on. Use downward angles to introduce feelings of claustrophobia or limits in your video, as shown in Figure 2.8. Notice the high, small horizon.

In contrast, upward shots open up your pictures. The horizon moves down, and you capture a greater percentage of sky, trees, and the tops of buildings. Upward angles introduce feelings of spaciousness and freedom. Use this angle to emphasize feelings of hope, opportunity, and openness. Figure 2.9 shows an example of an upward camera angle.

The neutral shot offers a person's-eye view of the world. By shooting neither up nor down, you more or less mimic the way that people see the world while walking. You view people, buildings, cars, and signposts straight on, in a normal day-to-day fashion. The neutral shot

allows you to convey place and atmosphere without the emotional overtones introduced by upward or downward shots.

Useful Shots for Editing

Much of the art of video editing depends on having the proper segments at hand, ready to use. The shots that provide important material for the editing process include establishing shots, cutaways, insert shots, pickups, entrance shots, and exit shots. Make sure that you spend the time to record at least some of these important shots, whether you plan to edit your videos yourself or have someone else do the work for you.

Figure 2.8

A downward shot creates a high, small horizon and a tight feeling of space.

Establishing Shots

As its name might suggest, the *establishing shot* allows you to set up a scene. Establishing shots help your viewers understand the location and circumstance of your video. Here are some examples:

- A city street to establish your location in a particular city
- The outside of a church to introduce a wedding
- A panoramic view of a river as an opening for your fishing trip
- A busy emergency room to jump-start the story of your new child's arrival

Figure 2.9

An upward shot opens up your image to spaciousness.

When you launch your video with this sort of overview, you quickly set the mood and place of the shots to follow. Figure 2.10, for example, introduces the mood and setting of the majestic red rocks at the Garden of the Gods Park in Colorado.

Use wide shots for your establishing shots. Move outside the immediate action. Look for a setting and an angle that help describe what this segment of your video is about.

Your establishing shots don't need to include any of your subjects. Similarly, they don't need to be filmed at the same time you shoot the rest of your video. You may find that the immediacy of a life event—such as blowing out birthday candles or welcoming a new child—does not offer the flexibility to set up and shoot establishing scenes. You can capture these shots before the event, or you can come back later.

When dealing with fictional subjects, establishing shots allow you to set a scene independently of reality. For example, say you want to film a sketch involving a customer and a drugstore clerk. By filming an establishing shot outside a real drugstore, you establish a link between the action in your sketch and such a locale. Use these shots to set up the action and anticipate the story that follows.

Figure 2.10

An establishing shot sets the place and tone of the video that follows.

Cutaways

A *cutaway* refers to a shot that allows you to seamlessly edit bits out of an overlong sequence. Cutting away to a person or object, and then returning to your main subject, allows you to create the illusion of continuity while editing sequences down to a usable length. Cutaways form the most important, and often the most overlooked, component of the editing process.

The most important and common cutaway is the *reaction shot*. This shot shows someone other than the speaker during an interview or talk. You see this shot nearly every day on news shows. Diane Sawyer provides particularly good reaction shots, as she puts her hand under her chin and sympathetically nods or otherwise moves her head (no one crinkles their brows quite like Diane, in my opinion). Other reaction shots might include looks of surprise, dismay, or horror in reaction to the narrative being offered by the primary subject. Figure 2.11 shows an example of a reaction shot.

Another type of cutaway focuses on the process or event being described by your subject. For example, as your subject discusses her wedding, you might cut away visually to a shot of her walking down the aisle, while continuing the narrative as a voice-over. As a fisherman talks about the one that got away, you might cut to a wall covered with snapshots of him and his best catches or to the stuffed marlin over the fireplace.

Good cutaways are vital to creating interesting and watchable videos. Whether before or after you interview a subject, take the time to look for cutaway material. Get some long shots of the environment and any collectibles and keepsakes that relate to the subject matter. Ask your subjects to show you how they perform the task they talk about. Take a variety of shots, including close-ups of their hands, medium shots of them at work, and long shots of them as they walk in their neighborhood with friends.

Figure 2.11

A reaction shot allows you to cut away from your main narrative to control the flow and interest of your video.

Insert Shots

Insert shots form a special subcategory of cutaways. They provide breaks from the normal visual sequence by introducing cues that work has progressed or time has passed. Unlike other types of cutaways, insert shots generally do not include voice-over narrative. Instead, the video cuts away to the insert shot and then returns to the main subject, presumably at a different time.

Common insert shots include clocks, calendars, newspapers, invitations, and so forth. They move the story along on the principle that a quick visual is worth, if not a thousand, then at least a few dozen words. The best insert shots are fluid and dynamic. A hand marking off the days works better than a static shot of a calendar. Builders working on a house at various stages will provide better insert shots than simple photos of the completed work to date.

When documenting a long-term event—such as putting on a play or introducing a new product to market—make sure to plan for these extra shots and record them as the work proceeds. And, as with other cutaways, make sure to film a variety of shots: wide, medium, and close-up.

Pickups

Pickups are the narrative opposite of cutaways. They refer to shots filmed at different times but from identical camera angles. When your subject wants to take a coffee break, the power goes out, or you lose your lighting, you can use a pickup to continue shooting as before. When you edit the video, you'll be able to use cutaways to transition seamlessly between pickups.

Clean Entrances and Clean Exits

In a clean entrance shot or a clean exit shot, the subject enters the scene or leaves it during the taping of the shot. For example, you might film a park bench. As you record, a person enters the scene and sits down. That is called a *clean entrance*. Similarly, when the person gets up and leaves the scene, you film that departure up to and including the point where the person is no longer in the shot. That is a *clean exit*.

Clean entrances and exits provide some of the most important and useful shots for editing. Without clean entrances and exits, a person may appear to "jump" between locations, as happens in the sequence shown in Figure 2.12 (in which the third shot is in a different location from the second one).

By having the subjects leave the scene entirely (in a clean exit), you allow your viewers to create a mental ellipsis between one scene and another. They've seen your subject depart from the first location. When the subject arrives at the second location (in a clean entrance), your audience understands that time has elapsed between the two segments. As shown in Figure 2.13, this technique introduces smoother transitions.

Don't think that clean entrances and exits should be limited to shots of people. Cars, bicycles, hands, animals, and other items provide excellent subjects as well. Suppose that you're filming someone taking a long car trip. When you shoot segments with a car making a clean entrance and exit at each important location, you can easily edit them together into a coherent video. As another example, imagine a cooking show in which a chef discusses a pastry technique. As the chef describes rolling out the dough, you show her hands enter the scene, roll the dough, and then depart. By doing so, you avoid the drudgery involved in matching the chef's original body position to her hands rolling the dough.

Figure 2.12

In this sequence, an uncomfortable dislocation occurs between the second and third images.

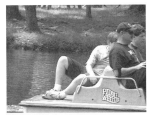

Figure 2.13

This sequence includes a clean exit and a clean entrance. This creates a smoother transition for leaving one location and arriving at a new one.

Advanced Shooting Techniques

Along with the types of shots discussed so far, you can use several shooting techniques to add interest to your video. Jump cuts and cutting on the action offer two techniques that allow you to change the type of shot—from close-up to long, long to medium, medium to long, and so on—with a visual flourish. Camera moves—pans, tilts, and zooms—also change the scene. These techniques, when used properly and sparingly, can provide nifty visual effects in your videos.

Jump Cuts

A *jump cut* introduces a sudden distance change between you and your subject. The picture jumps from near to far or far to near without transition. To create this effect, you shoot, stop, change the zoom, and then shoot again. This shot suddenly plunges your viewers into the action and can introduce a sense of urgency and excitement to your video. Jump cuts change image size without changing camera angle. Figure 2.14 shows an example of a far-to-near jump cut.

It's fairly hard to create seamless jump cuts with one camera and a human subject. People and animals inevitably move between takes. When aiming for this effect, instruct your subject to stay as still as possible. Record several takes to maximize your chances of getting it just right.

Figure 2.14

A jump cut changes distance without altering camera angle.

Cutting on the Action

Cutting on the action provides a way to add continuity during shot changes. In this technique, your subject begins a motion at one camera angle and then finishes it at another. For example, an elderly gentleman first seen in a wide shot might bring his umbrella up to his shoulder and begin to open it. You may then film a medium shot of him fully opening the umbrella. Edit these two shots together, and you provide a smooth transition for your viewers. The action ties these two camera angles together. Figure 2.15 shows the cutting on the action technique applied to show a subject doffing her hat.

When shooting these sequences, always instruct your subject to perform entire actions at both distances, as similarly as possible. This double shooting will better allow you to edit the shots together. You don't need to maintain the same camera angle for cutting on the action shots, as you do for jump shots. However, cutting on the action can improve the quality of your jump shots when you do keep your angles the same.

Figure 2.15

Cutting on the action allows you to tie together different shots by connecting them with an ongoing action sequence—in this case, removing a hat.

Shoot with the "Line" in Mind

The *line* is a key concept in videos and film. It establishes screen direction in the minds of your viewers. Screen direction refers to the way people interpret what is left and what is right on the screen. Also referred to as the *axis of action*, the line determines the direction people and things must face on screen to avoid confusing viewers as you cut from one shot to another in a sequence. When you mix this up, you "cross the line," producing a perplexing visual conundrum. Figure 2.16 is an example of crossing the line. The fourth frame simply does not fit with the others, because the subject is now facing right when she was facing left.

There may be times when you cannot avoid crossing the line in order to provide complete coverage of an event. The basic solution involves stepping the camera around to the other side of the line. By filming a sequence of shots in which you approach the line and then cross it, as shown in Figure 2.17, you introduce a visual continuity that allows your viewers to cross the line with you.

Camera Moves

Camera moves, when used sparingly, can add interest to your videos. Unfortunately, many new video enthusiasts tend to overuse these techniques, to the detriment of their footage and the final video. Still, it's worth learning how to use the camera moves well and appropriately.

Figure 2.16

When you "cross the line," your subjects may appear to jump from one side of the screen to another.

Figure 2.17

You can cross the line effectively when you allow the audience to move with the camera.

Figure 2.18

A zoom-out move allows your camera to expand from an individual to the entire scene.

One type of camera move is *zooming*. In this shot, the camera zooms in or out on a scene. Figure 2.18 shows how zooming out can reveal a more complete picture (in this case, the entire group rolling down the hill).

Another camera move is *panning*. When the camera pans, it moves sideways in one direction or another. To create the shots shown in Figure 2.19, the video camera panned across the group, to show each member of the family.

You can shoot spectacular pans by mounting your camera on a dolly. Dollies are simply moving platforms. Move the dolly as you shoot, and you create a pan. Famous filmmakers have used all sorts of oddball dollies, including wheelchairs and office stools. You can do the same. Just make sure to move your dolly smoothly and steadily.

A third type of camera move is *tilting*. Using this technique, the camera angles up or down during its move. In Figure 2.20, the video camera tilted up to give a sense of the action taking place.

Each of these three moves allows the camera to bring additional areas into view and lay them before the viewer.

Figure 2.19

Panning offers a convenient way to create a much wider scene than you can show at any one time in your camera's viewfinder.

Figure 2.20

Like panning, tilting allows you to capture a tall, vertical scene by moving the camera.

When to Use Camera Moves

The most important decision about camera moves is when to use one. A basic rule of thumb is that a camera move must add value to your video. If the shot can be done as well or better without a camera move, then skip the move. Never add a move to your video just to provide a special effect. Don't use moves because you're too lazy to set up a second shot. Avoid moves entirely when you're unsure what the outcome will be.

A camera move must do a job. You should know this job beforehand and approach your camera move with deliberation and thought. Camera moves generally perform two jobs: focusing attention and revealing additional information.

Use camera moves to focus attention When you focus your viewers' attention, you deliberately and visually orient their viewpoint toward important visual detail. Typically, you zoom into this feature. This feature might be the tattoo on the arm of a Holocaust survivor, the fine detail on a vase being hand-painted, or a handkerchief dropped by a kidnapping victim at a crime scene. A camera move offers a direct, visual method for bringing this feature into prominence.

Use camera moves to reveal information A revealing move allows you to show more information than can be seen with the original camera angle or a single static shot. A revealing move proves most effective when introducing new and distinct information. For example, consider a camera move that reveals the guest of honor's family all gathered offstage, waiting to surprise her. Consider the shot of a messy baby feeding herself zooming out to demonstrate the complete ruin made of the kitchen. Envision a quarterback concentrating on his next play as a camera move allows viewers to see the attending crowd, capturing the tension of the moment.

> The classic example of the revealing move involves the cartoon character who has just stepped off a cliff. As any student of cartoons will tell you, the character cannot fall until he has looked down and ascertained that there is no ground beneath him. As the camera moves down, it's revealed that there's nothing there. The character may now fall.

Guidelines for Capturing the Move

The most important rule for capturing camera moves is to use your tripod. Whether zooming in, zooming out, panning, or tilting, a tripod can help steady your camera and control its movement. That being said, here are a few more tips on filming with camera moves:

- Always record some static shots as well as moving shots. This allows you to have substitute shots during the editing process, in case the camera moves turn out badly.

- When in doubt, pan and tilt slowly rather than quickly. This helps you avoid strobe effects when your camera moves past regularly spaced objects, such as bricks or fence posts.

Strobe effects can be seen in many Western movies when the spoked wheels of a moving wagon appear to move too slowly, stop, or even spin backward. This visual illusion is due to a physical phenomenon called "aliasing," and occurs when the camera cannot record enough frames to keep up with the actual movement of the wheel.

- Even though you should generally move fairly slowly, try to limit the length of your moves. It's difficult to edit down a moving shot without introducing discontinuities, so shorter camera moves generally work better than longer ones.

- Move smoothly and at a consistent pace. Don't allow your move to slow down or speed up during filming.

- When panning or tilting, try to find a natural object to follow. For example, when panning across a merry-go-round, follow a particular horse. When filming a hotel, tilt to follow an outside elevator moving up the side of the building. If you look carefully, you can often find such naturally moving objects.

- Where possible, practice your shot a few times before shooting.

- You may want to shoot several versions to provide the best version for editing.

- Begin and end your move with well-composed shots (the subject of the next section).

Video Composition Tips

Beautiful and professional-looking videos do not happen by accident. You build them carefully and deliberately. The most important element of well-shot videos lies in composition. *Composition* refers to the way you arrange the visual elements of a shot. Good composition derives from careful thought and placement, following some classic rules of beauty. When you follow these rules, you'll produce better, more distinctive videos.

Use the Rule of Thirds

One of the rules for good composition is truly "classic." The ancient Greek and Egyptian philosophers discovered an important feature about beauty. Much of what we find attractive and beautiful incorporates a specific ratio, which is approximately 3:2. They called this ratio *Phi* (rhymes with "tie"), the "golden ratio," or even the "divine ratio." You can find this mathematical relationship abundantly in nature, such as in the way a tree grows, flowers bloom, or our body parts (fingers, hands, arms, and so on) are laid out.

The ancients incorporated this idea into their art and architecture. It was this transference from nature into art that came to be known as the *rule of thirds*. Basically, the rule is that things that are split into thirds, with features placed at the one-third mark and/or two-thirds mark, better than things with more arbitrary placements. It's as simple as that.

Whenever you look at a scene framed in your video camera, imagine a tic-tac-toe grid on top of it. Let these imaginary lines split the scene into thirds, vertically and horizontally. Keep these lines in mind as you try to align your scenes. When you place features along the lines, especially at the four intersections, you'll end up with better-composed scenes. It doesn't matter which lines or intersections you use.

Figure 2.21 illustrates the difference between shots composed with and without the rule of thirds. Notice how both portrait and nature shots improve with this rule.

Figure 2.21

The rule of thirds allows you to compose better and more balanced shots.

Simplify Backgrounds

Busy backgrounds draw eyes away from your main subject and provide unnecessary distractions. When you simplify your backgrounds, you'll improve your videos by placing the focus of interest where it belongs—on your subject. Figures 2.22 and 2.23 show the difference between a cluttered background and a simple one.

Here are some ideas for ways to simplify your backgrounds:

- Move your subject. Physically reposition your subject to a less busy setting.

- Move yourself and the camera. Scout around your subject to find a better camera angle to shoot from.

- Use a backdrop. You can hang a simple backdrop (like a plain-colored sheet) behind your subject while filming.

Composed without using the rule of thirds, a picture is not visually interesting.

Positioning the eyes on the top line improves

The horizon rests directly in the middle of the picture.

By shifting the horizon down to the bottom

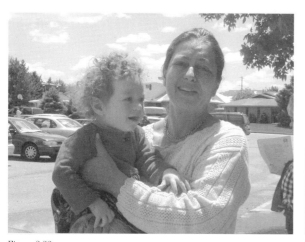

Figure 2.22

A complicated background removes the focus from the subjects of this scene.

Figure 2.23

A simple background emphasizes this subject.

- Get closer. Zoom in on your subject's face. The more of your subject you see, the less background you'll record.

- Drop down and shoot up at your subject. This way, you can avoid a lot of eye-level clutter.

Notice Visual Details

Figure 2.24

Pay attention to detail. Don't let a tree grow out of your subject's head.

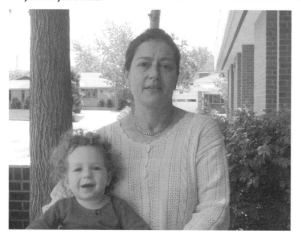

People often overlook the details. This typical human failing can bring a lot of grief to the video-making process. Too often, we allow ourselves to become fixated on our subjects at the expense of general visual awareness. We don't notice when small visual details pop into our scenes unannounced. However, our video cameras capture these details as patiently and reliably as they record our main subjects. If you do not learn to spot these visual problems before shooting, you'll be stuck with trying to fix them during editing. Instead, teach yourself to be vigilant and catch these problems proactively.

Learn to break out of your fascination with your subject. Stop, look, and think. Check out the entire picture. What details do not belong? Are there unsightly electrical outlets or signposts? Does a tree appear to be growing out of your subject's head, as in Figure 2.24? Look before you press the record button.

In Figures 2.25 and 2.26, you can see the difference between shooting your scenes care-lessly and first considering the background. Teach yourself to look before you ever press the Record button.

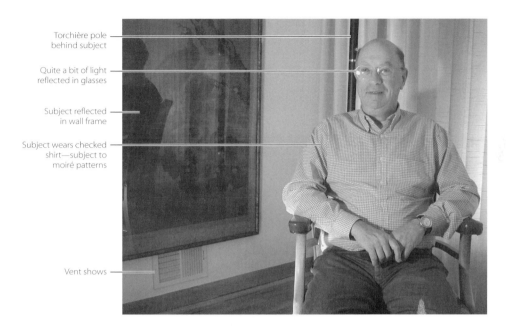

Torchière pole behind subject

Quite a bit of light reflected in glasses

Subject reflected in wall frame

Subject wears checked shirt—subject to moiré patterns

Vent shows

Figure 2.25

Without thought, you may include inappropriate visual elements in your shots.

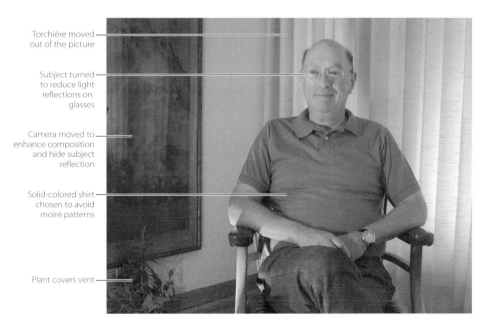

Torchière moved out of the picture

Subject turned to reduce light reflections on glasses

Camera moved to enhance composition and hide subject reflection

Solid-colored shirt chosen to avoid moiré patterns

Plant covers vent

Figure 2.26

Careful planning can help improve your shots.

Here are some cosmetic tips to help clean up your scenery:

- Hide unsightly background elements with a potted plant, a table, a dropcloth, or some other more attractive item. You can even place a backdrop behind your subject to change or replace the "natural" look of things.

- Move your subject. You can hide something by placing your subject in front of it. Or simply move your subject to another location.

- Move yourself. Find another camera angle that hides unwanted visual elements.

Frame Your Subject

When you shoot video through a natural frame, you add a touch of beauty to your pictures. Natural frames include windows, doors (like the one in Figure 2.27), tree limbs, sculptures, and other overhanging features. By adding a frame to your picture, you improve its visual composition by directing the viewer's eye toward the subject.

Figure 2.27

A natural frame adds visual elegance to your shots

When using frames, take special note of your depth of field. Make sure that both your frame and your subject stay in focus. Fuzzy features will defeat the entire purpose of framing. See the "Set Your Focus" section in Chapter 1, "Why Digital Video?" for details on depth-of-field considerations.

Move Closer to Your Subject

Human psychology assures us that people are fascinated by faces and, in particular, eyes. You can leverage this natural human tendency by using faces as your visual center. Don't be afraid to get up close and personal with your subjects. You don't need to include all of a person's hair, limbs, clothes, and so forth to create a memorable video. The more you concentrate on a person's face—and, particularly, a person's eyes—the better your videos will turn out.

Consider the shots shown in Figure 2.28. As you move in, focusing more narrowly on your subject, you provide a stronger center of interest and create a sense of intimacy with your viewer. The closer you get, the more interesting your subject becomes.

s by
our

Face Your Subject to the Center

A *leading look* refers to the way a person faces. This look can direct attention into the frame or out of it. Make sure to face your subject to the center. Figure 2.29 shows a shot that doesn't quite work because the subject is looking out of the frame.

Techniques for Filming People

Have you ever noticed how stiff and uncomfortable some people look in taped segments—those fake smiles and awkward postures? A good videographer can put people at ease and create more flattering shots of less photogenic subjects. Learn how to help your subjects relax and look their best. Not only will your videos improve, but your subjects may come back again for more!

Lighten the Atmosphere

It's important to get your subjects to relax. Let them know that they will not actually gain 10 pounds on camera unless they sit down with a full 10-pound box of chocolates and proceed to eat them as the video rolls.

Here are some techniques that may help lighten the atmosphere and relax your subject:

Talk to your subject As you get ready to shoot your video, start a conversation. Even before you begin an interview, talking can help. While talking, many people forget about posing, so they have better and more natural facial expressions.

Make them laugh Tell some jokes or silly stories. Laughter shakes people right out of their stiffness.

Give them something to do Props are great video tools. When people are busy doing something—anything—they tend to focus on the task and stop thinking about their facial expressions. Children may enjoy playing with a toy. Show an adult working on a hobby or doing a household chore. Ask your subject to talk about what he or she is doing. By filming these sequences *before* an interview, you allow your subject to become used to the camera.

Tape a lot of video footage People can keep those silly, stiff smiles on their faces for only so long. The more footage you shoot, the more those muscles will tire. Prepare to throw out a lot of early sequences. Eventually, the awkwardness will disappear. While interviewing, try to hold off the meaty questions until later.

Move them around Why not go to another room? You can go inside if you're outside or outside if you're inside. Each time you change locations, you get a fresh start and new facial expressions to work with.

Remember that the best footage doesn't show stiff smiles plastered on faces. In interviews, especially, you want to see the truest person looking out.

Figure 2.29

Face your subject to the center of the shot to avoid leading looks.

Flatter Your Subjects

The simple truth is that some people photograph better than others do. Some are natural models; others aren't. Whether you're dealing with a double chin or a prominent nose, you can help your subjects look their best by keeping a few tips in mind. Here are some common problems and suggestions for minimizing them:

Double chins You can minimize the prominence of double chins in your videos in two ways. First, ask your subjects to hold their chin up slightly. Second, shoot from a bit above the subject, as shown in Figure 2.30. Raise your tripod and shoot slightly down to deaccentuate the neck.

Weak chins In this case, you want to lower your tripod to slightly below your subject's face and shoot up. This changes the emphasis toward the top of the face and away from the bottom.

Wrinkles Wrinkles show their worst in bright light. Keep your lighting as diffuse as possible. This minimizes the shadows between wrinkles and flatters the subject.

Big or prominent noses If a nose presents a problem, avoid profile shots. To de-emphasize a nose, have your subject face the camera directly. Keep the camera level with the subject's face and avoid shooting up or down.

Thick eyeglasses or unflattering eyeglass frames You can use someone's glasses as a prop. For the "professor shot," have your subject hold her glasses in her hand and gesture with them. This shows more of the subject's face and avoids distortions around the eyes from both the lenses and from shadows created by the frames. This may not work for subjects with very poor vision or those who wear their glasses constantly. The former may look "dopey" during the shoot because they cannot see. The latter will seem unfamiliar to friends and family because the glasses are such an intrinsic part of the person. In these cases, consider the next suggestion instead.

Figure 2.30

Use a downward shot to hide a double chin.

Reflections from eyeglass lenses You can fix this problem in a number of ways. First, if your video camera offers a thread for lens attachment, you can add a polarized filter to minimize reflection. Second, you can slide the glasses up or down the subject's nose to produce less reflection. Third, you can keep the glasses in place but move your lighting to minimize the reflection. If you still cannot find a flattering shot, consider using the glasses as a prop, as described in the previous suggestion.

Blemishes When you're dealing with facial blemishes, use diffuse lighting. Consider keeping some basic cover-up makeup on hand to offer your subjects. Remember to use powder over the cover-up to minimize reflection.

Consider Makeup, Hair, and Costuming

Today's video cameras capture images in much the same way as you actually see them. If your subjects look good to you in person, they will probably look good on video, too. You do not need to spend a lot of time, effort, and money preparing your subjects to star in your video. Here are a few tips to keep in mind:

Grooming counts Video isn't forever, but it comes close. Encourage your subjects to spend a minute or two grooming themselves. Pay special attention to teeth and hair. This is one of the few times in life when it actually helps to have a straight part.

Tone down the makeup A little goes a very long way on video. When preparing for a video session, many women choose to put on more makeup than usual. This is usually a mistake. Makeup works best when it enhances natural features rather than replaces them.

Check for shine Forehead, noses, chins, and cheekbones are subject to shine. You might want to bring along a little cosmetic powder to help tone down reflection from these problem areas. (Diffuse lighting also can help minimize reflection off faces.)

Dress simply Have your subjects avoid loud patterns and clothing that is overwhelming. Stay away from stark black, solid white, and especially solid red, which bleeds across the screen. Softer colors with simple patterns work best. Local news anchors provide the best examples of what looks good on video. Turn on your evening news to see what the anchors are wearing and take their cue.

Tips for Videotaping Children

Capturing footage of children can prove particularly difficult. Kids are far more interested in video equipment than they are in acting "naturally" for the camera. Also, they tend to move around a lot, making precise focus a perplexing issue. Here are some tips to keep in mind when videotaping children.

- Shoot in well-lit situations. Cameras will focus better when there is more light available.
- Use manual focus to set an area where most of your action will take place. This avoids refocusing issues as kids move through the focus zone.

- Let the camera roll. You're more likely to obtain good footage over long periods of time than short, staged ones.

- Be unobtrusive. Kids find video cameras fascinating. You may end up with footage exclusively of fingers on your lens and your lens cap dancing in front of it.

- Use a lot of camera angles. Don't try to tell a story while shooting kids. You can edit together the best pieces later.

- Roll the camera while the kids are busy doing things. Don't worry about face shots or perfect angles. Some of the best footage will show the kids just being kids.

- Pull the kids away individually away from the main area to conduct individual interviews. You can edit these in later to provide the overall narrative for your video.

- Always shoot with proper parental supervision and permissions.

Microphone Choices

Today, nearly every video camera comes with a built-in microphone. As your video camera's quality (and price) increases, you'll find models with external microphone jacks, allowing you to use an external microphone. There are pros and cons to using built-in microphones, and many external ones to pick from if you choose to go that route.

The Rewards and Hazards of Built-in Microphones

A built-in microphone usually sits at the very front of your video camera, behind a grill. It provides excellent sound sensitivity. Using the built-in microphone works well for most consumer and small-business needs. It's always attached, and you don't need to spend any time setting it up. Built-in microphones basically allow you to forget about capturing sound and focus instead on capturing excellent pictures. However, they do have several drawbacks:

Lack of clarity Your video camera's microphone may lend a slight artificiality to recorded voices. Built-in microphones are directional and face forward, so they tend to pick up sound coming from in front of them. This limits the pickup of any natural reverberation from interior spaces. Also, the microphone built into your camera is probably a lower-end model, so it won't be as accurate as a better-quality external microphone.

Distance drop-off Sound reception decreases as your subject moves farther away from your camera's microphone. This drop-off in sound can become dramatic when recording at a distance. Most consumer-grade digital video cameras do not allow you to effectively record sound from more than 10 or 20 feet away. At the same time, the camera operator stands right next to the built-in microphone. When conducting interviews or conversation, these two voices record at dramatically different sound levels. Even the nonparticipatory camera operator must take care. The built-in microphone easily picks up small noises such as breathing and sniffling.

Don't confuse apparent nearness with actual proximity. Your zoom may make subjects appear close, but their voices remain just as far away.

Machine noise Built-in microphones are apt to pick up machine noises originating from your video camera. Your microphone will often record the small sounds of your zoom lens adjusting or the tape-advance mechanism winding. Even the electric hum of your camera may be picked up and recorded by the built-in microphone.

Wind sensitivity If you've ever tried recording in windy conditions, you'll know that wind noise is a tremendous hazard for built-in microphones. External microphones can be fitted with a windscreen (or tucked into your clothes), but that won't work with a built-in microphone, because the microphone is almost always mounted directly under the lens. If you use a windscreen on your built-in microphone, you will likely obscure part of your picture.

Windscreens are handy for external microphones. You can find foam windscreens at stores that sell audio equipment, such as RadioShack, for about $5.

No full-stereo sound Your digital video camera can record in full-stereo, CD-quality sound, but your built-in microphone probably won't be able to capture it. Stereo sound requires that sound be recorded from two different microphone placements, which translate into the left and right stereo channels. Built-in microphones are typically monophonic (although there are single-capsule microphone designs that capture stereo using two directional elements oriented in different directions).

If you've picked up some distracting background noise while filming, you may be able to edit it out with a noise-removal program. See Chapter 5, "Video Editing Techniques," for details.

External Microphones

Rather than deal with the problems and lower quality associated with internal microphones, many people opt to employ external microphones to capture better-quality and more professional sound. Many video cameras have an external microphone jack. Some higher-end models are built with an accessory shoe that allows you to hang a microphone, usually some sort of boom microphone, directly from the camera (like the large, fuzzy microphone attached to the camera following a TV news reporter).

If your camera offers an external microphone jack or other type of attachment option, and you've decided that's the way you want to go, your next decision is what type of external microphone to use. Consider the following questions.

- How far away will your subjects be from the camera?

- Will your subjects be moving, such as walking or running?

- How many subjects will you be filming at once?

The answers to these questions will help you determine what sort of external microphone to select. Distant subjects need distant microphones. Moving subjects may not be able to use microphones with cords. Multiple subjects need omnidirectional sound pickup.

Basic Tethered Microphones

You can purchase a basic tethered microphone for a few dollars at any audio equipment supply store. This type of microphone provides an inexpensive and convenient solution that allows you to move your microphone away from the camera.

The main drawback to this approach is that your subject must hold the microphone, or you must mount the microphone on the "set" before filming. You can avoid this awkwardness by using a tie-clip microphone (described next), rather than a tethered one. Another drawback involves the unidirectional nature of most tethered microphones. These microphones are often designed for a single speaker or singer, minimizing the unintentional pickup of background noise. They are not suitable for recording sound from groups of individuals.

> Many tethered microphones are assembled with built-in pop filters to reduce pop noise. *Pop noise* refers to the sound people make when saying "p." Microphones, particularly those that are hand-held or mounted on stands, capture these pops when the speaker's mouth is near. *Pop filters* are mesh screens that surround the sensor, reducing air velocity—the main feature of pop noise—yet otherwise allowing sound to pass through uninterrupted.

Tie-Clip Microphones

For about $25 to $35, you can purchase a good-quality tie-clip microphone at your local audio equipment supply store (such as RadioShack). These microphones attach discreetly to your subject's shirt, just like the ones you see on the TV news shows. Most models come with 6- to 10-foot cables. This means that you generally also need an extension cord.

> If you get an extension cord for your microphone, make sure that its connectors are the right size. There's nothing more frustrating than needing to run back to the store to buy adapters.

For a bit more money, you can purchase (or rent) a cordless tie-clip microphone. These microphones transmit sound signals without needing a direct-wired connection. You should be able to find cordless tie-clip microphones at your local music store. If the music store doesn't carry them, go to a local fitness club and ask an aerobics instructor where to find them. Because aerobics teachers need to move around a lot, they often use cordless microphones.

Keep in mind that like any cordless device (phones and intercoms, for example), wireless microphones are subject to interference. Make sure to monitor your sound signals while recording, as described shortly.

Omnidirectional Microphones

In general, when describing a microphone, the term *unidirectional* means that the microphone does not pick up sound equally from all directions. Unidirectional microphones work best for individual speakers (or singers). *Omnidirectional* indicates that the microphone will pick up sound from anywhere. Omnidirectional microphones provide the best sound-recording features for classrooms, interviews, and business meetings. These microphones allow you to capture sound from all directions. Look for the key words *360-degree pickup*.

Minimize AC Power Interference with Your Microphone

Take care when using AC power near your microphone. AC power runs at 60 hertz (Hz), a frequency that can produce an irritating hum on your video soundtrack. This occurs when the electromagnetic fields that surround your power line are picked up as radio signals. Your microphone acts like a radio receiver, and any connecting wires function as antennas.

CAPTURE BACKGROUND SOUNDS

You might be surprised how helpful simple background noise can be during the editing process. Take some time—a minute or two—to record some background noise before wrapping up your shoot. Don't feel that you need to capture an interesting scene. Point your camera at wall or a floor, or just leave on the lens cap (if your video camera will let you) and capture the background sounds.

Authentic background noises offer a number of convenient functions during editing, such as the following:

Replace ambient sounds With your recorded background noise, you can replace existing ambient sounds with similar, authentic sounds. This proves especially important when unexpected noises intrude. For example, an airplane might fly overhead or an ambulance may pass by. When you've recorded scenery, establishing shots, long shots, and so on, replacing the soundtrack provides the solution.

Blend shots Imagine conducting an interview first at a state fair and later in a barn. By introducing the fair sounds at a very low level, you create the illusion that the two scenes occur in proximity to each other. Your recorded background sound also lets you add audio continuity during cutaways and insert shots. Add your background noise, at full or reduced levels, and these shots will blend in more smoothly.

Keep in mind that like any cordless device (phones and intercoms, for example), wireless microphones are subject to interference. Make sure to monitor your sound signals while recording. You can use headphones to listen to the sounds being recorded by your camera. Most video cameras with a microphone jack also offer a headphone jack. Simply plug in a pair of headphones to listen to audio-in as you proceed with your taping. It's always better to catch interference problems when and where you can retape, rather than later, when you cannot.

Here are some tips to minimize interference problems:

- Use shielded wires wherever possible.

- Switch from direct AC power to battery power as needed to eliminate the hum. Batteries do not produce this interference effect.

- If you must run a microphone cable across a power cable, cross it at 90 degrees. Avoid running cables parallel to one another.

- Minimize the number of connections between your microphone and your camera. If you must use an extension, choose one with the exact connectors you need and avoid using additional adapters.

- Avoid shooting under fluorescent light. These lighting fixtures are notorious for the electrical noise they produce.

- Use chokes to further suppress wire emissions.

If you're wondering about that last suggestion, a *choke* is a piece of equipment specially designed to block electrical noise at radio frequencies. Chokes are built from coils or wire wrapped around ferrite cores. Coil chokes attenuate 60Hz AC noise by resisting rapid changes in current flow, while letting direct current (DC) pass freely. Ferrite-core chokes create inductance, which causes fluctuating magnetic fields that, in turn, generate electric fields. The electric fields help counter electric noise emission.

> Have you ever heard of a *humbucker*? It's a type of choke that combines two coils, each coil wound in an opposite direction. This combination of reversed directions helps cancel noise for many video and audio applications. A popular application of this is in the "humbucking" pickups used on many electric guitars.

Video Lighting Tips

When shooting videos, you need light. Without light, you cannot record pictures. And without good light, you're not likely to record good pictures. Good lighting makes the difference between drama and melodrama, between splendid and ordinary, between memorable and dull. So use your light well. Plan for light, think about light, and where possible, control your light to create the best and most beautiful video images you can.

Avoid Backlight

If there's a basic rule of thumb that will best guide you in lighting, it's this: Place your primary lighting behind you and let it shine on the front of your subjects. Backlight can ruin your videos.

Backlight occurs when your light source shines too close to your subject's back. Backlight tricks your video camera into thinking it's taking a picture of a very bright object. Your camera adjusts its light levels too high. Instead of picking up the primary light levels from your subject, it picks them up from the scenery. While the scenery appears beautiful and well-lit, your subject looks awful—usually as a silhouette against a bright and colorful background. Figure 2.31 shows an example of what can happen.

To avoid backlight, keep your light behind you. It does not matter whether your light comes from the sun or an artificial source. Shoot your pictures with the light directly at your back or just to your side. This allows your video camera to properly set exposure levels.

To find this proper lighting, you may need to physically move yourself and your video camera. If you cannot reverse direction completely, as when you film a subject in front of a famous monument, move in a circle around the subject until you find a happy compromise.

Figure 2.31

A backlit shot can entirely obscure your subject.

If you cannot avoid backlight, consider introducing supplementary lights. Add a general floodlight or even a spotlight to illuminate your subject and counteract the backlit situation. Try to add light subtly. Too much compensation lighting can flatten your subject's features and blend your subject into the brightly lit background. Many video cameras now come with built-in lights. If you do not have access to other light sources, consider switching on your camera's light to help add some front light. For another approach, you might be able to reflect some light back at your subject with silvery material (such as a space blanket) or with large pieces of light-colored posterboard.

Keep Light Indirect

Sunshine can work for you or against you. Even as you fill your camera with brilliantly lit images, you must constantly be aware of the hazards of natural light. While sunlight creates the most real, colorful, and beautiful pictures, it can also introduce unexpected difficulties. It can overilluminate, bleaching out scenes entirely, or it can hide your subject in artificial darkness.

Direct sunshine proves surprisingly unflattering to your subjects. Sunshine can fill faces with harsh shadows, making them look tired and old. It brings wrinkles into full view. Shadows on the neck may add an extra chin or two. Add squinting eyes into the mixture, and you have the lighting environment from hell.

Fortunately, there's a quick fix. Move your subject into the shade. Look for a tree, an overhang, a covered patio, or a trellis. Wait for a cloud to cover the sun. Shoot your footage on a hazy or overcast day.

Unlike direct sunshine, indirect light creates soft and beautiful pictures. It flatters your subjects rather than batters them. *Indirect light* means exactly that. Instead of light streaming directly from the sun onto your subject, it bounces off the walls, the ground, and the scenery around you. Your video camera still gets plenty of light, but it's a different, more playful, and far more flattering light. Figure 2.32 shows the difference between shooting in direct light and shooting in indirect light.

When you cannot avoid full sunlight, try to add light to fill in some of the harsher shadows. As with the backlit situation, you can use silvery material or lightly colored posterboard to reflect light. If possible, add diffuse floodlights to offset the harsh sunlight.

Consider the Time of Day

Contrast the warm, soft colors of sunrise and sunset with the harsh noonday sun. When you take out your video camera, consider how the time of day will affect the light. Choose a time that matches the mood you need. At midday, sunlight is strongest and most direct. Light appears at its whitest, and colors show at their most true and vivid. At sunrise and sunset, the color of light deepens and changes, often minute to minute. Colors are redder, kinder, and more dreamlike.

Figure 2.32

Direct light creates harsh shadows on the face. Indirect light provides a far more flattering shot.

Use changes in light to your best advantage. If you plan your video shoots in advance, consider how the time of day will affect your footage. Do you want to create a romantic setting? Perhaps you should wait until late afternoon or early evening. Are you seeking a dramatic landscape setting with lots of detail? Midday should work better. And don't forget those great sunset shots. When the last rays burn over the horizon, turning the clouds to fire, don't miss having your video camera in hand and ready to shoot.

If you can, avoid shooting videos of people near midday. Sunlight on faces works best when it's not shining straight down from above (as explained in the previous section). Instead, try to use the better light angles during morning or afternoon, when the sun is lower in the sky but still bright.

Use Light from a Window

Sunlight streaming through a window creates the most dramatic light of all. It offers an amazing mood setting for your video segments. Consider the differences in light that flows through stained glass, Venetian blinds, or sheer curtains. Whenever you find a well-lit window, think about the ways you can use it to shoot your footage.

The shots in Figure 2.33 show the difference between using artificial light and light through a window. The picture on the left was shot in artificial light, and it is rather flat and dull. The picture on the right uses light streaming in through a nearby window, which produces shadows and more depth in the scene.

Avoid Low-Light Filming

Today's video cameras provide excellent low-light recording capabilities. Their detectors can operate with very little illumination. However, if you have a choice, you should create your

video in well-lit conditions. When you use good lighting, you raise the quality of your video in several ways:

Improve the dynamic range you record *Dynamic range* refers to the difference between the darkest and lightest portions of your video. The bigger the difference, the greater the dynamic range. A large variety of colors and brightness simply looks better to viewers. Human vision is built to appreciate this diversity in hues and shades.

Decrease the amount of noise you record In this context, *noise* refers to the random, unintended image values added to and distributed across your digital picture. The opposite of noise is *signal*, which is the picture you actually intend to record. When you record in low-light conditions, the relative percentage of your signal decreases and the relative percentage of noise increases. This produces fuzzier, less attractive images.

> When you see deliberately grainy, murky video keep in mind that it probably wasn't shot that way. The effect was probably added in post-production. Real noise is too uncontrollable and you shouldn't ruin your footage by trying to capture that grainy look. Instead, shoot the best quality video you can and adjust the look of your footage during editing.

Avoid dark pictures When you film in low light, you end up with dark pictures. You can fix this to some extent with your video-editing software (by adjusting the brightness and contrast associated with each clip), but the pictures may not turn out as well as you would like. It's always better to film in brighter ambient light than to try to make up for it later during editing.

Figure 2.33

Artificial light usually cannot match the drama of natural lighting.

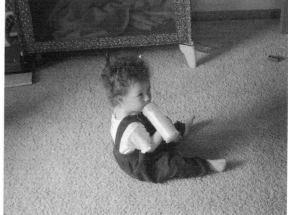

It takes very little light to improve your videos a lot. You'll be surprised how much difference just a bit of brightness can make. Here are some ways to shed some light on your subjects:

- Turn on the ceiling light. Even in daytime, a ceiling light can add vital illumination to your shots.
- Turn on all of the lamps in the room. Even the small decorative lighting fixtures can add some light.
- Bring in a lamp or two from another room.
- Tilt or remove a dark lampshade to let out more light.
- Turn on the lights in the hallway or the next room and leave the door open. Indirect light helps, too.
- Open a few window shades to let in the sunlight.
- Turn on your video camera's built-in light.

Build a Home Studio

You can assemble a workable, low-budget video studio. The key ingredients that contribute to an operational studio include decent sound and lighting. With the right equipment and some common sense, you can create a workspace that will lend itself to filming high-quality videos.

Get Your Equipment

Here is a list of the basic equipment you need to put together your home studio:

- A sheet to use as a backdrop. Any sheet will do, although flat works better than fitted, and a plain or neutral pattern is preferable to cute linen dinosaurs. Alternatively, you might hang a few yards of felt or velvet as a backdrop.
- Duct tape for hanging the backdrop (and a variety of other handy uses).
- One or two photographic-quality floodlight bulbs, such as General Electric's PhotoFlood bulbs. You can find these at your local camera store, for about $4 each. You may prefer the blue-tinted bulbs, which help cut some of the overly yellow floodlights.
- One or two aluminum clamp work lights. You can pick these up at your local hardware store for under $5. Make sure to choose work lights that can handle the heat from your floodlight bulbs.
- One or two additional household lamps to add mood, fill, or spot lighting.
- Various props, such as hats, potted plants, fake flowers, stuffed animals, and so on.
- Seating for your subjects. For interviews, try to pick comfortable chairs or sofas with a minimum of fabric pattern.
- Optionally, an external microphone (see the "Microphone Choices" section earlier in this chapter).

Set Up Your Studio

After you've done your shopping, follow these steps to get your studio up and running:

1. Pick a quiet part of the house. Try to find a room that doesn't get much traffic.

2. Duct-tape your backdrop to the wall. Be careful, because when you remove duct tape, paint or wallpaper may come with it. You may want to check with your parent, spouse, or landlord before you do this.

3. Dress your set. Set any props and furniture in place. See the next section for some tips.

4. Set up your tripod and video camera, and plan your shots.

5. If your microphones use batteries, make sure to install a freshly charged set.

6. Place your microphones and perform your sound checks.

7. Prepare your cueing system. If you plan to use cue cards, practice with them first.

> Memory can prove faulty, particularly under stress. A solution is to let your subjects use cue cards. Make sure to hold them near your camera, so it looks like your subject is looking at your audience and not at the cards. And keep your cues simple—they're intended to assist memory, not replace personality.

8. Screw your floodlight bulb into the work light and clamp it near an outlet. (If you cannot get close to an outlet, use an extension cord.)

9. Bounce your light off a wall or ceiling. This creates a softer and more indirect light.

10. Help your subjects become comfortable on your set.

11. Arrange any additional lights to fill out the lighting and minimize harsh shadows on your subjects' faces.

After you've set up your studio, you're ready to bring in some subjects and start shooting video footage.

Tips for the Home Studio

When you shoot footage in your home studio, keep these tips in mind:

* Video microphones are very sensitive. Try to pick a quiet time of day or ask other members of your household or business to refrain from loud activities during filming.

* Turn off your video camera's front light. Using your camera's light in these conditions can flatten the faces of your subjects and remove features. Instead, let the indirect light from the floodlights create more natural lighting.

* Move away from the wall. Keep your subjects at least a foot or two away from your backdrop. This softens shadows and de-emphasizes the backdrop.

- If fluorescent bulbs normally light your home studio, turn them off. These lights can create weird, greenish overtones in people's faces.
- Use extra sheets. If your studio's walls are dark, duct-tape a light-colored sheet to a nearby wall. Bounce your floodlight off the sheet rather than off the dark wall. That way, more light will travel to your subject.

Photographic floodlights get very hot. Use extreme caution when placing them to avoid fire hazard. These lights can burn fingers. Keep children away from your studio when the lights are on and until they have cooled off and been put away properly! Never leave these lights on and unattended.

Dress Your Set

You'll want to prepare your shooting area carefully, whether you're filming in a studio or on location. Allocate the time to set up and organize your furniture, props, and the area in general. Remember that your video will immortalize your setting, just as it does your subjects. Here are some tips for dressing your set:

Clean and declutter Whenever you shoot in a home, classroom, office, or other "natural" setting, spend a few seconds straightening up. Remove as many small and unnecessary items as you can from the shooting area. (It helps to bring a box along just for this purpose.) Rearrange pillows; flip some cushions. Try to create a pleasant, simple, and ordered setting.

Hide problems Don't let small problems scare you away from a great setting. A carefully placed throw rug, chair, or a potted plant can do a world of good to hide stains, outlets, wires, or other unwanted features.

Add special touches Your set should create an atmosphere that augments the story you record. Bring objects into your scene to expand a sense of place, time, and theme. Are you taping a scientist? Strategically place some models and posters. If you're shooting an ex–football player, consider arranging some trophies on the set. If your subject is a grandmother, you can probably find some framed pictures of her grandchildren to add to the scene.

Create an illusion When you do not have a perfect setting available, learn to improvise. A few small touches can introduce an illusion of place. Say you want to emulate a business meeting, but the meeting room is reserved until further notice. Water glasses, yellow steno pads, and newly sharpened pencils can transform a dining room into a boardroom.

Keep it simple A little set decoration can go a long way. Let your settings suggest rather than tell.

In This Chapter...

This chapter covered a wide range of techniques that will help you shoot better video. Here are just a few key points to remember:

- When you know the various kinds of shots and how to use them, you'll create better and more interesting movies. A close-up plays a different role from a long shot. A moving shot provides a different effect than a follow shot. Experiment and learn what to expect from each shot, and you'll be well rewarded with the results.

- Be judicious when using advanced shooting techniques. Jump cuts, zooms, and pans all play special roles. Use them because they help tell the story, not because they're cool or simply because you can. Shooting techniques should advance the video, not hinder it.

- Choose your microphone carefully. Pay attention to sound, and match the needs of your video to the microphone you select.

- Learn how to compose and light your shots. Simple techniques will add a professional flair to your personal videos.

Video Tech Talk

Curiousity lurks within the video hobbyist's psyche. Even though we claim that we just want to point the camera, shoot our footage, and go home, some nagging questions linger at the back of our minds. How does that work? What's *really* going on? Knowing the answers to these questions not only satisfies your curiosity, but also can make you a better videographer. By understanding the underlying technologies that power digital video and its products, such as DVDs, you gain significant knowledge that helps you plan and execute your digital video projects. In this chapter, you'll read about the most common video technical subjects.

This chapter covers the following topics:

- TV basics
- Video quality
- Digital video basics
- Video storage media

TV Basics

The evolution of TV technology molded the standards that grew into digital video. Many of the quirks and oddities of video production have their roots in TV's development. By understanding TV, you'll gain important insight into video. This section will discuss how TVs work and the standards associated with broadcasting.

How TVs Work

TV technology grew around a chemical called *phosphor*. Phosphor offers an intriguing property: When you direct energy at it, it glows. The more energy you use, the more it glows, and the brighter it appears. When you look at the picture on most commercial TVs, you're really looking at a treated plate attached to the front of the set. The phosphor-coated inside of your screen glows to create the illusion of light and motion as you view your favorite shows.

If you were to disassemble your TV and look inside, you would find something called an *electron gun*. This device produces beams of electrons, which shoot at the phosphor coating of your TV screen, lighting it up. Special focusing systems and magnetic fields direct the beam, making sure it hits the proper segment of the screen at the proper time. Figure 3.1 shows how this works.

The components that control your electron gun work quickly. The electron beam can draw a complete picture on your screen as many as 60 times per second. Despite this speed, a feature of phosphor presents a quality problem. As the phosphor coating absorbs energy from the electron beam, the glow lasts for only a certain amount of time. After a very short time, the glow uses up the energy, and the phosphor returns to darkness. In order to keep the picture looking right, the TV must keep refreshing the scene. (The frequency at which the electron gun redraws the screen is called the *refresh rate*.)

Figure 3.1

An electron gun produces an electron beam, which shoots at the phosphor coating of the TV screen.

Electron gun Electron beam Phosphor coating

Focusing system Screen

Figure 3.2 shows what would happen if your TV were to draw each image completely from top to bottom. By the time it hit the last row, the first row would have started to fade; by the time the top of the screen were refreshed, the bottom would fade. This would cause a very irritating flicker and destroy the illusion of smooth motion.

Fortunately, engineers found a solution, as illustrated in Figure 3.3. Instead of drawing the complete screen at once, they designed TVs to draw half the rows (the odd rows) first, skipping every other row, and then draw the other half (the even rows) to finish. This way, the top and bottom of the screen give off approximately the same

illumination. This method is known as *interlacing*, and it is used nearly universally in today's TVs. This allows the pictures to appear without flicker and produce a pleasing and nonirritating display. Each set of rows, either odd or even, used during interlacing, is called a *field*. The two fields combine to create an entire *frame*.

In order to record your favorite shows, you record the signal that creates the TV image. But that signal uses interlacing. Hence, your recording is interlaced, too. This means that when you work with video, you must always be aware of which of your materials have been interlaced and which have not. Video that does not use interlacing is called *progressive scan*. Instead of recording interlaced fields, a progressive-scan camera records the first line, then the second, then the third, and so forth in a single scan. Certain utilities, such as the well-named Deinterlacer (`www.iknowsystems.com`), allow you to convert from interlaced material. You can use noninterlaced video in projects that don't depend on TV projection technology, as well as to create better stills and slow-motion effects.

Color Space

Color space describes a way that people represent and refer to color information. Color spaces have had far-ranging influence, from international standards to the development of video cables.

A number of color space standards exist. Perhaps you've heard of RGB, the system most used by computers, which separates colors into red, green, and blue components. If you've worked in print media, you may have encountered CMYK. This space uses ink colors—specifically, cyan, magenta, yellow, and black—to describe final printed output. YIQ refers to the color space used to broadcast color TV.

The *Y* in YIQ refers, cryptically, to *luminance*, which is brightness. Back in the days of black-and-white TV, broadcasters used to transmit this information to tell TVs how bright or how dark to paint each part of the screen. When color TV entered the scene, broadcasters

Figure 3.2

Unless continuously energized, phosphor fades over time. If this TV picture were simply drawn top to bottom, the top might start to fade by the time the bottom of the picture was drawn.

Figure 3.3

To avoid fade effects and the flicker they produce, TV engineers introduced Interlacing. On an interlaced screen, only one field (half the lines) is drawn at once.

scrambled to figure out how to add color information to this signal, yet still allow black-and-white TVs to function. The compromise they hammered out, the YIQ color space, remains with us today.

The *I* and *Q* in YIQ refer to something called *chromaticity*, which is another way of saying color. By applying simple mathematics to the Y, I, and Q values transmitted across the airwaves, your TV figures out how to display the red, green, and blue levels needed to create a color image. If you own a black-and-white unit, your TV simply discards the I and Q signals, displaying the monochrome image only.

As you'll learn in the "Country Systems" section coming up soon, Phase Alternation Line (PAL) is a video standard used by some countries, such as Japan and Australia. PAL broadcasters use a slight variation of YIQ, called YUV or YCrCb. Both YIQ and YUV are often known as YCC (CC means color), referring to the luminance and chrominance, without specifying further color information.

Color Sampling

To conserve bandwidth, digital video uses *color sampling*. This method takes advantage of the human sensitivity to luminance (Y) over color (CC). Humans react more strongly to brightness changes than to color changes. (As a rule of thumb, the human eye reacts most strongly to Y-coded brightness, then to I-coded color, and then to Q-coded color.) This lets broadcasters cheat a little. Even though the data skips some of the color information, viewers are fooled into thinking they're looking at an original, uncompressed video. Color sampling is so intrinsic to digital video that it usually occurs without us ever noticing.

Color sampling comes in four flavors, as illustrated in Figure 3.4:

- 4:4:4 color sampling refers to uncompressed, original data. For every four frames, the color component appears in each frame. Digital video rarely uses this approach.

TV SAFE ZONES

Nearly every picture-tube TV "overscans," losing a little picture information on each side of the screen. This problem gets worse as a TV ages. To compensate for overscanning, broadcasters use safe zones. A *safe zone* is basically the center 80 to 90 percent of the image. Using the safe zone ensures that important image elements appear correctly, even on older TV units.

Safe zones come in two varieties: a slightly larger *action safe zone* and a smaller *text safe zone*, for titles, captions, and other text-based display. This provides clear viewing of digital video material, no matter how poorly adjusted a TV set may be.

As you might expect, overscanning does not affect newer LCD-based TV units.

- 4:2:2 skips some color data. For every four frames, the color component appears in only two frames. This high-quality color sampling is used primarily for broadcast and is supported by the MPEG-2 format (a widely used compression format).

- 4:2:0 works just like 4:2:2, except that the color component is split in two; only half appears in each color frame. This places 4:2:0 somewhere between 4:2:2 and 4:1:1 in terms of color information. Many PAL-format camcorders and DVDs use this format.

- 4:1:1 skips the color component for three out of every four frames. Digital video uses this color sampling to produce good-quality, consumer-grade video.

Component Video, S-Video, and Composite Video

Component video, S-Video, and composite video refer to ways to transmit video. When using *component video*, each element of the color space transmits separately. For example, for an RGB signal, the red information arrives on one cable, the green on another, and the blue on another. In the case of YCC, one cable produces luminance and the other two cables produce the color components. Component video offers the best-quality video available. Most prosumer video uses component video.

S-Video is similar to component video, but with an exception. It transmits only two signals, luminance and chrominance, each on a separate wire. While a step down from component video, it still provides better signals than composite video. More and more mid- to high-grade consumer video equipment supports the S-Video standard.

With a *composite video* system, all three signals arrive together. Your TV or other video device must separate the signals in order to display the picture correctly. Often, these systems use a type of coaxial cable (*coax* for short) to transmit the data. Coax generally refers to a thick, round, insulated cable that transmits a composite signal down a central wire. If you use RCA cables with the yellow, red, and white connectors, you're using composite video. Only the yellow cable provides a video signal. The red and white connectors transmit stereo sound. You'll find coax connections on older TVs and converter cards. Nearly all consumer-grade video systems support RCA connections.

Figure 3.5 illustrates the connectors for each type of video cable.

Figure 3.4

Color sampling allows digital video and broadcasters to transmit less data.

4:4:4 color sampling (uncompressed; rarely used in digital video)

4:2:2 color sampling (high-quality broadcast video)

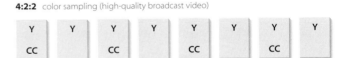

4:2:0 color sampling (PAL camcorders and DVDs)

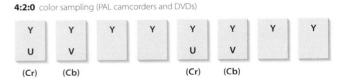

4:1:1 color sampling (consumer-grade digital video)

Y = Luminance (brightness)　　**CC = Chrominance (color component)**

Country Systems

TV standards vary. In the U.S. and Canada, TVs display 525 picture lines. When you watch TV in England, you'll see 625 picture lines instead, roughly 20 percent larger than a U.S. TV picture. This difference occurs because the U.S. and England use different *country systems*. These systems define video standards for TV signals used around the world.

NTSC, PAL, and SECAM

The most widely used standard (in total number of TV sets) is NTSC, which stands for National Television Standards Committee. NTSC video uses a 525-line signal transmitted at 29.97 frames per second (fps). You'll find NTSC used throughout the Western Hemisphere and wherever U.S. influence has been strong, such as in South Korea and Taiwan.

PAL is the video standard for TV signals used in Western Europe, Australia, Japan, and many other countries that do not specifically support the NTSC standard. PAL video is made up of 625-line signals transmitted at 25fps.

Nearly every country, except France, uses either the NTSC or PAL standard for TV. France uses a PAL derivative called SECAM. (You can also find SECAM around the Middle East and French-speaking Africa.) You can think of SECAM as PAL with a French accent. SECAM videotape recorders can record and play back in PAL format. French consumers buy PAL DVD players that play back on their SECAM television sets.

The differences in both frame rate and number of picture lines means that you cannot swap videotapes with someone who uses a different country system. Don't try to send your home videos to a friend in Australia. He won't be able to play them without purchasing an expensive multisystem VCR. Even then, the image may appear compressed or stretched out on his screen.

The software you use to create desktop video will generally allow you to choose between country systems both for input and output. Be aware, however, that even if you produce a PAL video on your PC, you cannot record it correctly with your NTSC VCR.

DVD Region Coding

When DVD came along, many people thought it would allow them to share videos between countries. However, the Motion Picture Association of America (MPAA) introduced a system called *regional coding* to DVD production to prevent this.

In theory, the MPAA developed regional coding to protect theatrical distribution markets. Motion pictures are released at different times in different international markets. Regional codes prevent DVDs from being imported into markets

Figure 3.5

Component video, S-Video, and composite video technologies use different connectors.

Component video delivers each signal on a separate wire for highest quality video.

S-Video delivers luminance and color component signals on separate wires.

Composite video combines the signals onto one central wire.

in which the theatrical runs have not completed. This encourages people to view films in theaters rather than at home and helps ensure revenues from the theatrical release.

In practice, regional coding means that if you purchase a commercial DVD from England (region 2), or Australia (region 4), you will not be able to play it on your U.S. DVD player (region 1). Regional coding does not, however, affect most homemade DVDs or other formats for burning video onto CDs (such as miniDVD and VCD, discussed in the "Video Storage" section of this chapter). The coding applies only to commercial products. The DVD regional codes are shown in Table 3.1.

REGION	COUNTRY
1	U.S., U.S. Territories, and Canada
2	Europe, South Africa, Middle East (including Egypt), and Japan
3	Southeast and East Asia (including Hong Kong)
4	Australia, New Zealand, South America, Central America, Mexico, the Caribbean, and Pacific Islands
5	Africa, the Indian Subcontinent, Eastern Europe (former Soviet Union), Mongolia, and North Korea
6	People's Republic of China
7	Reserved for later use
8	International venues such as airplanes and cruise ships

Table 3.1

DVD Regional Codes

To bypass the regional coding, many gray-market entrepreneurs have introduced "region-free" DVD players that use the universal region 0. Recently, the MPAA has introduced a new level of technology that checks to see if a player is set to region 0. If so, the DVD will refuse to play. This new technology is called Regional Code Enhancement (RCE). The movie *The Patriot* was the first commercial DVD published with RCE. RCE has become more common and appears on many new DVD releases.

> The Content Scrambling System (CSS) is another DVD protection introduced by the MPAA to protect movie copyrights. A recent furor arose when Linux enthusiasts developed and released a descrambler, called DeCSS, that allowed users to play DVDs on their Linux-based computers. While the program was developed to view commercially purchased DVDs, the MPAA feared it could be used to illegally pirate discs. For this reason, the DeCSS program was generally banned from the Internet.

Video Quality

Video quality derives from three factors: frame rate, resolution, and compression. As the frame rate and resolution increase and the compression decreases, quality rises dramatically. Admittedly, it does so at a cost. These costs take two forms: bandwidth and storage.

Bandwidth refers to the amount of data that a system can push through some communications device at any time, otherwise known as the *bit rate*. When you use a 56 kilobits per second (Kbps) dial-up modem, it takes much longer to send or receive a 1MB video than it would with a 384Kbps DSL line. The modem offers a lower bandwidth than the DSL line, because it transmits less data per second. Bandwidth proves to be important in the world of video because there's a huge amount of data associated with any video, no matter how basic.

IEEE-1394 (FireWire or I-LINK) offers another demonstration of bandwidth efficiency. It allows you to transfer high-quality video in real time from your camera to your computer. Older USB connections cannot handle this sheer quantity of information effectively. With USB, you must trade off between quality, video size, or real-time. Serial connections cannot handle real time video at all. However, newer USB-2 ports allow near-1394 efficiency because they offer higher bandwidth capacity.

Storage refers to the total space used to store your video. Unsurprisingly, the bigger the video, the larger the space needed. This rather obvious component comes into play when you start to think about *how* you'll store the video. A small, highly compressed, low-frame-rate video might take up a few megabytes. In contrast, a longer, better-quality, high-frame-rate feature might occupy literally tens or hundreds of gigabytes. You can easily store the former on your hard drive or on a CD. The latter might require you to purchase new drives and store your videos on advanced recordable DVDs (discussed later in this chapter, in the "Video Storage Media" section).

The better the video, the higher the bandwidth and storage demands will be. Producing desktop video often requires compromises; you must balance production values with your computer's limitations.

Frame Rate

Many people have tried to explain the magic of movies and video. Some attribute it to a physiological feature called persistence of vision. In *persistence of vision*, our eyes and brain try to hold onto a series of sequential images, forming the illusion of motion. Others point to more general cognitive functions that allow us to integrate and interpolate movement. Whatever the reason, the main fact is clear. When we're shown a series of pictures at a certain rate, they begin to fuse together into an illusion of smooth movement. This rate is called the *critical fusion frequency* (CFF) and refers to the rate at which the screen needs to refresh in order to avoid flicker and allow the picture to appear steady to the viewer.

As a rule of thumb, the higher the frame rate, the smoother the motion you'll experience. Generally, 10fps offers the absolute lowest frame rate that lets us perceive smooth motion. Video that is slower than 10fps appears jerky with a strong jitter. At about 24fps to 30fps, video runs smoothly without perceptible roughness. Motion pictures project film at 24fps. Most TV systems broadcast at approximately 30fps.

Figure 3.6

Higher frame rates require more bandwidth and storage. Reducing the number of frames per second reduces both storage and bandwidth requirements.

Figure 3.7

Smaller frames reduce both storage space and bandwidth requirements.

Of course, as the frame rate increases, so will the total number of frames you'll need to process and store per second. More frames mean more disk space and, if you plan to broadcast over the Internet, more bandwidth to transmit your video. Figure 3.6 illustrates how the frame rate affects the storage and bandwidth requirements.

Less Bandwidth Resolution

Resolution refers to the amount of picture detail in each video frame. The terms *horizontal resolution* and *vertical resolution* refer to the number of samples (or picture elements, called *pixels*) that lie, respectively, along the width and the height of a frame. As the resolution increases, you see more picture detail, so the image becomes clearer and easier to view. Of course, as the resolution increases, so does the size of each frame, and that brings us back to bandwidth and storage.

Large frames, no matter how beautiful they look, occupy a lot of bandwidth and storage space, as illustrated in Figure 3.7. There is also a multiplication factor in effect. If you increase frame resolution by as little as 10 percent, you end up increasing the size of your entire movie by 10 percent. A 10 percent increase in frame resolution isn't really much improvement, but a 10 percent increase in movie size can be huge.

Compression

Compression allows you to store video data more efficiently by squeezing the picture down to a manageable size. With compression, your video presents the same (or almost the same) picture information while using a smaller amount of storage. It's as if your video camera carried around wallet-sized versions of your pictures rather than individual 8×10 glossies.

More storage
More bandwidth

Less storage
Less bandwidth

Figure 3.8

Increasing compression reduces storage and bandwidth requirements, but also lowers picture quality.

As the compression rates rise, storage requirements decrease. Pictures fit into a smaller space. While this might seem like an ideal solution for both bandwidth and storage issues, you must take two key compression factors into consideration: lossiness and decompression time. These factors greatly affect the quality of the final video.

Lossiness refers to a quality decrease produced by the compression process. Lossiness means that the picture you see when you decompress won't be exactly the same picture you originally compressed. You lose image detail and gain errors termed *compression artifacts*. You'll notice these errors particularly around slants and diagonals. As the compression factor increases, so will the errors associated with the video. Figure 3.8 illustrates this concept.

Time is the other factor associated with compression. A compressed video needs to be restored (decompressed) to be viewed. It takes time—often a lot of it—to decompress your video. If this is done before watching the video, there's no problem. However, if you need to watch the video at the same time as you decompress it, decompression time makes a difference. Few things are harder to watch than a video that keeps pausing to decompress the next segment. Anyone who has attempted to watch a DVD on an old, slow computer with software decompression has had this experience.

> Standard digital video uses a 5:1 compression ratio. A video compressed for the Web might be compressed as much as 50:1 or even 100:1.

Codecs

Codecs refer to a large variety of algorithms that COmpress and DECompress video and other types of images. There's nothing magical or remarkable about codecs. They're simply a number of standards that people have developed to optimize some playback feature or another. Some codecs produce highly compressed, fast-playing videos. Others offer excellent motion reproduction or good-quality stills. The key to all of this is, of course, compression. If we didn't need to compress video, we wouldn't need to use codecs at all. As it is, each codec serves a different purpose. Table 3.2 lists some of the more common codecs currently in use.

> You may notice that there is no MPEG-3 listed here. MPEG-3, with a resolution of 1920×1080, was originally designed to support high-definition TV (HDTV) before the standard became folded into MPEG-2.

CODEC	APPLICATION
DV	Hardware-encoded consumer video
MPEG-1	Primarily VCDs
MPEG-2	DVDs and VCDs
MPEG-4	High-quality Web video
Real Media	Real-time streaming Web video
Windows Media Video	Real-time streaming Web video
Cinepak	High-motion video, works on older computers
Intel Indeo 3	Low-motion video, works on older computers
Sorenson	High-quality video for CD-ROM
Indeo Video Interactive	High-quality video for CD-ROM

Table 3.2

Common Codecs

Compression and decompression times are key factors when using codecs. Some codecs, known as asymmetric codecs, are built so that they take a long time to compress video, but they decompress video rapidly. This allows the viewer to watch movies in real time, even though it might have taken a long time to compress each minute. The various Motion Picture Experts Group (MPEG) formats are good examples of asymmetric codecs.

Types of Compression

Today's technology offers two basic flavors of video compression: intraframe and interframe. *Intraframe compression* squeezes down a single frame at a time, without reference to any other frame. This method, also called *spatial compression*, searches for solid blocks of color within an image and compresses those areas. It also compares the even and odd lines of the image (the fields) and compresses the picture using field similarity.

Interframe compression uses the similarity between sequential frames to save space. Rather than store entire frames, the computer stores just the differences between one frame and the next. Interframe compression is often called *temporal compression.*

Each method allows a computer to reduce the data size associated with storing and transmitting video. Encoding standards may use one or both of these methods. Standard digital video, for example, uses only intraframe compression. The MPEG-2 standard, found on commercial DVDs, uses both. Table 3.3 summarizes some common video compression formats.

FORMAT	RESOLUTION	COMPRESSION TYPE
MPEG-1	352×240	Intraframe
MPEG-2	Ranges from 352×240 to 1920×1080; typically 720×480	Interframe and intraframe
DV (DV-25)	720×480	Intraframe
Cinepak	Varies	Interframe and intraframe
Intel Indeo 3.2	Varies	Interframe and intraframe

Table 3.3

Common Video Compression Formats

MPEG-2 Interframe Compression Basics

This book would be remiss if it didn't offer you a quick tutorial in MPEG-2 interframe compression. MPEG-2 is used so widely that it helps to know how it works. MPEG-2 uses three types of frames:

I (intraframe) frame This is a type of key frame. Key frames derive directly from the video and are not calculated from other frames. I frames are the largest frames and must store the most data.

P (predictive) frame This frame is derived from the frame before it and specifies how it differs from the frame it follows. P frames are smaller than I frames, requiring much less data storage. P frames are a type of difference frame. All difference frames are calculated from other frames, so they store much less data per frame.

B (bidirectional) frame This frame is computed from both the frames before and after it. B frames are the smallest of the three frame types. Like P frames, B frames are difference frames.

MPEG-2 frame sequences can include any combination of I, P, and B frames. Most encoders use a prebuilt fixed pattern such as IBBPBBPBBIBBPBBPBB. Technologically advanced encoders, in contrast, will try to optimize the frame placement based on the quality and features of the video itself. The key frame frequency helps determine both the size and the quality of the compressed video, as illustrated in Figure 3.9. More I key frames preserve image quality but at the cost of greater size and bandwidth.

MPEG-2 compares successive frames by dividing pictures into blocks. When successive blocks prove sufficiently dissimilar, the change is recorded onto a difference frame, either a B or P frame. As illustrated in Figure 3.10, the difference frame stores only those parts of the picture that have changed.

Figure 3.9

With MPEG-2 compression, as key frame rates increase, so do image quality, storage, and bandwidth.

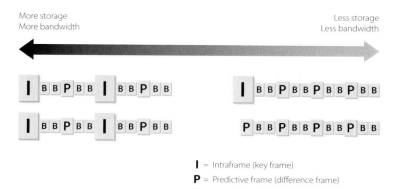

I = Intraframe (key frame)
P = Predictive frame (difference frame)
B = Bidirectional frame (difference frame)

Frame n

Frame n+1

Difference frame

Figure 3.10

Difference frames store only those video blocks that have changed between successive frames.

Digital Video Basics

Now that you know some of the basics associated with video technology, let's take a look at how digital technology contributes to modern video. The following sections discuss how digital video cameras work, digital video standards, and some drawbacks of digital video.

How Video Cameras Work

All video cameras operate in much the same way. Light enters the camera. The camera lens focuses this light onto a detector. The detector creates an electrical signal. A magnetic tape of some sort records this signal.

Nearly every video camera on the market uses the same type of detector, called a charge couple device (CCD). CCDs transform light into levels of electricity that can be recorded onto a tape. It is how this information is recorded that differentiates analog and digital video cameras.

Some cameras use better quality CCDs than others do. Top-end cameras offer multiple detectors. The very best cameras use larger CCDs to stabilize your image. In general, you get what you pay for.

Analog video cameras record a signal that represents image brightness directly to tape. Signals range as low or as high as the detector can measure, and they can include any level within that range. Digital video cameras, in contrast, can record only specific levels. You might wonder why this is considered an advantage. After all, an analog camera can record an almost infinite range of values representing the signal, while the digital camera plods along with whole levels such as 15, 16, 17, 18, and so on. Here's what digital will do for you:

- Digital signals allow you to transfer your video data directly to a computer. Once you import your video, you can edit, enhance, and play with it. Computers only speak digital.

- Digital signals guarantee data accuracy. If you record level 252, you're going to get level 252 played back. There's no approximation or round-off error with digital. Digital video cameras also use built-in error correction to make sure that the data you record is as perfect as can be.

- Digital tapes are manufactured to higher standards than analog tapes. Although you pay more for digital video media, you receive a better-quality product for the money.

- Digital produces no generation effects. Each time you record to a new copy, you're guaranteed to reproduce the original exactly. You do not lose any information or gain unwanted noise.

If you add a tiny bit of noise to an analog signal, it sticks. You cannot get rid of it, no matter how you try. With digital, you either make that quantum leap from 1 to 2 and 2 to 3 or, as things normally go, you don't. You would need a whole truckload of noise to push a (real) signal 1 to a (noise-induced, wrong) signal 2. That almost never happens with digital.

Digital Video and Videotape Standards

Several years ago, a consortium of electronic companies joined together to form a standards committee for consumer-grade digital video. This group, called the DVC Consortium, included many high-profile companies such as Sony, Philips, Panasonic, Hitachi, and Sharp. As of today, more than 60 companies have joined. The standard they developed includes the following features:

- Stores video information using a 25-megabit per second (Mbps) data stream. This streaming technology is better known as DV-25.

The actual data stream associated with DV-25 can run as high as 36Mbps after you add in audio, time codes, error correction, and other features.

- Uses intraframe compression to store data. This means that each video frame is compressed individually, without using data from the previous frame or next frame.

- Includes interfield compression, because each video frame is composed of two halves, called fields. This allows tighter compression at the expense of rapidly moving objects. Because of this, the standard sometimes produces a slight blockiness effect near moving edges.

- Uses 720 samples per scanline. You'll find 525 of these lines on a standard TV screen (625 if you live outside the U.S. in a country that supports the PAL format). In the U.S., you'll encounter video frames whose sizes are at best 720 pixels wide by 525 pixels high.

The DVC Consortium also developed a tape standard called MiniDV. MiniDV provides the most widely used standard for digital video cameras. You can find MiniDV tapes for sale in Wal-Mart, Target, and other discount stores. MiniDV offers excellent resolution and color-recording capabilities. Many consider MiniDV recordings to be of broadcast quality.

Digital8 is a standard introduced by Sony to offer backward compatibility with the older Hi8 and Video8 formats. Digital8 cameras can play these older tapes, automatically converting them to digital video format. Digital8 tapes can prove a bit harder to find than the pervasive MiniDV tapes and often cost a bit more.

Digital Video Drawbacks

For all its promise, digital video technology does have some drawbacks. It's only fair to apprise you of the negative aspects as well as the positive ones.

Feathering and dot crawl When you look at fine detail on digital video, you may find a slight feathering or crawl effect. You'll see this effect near the sharp edges of text, along natural diagonal lines, and on other edges. This effect is caused by compression and is most visible when you place white lettering on a blue background.

Motion blocking This effect occurs when an on-scene object moves quickly. Recall that the camera first records one field of a frame, and then records the next field. When your digital video camera compresses these two fields after a rapid change, it needs to balance the difference in fields with the amount of space it has available to store the picture. When fields are similar, the data compresses easily. When fields differ due to movement, the digital video format must save space to fit in that extra information. It does this by using a cruder compression scheme; hence, you get the blockiness that borders the object and tends to travel with it across the screen.

Banding Banding results from a dirty camera head. Digital video cameras have two record heads. When one record head becomes soiled (with tiny particles shed from the videotape, for example) and cannot read data, you end up with a striped image. You can diagnose this problem right away. You'll see 10 bands (or 12 bands outside the U.S.) across your screen. Every other band will show a live picture. When this occurs, try using a head-cleaning tape. If that doesn't work, you may need to service your camcorder.

Video Storage Media

Today's video technology offers a virtual smorgasbord of distribution media. From the tried and true to the new and daring, one of these video-storage schemes should be right for you.

Videotape

Videotape may seem "old hat," but it provides a cheap, convenient, and easy-to-distribute medium for your videos. Of all the media, videotape allows you to share with the widest audience. VCRs are an almost universal technology.

Several products allow you to broadcast your movies from your computer through a video cable to your TV or VCR, where you can record directly onto a tape. This technology allows you to copy and distribute your movies with ease. And videotapes have the advantage of being able to store up to eight hours of video on a single tape.

DVDs and Recordable DVDs

DVD stands for digital versatile disc. In many ways, DVDs are bigger, faster, and more robust compact discs (CDs) that can store video as well as audio and data. DVDs can store many gigabytes of data, in contrast with the sub-gigabyte capacity of most CDs. DVDs use MPEG-2 compression to provide high-quality video and audio. The DVD player has found broad acceptance, becoming the most rapidly adopted consumer-electronics product *ever*.

Early in 2001, recordable DVDs entered the consumer marketplace. Compaq and Apple led the pack, introducing Pioneer's DVD-R drives (like the one shown in Figure 3.11) into their high-end prosumer computers. Soon after, Philips introduced a competing DVD+RW standard, which has not competed well against the more successful DVD-R/DVD-RW standard. Some will compare this to the old struggle between VHS and Betamax. Unlike that classic competition for market share, though, the differences between the two technologies are very slight.

Although the "minus" standard offers both write-once recordable and rewritable versions (DVD-R and DVD-RW), the "plus" standard has no one-time-use equivalent. It comes only in DVD+RW. For more information about the two standards, see Chapter 10, "Burn Your Movies to DVD and VCD."

Figure 3.11

**A Pioneer A-103
DVD-R/RW drive**

DVD-R drives allow aspiring videographers to create and burn their own DVD products. These homemade DVDs will work in most DVD players. With prices for DVD-R drives hovering around $200, and DVD-R blanks selling for well under $1 apiece (for unlabeled brands; labeled brands still sell for about $3 to $4 each), DVD-R's popularity has skyrocketed.

As of today, DVD-Rs do not yet provide the storage capacity or encryption techniques you'll find on commercial DVD offerings. In particular, DVD-Rs offer less space. They can store only about 60 to 90 minutes of video. However, DVD-Rs are an excellent match to the more modest needs of consumer and small businesses. Clearly, DVD-Rs will not set you up in the DVD-publishing business. However, if you want to share home videos with family or you want to create a small production run of your in-house video-based product catalog, DVD-Rs may provide the solution.

> Stand-alone DVD recorder units that operate like digital VCRs have now appeared on the market, starting at about $550. Standouts include the Panasonic DMR-E20 (DVD-R) and the Philips DVR-1000 (DVD+RW).

Some DVD players support a type of DVD-on-CD recording called *miniDVD* or, less often, *cDVD*. Although support is growing, only a few DVD players can play miniDVDs, most notably some Pioneer, Apex, Yamaha, and Hitachi models. Make sure to check the Internet for compatibility before purchasing a player.

VCDs

Video compact discs (VCDs) are CDs that store video. VCDs have proven popular in the Far East. Now they are gaining a foothold in Europe and the U.S., as more and more commercial DVD players offer VCD playback.

Unlike miniDVDs, VCDs use a particular and characteristic menu and folder structure. You can easily build a pleasant interface to front your VCD in many video-creation and CD-burning programs. While a miniDVD cannot be played back without a DVD player, most VCDs can be played on any computer if you already own some sort of MPEG player, such as Windows Media Player or QuickTime.

DVD players vary in their willingness to play VCDs. Some will play only CD-RW VCDs; others play both CD-R (record once) and CD-RW (rewriteable) VCDs. Although stand-alone VCD players exist, they are generally not found in the U.S. and Europe. (See Chapter 8, "Burn Your Movies to DVD and VCD," for details on playing VCDs.)

> The big manufacturing push today is to make DVD players compatible with more formats. While miniDVD support still proves scarce, this derives from technology issues, not marketing strategy. The new MultiPlay standard means that VCDs will play on most consumer DVD players in the future.

VCDs come in three flavors:

- Standard VCDs use MPEG-1 compression to store video, allowing a single CD-R or CD-RW to hold approximately 74 minutes.

- Super VCDs (SVCDs) use a variable bit rate and can store video using either MPEG-1 or MPEG-2 compression. With a higher resolution—480×480 for NTSC and 480×560 for PAL—SVCDs generally store less video, typically around 30 minutes' worth.

- Extra VCDs (XVCDs or XSVCDs) are like SVDs with higher bit rates, up to 3.5Mbps. This standard is fairly new and not widely supported. Many people use the term XVCD to refer to any nonstandard VCD format.

> Realistically, VCD technologies may offer only a stopgap format while consumers wait for recordable DVD. Expect these to fall out of use as DVD+RW, DVD-R and DVD-RW technologies fully emerge over the next few years.

Streaming Media

As more and more households hook up to the Internet with high-speed broadband connections, the possibility of sending video over the Internet has become real. With *streaming media*, you can broadcast your movies to friends, family, customers, and business partners around the world. A host, called a *server*, stores your movie online, to be transmitted upon request. As of today, three standards dominate this arena:

RealNetworks RealNetworks has made a name for itself with its RealVideo offerings. RealNetworks focuses exclusively on delivering streaming content over the Internet in real time. Its SureStream technology provides excellent-quality delivery for both live and on-demand product.

QuickTime QuickTime represents Apple's entry into the multimedia market. While QuickTime provides top-notch streaming content, both live and on-demand, it also offers an offline media architecture. QuickTime provides the richest mix of content type, combining video with text, sound, 3D, virtual reality, and so on.

Windows Media Microsoft proves to be the third, and arguably the biggest, player in the streaming video world. The developers built support for creating Windows-based movies directly into the Windows operating system, beginning with Windows Me.

These technologies promise flexible, powerful, and exciting methods for sharing video. See Chapter 9, "Share Your Movies with Streaming Video" for details on streaming media.

In This Chapter...

This chapter has delved into many technical issues that surround the use of digital video. Here are some thoughts to take away with you after reading through the chapter:

- Many of the quirks and oddities in digital video production derive from the history and technology of broadcast TV.

- In today's global technology, it helps to know your country systems and region codes, particularly when you share and distribute your videos with people in other countries.

- Bandwidth tradeoffs are inevitable with current technology and today's digital video. Make informed choices. Understand how frame rate, resolution, and compression affect video quality.

- Digital signals and digital standards provide real improvements over analog technology. A key benefit is that digital video allows error-free copying without generation effects and the introduction of noise.

- Recordable DVD (DVD-R, DVD-RW, DVD+RW) continues to become more available and less expensive. If you cannot afford it this year, you may be able to next year.

Transfer Video to Your Computer

Some camcorders offer quick and easy video transfer; others need special cables and equipment for the job. The type of camera you buy and the computer you use will dictate how you can move your footage between your camcorder and your PC.

In this chapter, you'll learn how to prepare for and perform video transfers. You'll also learn some ways to avoid dropped frames, an important video-transfer issue. After reading through this chapter, you'll be ready to connect your camera to your computer and bring your video over to your computer.

This chapter covers the following topics:

- **Prepare your digital video camera for transfer**
- **Prepare to transfer from an analog source via the 1394 standard**
- **Prepare to transfer analog video with a non-1394 digitizer**
- **Transfer your data**
- **Avoid dropped frames**

Prepare Your Digital Video Camera for Transfer

Nearly every modern commercial-grade digital video camera—from the top of the line all the way down to a bare-bones budget unit—arrives equipped with a 1394 port. 1394 ports make video transfer simple and direct by offering two-way controlled, high-speed data connections. Depending on the manufacturer, your 1394 video-transfer port might be called IEEE-1394, FireWire, or I-LINK. Each of these names refers to an identical technology (apart from trademark issues). The 1394 standard allows you to connect a wide range of cameras to your computer system and be assured (more or less) that they will operate in a similar manner. Figure 4.1 illustrates the concept.

A digital video camera is just one of many types of devices you can use with IEEE-1394. You can find a plethora of external drives, data-capture devices, and so forth that work with 1394. When you've filled up all the internal hard drive bays of your computer, consider acquiring a fast and economical external 1394 hard drive to store extra video footage. For example, you might find a standard 80GB hard drive (such as Ultra ATA 7200) for about $100 and install it in an external FireWire (1394) enclosure that costs about $70. Once assembled, you can plug in this device and use it as desired when you want to archive digital video. (This ability to add and remove the drive while the computer is running is called *hot swapping*.)

Check Your Supplies

To take advantage of your digital video camera's onboard 1394 port, make sure to have the following items on hand:

- A reliable power source, such as a well-charged battery or an AC adapter
- A computer with a 1394 card installed
- Software that can import video through the 1394 port, such as Ulead VideoStudio (`www.ulead.com`), iMovie (`www.apple.com/imovie`), or another standard video-editing package
- A 1394 cable

Figure 4.1

The IEEE-1394 standard allows you to connect a variety of devices to your computer for high-speed data transfer. Most digital video cameras offer a 1394 connection.

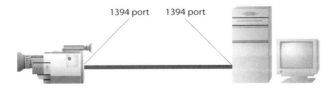

You can expect to pay $8 to $25 for a 3-foot or 6-foot 1394 cable. If your local store charges more than that, ask the clerk to check the store's national pricing. You may want to shop around for the best deals. You'll also find better prices on the Internet. Anandtech's Web site (http://forums.anandtech.com/categories.cfm?catid=40) offers excellent coverage of current technology. It hosts a "hot deals" forum, where you may find good prices on digital video equipment, cables, tapes, and so on.

Make sure to purchase the proper cable for your needs. If you have a four-pin camera socket and a six-pin computer socket (the most common configuration), make sure that you purchase a four-pin-to-six-pin cable. Other standard cables are four-pin-to-four-pin and six-pin-to-six-pin. See the next section for some tips on identifying the sockets.

Prices vary by cable length, The 3- and 6-foot lengths are the most common. In general, if possible, buy at least 6-foot cables. Longer cables can be helpful when you're setting up your system.

When working with digital video, you will need a computer with a big, fast hard drive. Digital Video works best with lots of space and lots of speed. You need 1GB of hard disk for each 5 minutes of video. It takes nearly 13GB of storage to save a 1-hour DV-25 video. (DV-25 is the digital video standard, as discussed in Chapter 3, "Video Tech Talk.") Be prepared. Buy the biggest disk you can and opt for faster RPM speeds.

Know Your Digital Video Connections

You'll need to know where to connect your 1394 cable to your camera and computer. Locate and identify the connections as follows:

Locate the 1394 socket on your camera Finding the 1394 socket on your camera can prove harder than it sounds. Most sockets are hidden behind some sort of cover or protective shell that you must open. For example, Figure 4.2 demonstrates how you need to maneuver to gain access to the port on one fairly inconvenient JVC model. For this camera, first, push the hand strap down an inch or two. Next, open the rubber cover and push it out of the way. Only then can you reach the 1394 port, found just below the DV IN/OUT label. (The logo to the right of the port refers to I-LINK). Port accessibility varies by camera, so make sure to check your camera's manual for the exact location of the socket on your unit.

Identify the type of socket on the camera 1394 sockets come in two flavors: six- and four-pin. A few digital video cameras offer six-pin connections, but most use four pins. Figure 4.3 shows both connector types. The six-pin socket, on the left, has a longer, almost rectangular

head, with one side slightly rounded to make it easy to orient the connector. When you peer inside the socket, you'll see six metal leads—three on each side of the head. The four-pin socket, in contrast, has a crimped-looking head. You'll find four tiny leads on the crimped side. As with the rounding on the six-pin socket, the crimping orients the connector correctly, ensuring a proper fit into the socket.

Identify the socket on your computer While most digital video cameras use four-pin connectors, nearly every 1394 computer card uses a six-pin connection. Make sure to examine the socket on your computer to determine which type of connector it uses.

> If you're curious, the difference between four-to-six connections and six-to-six connections depends on how the 1394 device is powered. Four-pin units are expected to be self-powered. Six-pin units generally derive their power from the 1394 connection, with the power passed on the extra two pins.

Prepare Your Video Camera

Now that you have all of your supplies and found the sockets, you can get your digital video camera ready for the transfer. Follow these steps:

1. Remove any tripod mounting screws before placing your camera down on a surface. A camera with a tripod mount in place can prove extremely unstable. When you put it down, it may topple over. Make sure that the camera sits firmly where you place it, and you'll avoid a costly mistake.

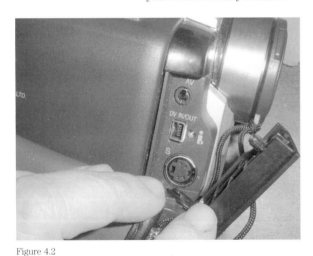

Figure 4.2

Some IEEE-1394 connections prove harder to find than others. This four-pin connection is labeled as DV IN/OUT and with the I-LINK logo.

Figure 4.3

IEEE-1394 sockets use two standard connection types: six pins (left) and four pins (right).

2. Connect the 1394 cable to your camera and computer. Insert the cable firmly, making sure that it's fully seated. Don't twist, bend, or otherwise force the connection. The cable should attach easily and remain in place.

3. Turn on your camera and set it to playback mode. When starting up, video-editing programs look for a camera already connected to the 1394 port. Make sure that you're using a well-charged battery or, better yet, an AC adapter to provide long-term, good-quality power to your camera. The camera may remain powered on for the duration of your editing session.

4. For Windows systems, you may need to install drivers. Whether or not you've used your 1394 port before, Windows may detect it as a new device and ask you to install drivers. If the drivers are present on your hard drive, you can press the Enter key and let Windows search for the driver.

5. Queue the tape. If you have not done so already, load your tape and play back a few seconds on your camera to make sure that the tape starts roughly at the correct location. 1394 connections allow you to control the playback (play, fast forward, and so forth), but holding down the mouse button to fast-forward or rewind with a video preview can be a pain. Save yourself both time and annoyance by queuing the video to the correct place before you begin.

6. Monitor the sound. Many 1394 connections—in particular on the PC/Windows platform—do not offer sound playback during capture. You can, however, listen to the sound by raising the volume on your camera.

7. Put down the camera. Feel free to place your camera in a location a bit out of the way. Save your desk space for more important items. The 1394 standard offers full camera control, so your software will handle all of the playback. You don't need to keep the physical buttons within easy reach. Place the camera on a flat, stable surface, and don't worry about any further manual interaction.

After you've completed your preparations, you're ready to transfer your video. See the "Bring Over the Data" section later in this chapter for details.

Prepare to Transfer from an Analog Source

If you have an analog camcorder, you can purchase a converter box to take advantage of 1394 power. In fact, 1394 converters can provide a video stream from any analog source, including cable, VCR, DVD player, hard-drive-based TV recorder, and other devices. Among other features, this allows you to transfer home movies onto your computer and into your video-editing software. Keeping fair-use guidelines in mind, this also allows you to digitally record your favorite shows and bring them along on VCD or DVD (for personal use, of course) when you travel.

Some popular converter boxes include Miglia's Director's Cut (www.miglia.com), Dazzle Hollywood DV-Bridge (www.dazzle.com), Canopus ADVC-1000 (www.canopus.com), and the Sony line (www.sony.com). Converter box prices start at about $200. You can order units directly from the manufacturers, from video-specialist vendors, and from computer suppliers such as Dell and Apple. Many office supply stores (such as Staples and Office Depot) and computer specialists (such as CompUSA) stock at least the Dazzle box. Before purchase, you may wish to search the Internet for opinions about the quality and reliability of the item you're considering.

Digital converter cards, or video-capture boards, provide an intriguing alternative to external converter boxes. Many cards come equipped with 1394 ports as well as analog video connectors, and they allow you to hook up an analog camera (or VCR, cable, or other analog source) as easily as a digital video camera. Many cards also provide high-end, hardware-based video-effects processing. As with nearly everything in life, you get what you pay for. These cards fall into what many call the "prosumer" product line rather than the more budget-minded consumer arena. Better-quality cards can cost $1,500 or more and include the Canopus DVStorm (www.canopus.com), Pinnacle DC 1000 (www.pinnaclesys.com), and Matrox RT2000 (www.matrox.com).

Check Your Supplies

You'll need to gather together the following items to use a 1394 connection with your analog camera or other analog source:

- A reliable power source, such as a well-charged battery or an AC adapter
- A digital video converter card or a 1394 video converter box, and in some cases, an adapter to power the converter box

> The need for powering the converter varies by manufacturer. The Director's Cut box is self-powered, but the Hollywood DV-Bridge box requires external power. A digital video converter card installed in your computer requires no additional power.

- A video cable to connect your analog camera to the converter box or card (typically via RCA composite plugs or S-Video)
- If you're using S-Video, an audio cable (usually with white and red RCA plugs) to provide sound
- If your converter box provides audio-out, optionally, an audio cable with white and red RCA plugs on one end and a mini-plug adapter (suitable for microphone or line input) on the other

- If you're using a converter box rather than a converter card, a computer with a 1394 card installed

- If using a converter box rather than a converter card, a 1394 cable

- Software that can import video through the 1394 port, such as Ulead VideoStudio, iMovie, or another standard video-editing package

Figure 4.4 shows the two ways of connecting an analog camcorder to a computer.

To connect to your converter box, you'll need some cables. A three-plugged RCA-to-RCA cable will connect all three elements—sound and video—to your converter box in one fell swoop. If you decide to go with an S-Video connection, you'll need to connect audio as well. S-Video cables do not transmit audio, although they provide higher-quality video. In general, for S-Video, you can use the same three-plugged RCA cable, but do not connect the yellow video plugs.

> Most converter boxes come equipped with cables. If this isn't the case with your converter box, contact the manufacturer, who should be able to help you locate the specific cable you need.

For the 1394 connection between a converter box and computer, you'll need 1394 cable. Some vendors do not include a cable with the converter box, but most offer them as an accessory at a reasonable price. Make sure to purchase the proper cable for your setup. If you have a six-pin converter socket and a six-pin computer socket, make sure you purchase a six-pin-to-six-pin cable. Other standard cables have four-pin-to-four-pin and four-pin-to-six-pin connectors.

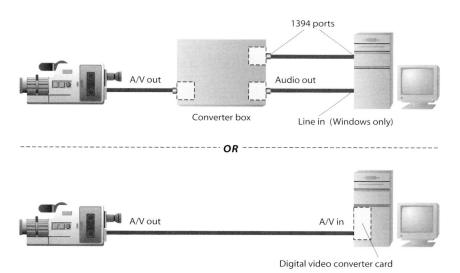

Figure 4.4

An analog-to-digital converter box or digital video converter card allows you to connect an analog camcorder to your computer to import digitized video data.

Cable prices vary by length, with 3- and 6-foot lengths being most common. In general, buy at least 6-foot cables. Longer cables are helpful in setting up various configurations between cameras, computers, connector boxes, and so forth.

Know Your Analog Connections

You'll need to know where to connect cables to your analog camera or other analog source, converter box, and computer. Locate and identify the connectors and sockets as follows:

Locate the audio/video-out port or connectors on your camera Although the name varies by camera, most analog cameras support some type of audio/video-out (A/V-out) port. Locate this port on your camera and find the cable or cables that connect to it. Refer to your camera's manual for details. The look, label, and location of this port vary, depending on your particular camera model. Most VCRs and cable boxes provide video output via a yellow RCA video-out jack and/or an S-Video socket. With regard to audio, most provide white and red RCA-style audio-out jacks.

Identify the 1394 socket on your converter box 1394 sockets come in either a six- or four-pin configuration. Most converter boxes use a six-pin jack. (See the "Know Your Digital Video Connections" section and Figure 4.3 earlier in this chapter.)

Identify the socket on your computer Nearly every 1394 card uses a six-pin connection. However, you should examine your socket to determine which type of connection your computer uses.

Prepare Your Converter Box

If you're using a converter box, like the one shown in Figure 4.5, you'll need to get it ready for the video transfer. Follow these steps to prepare your converter box:

1. Connect the 1394 cable to your converter and computer. Insert the cable firmly, making sure that it's fully seated. Don't twist, bend, or otherwise force the connection. The cable should attach easily and remain in place.

2. Connect the audio cable. Unlike with Macintosh systems, most external Windows converter solutions do not provide audio feedback during video capture. If you purchased an audio cable (available at stores that sell audio equipment, such as RadioShack), connect the RCA plugs to the converter's audio-out sockets and the mini-jack to the line-in port on the back of your computer. Some converter boxes, such as the Director's Cut, provide headphone support, so you can listen while recording, without connecting any more cables.

3. Attach a monitor. Better converter boxes allow you to connect a monitor to the video-out port. This lets you watch your digitized video in full resolution as it transfers to the

computer. A monitor display provides a great improvement over the rather tiny video playback areas provided by most video-editing software.

Figure 4.5

A converter box allows you to transfer video from your analog camera to your computer in digital format.

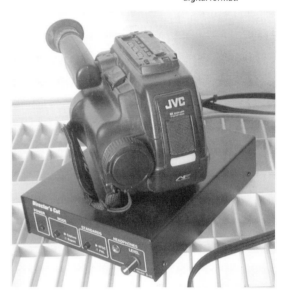

4. If necessary, attach a power source to your converter box. While some boxes provide their own power through the 1394 connection, others need a separate power source. When working with such a box, be sure to make allowances for access to surge-protected AC power and anticipate any limits associated with the length of the power cord.

5. Power on your converter box. When starting up, many video-editing programs look for a camera already connected to the 1394 port.

6. Set the mode on the converter box so that it will import an analog signal and export digital data. This function might be labeled as Capture, A to D, or something similar.

7. For Windows systems, you may need to install drivers. Whether or not you've used your 1394 port before, Windows may detect it as a new device and ask you to install drivers. This usually involves letting Windows search for the driver and install it.

Prepare Your Analog Camera

Before transferring data, prepare your camera by following these steps:

1. Remove any tripod mounting screws before putting down your camera. This ensures that the camera will sit firmly on the surface and will not topple over.

2. Connect A/V cables to your camera. Most units older than a few years use a cable with some proprietary plug at one end and a trio of RCA plugs at the other. Some newer units provide S-Video support and separate audio and video connections. Refer to your camcorder's manual for specific details. Connect any and all output cables to your camera, as you would to play back to a VCR or TV.

3. Connect A/V cables to your converter box. Most converter boxes come with both RCA and S-Video connections. If your camera provides the three RCA plugs, hook them to the video (yellow jack), left audio (white), and right audio (red) sockets. Match the plug color with socket color. If you're using S-Video cable, plug it into the appropriate jack. Make sure to align the cable correctly. Do not force it into place. Be aware that S-Video does not supply an audio feed. Make sure to connect the audio-out from your camera to the audio-in on your converter box.

4. Power on your camera. Make sure you're using a well-charged battery or an AC adapter to provide long-term, good-quality power to your camera. The camera may remain powered on for the duration of your editing session.

5. Load your tape and forward it to the start of your session, but do not begin playback.

6. Put down your analog camcorder, keeping it close at hand. With no direct 1394 support, you'll be responsible for controlling the playback. This means that you'll need to press the play, stop, pause, and other buttons on the camera.

After you've completed your preparations, you're ready to transfer your video. See the "Bring Over the Data" section later in this chapter for details.

Prepare Your VCR or Cable Connection

Video transfer from a VCR, cable box, or another analog source differs only slightly from transfer from an analog camera, as illustrated in Figure 4.6. Prepare your converter box and analog source (substituting it for the "camera" in the instructions), as explained in the previous sections. Then proceed as follows:

1. Connect A/V cables to your converter box. Most converter boxes come with both RCA and S-Video connections. If your analog source provides the three RCA jacks, connect them to the video (yellow jack), left audio (white), and right audio (red) sockets. Match the jack color with the socket color. If you are using S-Video, plug the S-Video cable into the appropriate jack. Make sure to align the cable correctly and do not force it into place. Be aware that S-Video does not supply an audio feed. Make sure to connect the audio-out from your analog source to the audio-in on your converter box.

2. Power on the TV. Most Windows editing programs do not provide sound feedback during video capture. Your VCR or cable box is probably already hooked up to a TV. Turn it on to provide a simple monitor for your video.

3. If you are working with a VCR, load your tape and forward it to the start of your session, but do not begin playback.

After you've connected your equipment, you can transfer your video. See the "Bring Over the Data" section later in this chapter for details.

Prepare to Transfer Analog Video with a Non-1394 Digitizer

1394 offers today's most powerful way to transfer video using the digital video standard, but there are a variety of other technologies that can bring video to your desktop. Whether port-based, box-based, or card-based, these digitizers accept analog video and transform it into a digital stream that you can save and edit on your computer.

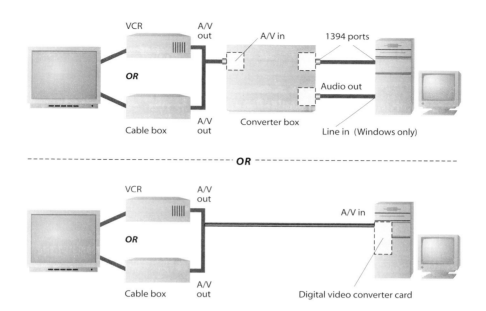

Figure 4.6

To capture video from a VCR or cable box, you need to convert your analog signal to digital form. To accomplish this, connect your video signal through a converter box or card.

These solutions differ from 1394 in the following ways:

Lower quality The video they produce is often of a lower quality than digital video, typically with more noise, lower frame rate, and lower resolution. This depends to a great extent on the quality of the capture solution and the quality of the original.

Codec use They do not use the DV-25 standard. Instead, they produce video using a variety of codecs, typically AVI, QuickTime, MJPEG, or MPEG. By compressing directly to these standards, they offer express access to many technologies, including online streaming and VCD creation.

Special software requirements They often require special-purpose software. Some digitizers don't like to work with standard software such as iMovie or VideoStudio. For example, the Dazzle DVC-II uses the bundled MovieStar program to capture and edit video. In contrast, while the MyTV box comes bundled with MovieWorks, any QuickTime-compliant application will recognize and work with this box, including FinalCut Pro and Adobe Premiere. In fact, most good-quality video programs can import AVI and QuickTime files.

On the upside, along with their lower costs (expect to pay somewhere between $50 and $200 for your converter), non-1394 solutions have the advantage of producing smaller video files than 1394 converters produce. A 1-minute 320×240 QuickTime movie might prove to be as small as 3MB. Contrast this with the 200MB required for 1 minute of DV-25 video. This makes these digitizers an attractive solution for Web-based movies. (See the "A Low-Budget

Setup" section in Chapter 1, "Why Digital Video?" for more information about types of non-1394 video-capture devices.)

Table 4.1 shows a small sampling of the video-capture solutions available from Dazzle (www.dazzle.com), El Gato (www.elgato.com), and Eskape (www.eskapelabs.com).

Table 4.1

Some video-capture solutions

CONVERTER	CODEC	TYPE	CABLE SUPPORT
Dazzle DVC-II	MPEG-1, MPEG-2	PCI card	S-Video, RCA composite
Dazzle DVC-80	AVI	USB/ box	S-Video, RCA composite
El Gato EyeTV	MPEG-1	USB/box	S-Video, RCA composite
Eskape MyTV/fm	MJPEG	USB/box	S-Video, composite, coax
Eskape MyVideo	MJPEG	USB/box	S-Video, composite

With the exception of Eskape MyVideo and El Gato EyeTV, the converters listed in Table 4.1 only capture video. MyVideo and EyeTV can both capture and export video. You'll find many other converters available on today's market, including excellent offerings from ATI (www.ati.com), Hauppauge (www.hauppauge.com), and other vendors.

Check Your Supplies

To digitize your video with a video converter such as Dazzle DVC-II or Eskape MyTV, you'll need a video cable to connect your analog source with the digitizer. To connect to your converter, you'll need some other cables:

- A three-plugged RCA-to-RCA cable will connect all three elements—sound and video—to your converter in one fell swoop.

- If you decide to go with an S-Video connection, you'll need to connect audio as well. S-Video cables do not transmit audio, although they provide higher-quality video. You can use the three-plugged RCA cable, but don't connect the yellow video plugs.

- A coaxial cable can connect your VCR or cable to the antenna-in port on some converters. This cable carries both audio and video data.

Know Your Connections

Locate the connectors on your equipment, as follows:

Camcorder connections Most analog camcorders support some type of AV-out port. Locate this port on your camera and find the cable or cables that connect to it. Most units older than a few years use a cable with some proprietary plug at one end and a trio of RCA plugs at the other. Some newer units provide S-Video support and separate audio and video connections. Refer to the manual that the manufacturer shipped with your unit for specific details. Connect any and all output cables to your camera, as you would to play back to a VCR or TV.

VCR or cable box connections Many VCRs and cable boxes provide video output via a yellow RCA video-out jack, a coaxial audio-out, and/or an S-Video socket. With regard to audio, most provide white and red RCA-style audio-out jacks.

Converter box connections Most converter boxes come with both RCA and S-Video connections. Some offer coaxial antenna-in. If your camera provides the three RCA jacks, connect them to the video (yellow), left audio (white), and right audio (red) sockets. Match jack color with socket color. If S-Video is the way you need to go, plug the S-Video cable into the appropriate jack. Make sure to align the cable correctly and do not force it into place. Be aware that S-Video does not supply an audio feed. Make sure to connect the audio-out from your camera to the audio-in on your converter box. When using coaxial cable, make sure to screw the cable firmly in place without bending the central metal wire that carries the data.

Prepare to Transfer

After you've connected all of the cables, power on your camera (make sure that you've removed any tripod mounting screws beforehand). If you are transferring video from a VCR or cable box, turn on the TV to provide a simple monitor for your video.

Load your tape in your camera and forward it to the start of your session, but do not begin playback. Set the camera aside in an easily accessible location. With no 1394 support, you'll be responsible for pressing all of the playback buttons on the camera. If you're working with a VCR, load your tape and forward it to the start of your session, but do not begin playback.

With your camcorder or other analog source, digitizer, and computer set up properly, you're ready to begin transferring your video, as described in the next section.

Bring Over Your Data

After you've prepared to transfer data from your digital video or analog camera, or another analog source (as described in the previous sections in this chapter), you're set to capture video. It takes just a few steps to bring your data over to your computer:

1. Choose capture mode. Most software requires you to enter capture mode before you can begin to record video. This step varies widely by manufacturer, so check the software manual and follow the directions there.

2. Start a live preview. Set your software to allow you to preview data as it arrives. In general, the video appears in a small window on your screen. You'll be able to listen as well as watch if you're using a Macintosh or if you've connected an audio cable to the line-in port of your PC.

3. Enable scene detection. If possible, turn on the scene detection feature. Some software does this automatically. For other software, you may need to track down this option and enable it. Scene detection allows your computer to automatically split your video into

clips, based on where you started and stopped your shots. It's very convenient and a great way to save time while editing.

4. Start your video. If you're working with a digital video camera, click the Play button on your screen. For any other setup, press the Play button on your video device (VCR, camcorder, and so on).

> If you've used 1394 before and are now performing a non-1394 transfer, it may take you several minutes of pushing that Play button on your screen until you realize that you need to get up and walk over to the VCR instead.

5. Start the data capture. With your video running, you can now begin to capture your data. You'll need to click the appropriate on-screen button. Depending on your software, the actual label for this function will vary. Look for functionality labeled something like Import, Record, or Capture.

6. Wait while your video plays. Don't get overly anxious or jump too quickly to stop it. You can always edit out any extra bits at the beginning and end of your clips. Also, don't worry about producing individual clips at this time. You can cut the footage apart later during editing.

7. Stop the data capture. Once you've fully transferred your video, click the on-screen Stop button. If you're connected via 1394, this will stop the playback on your camera as well. If not, you'll also need to press the Stop button on your video device.

Congratulations, you have successfully transferred your video onto your computer. You're ready to jump into the exciting world of video editing (the subject of Chapter 5, "Video-Editing Techniques").

Avoid Dropped Frames

Computers have a lot to do. They need to create the pretty pictures that you see on your screen, manage file access, write information to and read information from disks, and much more. Each of these jobs takes time and attention. Your computer must juggle these tasks and decide which one takes priority at any moment.

The key thing to remember about video capture is that it occurs in real time. If your computer must stop and pay attention to a particular task like running a screensaver or printing a page, it might miss a vital part of your video. The video doesn't know how to stop and wait for the computer to catch up. When this occurs, you may lose, or *drop*, video frames that should have been captured during that time. These dropped frames can introduce unwanted gaps or hesitations into your digitized video.

You can learn how to avoid dropped frames. Some surprisingly simple procedures and precautions can help with this problem:

Don't run other programs You shouldn't play a game, run a spreadsheet, or perform some other computer task while you wait for your video to arrive. By dedicating your machine strictly to video transfer, you keep other programs from intruding on your video software's processes.

Turn off screensavers Screensavers are one of the worst offenders when it comes to dropped frames. Disable any routines that handle screen dimming and screensaver display.

Disable any virus scanners Virus scanners operate in the background and consume precious CPU cycles and cause unnecessary disk accesses. Make sure to turn off these programs during video capture.

Disable additional background processes Turn off any background programs that you can. Any program that runs while you capture video can potentially interrupt and disrupt the capture process.

Disable virtual memory Virtual memory offers a way to use more memory than your computer physically owns. To do this, your system swaps memory segments in and out of RAM and stores unneeded parts on disk. This swapping scheme can interfere with video capture. Consider disabling virtual memory entirely. If possible, purchase additional physical memory for your system.

Enable Direct Memory Access (DMA) Windows users may be able to minimize dropped frames by enabling DMA on IDE hard drives. You can set DMA in System Properties by selecting your disk drive from the Device Manager and checking the DMA box in the appropriate settings panel. As this panel varies by your version of Windows, please check your documentation to determine which panel hosts the DMA box. Click Apply and reboot your computer to make your change take effect. Note that not all hard drives and motherboards support DMA.

Turn off CD-insertion notification Many people like to listen to music CDs while transferring video. While this probably won't affect your transfer, inserting and removing your CDs will impact the transfer process if you've left on the insertion notification feature. To ensure that your video transfer won't be interrupted, disable CD-insertion notification. You can always turn it back on later.

Delete temporary files On many Windows platforms, the operating system holds onto a huge amount of unnecessary old data. If you have a Windows system, make it a habit to run Disk Cleanup before you start your video session. That program removes Recycle Bin files, temporary Internet files, downloaded program files, and temporary program files.

Defragment your disk Hard disks prove much more efficient when you write to a single, continuous free area than when you skip around to place your data (called *fragmentation*). By minimizing disk-head movement, you optimize your writing speed and prevent data-writing delays. *Defragmenting* can often speed up your video transfer and help avoid dropped frames. Run a defragmenter program, such as Disk Defragmenter in Windows.

Use another disk Many serious video enthusiasts use a second disk to store video files. By devoting a disk to video data storage, you can free the main disk and avoid competition for disk access and head movement. If you can, use a second disk that is configured as "master" on the second IDE channel (rather than as a "slave" on the primary IDE channel) for faster data transfer.

Avoid writing to a second partition Although a partitioned disk looks like two (or more) separate disks on your computer, there is only one physical disk. If you're running the capture software on one partition and capturing the data to a second partition on the same drive, you're making your system work harder and less efficiently, and this may cause it to drop frames. If you own only a single hard drive, make sure to capture video to the same partition that is running the video-capture program.

Use a faster drive Although you can capture data effectively with a 5400 RPM hard drive, you'll do better overall with a 7200 RPM unit. The faster the data transfer, the less overhead your computer may need and the fewer dropped frames you'll encounter.

Use an internal drive Many video-capture programs do not write effectively to external USB-2, SCSI, or FireWire drives. If possible, capture your video data to an internal drive, rather than to an external drive. It's a good idea to reserve your external drives for archived data or video editing.

Use a faster computer Don't discount the role of a fast computer in effective video transfer. The faster the computer, the less competing processes will affect video capture.

All these recommendations are helpful, but you may still encounter dropped frames. The ability to fix your footage by inserting extra frames is offered by only professional-level video-editing software. When you run across this problem, consider redigitizing your footage. If the problem reoccurs on a regular basis, you may need to change to a higher-end setup.

In This Chapter...

This chapter covered many techniques you can use to transfer video to your computer. Here are some key points to keep in mind after reading through this material:

- Use the correct type of cables. IEEE-1394 offers three different (yet standard) cable types. Your analog converter may offer S-Video, composite, or coaxial input. Choose the one that works with your equipment. And don't forget that you'll need extra audio

cabling if you go with S-Video. Review the material in this chapter and in your manufacturers' user manuals to determine which cable types you need. Never try to force a cable that does not slide in smoothly and correctly into its socket.

- Take time in advance to check your supplies and make sure you have everything on hand that you need to do the video transfer. It's frustrating to get ready for transfer, just to discover that you're missing an essential cable.

- When you transfer data, don't forget to queue your tapes carefully to a few seconds before your footage and begin the video transfer before the footage actually starts. Assume that it will take at least a second or two for everything to gear up into running order. Don't lose the start of your footage by queuing too close to its start.

- Although you can edit low-quality non-DV-25 video in VideoStudio, QuickTime Pro, and other video-editing packages, don't assume that this provides a quality replacement for working with real DV-25 digital video. You'll only be disappointed. If you're doing video work that counts—for home, business, or recreation—use real digital video standards whenever possible.

- Dropped frames happen to everyone. Don't be shocked when they occur. Instead, stop what you're doing. Analyze your system. Look through the fixes listed in this chapter and apply them. They should help you to achieve clean video transfer.

Video-Editing Techniques

Through editing, you manipulate your video footage to produce a final presentation. Editing allows you to trim, order, and process your clips. A good editing job can transform dull footage into an intriguing movie.

Edits are not done randomly. Both theory and practical know-how drive this task. You'll find that the process involves dedication and attention to detail. Be prepared to spend a lot of time editing your video. It often takes one hour of work to put together just one minute of completed footage. This 60-to-1 ratio is not unusual. The more you work with video and learn to edit, the more you'll understand why a 95-minute Hollywood film often takes a whole year to shoot and produce.

This chapter covers the following topics:

- Split and trim clips
- Assemble a rough cut
- Add effects
- Remove unwanted background noise
- Add a soundtrack

Split and Trim Clips

Once you've finished videotaping and transferring footage to your computer, you're ready to start editing your work. The first step of this process involves splitting and trimming video into discrete clips. These edited clips will be your building blocks for constructing your final movie.

Your footage will include the actual scenes you want to use, as well as various shots that you don't want to include. Your first job involves shaving this material down into usable clips. Discard any obviously flawed parts. Figure 5.1 illustrates some common errors: out-of-focus shots, shots taken when you thought the camera was turned off, artifacts produced by stopping the recording, and shots that simply make no visual sense.

Figure 5.1

Video footage often contains visual flaws that you should trim away.

A focus error: The background remains in focus while the subject is blurred.

An operation error: The camera operator forgot to turn off the camera and shot video of his foot.

A video error: The digital camcorder produced a short spurt of random blocks at the start of this scene.

A composition error: The camera operator zoomed in too far.

At the end of this splitting and trimming step, you'll have thrown away useless footage and created a number of clips suitable for sequencing. Don't aim for final quality at this point. The goal here is to discard the obviously bad shots and reduce the video to usable pieces.

Transform Raw Footage into Clips

Better-quality video-editing programs offer some type of automatic scene detection during capture. Scene detection allows your computer to automatically split your footage into individual scenes. Most programs, including Ulead VideoStudio and iMovie, look for the breaks where you pressed the record button on your video camera. This approach works well and produces natural splits. Other programs, like Roxio's VideoWave, look for large changes in adjacent frames. This latter method does not work well, at best producing a huge number of splits at fairly arbitrary locations. Refer to your video-editing software's user manual to determine which approach it uses for scene detection.

Automatic scene detection will not work when you keep the camera running between takes. If you record in this fashion, spend the time to segment your footage into individual shots. You should do so even when the shots logically follow one another. By creating individual clips now, you'll have much more flexibility in assembling your movie later. You will be able to reorder your shots, insert clips or titles, or perform other edits.

If your program does not support scene detection, you will need to split your scenes manually. The general steps for splitting footage into clips are as follows:

1. Move the video playhead and watch the playback in the preview window until you find a new scene.

2. Carefully adjust the position of the playhead to the start of that scene.

3. Apply the split function to the footage at the playhead location.

4. Repeat steps 1 through 3 until you've split the entire footage into basic clips.

Trim Your Clips

After splitting your footage into clips, use your video-editing software to trim them. Trimming clips involves removing unwanted sections from the start and end of each scene. At the same time, you can resize clips down to manageable portions, suitable for inclusion in your video.

During this step, concentrate on producing clips with a logical beginning and end. You should be able to play these clips without noticing any production issues. Trim off all spoken directions such as "Action!" or "Cut!" or "Please stop looking at the camera." At this point, don't worry about long segments or proper sequencing—that comes later in the editing process. For now, keep all possibly usable portions.

The specific steps for trimming depend on your video-editing software. Instructions for using iMovie and VideoStudio follow in the next two chapters of this book.

Assemble a Rough Cut

After splitting your footage into individual clips, your next step is to assemble them to form a rough "cut," or version, of your movie. Order your clips so they make sense, with a logical progression. This progression of video clips is called a *sequence*.

The human mind reacts differently to sequences than it does to single images, and it is this basic facet of human nature that allows a series of images strung together to hold the viewers' interest. The images that make up a sequence are called shots. As you saw in Chapter 2, "Compose, Light, and Shoot," there are many different types of shots that you can use to create your videos. From close-ups to long shots, and POV shots to establishing shots, filmmaking offers an entire visual language. Learn the rules of this language, and you'll create videos that grab and hold your audience's attention.

To make an effective video, you'll need to review, assemble, adjust, and analyze your work. This can be a lot of fun, like playing with children's building blocks. Everything fits together just so. You choose the order. When you don't like the way things work, you move clips around and try a different approach.

Review Your Footage

Sit down and review your footage, before you even start to assemble it. Video is a form of communication, just like writing. Your job is to tell a story, preferably an interesting one. Your video shouldn't just provide a running visual transcript of what happened during shooting. Instead, it should provide a compelling narrative. Each part of a story must propel the reader, or in this case, the viewer, and do a job.

Watch your footage as a viewer and not as a participant. When you allow yourself to be flexible and to review the clips impartially, you'll be better able to assess what parts work well and what parts do not. Don't fall in love with your footage. Learn to discard footage that doesn't help tell your story. Unless a clip is necessary and important to your sequence, leave it out. Also, allow yourself the freedom to diverge from your original script and storyboard as needed.

Assemble Your Clips

Use your video-editing program to lay out your clips in order. Most video-editing software suites offer at least two types of editing displays:

A timeline A timeline display allows you to assemble clips by length. The duration of each clip determines the amount of space it occupies on the timeline. Often, along with the video clips, sound clips and other nonvideo elements are displayed in distinct parallel bars.

A storyboard A storyboard display uses a thumbnail approach, where each clip is laid out in order. Each representative block (usually a square with an image from the clip) is displayed as the same size. Storyboards do not show audio and special-effect elements the way that timelines do.

Assembly Steps

The timeline and storyboard editing displays allow you to lay out your clips and arrange them. Your goal is to order your clips so they progress in a logical fashion. Here are the general steps in the process:

1. Select your editor's timeline or storyboard display.

2. Drag your clips onto the timeline or storyboard.

3. If needed, reorder your clips by dragging them to their new location.

4. Preview your rough cut by using your software's playback button. Some editors will need to render the cut before providing playback. Others will provide playback in raw mode.

5. Adjust the sequence until you're satisfied.

You'll read more about using timelines and storyboards in the following chapters, which cover specific video-editing programs.

When you work with your footage as described here, you're doing *nonlinear editing*—compiling, ordering, and reordering your clips as you please. You don't need to play your clips consecutively, in a *linear* fashion, until you're ready to produce a final video. In the old days, a video producer needed to sequentially play back clips to form a master tape, one clip at a time. Today's video hobbyist has flexibility and freedom only dreamed of by yesteryear's counterpart.

Assembly Tips

There are many common sequence rules that can help you put together your footage. Here are some commonly used rules:

Change! This is the single most important video-assembly rule. People find it difficult to pay attention to the same image for more than a few seconds. When you're assembling your clips, remember to keep changing the picture. When laid out in sequence, each shot should, ideally, change both the camera angle and size. Big visual differences make more interesting sequences. Don't just change the zoom, going from close-up to medium, for example. Try to use shots taken from a physically different location.

Work with the line Always keep a mental image of who and what resides on "stage left" and on "stage right." When you assemble your clips, make sure to select footage that works with this layout. Don't allow your subjects to "cross the line" by appearing first on one side of the psychological line and then jumping to the other side. (See the "Shoot with the 'Line' in Mind" section in Chapter 2 for more details and an example of crossing the line.)

FILM SCHOOL 101: KEEP CHANGING!

Here's an exercise that I learned in my first college film course. Take a look at the picture shown below. Make it a long look. In fact, try to look at it for a full 30 seconds. Don't forget to count: Say "one Mississippi, two Mississippi, three Mississippi…" all the way to thirty.

It's likely that you didn't make it to "thirty Mississippi," or if you did, it was a burden to do so. Staring at a single picture for a long time is hard work in terms of the human cognitive system.

Now, look at the sequence of pictures shown below. Instead of staring at any one picture for a whole 30 seconds, look at each of the six pictures for 5 seconds.

A lot easier, wasn't it? This is precisely what my teacher conveyed during that first lecture: Humans are built to look at things a little bit at a time. When we're forced to look at a single, static picture, we get bored quickly and our attention drifts. When the pictures and the information within the pictures change, we're more likely to stay tuned to see what comes next. This is simple human nature and relates to the way our brains are wired for new stimulation.

Place establishing shots at the beginning of sequences Establishing shots set the stage for the action that follows. Typical shots include exteriors, signs, and landscapes. When using these shots, make sure to insert them before any other footage. (See the "Useful Shots for Editing" section in Chapter 2 for more details and an example of an establishing shot.)

Limit your clips to under 10 seconds each This doesn't mean that you need to tell your whole story in 10 seconds. A sequence of clips can tell a longer story better than any single clip can relay the tale. Professional TV and movie productions follow an even tighter rule, rarely exceeding 3 to 5 seconds per shot.

Keep it short Short films usually work better than long ones. Don't include footage just because "it's there." Tell your story and then stop.

Use Cutaways to Edit Sequences

You may feel helpless when your subject takes control of the footage and, for example, begins to talk and talk. Nothing is more boring than watching someone drone on for minutes on end, as in the example shown in Figure 5.2 (a series of shots taken at about 10-second intervals).

These shots go on for a long time and violate the rules covered in the previous section. To solve this problem, use cutaways. Cutaways allow you to edit your sequences by removing the tiresome bits, and they provide more visual interest for your audience.

Figure 5.2

When editing, recover control of your footage from your subject with careful cuts.

Figure 5.3

Cutaways allow you to trim large portions of footage away without interrupting the natural flow of your scenes.

Let's say that your subject talked for about one minute, much of which content is not terribly interesting. By cutting away to another person as she listens, you might edit the audio down to only 30 seconds. During the first 10 seconds, you show the speaker, just as in the original version. In the next 10 seconds, you show the listener, adding the speaker's next 10 seconds of voice. Then you cut back to the speaker, but only to her final 10 seconds. The shots would look like the sequence shown in Figure 5.3.

> To create this effect, you'll need to divide the speaker's footage into parts, disassociate the voice track, mute the listener's footage, and add the speaker's voice track over it. Specific instructions on how to perform these steps using iMovie and VideoStudio appear in the next two chapters.

This editing accomplishes a number of improvements:

- It dramatically reduces scene length, making the monologue a more reasonable size.
- It adds visual changes, which maintains interest during the single-person narrative.
- It hides the cut material. The second shot creates a diversion, so you do not need to match the continuity between the first and third shot.

A cutaway is an invaluable tool. In this example, if you simply trimmed away the middle of the scene, omitting the cutaway, the speaker would appear to jump awkwardly between the spliced shots.

Analyze Your Video

Before proceeding, play back your video a few times. This rough cut will give you a good idea of how your final movie will progress. Determine whether or not you've captured the full story. Watch for missing or flawed segments. You might need to go back and reshoot these.

Don't proceed until you feel that you've assembled the whole story. The video may still look crude and unfinished, or it may look pretty good. You still have a few steps to go, but by this point, you'll have put together your video's skeleton. The next few steps will help flesh it out.

Add Effects to Enhance the Story

The next stage of video production involves adding effects to your rough cut. These sound and visual enhancements help bring you closer to a finished cut. Effects don't necessarily involve big, splashy visual and sound productions. The best effects can be quite subtle. Make these effects work for you without compromising the superiority of your video. A little goes a long way.

Effects can include visual enhancement, titles, sound effects, and transitions. While, in theory, you can add these effects in any order, you might find it easiest to add them in the order just listed. Visual enhancements and titles are least affected by change because they involve only a single clip at a time. If you move a clip, you won't need to redo the enhancement or title. In contrast, transitions are quite location-dependent. If you shift a clip, you'll need to redefine the transitions that surround it.

> While you're reading about the various effects, there is one rule to remember: Keep it simple. Never insert a title, sound, effect, or transition unless it has a specific job to do. Applying effects just because you can usually leads to bad moviemaking. *Schindler's List* provides a striking example, shot in black and white except for the red coat of the doomed little girl. This one patch of color evokes the beauty and potential of her life and the tragedy of its loss.

Visual Enhancement Effects

Visual enhancement plays two different roles in your footage. One purpose is to attempt to fix poor footage. For example, you can enhance video shot with low light or poor contrast. In general, if possible, you should reshoot footage rather than process it with visual enhancement. The image quality you produce will never match that of correctly filmed clips. At best, this correction provides a work-around for once-in-a-lifetime experiences. You obviously cannot ask a bride to redo her wedding just because you didn't use enough lighting. The frames shown in Figure 5.4 demonstrate how a contrast adjustment can remedy overexposed footage.

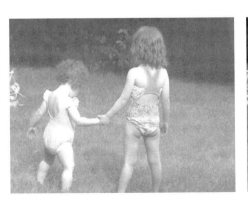 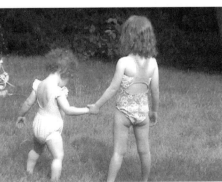

Figure 5.4

A contrast adjustment helps remove the over-lit haze of the left video image to produce the better defined video to the right.

Figure 5.5

A camcorder effect
gives this footage a
hand-held video look.

Another purpose of video enhancement is to add visual moods. For example, you can use effects to transform your video to black and white, or to add an old-time sepia tone. Figure 5.5 shows a "shot-through-the-camcorder" effect, complete with lines and flashing record light. As with all other effects, mood-rendering enhancements work best when you have a good reason to use them.

Titles

Titles supply important textual information to your videos. Use them to insert text, subtitles, credits, and so forth. In addition, consider using title cards (also called *title boards*) to introduce various "chapters" within your movie.

Most video-editing programs allow you to superimpose text directly over footage or over a static image. A plain, black background proves to be the most popular title card choice. The examples in Figure 5.6 show both formats: a title superimposed over the video and a title on a black background.

Figure 5.6

Most video-editing
programs allow you
to add text over
footage or over a
solid background.

Here are a few rules that will help you produce effective titles:

Keep it short Short titles work better than long ones. A picture is worth a thousand words. Don't try to replace your video with those thousand words. A video is no place for long reading. When George Lucas included that long text introduction to *Star Wars*, he paid homage to the 1930's serials. This was not a general endorsement of the technique.

Keep it big Large text works better than small text. Don't expect people to put on their reading glasses before watching your videos.

Keep it plain Don't use outrageous fonts that may confuse your viewers. Stick to easy-to-read fonts. The title shown in Figure 5.7, incidentally, reads "Fun in the Sun," not "Fub ib the Sub."

Keep it meaningful As with other types of effects, titles work best when you have a good reason to use them. Make sure your titles add something to your story.

Sound Effects

In Hollywood, specialists called *Foley* technicians carefully add sound effects to movies. Armed with such obscure material as celery stalks (good for reproducing body thumps and punching sounds) and thousands of pairs of shoes to match an actor's exact tread, these artists create audio presentations that transcend reality. Your film probably will not need such elaborate sound enhancement. Still, you may consider adding sound effects to your films for a variety of reasons:

- When your camera records far-off video, it rarely picks up good-quality sounds. By adding subtle cues, like the sound of a door closing or footsteps, you can enhance your footage and provide greater realism.

Figure 5.7

A bad font choice transforms "Fun in the Sun" to "Fub ib the Sub."

- Special effects, such as those detailed in Chapter 11, "Digital Video Fun," are often improved by adding audio clips to the visual effects. You can add a loud roar to a make-believe earthquake or a mechanical whirr to a teleportation effect.

> Although most better video-editing programs allow you to drag sounds to your timeline, some require you to attach sound files to a particular clip. Check the user's manual that ships with your editing program for specifics.

- Soft beeps and pings can highlight important steps in instructional videos.
- Voice-overs allow you to add narration to your movies. Use these to place dialogue and description over the context of your scenes.

> Voice-overs are a great way to add meaning to videos of children. As you know, kids are hard to pin down. They wiggle, move in and out of the frame, and often face the wrong way when speaking. Adding narration—yours or theirs—can make a huge difference in your final product.

As with all effects, a little goes a long way. Keep your sound effects small, subtle, and appropriate.

So how do you produce these sound effects? Many movie-editing packages ship with small sound-effect libraries. You can purchase more complete libraries from a variety of commercial sources, such as music or video-specialty stores and online. Look for royalty-free products that you can use for yourself and still distribute to others.

You can also find free sound effects online. Many sound creators have released home-made sound effects on the Internet for general use. You can easily find these by using a search engine. When you search for "free sound effects," hundreds of sites will pop up.

> When considering using free sound effects, make sure to first check out the authenticity of the authors. People can legally distribute only those sounds they have created themselves.

Another alternative is to create your own sound effects. You might be surprised at the quality of sounds you can make with your computer, a microphone, and a simple sound-editing program. Before you give up on finding that "perfect" sound, consider making your own.

Transitions

Transitions, also known as *wipes*, affect the way that one video clip flows into the next. Figure 5.8 shows just some of the transitions you might find in your video-editing program.

Transitions work by creating a series of transitional frames that start with the first clip and transform over time to the second clip. Transitions do not stop the footage. The subjects in your clips will continue to move, talk, and so on as the wipe occurs. In the wipe shown in Figure 5.9, note the hands and feet of the participants. They all continue to change during the transition.

As with other effects, transitions are often abused. There are three styles, however, that offer a way to move smoothly between clips. The fade-in, fade-out, and cross-dissolve effects are quite subtle, adding a soft feel to the final footage. Viewers won't even know you've used them. This is not true of most of the other transition styles, so use them with thought and care. The best transition is often the plain cut between shots.

Figure 5.8

A set of typical video wipe patterns

Traditionally, *wipes* referred strictly to an old film-based editing technique. In this technique, one shot replaced another by following an imaginary line until the first shot was totally covered. This usually involved a clever use of scissors and splicing tape. Because of computer technology, today's transitions offer much more complex transformations than yesterday's wipes.

Figure 5.9

A typical push-right wipe introduces new footage to the left of the old footage, replacing it while moving the old footage off screen.

REMOVE UNWANTED BACKGROUND NOISE: A PRO USER OVERVIEW

If your video includes some distracting background sounds, you may be able to address the problem with some high-powered software. Today, you can find about a half dozen or so noise-removal software packages. But be aware, this technology can be costly, and this approach is generally for the more professional videographer.

Many of these noise-removal programs are packaged as Direct-X plug-ins that work with audio editors, such as Sonic Foundry's Sound Forge (www.sonicfoundry.com), Micro Technology Unlimited's (MTU's) Microeditor (www.mtu.com), and Syntrillium Software's Cool Edit Pro (www.syntrillium.com). Here's a view of Sonic Forge's WaveHammer tool in action.

Top noise-reduction plug-ins for Window systems include Sonic Foundry's Noise Reduction (www.sonic-foundry.com), MTU's DNoise (www.mtu.com), and Tracer Technology's Diamond Cut Millennium (www.diamond-cut.com). On the Mac, you can choose from Sonic's NoNOISE (www.sonic.com), CEDAR's declick and dehiss (www.soundscape-digital.com), Digidesign's DINR plug-ins for Pro Tools (www.digidesign.com), and Arboretum's Ionizer and Ray Gun (www.arboretum.com).

Background noise comes in two basic flavors: random and cyclical. As you might expect, random background noise cannot be predicted. Car horns honking now and again in heavy traffic produce random noise. It comes, it goes, and you cannot describe it mathematically. Because of this, noise-removal packages do not attempt to deal with random noise. Cyclical noise, however, produces waveforms that can be predicted. For example, a steady stream of cars going by just off in the distance produces cyclical noise.

Cyclical noise includes two types of noise: limited and broad spectrum. Motor sounds, 60Hz hums, and even ambient background noise generally produce sounds within a narrow frequency spectrum. Noise-removal packages excel at removing these types of sounds. In contrast, broad-spectrum noise refers to sounds that span over a wide range of frequencies. Air conditioners, for example, produce white noise with a very broad spectrum. A noise-removal package can remove some white noise, but it may take multiple passes to achieve this, and the quality of the rest of your audio track may suffer incremental losses after each pass. In fact, audio quality loss is a hazard, no matter which approach you take and what sort of cyclical noise you attempt to remove. For example, removing broad-spectrum white noise may introduce an unpleasant, metallic tunnel sound effect.

Each noise-removal package differs in what it can remove. Some packages are quite specific about which noises they handle. Others introduce a more general removal approach. Some allow you to select a sound sample (a section of the track that contains just the background noise you want to remove) and remove it from the entire track. Others use a mathematical formula to decide which sounds are to be kept and which sounds are to be discarded. Here is a view of Sonic Foundry's Spectrum Analysis tool in action.

These packages also vary in the quality of audio they create and the degree of error they introduce while cleaning your audio track. A basic rule of thumb is that you get what you pay for. Expect to pay more than $200 and as high as $600 for better quality plug-ins. And no, that price does not include the audio editor in which the plug-in runs.

Consider this list of noise sources that provide good or excellent candidates for removal:

- System noise of various flavors, such as noise from your camera
- 60Hz hums and harmonics
- Pops, clicks, hisses, and rumbles from taped sources
- Natural sounds, like noisy crickets and room ambience
- Heating and air conditioning equipment
- Ambient noise from within a train or airplane

Now, consider this list of poor candidates for removal:

- Any noise that involves the Doppler effect, such as passing cars, train whistles, or an airplane traveling overhead
- Unpredictable random noises such as wind blowing through treetops
- Any really loud noise that overwhelms the signal

Noises that involve the Doppler effect introduce variable-frequency noise, which cannot be removed by any of today's packages. However, sufficient distance from a variable-frequency source, particularly highways, can cause noises to blend together. These blended noises form more regular frequencies, and they can be removed to some extent.

Add a Soundtrack

Soundtracks can add a wonderful audio experience that propels your movie. A good sound-track can create a mood, set the atmosphere, and unify your visuals.

You can find a variety of royalty-free soundtrack solutions for your videos. These include mixer programs, track-adapter programs, and track libraries. Each solution offers a different way to create or find a soundtrack that works for you. The following sections provide an overview of four ways to create soundtracks.

Many people are tempted to use tracks from their commercial CDs for their video sound-tracks. This is not a good idea. Fair-use guidelines prohibit copying audio and transmitting it. Including this material in your movies is considered essentially the same as copying and transmitting it. Use royalty-free soundtracks instead.

Mix Sounds with Mixman StudioPro

Mixman StudioPro (www.mixman.com) allows you to create royalty-free audio by combining prere-corded tracks. This program allows you to "play" the sounds within a mix to create a unique and personalized set. A trial version of Mixman Studio is included on this book's CD. As shown in Fig-ure 5.10, Mixman offers a number of tools, including a Recording Studio, an Effects Studio, an Editing Studio, and, most important for video soundtrack purposes, the Remix Studio.

As this book was going to press, Mixman introduced StudioXPro, which offers numerous enhancements and an entirely new track-building studio. All three products (Studio, StudioPro, and StudioXPro) will be available in early 2003 for purchase. Be sure to check the Mixman site for updates to their demo package.

In Mixman StudioPro, you can load a set of related tracks in the Remix Studio, shown in Figure 5.11. Mixman arrives with several dozen of these standard mixes, with names like "Go Edna Go" and "Latin Groove."

By loading a standard mix, you ensure that all the tracks work together well. For example, the "Latin Groove" mix contains tracks that include bongos, piano stabs, a flute solo, a horn riff, and so forth. The two turntables allow you to load up to 16 tracks at a time.

Here's how you can create an audio track for your video:

1. Enter the Remix Studio.

2. Click the Open Mix button and load a mix from the standard mix set. (You'll need to wait for the mix to load.)

3. Click the Play button and experiment with the mix. Get a feel for which sounds do what and where they're located. To play a track, click one of the 16 track buttons that edge the turntables. To mute that track, click it again. The track will suppress playback until you turn it back on.

4. When you've mastered the mix, click the Stop button to end play mode.

5. Make sure you're prepared to to go "live." When you're ready, click Record to begin recording. Use the track buttons just as you did while experimenting. Make sure to record a long enough track. Match the track time to the length of your video, or make it a bit longer to allow for editing.

6. After recording, click the Stop button. Then leave the Remix Studio.

7. In the main window (the one that provides access to all four studios), click the Export Mix button, located in the lower-right area of the screen. It looks like an arrow pointing down and right.

8. When the dialog box appears, select a format in which to save your mix. The WAV format is most useful for PCs. Navigate to the location where you wish to save the file, enter a filename, and click Save.

 After following these steps, you'll have created a personally authored soundtrack that you can import to your editing program and use with your video.

Figure 5.10

Mixman StudioPro offers four studios for working with sound-tracks.

Figure 5.11

The Remix Studio allows you to load and play tracks to build your own soundtrack.

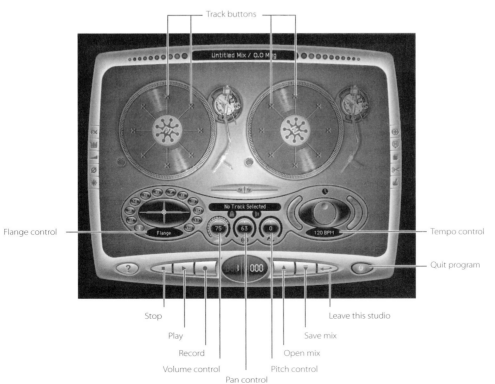

Create a Soundtrack with Sonicfire Pro

Sonicfire Pro (`www.sonicdesktop.com/sonicfire`), available for both Mac and PC platforms, offers a powerful soundtrack-editing solution for video designers. This package allows you to create and edit your sounds and associate them with key moments in your video. Sonicfire Pro arrives with two music CDs. You can purchase more tracks and styles to expand your library.

Sonicfire offers a tool that makes soundtrack creation incredibly easy—Maestro. Sonicfire's Maestro will create a custom, royalty-free soundtrack for you by walking you through a creation wizard. All you need to do is start Maestro and answer a series of questions. Here are the steps for using Maestro to make a soundtrack:

1. Choose Timeline → Maestro and wait for the first Maestro screen to appear.

2. Select the way that you'll use your soundtrack, as shown in Figure 5.12. The text on the right offers an explanation of your selection. Then click Next.

3. On the second screen, you are offered a variety of musical styles. Figure 5.13 shows the choices for a background soundtrack. Pick a style and click Next.

4. Next, Maestro prompts you to pick a source. This source sets the theme for your music, but does not specify the actual execution. Figure 5.14 shows the choices for a Classy background soundtrack. Pick your source and click Next.

5. The next step, shown in Figure 5.15, allows you to set the track duration. Enter the length you need. If you want to create a repeating track, click Loopable. Click Next to finish this step.

Figure 5.12

Use Sonicfire Pro's Maestro to choose the way you'll use your music.

Figure 5.13

Maestro allows you to pick a style for the soundtrack you're building.

6. Sonicfire will prompt you to load a source CD into your drive. (If you like, you can copy your sound files to the hard drive so you don't need to put the CD in each time.)

7. Maestro allows you to select from several performances of your piece. Figure 5.16 shows the choices for the Piano Sonata source. Preview these styles by clicking the Play button at the bottom of the list of choices.

8. After choosing your performance, click Finish. Wait as Sonicfire Pro builds your soundtrack.

9. Select File → Export to export your track.

10. In the export dialog box, shown in Figure 5.17, navigate to the location where you wish to store your file, enter a filename, choose a file type (such as AIFF or WAV), and click Save.

Figure 5.14

The source provides an inspiration—not a score—for your music.

Figure 5.15

Set the duration you need your music to last.

Figure 5.16

Choose a performance type to set the kind of instruments that will be used.

Figure 5.17

Export your new soundtrack to disk for use in your video-editing software.

Obtain Soundtracks from the Music Bakery

The Music Bakery (`www.musicbakery.com`) offers royalty-free music CDs. You can use these to accessorize your videos with high-quality soundtracks. Your music arrives on a standard CD, featuring professionally produced music. To use this music, simply import the tracks into your video as you would import any other sound file.

The Music Bakery site sells both thematic CDs—such as romantic, motivational, and tranquil—and regular issues for subscribers. Each theme comes with a variety of styles, including mixes (also called underscores or background music) of various lengths. A typical theme includes about eight to ten of these variations. For example, the Urban Acrobat— inspired by city skateboarders—consists of five full mixes and four underscores. The sound duration ranges from 15 seconds to a full 2 minutes and 30 seconds.

The downside is that a Music Bakery CD costs somewhere between $60 and $160. However, if you have a big budget for you home movie or if you're making a professional video for your business, you might consider this approach.

Find Music at FreePlay Music

FreePlay Music (`www.freeplaymusic.com`) offers a new and exciting alternative for obtaining royalty-free soundtracks. You'll find a huge collection of music on this Web site. The music is free for use in personal, private videos and in videos that are broadcast (such as on TV or over the Internet). The use of FreePlay music in a revenue-generating manner does require the user to obtain a license directly from FreePlay Music. Although this license is not free, FreePlay Music charges less than competing music libraries.

Typically, editors or producers of video for broadcast must choose between commissioning their own music or purchasing a library of music "pre-cleared" of up-front fees before they can submit their work to a broadcaster for public performance. The use of FreePlay Music in any media destined for broadcast will not result in any additional costs to broadcasters over and above what they already pay the Performing Rights Organization. Instead, this music is made available free of up-front charges if the music will ultimately be broadcast. FreePlay Music has extended this use of its music to all private, noncommercial insertions in any media of any kind.

In This Chapter...

This chapter described how to assemble a video from your raw footage. Here are key points about production basics that you should keep in mind:

- The goal of video is to create a compelling and interesting narrative, no matter what the subject is. Make sure you have a story to tell with your movie—whether you're recording a wedding, selling a product, or capturing family moments.

- Invest time in creating clean, trimmed clips, and you'll be well rewarded when you're ready to build your movie. Good building blocks help make good videos.

- Pay close attention to the flow of you movie while building your first cut. Don't fall in love with your footage. If it doesn't work, leave it out—no matter how much you like that particular video segment.

- Don't start adding effects, such as titles and transitions, until you've built a good rough cut. Start with the basics and add the trimmings later.

- Use titles, sound effects, transitions, and other effects with care. These elements are typically overused and distracting in video. When in doubt, leave it out.

- A good soundtrack can bring a video together. Choose a track with care. Select one that works with your footage without overwhelming it. And do make sure that you're not violating copyright laws.

iMovie Simplified

iMovie, which comes bundled with new Macintosh computers, offers one of the simplest and most elegant consumer-grade movie-editing packages available today. iMovie seamlessly combines video-editing power with surprising ease of use. Best of all, it's free. In fact, iMovie is reason enough to consider switching from a Windows system to a Macintosh.

It takes relatively little time to build your basic set of iMovie skills. In this chapter, you'll find step-by-step instructions that guide you through the most common video-production tasks. Try these out with your own digital video materials, and you'll rapidly gain mastery of this handy program.

This chapter covers the following topics:

- The iMovie interface
- Manage your projects
- Import video and pictures
- Manage your clips
- Manage your video's sound
- Add wipes and other special effects
- Add titles to your footage
- Export your movie

The iMovie Interface

iMovie's developers created a deceptively simple interface, as shown in Figure 6.1. The interface includes the following main elements:

- A preview/playback window, called the Monitor, on the left side of the screen

- A scrubber bar, which allows you to examine and edit your footage, beneath the Monitor

- A palette display, which shows your clips (called the Clips Shelf) or one of the iMovie editing palettes

- A free disk space monitor and a trash monitor (which indicates those files marked for deletion associated with the current project) below the palette display

- The movie timeline/clip viewer across the bottom of the screen

Figure 6.1

The iMovie interface provides all the tools you need in a single, easy-to-use screen.

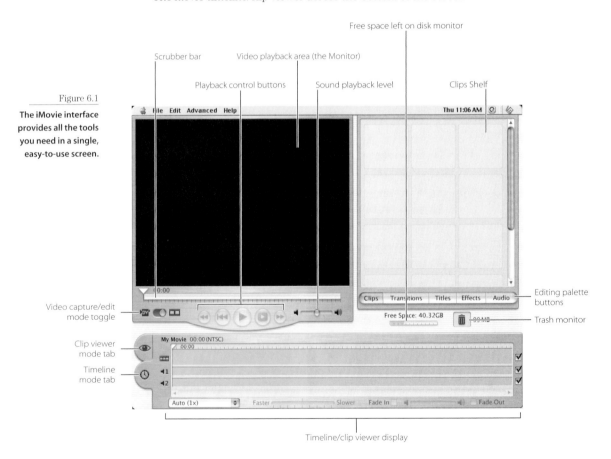

iMovie offers two modes that allow you to edit your video: timeline and clip viewer. (The clip viewer is the same as the storyboard or filmstrip in other video-editing programs.) The tabs on the left side of the current mode's display switch between timeline (the tab with the clock icon) and clip viewer (the tab with the eye icon) mode.

The Timeline

The timeline, shown in Figure 6.2, combines video and audio sequencing in a single, powerful workspace. It has the following elements:

- The label in the upper-left corner indicates the project (movie) name, length, and broadcast format (such as NTSC).

- The video track shows the clips you've added to your movie in order, labeled with a small thumbnail. The width of the clip indicates duration; wider clips last longer. The playhead (the downward-pointing triangle) above the clips indicates the current position in the track.

- The two audio tracks below the video track show the audio files imported into the project. Between the two audio tracks and sound attached to the video track, iMovie offers three layers of sound that can play back simultaneously. There is no real difference between the two audio tracks, and each one supports overlapping sounds within a single track.

- The check boxes to the right of each track control audio playback. When you uncheck the box next to a track, you mute the audio for that track.

- The zoom indicator in the bottom-left corner shows the current size of your movie track display. Use the drop-down menu to shrink or expand the movie display.

In the zoom indicator, larger numbers zoom further into your movie, allowing frame-by-frame manipulation. Smaller numbers provide a more comprehensive overview, shrinking the size to let you see more clips at once. Choose Auto to size your entire movie into the display at once. This allows you to view all components in a single display.

- The Faster/Slower slider to the right of the zoom indicator lets you adjust the selected clip's playback speed, for a fast-motion or slow-motion effect.

- The Fade In box to the right of the Faster/Slower slider lets you fade in the audio at the start of the selected clip.

- The slider to the right of the Fade In box controls the selected clip's overall volume.

- The Fade Out box in the bottom-right corner lets you fade out the audio at the end of the selected clip.

Figure 6.2

The iMovie timeline shows each clip in proportion to its length.

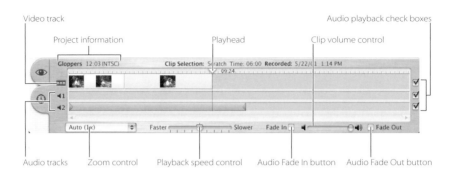

Figure 6.2

The iMovie timeline shows each clip in proportion to its length.

The Clip Viewer

The clip viewer, shown in Figure 6.3, allows you to order your clips in a simple and direct fashion. The clips appear with thumbnails that make them easy to identify. Also, each clip is labeled with its time duration.

> The labels at the bottom of each clip in this example are user-defined. Double-click any clip to change its label.

The Palettes

iMovie provides five palettes for editing your videos. You can access each one by clicking its button at the bottom of the palette display:

- The Clips Shelf stores not-yet-used footage. When you import your video, the clips appear here.

- The Transitions palette lets you add special transitional effects between adjacent clips (see the "Apply Transitions" section later in this chapter).

- The Titles palette lets you add text over your video (see the "Add Titles to Your Footage" section later in this chapter).

Figure 6.3

iMovie's clip viewer creates a thumbnail-by-thumbnail filmstrip of your movie.

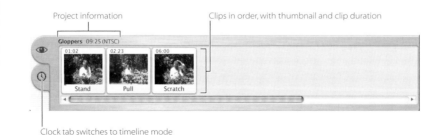

- The Effects palette lets you add photographic effects to your clips (see the "Use Visual Enhancement Effects" section later in this chapter).

- The Audio palette contains settings for your video's sound (see the "Manage Your Video's Sound" section later in this chapter).

Figure 6.4

An iMovie project consists of a project file and a Media folder.

Manage Your Projects

An iMovie project is composed of a project file and a Media folder, as shown in Figure 6.4. Together, these two items contain all of the data and information associated with each video project.

The project file (the Emma's Earthquake file in Figure 6.4) stores all the information about how you put together your movie. This includes the clip order, any volume and start/stop controls associated with clips, and so forth. The project file is basically a complete description of how these individual elements combine to make up your final movie.

The Media folder stores all media associated with this project, both video and audio. This includes all video and sound clips that iMovie creates. When you introduce titles, transitions, and effects to your movies, iMovie actually builds clips for these and stores them in the Media folder.

The very first time you start iMovie, you will see the screen shown in Figure 6.5. After you've used iMovie, when you start it up again, it automatically loads your most recent project.

You can create, save, and open your iMovie projects as follows:

Create a new project If the "first-time user" dialog box (see Figure 6.5) opens, click the New Project button to start a new project. Otherwise, press Command+N or choose File → New Project. When the New Project dialog box appears, enter a name for your project and click the Create button. iMovie automatically creates a new project folder with the name you specified. Within that folder, it places a fresh project file and Media folder.

Save your project After you've started a new project, you can save your work at any time by pressing Command+S or selecting File → Save Project. iMovie will save your current work and update your project file.

Figure 6.5

This introductory screen appears the first time you launch iMovie and whenever iMovie cannot find a current project to work on.

Open a project You can recover any project by opening it in iMovie. Press Command+O or select File → Open Project. In the dialog box that appears, navigate to the appropriate project folder, select the project file, and click Open.

Import Video and Pictures

iMovie allows you to import video directly into your project, ready to use. Your video clips are stored with that project, in the Media folder. Many video-editing programs differ from iMovie in that they import videos into libraries. You must then load clips from your library into your project.

iMovie's clip-storage arrangement helps you organize your work. The one drawback to this approach is that it can take up a lot of space if you use a clip in more than one project. For each project in which the clip appears, iMovie copies that clip and stores it in the project's Media folder. If you use a clip in five projects, you end up with five copies. This demands more room on disk, but it also allows you to edit or delete each copy without affecting any other project. For example, when you're finished with the project, you can delete the project folder, and you've deleted all of the clips associated with that project in one step.

Import Video into iMovie

iMovie supports only DV-25 video. You cannot import or edit any other video format.

> QuickTime Pro (www.apple.com/quicktime) allows you to export a number of video formats to DV-25 files. This QuickTime Pro upgrade costs $30, and it can work with many file formats, including MOV, MPEG, and AVI.

When you import your video, iMovie provides automatic scene detection. It finds where you started and stopped each scene, and divides the footage into individual clips at these points. If, for some reason, you want to disable this feature, choose Edit → Preferences → Import (Movie → Preferences → Import in iMovie for OS X) and uncheck the Automatically Start New Clip at Scene Break option.

To import video into iMovie, follow these steps:

Video capture mode

Playback/edit mode

1. Click DV to select the video capture mode from the capture/playback toggle.

2. If your video camera has IEEE 1394 (FireWire) capa– bility, use the playback controls to set the tape to the proper position. If your camera cannot be controlled from your computer via FireWire cable, you'll need to cue the tape manually.

3. Click the Import button to begin the capture process.

4. Wait for the video to play through. Clips automatically appear in the Clips Shelf as they are captured.

5. Click the Import button again to stop the capture process.

6. Use the playback controls to stop the tape.

7. Click the filmstrip icon to select the playback/edit mode from the capture/playback toggle.

You should load all of your footage into the computer at once. Cut your footage into pieces *after* importing it, rather than during the import process. If you import everything at once, you can easily cut and trim your footage using iMovie's handy features. Trying to create individual clips with the Import button is a hit-or-miss proposition; often, you click too early or too late. This forces you to try over and over to get it just right.

Import a Picture File

You can also bring picture files into your projects. iMovie allows you to import PICT, JPEG, GIF, Photoshop, and BMP graphic file types.

To import a picture file into your project, press Command+I or select File → Import File, navigate to the file you wish to import, and click Import. After you import a picture or video file, the clip will appear in your Clips Shelf.

Manage Your Clips

After you've imported your video into iMovie, you can work with your clips to produce your movie. First, split a clip to divide it into segments. Then select the clip area you want to work with. Finally, edit the clip by changing its length, removing part of it, cropping it, creating a still, reversing it, or duplicating it. The following sections describe how to split clips, mark selections, and edit clip selections, as well as assemble your video.

Split Your Clips

Follow these steps to split a clip into segments that you can use and edit separately:

1. Click a clip in the Clips Shelf to select it and load it into the playback window.
2. Drag the playhead (the downward-pointing triangle) into position as desired.
3. Press Command+T or select Edit → Split Video at Playhead.

iMovie will split the clip, select the second segment, rename it to distinguish it from the first segment, and load it into the playback window.

Mark a Selection

To create a selection within the frames of an individual clip, you need to mark the selection. Follow these steps to mark a selection:

1. Click any clip in the Clips Shelf to load it into the playback window.
2. Move the triangular playhead to the start of your selection.
3. Press the Shift key and hold it down.
4. Move the playhead to the end of your selection. Release the Shift key and the mouse.

Two small triangular markers appear at the start and end of your selection. A section of the scrubber bar will turn yellow to reflect your selection. At this time, you can change the selection as follows:

- Click either marker to move the playhead to that marker.
- Move one marker past the other to select in the opposite direction.
- Press Command+D to clear the selection and the playback window.

Edit Your Clip Selection

After you've selected part of a clip or an entire clip, you can edit it in a variety of ways, ranging from changing the selection size to speeding up or slowing down a clip.

Enlarge or shrink a selection To change the size of a selection, just move the appropriate marker. Move the start marker to the left to enlarge the selection or to the right to shorten it from the beginning. Move the end marker to the right to enlarge the selection or to the left to shorten it from the end.

Remove a selection To remove your selection, press the Delete key, press Command+X, or choose Edit → Cut. iMovie will cut your selection from the clip and load the cut selection onto the system clipboard. It then creates new clips from before and after your selection.

Crop a clip To crop your clip, removing all unselected areas, press Command+K or choose Edit → Crop. iMovie will trim your clip, retaining only the part you've selected and discarding any parts before and after the selection.

Create a still To create a still clip, move the playhead to any frame and press Command+Shift+S or select Edit → Create Still Clip. After you've created a still clip, you can select and edit it just like any other video clip.

> By default, still clips last 5 seconds. To change the default still length, select Edit → Preferences → Import (Movie → Preferences → Import in iMovie for OS X), enter a default length (valid durations fall between 0.5 and 60 seconds), and click OK.

Reverse a clip To reverse a clip, first select it. Then press Command+R or choose Advanced → Reverse Clip Direction. This instructs iMovie to reverse the direction in which the clip is played.

Duplicate a clip To duplicate a clip, first select it and press Command+C or choose Edit → Copy. Next press Command+V or select Edit → Paste to paste it. iMovie will create a duplicate of your clip and place it on the Clips Shelf.

Slow down or speed up a clip With iMovie, you can slow down or speed up a clip. In timeline mode, select a clip and adjust the Faster/Slower slider at the bottom of the timeline. As you do this, notice how the length of the clip changes to reflect the speed.

Assemble Your Video

To put together your movie, you can add clips, remove clips, and rearrange clips.

Add a clip To add a clip to your video, drag it from the Clips Shelf to the clip viewer or the timeline. Move the clip to where it should go. Any clips around it will adjust to allow its placement.

Remove a clip To remove a clip from your video, switch to clip viewer mode. Drag the clip back to the Clips Shelf. To delete a clip entirely, select it and press the Delete key.

Rearrange clips To move a clip, switch to clip viewer mode. Drag the clip to its new location. The other clips will adjust their position to accommodate the change.

Manage Your Video's Sound

iMovie offers a variety of ways that you can import, add, edit, and adjust sound to match the needs of your video. You work with your sounds using the audio tracks of the iMovie timeline. The tracks represent audio channel 1 and audio channel 2.

Import Sound Files

iMovie supports AIFF sound files. You can import these into your projects. To do so, follow these steps.

1. Switch to timeline mode.

2. iMovie places imported audio at the playhead location. Move the playhead accordingly.

3. Press Command+I or select File → Import File.

4. In the Import dialog box, navigate to the file you wish to import and click Import.

 When you import an audio file, it goes directly to iMovie's timeline.

Add Sounds

Through iMovie's Audio palette, shown in Figure 6.6, you can add sound effects, record voice clips, and record music from a CD. To open the Audio palette, click the Audio button at the bottom of the Clips Shelf.

 You can add sound effects, recorded voice clips, and recorded music.

Add a sound effect iMovie comes packaged with a small library of sounds, such as a drumroll and applause. To add an iMovie built-in sound effect, open the Audio palette and select an audio clip from the sound effects list. (The list shows the audio clip's duration in seconds.) iMovie will play the clip for you. Drag the audio clip to the timeline.

Add a voice clip Through iMovie, you can make a voice recording and add it to your project. In the timeline, move the playhead to where you want your voice clip to start. Make sure a microphone is plugged into your Mac. Then open the Audio palette and click Record Voice. Speak, sing, or create whatever aural effect you wish to record. Click Stop when you're finished. Recorded sounds automatically appear at the playhead, marked in orange.

Figure 6.6

The Audio palette allows you to choose audio from a library of prerecorded sounds, record your own audio, or import a track from a CD in your computer's CD-ROM or DVD drive.

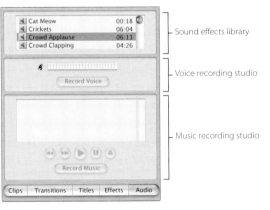

— Sound effects library

— Voice recording studio

— Music recording studio

Add recorded music To add music from a CD to your video, open the Audio palette, and then insert a CD into your Mac. The playlist appears as a scrolling list. To import an entire track, just drag it to the timeline. Otherwise, select your track and start playback. Click Record Music to begin, wait until you've recorded enough, and click Record Music again to finish. Recorded sounds appear at the playhead, marked in purple. Make sure to avoid copyrighted music if you intend to distribute your video or use it in public performances.

Edit Your Sound Clips

You can edit your video's sound clips by changing their start and end points, moving them, locking them to video clips, and separating them from video clips.

Set sound start and end points To set the start and end points of your sound, in timeline mode, drag the end arrows associated with the audio. The adjusted sound clip will look something like Figure 6.7.

Move a sound clip To move a sound clip, drag it to a new location. Sound clips can reside in either audio channel 1 or audio channel 2. (The two audio tracks are indistinguishable in the way that they work.) Audio clips can overlap without conflict. After resizing an audio clip, you can drag the new beginning all the way to the start of the video, if you like.

Tie down a sound iMovie allows you to connect a sound to a particular video segment. By locking the sound to the clip, you ensure that the two elements—video and sound—travel together. This means that if the video clip shifts, the sound moves with it. To tie down a sound, click the audio clip to select it, move the playhead to a section of video, and then press Command+L or select Advanced → Lock Audio Clip at Playhead. To remove a lock, select the audio clip and press Command+L or choose Advanced → Unlock Audio Clip.

Disassociate sound Although they are combined by default, you can separate a video clip into separate audio and video components in iMovie. This feature allows you to create perfect cutaways without disturbing the audio track of your video. To separate audio and video, select a video clip and press Command+J or choose Advanced → Extract Audio. iMovie separates the audio from the video and places the audio onto one of the two audio tracks.

Delete a sound To remove a sound from your project, simply select it and click Delete.

Figure 6.7

An adjusted sound shows both the original and new boundaries.

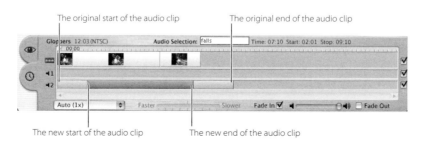

Control Sound Volume

The volume slider bar on the bottom of the timeline allows you to adjust the relative volume of any audio or video clip. To do so, select the audio or video clip and slide the round control to the left (softer) or right (louder).

The check boxes at the right of the three tracks in the timeline allow you to turn off the sound for an entire track. Uncheck any of these boxes to mute the track associated with it. Recheck the box to restore previous audio levels.

Another way that you can control volume is to use iMovie's Fade feature. Select an audio or video clip and click the Fade In box, the Fade Out box, or both. By selecting a Fade option, you instruct iMovie to gently fade sounds in at the start of the clip or out at the end. To set the fade length, double-click any clip. The Clip Info dialog box appears, as shown in Figure 6.8. This dialog box contains sliders that allow you to increase or decrease the time associated with your fade.

Figure 6.8

The Clip Info dialog box allows you to control audio fade-in and fade-out effects.

Add Wipes and Other Special Effects

Special effects offer a way to augment your video footage. When used sparingly, they can provide a bit of spice and elegance to your movies. But be careful not to overdo effects—a little goes a long way.

> You can also add slow or fast motion to a clip or reverse its direction. See the "Edit Your Clip Selection" section earlier in this chapter for details.

Apply Transitions

Transitions, also called *wipes*, change the way that one clip flows into the next. Common transitions include fades and cross-dissolves.

iMovie offers its selection of transition effects on the Transitions palette, as shown in Figure 6.9. This palette includes a preview window and speed control, as well as the list of available transition effects. The example shown in Figure 6.9 includes several third-party transitions from GeeThree's Slick Effects and Transitions plug-in. See the "Get More Special Effects" section later in the chapter for details on importing transition effects.

> The preview window in the Transitions palette does not provide a continuous preview of the chosen transition. For the most part, the preview will appear black (as in Figure 6.9), except when a transition is first chosen from the scrolling list.

Figure 6.9

The Transitions palette lets you choose ways in which one clip changes (or "wipes") into another.

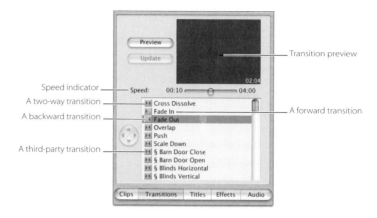

Transitions can operate in one of three ways:

- Forward transitions affect the following clip. These are marked with a forward arrow.

- Backward transitions affect the clip that precedes them. These are marked with a backward arrow.

- Two-way transitions affect both the following and previous clips. These are marked with both forward and backward arrows.

To create a transition, follow these steps:

1. Click the Transitions button at the bottom of the Clips Shelf to open the Transitions palette.

2. Scroll through the list of transitions and select the one you wish to use. You can sample the transition by selecting it and clicking the Preview button.

3. Set the transition speed with the speed slider. This lets you specify the transition duration.

4. Drag the preview window to place the transition into position on either the timeline or clip viewer. You may place the transition before, after, or between clips.

You'll need to wait for iMovie to render the transition. In either timeline or clip viewer mode, you can watch the tiny red progress bar. In clip viewer mode, you watch the frames-completed count. After rendering, the transition appears between adjacent clips, as shown in Figure 6.10.

After you've added a transition, you can remove or modify it. To remove a transition, just select it in the timeline or clip viewer and press the Delete key. To change a transition's properties, double-click the transition to bring up the Clip Info dialog box. Here, you can change the clip's name and specify sound fade-in and fade-out effects. In addition, you can use the slider at the bottom of the timeline to adjust the playback volume for the transition clip.

After modifying a transition, you'll need to wait as iMovie rerenders the frames that make up that transition.

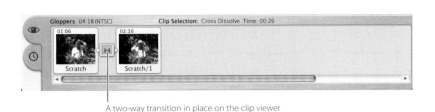

Figure 6.10

Transitions appear between adjacent clips as a small connecting rectangle.

A two-way transition in place on the clip viewer

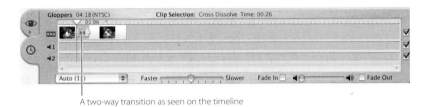

A two-way transition as seen on the timeline

Use Visual Enhancement Effects

iMovie effects allow you to alter footage by applying transformations like those you find in an image-processing program such as Photoshop. Typical effects include brightness, contrast, color, and focus adjustments. iMovie blends the effects so that they appear and disappear gradually without a sudden change.

To add an effect, follow these steps:

1. Select a clip in the timeline or clip viewer.

2. Click the Effects button at the bottom of the Clips Shelf to bring up the Effects palette, as shown in Figure 6.11. (Figure 6.11 includes third-party effects, as described in the next section.)

3. Select an effect from the list.

4. If desired, click Preview to see a sample of the effect in the preview window.

5. Set the Effect In and Effect Out times with the corresponding sliders to specify when the effect begins and ends in your clip.

6. As necessary, adjust any effect options, which appear beneath the effects list. These options depend on the chosen effect and offer context-specific controls.

7. Click Apply. Wait as iMovie adds the effect to your clip. Watch the red progress bar in the timeline or the frame count in the clip viewer.

Figure 6.11

The Effects palette allows you to adjust the visual look of a clip.

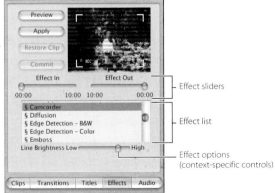

Effect sliders

Effect list

Effect options
(context-specific controls)

> Line brightness is an effect-specific option included by the GeeThree programmers. It appears only with the Camcorder effect. This option controls the brightness of the "video recorder" overlay.

8. Play your clip and make sure it meets your expectations. If it does, click Commit. Otherwise, click Restore Clip.

> You can wait to commit to an effect or restore your clip. iMovie keeps the original on hand until you choose to commit or until you add another effect, transition, or title to your clip.

Get More Special Effects

If the effects, titles, and transitions provided with iMovie don't fully meet your needs, you can add more. In March 2002, Apple released an official application programming interface (API) for iMovie 2 developers. Since that time, many new third-party plug-in packs have appeared on the market. The creativity and ingenuity of these third-party packages have added greatly to iMovie's basic functionality. Apple Computer's iMovie plug-in web page (`www.apple.com/imovie/plugin`) features many of these offerings.

Apple Computer also offers a free expansion pack, called the iMovie plug-in pack. Stop by `www.apple.com/imovie` to download your copy. (OS 9 users should visit `www.apple.com/imovie/macos9/` instead.)

The following sections review the plug-ins available from GeeThree, Virtix, eZedia, and Stupendous Software. Samples of all four packages are available on the CD that accompanies this book. Unless otherwise noted, these plug-ins are available for both OS 9 and OS X systems.

GeeThree Plug-ins

GeeThree (`www.geethree.com`) offers several comprehensive sets of iMovie plug-ins.

Slick Transitions and Effects This $30 package includes about 40 transitions and 15 effects. You'll find spins, barn doors, blinds, camcorder, film noise, edge detection, and emboss effects to expand your iMovie visual vocabulary.

Slick Transitions and Effects Volume 2 Volume 2, also $30, adds even more transitions (for more than 50) and effects. Highlights include vapors, washes, spirals, and fluids (wipes that reflect their names; for example, vapors allow the new clip to vaporize onto the screen).

Slick Transitions and Effects Volume 3 With Volume 3, GeeThree includes more than 30 new title plug-ins, nearly 70 transitions, and a dozen effects. The expanded range of title plug-ins makes this $50 volume particularly popular. You'll find large-sized title overlays including those named Vellum, Aperture, Marquee, and NewsFlash. New transitions include soft wipes, ripples, and flaps/flops.

COMMON VIDEO EFFECTS AND TRANSITIONS

The practical use of many of the effects and transitions offered by third-party developers might not be immediately obvious. Here are a few key descriptions to help you navigate.

Overlays and mattes Place imported images (such as pictures and titles) above your video using transparency and translucency to allow portions of your videos to show through.

Picture-in-picture effects Place video clips and still images above portions of your video.

Blue-screen effects Also called *chromakey*, lay footage shot against a solid-colored background over another video. With the solid background hidden, the underlying video shows through. This effect is used in TV weather broadcasts. Curiously enough, most "blue screens" are now actually green.

Split-screen effects Merge two video sources, usually side by side, to form a single screen. This effect is used widely in movies where one actor plays two roles (such as twins).

Barn doors, blinds, spins, and peels Refer to ways that an outgoing video segment leaves the screen to reveal the next video portion. Barn doors split a video in half and leave symmetrically to either side. Blinds create vertical or horizontal lines of video that shrink away. With spin transitions, either the incoming video appears to spin into the screen or the outgoing video appears to spin away. Peels remove the outgoing video in a diagonal direction to reveal the incoming source.

Slick Transitions and Effects Volume 4 Volume 4, another $50 package, adds advanced video effects via four special-purpose plug-ins: Effects (overlay mattes), Compositing (blue-screen effects), Picture-in-Picture, and Split-Screen. This volume also includes the SlickMotion application, which allows you to pan and zoom across still images to produce video clips for your iMovie projects.

GeeThree offers several deals on their Slick Transitions and Effects packages. Volumes 1 and 2 together cost $50. Volumes 3 and 4 are $90. If you buy all four volumes at once, the price drops to $135.

Virtix Plug-ins

The Virtix (www.virtix.com) iMovie plug-in collections stand out for their tight image-control functions, including letterboxing, panning, zooming, and color correction.

Virtix Spectra This $25 package offers 20 color-adjustment filters. Spectra allows you to tint scenes, shift colors, make day look like night, or do simple color correction.

Virtix Bravo Another $25 package, Bravo includes 20 special effects, such as those named Laser, Lightning, and Smoke. You'll also find more practical effects like Pixel Fixer, which is useful for fixing broken pixels on video recorded with a damaged camera.

Virtix Echo The Echo package provides 18 professional-grade special-effect transitions, including a variety of standard transitions, such as wipe and page peel, as well as cutting-edge offerings, including materialize and burn-through. Its cost is $25.

If you want to pick up both Bravo and Echo at once, Virtix offers a combo deal for just $40.

Virtix Zoom This $20 plug-in allows you to work on clip images. With Zoom, you can enlarge portions of the image, crop out unwanted elements, and add slow-moving or super-fast zoom-ins and zoom-outs. Zoom includes filters optimized for video and filters optimized for imported stills.

Virtix Pan & Scan This $20 package works with OS X systems only. It provides the tools you need to enlarge, pan, and scan across video and imported stills. The controls allow you to choose between slow, documentary-style pans or quick swish pans, which blur the image. Like the Zoom plug-in, Pan & Scan includes filters optimized for video and for imported stills.

Virtix 16x9 Converter This $25 plug-in converts footage shot in 16×9 format to 4×3 format.

eZedia Plug-ins

eZedia (www.ezedia.ca) recently joined the iMovie revolution with three high-quality, post-production plug-ins. These packages work with OS X systems only.

eZeMatte This $29 package allows you to place image mattes over iMovie clips to add customized graphics to your videos. With eZeMatte, you can easily add borders, frames, themes, and logos. You can also set the transparency to allow the underlying movie to show through as desired.

eZeScreen This $39 package provides easy-to-use blue-screen effects. With eZeScreen, you can position a second movie over your iMovie clip and adjust the transparency and fade levels of any color. This allows you to add animated logos, talking heads, and any QuickTime-supported movie to your project.

eZeClip This $29 package includes picture-in-picture and split-screen effects. It offers resizing, looping, borders, and drop-shadow controls to customize the look of your video.

Stupendous Software Plug-ins

Stupendous Software (www.stupendous-software.com) recently introduced several new effects-only plug-in packages for iMovie. Each of these packages costs $25.

Color Effects This package includes 32 effects that allow iMovie users to adjust the colors and framing associated with their footage.

Crops & Zooms This package includes 30 cropping, zooming, and scaling effects.

Glows & Blurs This package provides 25 effects that produce glow, blur, and diffusion image operations on iMovie footage.

Time Effects This standout package introduces 12 time-distorting effects that allow users to slow or speed their clips in various ways. Unlike the built-in iMovie speed slider, this plug-in smoothly interpolates frames instead of repeating them.

Add Titles to Your Footage

iMovie titles can display text over footage. This feature allows you to add subtitles, credits, captions, and title cards (black screens with white words) onto your videos.

Insert a Title

To insert a title, follow these steps.

1. Select a clip in the timeline or clip viewer.

2. Click the Titles button at the bottom of the Clips Shelf to bring up the Titles palette, as shown in Figure 6.12.

3. Select a title style from the list. You can see how the style looks in the preview window.

4. Type the text for the title into the text-entry boxes at the bottom of the palette.

5. As appropriate, set the following options:

 • Drag the Speed slider to adjust the speed of the titling sequence. For example, you can set how quickly the letters appear in sequence on the screen for the Typewriter title style.

 • Drag the Pause slider to set how long the completed title appears on the screen.

Figure 6.12

Add text to your movies with the iMovie Titles palette.

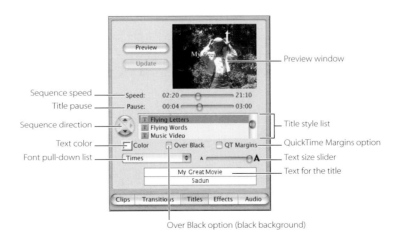

- Click the arrows in the direction wheel to set the direction of the title effect. Many title effects arrive onto your screen from one side or another. Point the effect in the direction you wish—top, side, or bottom.
- Click the Color box to select another color for the text.
- Click the drop-down arrow next to the font name to select another font from the drop-down menu.
- Drag the text size slider to adjust the text size.

Keep your titles moderately sized. If they're too big, your TV's natural tendency to overscan (explained in Chapter 3, "Video Tech Talk") may cut off parts of the title when you play your video.

- Click the Over Black option to create a title card with a black background. When this option is not selected, the title appears over an existing video clip.
- If you plan to export your movie to QuickTime, check the QT Margins box. If you plan to export to a TV or VCR, uncheck it.

Make sure to deselect QuickTime (QT) Margins when you plan to export your movie to a TV screen. By unchecking this option, you ensure that the edges of the TV screen will not cut off parts of your text.

6. Drag the preview window down to a video clip.

Wait as iMovie adds the text to your clip. Watch the red progress bar in the timeline or the frame count in the clip viewer.

Change or Remove a Title

After you've added titles, you can modify or remove them. Here's how you can change the title already applied to a clip:

1. Switch to clip viewer mode.
2. Click the Titles button to bring up the Titles palette.
3. Select the clip.
4. Edit the text associated with that clip and change any settings for it in the Titles palette.
5. Click the Update button. Then wait for iMovie to update the title applied to your clip.

To remove a title from a clip, select the clip in clip viewer mode, click the Titles button, and press the Delete key.

Export Your Movie

To create movies, you use the Export Movie function. When you're ready to export your iMovie video, press Command+E or select File → Export Movie to bring up the Export Movie dialog box. You may export to your camera, to QuickTime, or to iDVD (in version 2.0 and later). Select a destination, set any options you desire, and click Export. The following sections describe the iMovie options for each type of export.

Export Your Movie to a Camera

iMovie uses the 1394 standard to export your completed movie to a digital video camera or another 1394-based (FireWire) device, such as an analog/digital converter box. When you choose the To Camera option from the Export drop-down menu, you see the options shown in Figure 6.13.

The Export Movie dialog box offers a Wait option, which lets you specify the number of seconds to delay before iMovie begins to export your movie. This allows you to prepare your camera or other 1394-device after choosing the Export option. You can also specify a black-only prelude before your movie plays and/or a black-only finish after your movie plays, both measured in seconds.

Export Your Movie to QuickTime

You can export your iMovie production to any of a half-dozen or so QuickTime movie formats. When you select the To QuickTime option from the Export drop-down menu, the Export Movie dialog box includes a Formats menu, as shown in Figure 6.14.

The Formats drop-down menu offers the following choices:

Email Movie, Small This option offers a small (160×120 pixels) picture with mono 22KHz sound. It provides the most limited presentation possible. If the picture were any smaller, the viewer wouldn't be able to make sense of it. If the frame rate were lower, the video would look like a series of still pictures. Make sure to check the QuickTime 3.0 Compatible box when e-mailing your movie to someone with an older QuickTime player.

Web Movie, Small This option creates a compact movie suitable for saving on and recovering from the Web using progressive download. Occupying only 240×180 pixels, this format provides a step up from e-mail settings, while still conforming to limits related to using 56Kbps dial-up modems. Other improvements include stereo sound and a slightly higher frame rate.

Figure 6.13

When exporting your movie to a camera, you can set times for getting the camera ready and black-only padding around the footage.

Figure 6.14

When exporting your movie to QuickTime, you can choose from several predefined export formats.

Figure 6.15

The Expert QuickTime
Settings dialog
box allows you to set
your export prefer-
ences precisely.

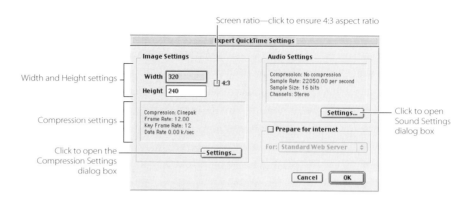

Streaming Web Movie, Small Screen ratio—click to ensure 4:3 aspect ratio

Width and Height settings

Compression settings

Click to open the
Compression Settings
dialog box

Click to open
Sound Settings
dialog box

Streaming Web Movie, Small This option uses a streaming format to save your small Web movie. This permits you to upload your movie to a streaming server, such as www.singlereel.com, which allows you to play your movie in real time as the download occurs. (See Chapter 9, "Share Your Movies with Streaming Video" for an introduction to streaming media.)

CD-ROM Movie, Medium This option saves a medium-sized movie (320×240 pixels) with a 15fps frame rate, suitable for storing on and playing back from a CD-ROM.

Full Quality, Large This option creates a broadcast-quality movie (720×480 pixels), using a full frame rate and stereo sound.

Expert This option offers a full range of expert settings, allowing you to customize your movie as you wish. Choosing it brings up the Expert QuickTime Settings dialog box, shown in Figure 6.15. Here, you can review the image and audio settings. To change the settings for the movie's compression or audio, click the corresponding Settings button. If your movie is designed for the Internet, click the Prepare for Internet check box, and then choose either Standard Web Server (for a progressive download) or QuickTime Streaming Server (for streaming the movie) from the For drop-down menu below the check box.

Figure 6.16

iMovie and iDVD inte-
grate with each other
using the handy For
iDVD export choice.

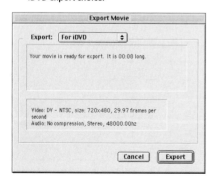

Export Your Movie to iDVD

To save your movie in a QuickTime file suitable for iDVD import, choose the For iDVD option in the Export drop-down menu, as shown in Figure 6.16. Click Export, and you'll produce a movie with full-broadcast-quality size and frame rate, and CD-quality sound.

In This Chapter...

This chapter provided a quick tour of many features you'll find within iMovie. iMovie is one of the best (probably *the* best) and easiest to use consumer-grade video-editing software packages available today. A lot of Macintosh users put off upgrading to the $999 Final Cut Pro editing suite when they discovered just how powerful iMovie can be.

The iMovie interface is surprisingly simple considering the job it does. Don't be lulled, however, by the seeming simplicity. You can do professional-level work with iMovie. Take the time to learn the interface, and you'll be well rewarded by the results. For the latest on iMovie, you can visit Apple's Web site (`www.apple.com/imovie`).

To learn more about iMovie, check out *iMovie 2 Solutions: Tips, Tricks, and Special Effects*, by Erica Sadun (Sybex, 2002). With full-color, step-by-step illustrations, *iMovie 2 Solutions* offers a unique tricks-and-tips approach to taking full advantage of iMovie's features.

After reading this chapter, you might want to keep the following points in mind:

- Creating basic videos with iMovie involves little more than importing your clips, trimming them, and putting them in order. With just a few steps, you can produce good-quality digital videos. Of course, you can build your videos up from there, adding complexity, but straightforward videos are a snap to create.

- Transitions and effects, when chosen with care and used judiciously, can add pizzazz and style to your results. You'll find great transition and effect packages from third-party developers that are well worth the cost.

- Apple DVD Superdrives have plunged in price, and you can find DVD-R blanks for under $1 each. iMovie's excellent integration with iDVD makes it worth your while to explore publishing your digital videos on DVD.

VideoStudio Skills

Ulead VideoStudio offers a basic video-editing package that provides all of the tools you need to get started with video production. Based on a step-by-step approach, VideoStudio allows you to build your videos a little at a time. In this chapter, you'll meet Video-Studio 6 and learn essential techniques to create a movie from your video footage. You'll discover how to import, edit, and produce a final video. You can apply these techniques using the trial version of VideoStudio 6 provided on the CD that accompanies this book.

VideoStudio 6 is actually the "little brother" of Ulead's better-known MediaStudio Pro. MediaStudio provides an upgrade path for users who want a more powerful and professional editing package. For up-to-date information on both VideoStudio and MediaStudio, visit Ulead's Web site at www.ulead.com.

This chapter covers the following topics:

- **The VideoStudio interface**
- **Manage your project**
- **Import video and images**
- **Manage clips**
- **Manage the video's sound**
- **Add special effects**
- **Overlay text and pictures**
- **Create the video**

The VideoStudio Interface

VideoStudio's screen, shown in Figure 7.1, is divided into the following main areas:

- A main menu of steps across the top of the screen, which changes based on your current activity

- An options panel in the upper-left corner, which includes options for the current activity, such as creating and saving projects and opening files

- A preview/playback window in the upper-middle area of the screen

- A set of command buttons beneath the preview window, for accessing global functions (such as setting your capture device), the Undo function, the Redo function, and VideoStudio Help

- A media library area in the upper-right corner, with a context-sensitive drop-down menu to access a large number of effects, clips, graphics, and other project elements

- The movie timeline/storyboard display across the bottom of the screen. The two tabs at the left of the display allow you to toggle between timeline and storyboard mode.

Figure 7.1

The VideoStudio 6 interface provides tools for video production.

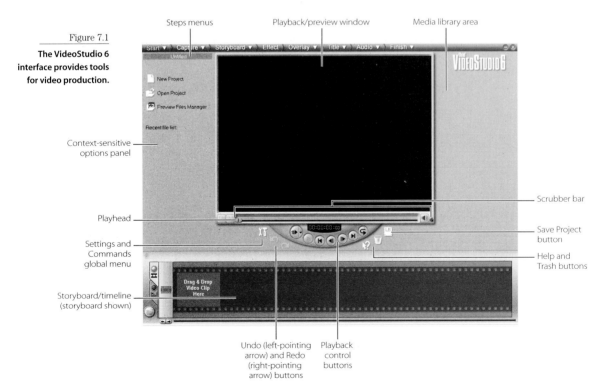

The Storyboard

The storyboard, shown in Figure 7.2, allows you to order your clips in a simple and direct fashion. Reordering clips may not sound particularly impressive, but proves to be a key component of video production. The VideoStudio storyboard makes it easy to build up your video by placing clips into their proper positions before you start adding special effects, audio, and so forth. The clips appear with thumbnails that make them easy to identify. The slider at the bottom of the storyboard display lets you view all of your clips.

The Timeline

The timeline, shown in Figure 7.3, combines video and audio sequencing in a single, powerful workspace. The timeline allows you to work with your clips over time as you add special effects, customize audio tracks, and so forth. Clips appear in order, labeled with small thumbnails. The clips include multiple thumbnails that indicate video content. The clip boundaries are identified by small vertical bars. Below the clips are three tracks: a text and effect track, a voice track, and a music track.

Manage Your Projects

With VideoStudio, the project is your most fundamental component. It is the thing you work on and "produce" to create a final movie. Before you can do anything else in VideoStudio, you must first create a project. VideoStudio creates a file for each project you save. In this project file (which, by default, has a `.vsp` extension), VideoStudio stores information about how you assembled your movie, including the clip order, length, and audio effects. The project file forms a complete description of how these individual elements combine to make up your final movie.

Figure 7.2

The VideoStudio storyboard offers a sequential view of your clips, without regard to individual clip duration.

Figure 7.3

The VideoStudio timeline displays clip content over time.

Figure 7.4

**In start mode, the
options panel allows
you to create a new
project or load an
existing one.**

Unlike earlier versions of VideoStudio, version 6 does not mandate that you use a single project folder. It allows you to save your video clips and your project file separately, if desired. You can choose to use a unified project folder (as iMovie does) or to store your clips in a general-use video library folder.

Create and Load Projects

VideoStudio always launches in "start" mode. The buttons for creating and loading projects automatically appear in the options panel on the top-left side of your screen, as shown in Figure 7.4. A list of recent files appears beneath these buttons to offer one-click access to current projects.

To create a new project, follow these steps:

1. If desired, create a new folder in your My Documents folder to store your project and video. You may skip this step if you plan to save your work in an existing folder.

2. Click the Start step in the main menu.

3. Click the New Project icon in the options panel. The New Project dialog box appears.

4. Click the button labeled with three dots to the right of the Working Folder text box, and then navigate to where you wish to store your project videos.

5. Select a template for your project. A basic 720×480 NTSC DV AVI file, as shown in Figure 7.5, should work for most North American video hobbyists.

> Readers who live outside North America will want to choose between NTSC and PAL, based on their country of origin. Chapter 3, "Video Tech Talk," discusses country systems in more detail.

6. Click OK.

7. Click the Save Project icon, which is located under the preview window on the right and looks like a floppy disk. A Save As dialog box appears, as shown in Figure 7.6.

8. Navigate to where you wish to save your project, enter a project name, and click Save. VideoStudio 6 creates your project and saves it in the folder you selected.

After following these steps, you'll have set up your new project within VideoStudio.

> While working on your project, you may click the Save Project icon at any time to update your project file and save all your changes to date.

Figure 7.5

When starting a new project, make sure to specify a directory to store your captured video and a template for your project.

Figure 7.6

The Save As dialog box lets you create a new project file in the directory you specify.

Open an Existing Project

Follow these quick steps to open an existing project.

1. On the Start menu, click the Open Project icon in the options panel (shown earlier in Figure 7.4). A Windows Open File dialog box appears.

2. Navigate to where you stored the project file and select that file.

3. Click Open.

VideoStudio will load your project file and all the relevant clips into your workspace.

Import Video and Pictures

In this section, you'll learn how to import video and images into your VideoStudio project. VideoStudio imports your media directly into the folder you specified when starting a new project. All your clips will be stored in this working folder, unless you change the preferences associated with your project. (You can access your project preferences by clicking the Settings and Commands icon, located under the preview window on the left, and choosing Preferences or by pressing F6.)

Did you choose to create a single project folder? Having all of your project's clips stored with the project, rather than in a central clip library, can make it easier to manage your projects. You can load your clips, edit them, and create your final project. When you're finished and have produced your movie, you can clean up completely. When you delete the project folder, you've deleted all of the clips associated with that project in one step.

One nice feature of VideoStudio is its large-file capture capabilities. Unlike Roxio Video-Wave and other Windows-based editors, VideoStudio allows you to record files larger than 4GB at a time. This 4GB limit, which applies to Windows platforms using the FAT32 file system (older systems that use FAT16 have a 2GB limit) prevents you from recording more than about 15 or 20 minutes of digital video. VideoStudio gets around this by creating new files to store the extra material. It does this seamlessly and behind the scenes.

Capture Your Video

VideoStudio supports a wide-range of video formats, including DV, AVI, AutoDesk, Animated GIF, QuickTime, and MPEG. It also provides an automatic scene detection feature, which finds where you started and stopped each scene and divides these segments into individual clips.

> VideoStudio can both import pre-existing video clips and capture video from a digital video camera. The instructions here describe the procedure to capture data from your camera. If, instead, you wish to import a video file, follow the directions below in the "Import Pictures" section, but choose Add Video instead of Add Image.

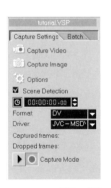

Figure 7.7

The VideoStudio 6 video-capture options appear when you select the Capture step.

To capture video into VideoStudio, follow these steps:

1. Click the Capture step in the main menu. The options panel changes to display context-specific video-capture options for controlling the process, as shown in Figure 7.7.

2. Ensure that the Format and Driver settings displayed match the video setup you're using. In Figure 7.7, VideoStudio correctly recognizes that a JVC video camera is hooked up to import DV video. If the settings are incorrect, use the pull-down menus (downward-pointing arrows) to the right of each option to select the correct choices.

3. Be sure to check the Scene Detection option. This allows VideoStudio to detect where you started and stopped each shot.

4. Make sure that Capture Mode is set (at the bottom of the options panel). If the setting is Playback Mode, click the red circle to switch modes.

5. Optionally, if you wish to add clip thumbnails to the active media library on the right portion of the screen, click Options, choose Capture Options, check Capture to Library, and click OK. The video clip files themselves are still imported into your default folder, but VideoStudio adds a thumbnail of each clip to the library for later reference and reuse with other projects.

6. Start your video playback by clicking the Play button under the preview/playback window.

7. Click the Capture Video icon at the top of the options panel. This icon has a red spot. Against most expectations, when you click this option, the red spot will turn off and the video will record. Yes, the red light is *off* while you are recording.

8. Monitor your video in the playback window. A running count of captured and dropped frames will appear in the options panel, below the Format and Driver display. See Figure 7.8 for an example.

Figure 7.8

VideoStudio 6 keeps track of the number of frames captured and the number of dropped frames.

> While it's likely you won't notice most of the dropped frames in your video, you may encounter occasional audio glitches where they occur. VideoStudio will repeat the video from the previous frame, but it cannot insert matching audio.

9. When you've recorded enough footage, click the Capture Video icon again.

10. Click the Stop button under the playback window.

After following these steps, you'll have imported video onto the timeline and stored it in your project folder. If you checked the Capture to Library option (as noted in step 5), your clips will also be stored in the media library. Move the slider at the bottom of the timeline or storyboard display to view all of your clips.

> VideoStudio offers an interesting Batch Capture feature that will capture only the footage you've specified. To see how this feature works, click the Batch Capture tab at the top of the options panel. Playback starts automatically. Use the two buttons on the left side of the scrubber bar to mark your footage in and out. When you're finished, click the Stop button under the playback window. Click the Capture Video icon in the options panel. VideoStudio will automatically record those segments for you, skipping the rest of the footage and saving you a great deal of disk space.

You'll find it easiest to load all of your footage into the computer at once, rather than trying to create individual clips with the capture function. Controlling this process with the Capture Video button is a hit-or-miss proposition. Often, you click too early or too late. This forces you to try over and over to get it just right. If you simply import everything at once, you can cut and trim your footage easily using VideoStudio's functions.

Import Pictures

VideoStudio allows you to import a huge variety of image types. To import a picture into your project, follow these steps:

1. Select the Storyboard step from the main menu.

2. Click the Insert Media Files button, located to the left of the storyboard or timeline display.

3. Select Add Image.

4. If you would like to see all of the supported formats, select All Formats and scroll through the list.

5. Navigate to the image file you wish to import and click Open.

VideoStudio will import your picture directly into the storyboard or timeline.

Manage Your Clips

After you've imported your video into VideoStudio, you can work with your clips to produce your movie. First, split and trim your clips. Then you can create still clips, and copy and remove clips if desired. Finally, assemble your clips into a sequence.

Prepare Your Clips

Use VideoStudio's Storyboard step to split and trim your clips, as well as to create stills. When you select the Storyboard step in the main menu, the options panel displays video-playback information and controls, as well as buttons for splitting and saving clips, as shown in Figure 7.9.

You can work with your clips as follows:

Split a clip To split a clip into segments that you can use and edit separately, select the Storyboard step from the main menu and double-click any clip. Move the playhead to where you wish to split the video clip. (Watch the playback window to identify the split point). Then click the Split Video icon in the options panel. VideoStudio will split your clip at the playhead into two separate clips.

Figure 7.9

The VideoStudio 6 clip-preparation options appear when you select the Storyboard step.

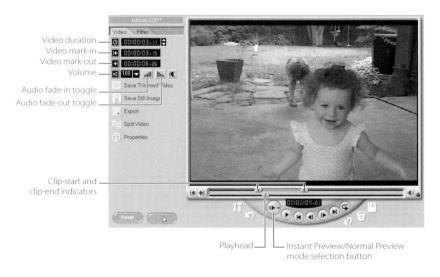

Trim your clips To trim your clips, adjust the clip-start and clip-end indicators in the trim bar (located just above the playhead). Click the Apply button (on the left, beneath the options panel) to apply your changes. Alternatively, select a clip in the timeline. (Click the timeline tab to move from the storyboard to the timeline.) Yellow bars appear at the ends of your clips. Adjust these bars to contract or expand your clip. Again, click Apply to commit the changes. If desired, you can save this trimmed clip as a new file by clicking the Save Trimmed Video icon in the options panel. VideoStudio will trim off the ends, render the new clip, add it to the current video library, and store the new file in your project folder.

Create a still To create a still, move the playhead to the position desired and click the Save Still Image icon in the options panel. VideoStudio will add a copy of your frame to the default image library and save the image file to your project folder. To add this still to your movie, just drag it from the library to the storyboard.

Duplicate a clip To duplicate a clip, drag it to the video library. This adds a thumbnail of your clip to the library for easy reference. Next, drag the thumbnail back to the timeline. VideoStudio will duplicate your clip and place a copy in the new position.

Remove a clip To remove a clip, right-click it and select Delete. If you delete a clip by mistake, make sure to click the Undo button (beneath the playback window, on the left) to restore your clip.

> VideoStudio allows you to play your clips back in either of two ways. You can choose Instant Preview, for a lower quality but realtime playback, or High Quality Preview, for a fully rendered result. To select either preview mode, choose from the drop-down menu directly adjacent to the right of the Instant Preview button in the playback area. (See Figure 7.9)

Assemble Your Video

To put together your movie, you can add clips, remove clips, and rearrange clips. Use the following techniques to assemble your video:

Add a clip To add a clip to your video, drag it from the library to the storyboard. Move the clip to where it should go. Any clips around the new clip will adjust to allow its placement.

Remove a clip To remove a clip from your video, click the Storyboard step in the main menu. Right-click a clip and choose Delete.

Rearrange clips To rearrange a clip, click the Storyboard step and choose the storyboard display. Select a clip and drag it to its new location. The other clips will adjust as necessary.

Manage Your Video's Sound

VideoStudio offers a variety of ways that you can import and adjust sound to match the needs of your video. The Audio step in the main menu offers options for importing and recording sound. You can edit your video's sound, including moving an audio clip and extracting the audio component of a video clip. Additionally, you can add sound fade-in and fade-out effects.

Import Sounds and Add Sound Effects

VideoStudio supports AVI, AIFF, QuickTime, MP3, MPEG, RealAudio, WAV, and WMA (Windows Media Audio) files. To import an audio file, follow these steps:

1. Select the Audio step from the main menu. You will automatically enter timeline mode.

2. Click the Load Audio button, located at the top-right side of the library area. The icon looks like a file folder.

3. Navigate to your audio file and click Open. Video Studio adds your audio clip to the library.

4. Drag the audio clip to the music track in the timeline.

You can also use VideoStudio's built-in sound effects. VideoStudio comes packaged with a small library of sounds, including thunder, a train, animal sounds, and so on. To use a sound effect, select the Audio step, and then drag an audio clip from the library to the music track in the timeline.

Add a Voice-over

Figure 7.10

The options panel in the Audio Step allows you to record a voice- over for your video.

All you need is a microphone to create a voice-over for your videos. VideoStudio's Audio step makes it easy to add your voice recording to your video. Follow these steps to record a voice-over:

1. Choose the Audio step from the main menu. You will automatically enter timeline mode.

2. Move the playhead to where you wish to add a voice-over.

3. Make sure the Record with Preview option is checked. You'll find this option just under the Record button in the options panel, as seen in Figure 7.10.

4. Click the Record button.

5. Make any volume adjustments using the level meter provided in the Windows pop-up window.

6. Click Start to dismiss the pop-up window and begin your recording.

7. Start speaking. Watch the video play back as you talk. It travels, indicating the part of the video you're narrating over.

8. Click the Record button to stop recording.

Edit Your Sound Clips

You can edit your video's sound clips by changing their start and end points, moving them, and separating them from video clips.

Set sound start and end points To set the start and end points of your sound, drag the yellow bars at the ends of the clip in the music or voice track in the timeline. These bars allow you to shorten or expand your previously shortened clip.

Move sound To move a sound clip, drag it along the music or voice track in the timeline to a new location.

Extract sound In VideoStudio, you can extract the audio component your video. To do so, select the Finish step in the main menu. Click the Create Sound File icon in the options panel. Navigate to where you wish to save your audio. Then choose an output format—MPA (MPEG audio file), RM, WAV, or WMA—from the type drop-down menu. Enter a filename and click Save.

Control Sound Volume

Volume-adjustment controls appear in the options panel for many VideoStudio steps, including Storyboard and Audio. To adjust the sound for any audio or video clip, start by selecting that clip. Next, turn your attention to the options panel and locate the clip volume icon. Select a magnification factor from the drop-down menu and click Apply to apply your change.

You can also have your sound fade in at the beginning of a clip or fade out at the end of a clip. First select the clip. Then click Fade-In, Fade-Out, or both on the options panel. Click Apply to confirm your change.

Add Special Effects

Special effects offer a way to augment your video footage. When used sparingly, they can provide a bit of spice and elegance to your movies. But be careful not to go overboard applying them—a little goes a long way. VideoStudio offers two types of special effects: transitions and filters.

Use Transitions

A transition changes the way one clip flows into the next clip. Common transitions include fades and cross-dissolves.

Follow these steps to add a new transition:

1. Click the Effect step from the main menu. Small squares will appear between each video clip, as shown in Figure 7.11.

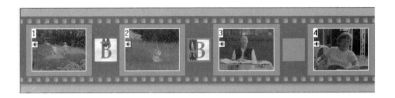

2. Click the library drop-down menu to choose from the 12 effect libraries, each full of transitions.

3. Select a transition from the library. Small animations demonstrate each effect. To preview an effect, double-click it and click the Play button beneath the preview window.

4. Drag an effect to any square on the storyboard.

5. Click the effect, and then click the Play button beneath the preview window to view it.

Transition-specific controls appear whenever you select a transition from the storyboard. You can use these controls to change the way the effect occurs. Make sure to click Apply to confirm your changes before moving onto your next task.

You can remove, move, and replace transitions as follows:

- To remove a transition, select it and press the Delete key.

- To move a transition, drag it to a new position on the storyboard.

- You replace a transition when you drag a new effect over an old one.

Apply Filters

Filters allow you to alter footage by applying transformations like those available in image-processing programs such as Photoshop. Typical effects include brightness and contrast adjustments, and blur and emboss effects.

Follow these steps to apply a filter to a video clip:

1. Click the Storyboard step in the main menu.

2. Select Video Filter from the library pull-down menu.

3. Select a clip on the timeline.

4. Double-click a filter from the library to begin to apply that filter to the selected clip.

5. VideoStudio loads the controls for the filter into the options panel, as shown in Figure 7.12. Use these controls to adjust the way the filter is applied to your clip. Make sure to click Apply to commit the new effect.

You can use the filter controls to modify or remove a filter after it is applied. Just choose the Storyboard step and select the clip with the filter you want to change. Select any of the applied filters from the list in the options panel (Figure 7.12). You can either click the filter or use the arrows to move up and down the list. Adjust the controls as desired. If you want to remove a filter from a clip to restore the original material, click the X button at the bottom-left side of the Applied Filters list. When you're finished making changes, click the Apply button to apply the updated filter.

Figure 7.12

Context-sensitive controls appear in the options panel when you add filters to your clips.

Overlay Text or Pictures

VideoStudio's Overlay and Title steps allow you to add text, images, or video to display over your footage. These steps provide many controls for tuning titles for just the effect you want.

Add a Text Title

You can add subtitles, credits, and title cards (text on a black background) to your videos. To insert a text title, follow these steps:

1. Choose the Title step from the main menu. You will automatically enter timeline mode.

2. If VideoStudio has not already done so, select Title from the library pull-down menu.

3. Choose a prebuilt title and pull it down to the title track on the timeline. If you would rather build a title from scratch, double-click the preview window after entering timeline mode.

4. Click the new title in the title track to select it. You can view your title immediately by clicking the Play button beneath the preview window.

> Preview speed depends on the power of your CPU. The first time through, VideoStudio creates a cache that stores this preview. Playback speed improves to real time with the second and subsequent previews.

5. Click within the preview window and edit the text as desired. The controls in the options panel allow you to pick a font, size, color, and many other attributes.

6. Optionally, select Animation from the library pull-down menu, choose an animation style, and drag it on top of your title in the timeline. (Alternatively, you can select the title, double-click an animation, and click Apply). To edit your animation, click the Animation tab on the options panel and use the controls to adjust the way the animation occurs.

7. Click Apply to commit your changes.

Add a Video or Image Overlay

Video and image overlays allow you to place pictures, rather than text, over your footage. Figure 7.13 shows an example.

To insert a video or image title, follow these steps:

1. Choose the Overlay step from the main menu. You will automatically enter timeline mode.

2. Select Image or Video from the library pull-down menu.

3. Pull a video or image down to the overlay track on the timeline.

4. Click the Motion tab at the top of the options panel.

5. Select a motion option from the Motion Style drop-down menu. Options include static placement, scrolling to the right, scrolling to the left, and so on.

6. Select an anchor position from the Position pull-down menu. Many people like to use an upper-left anchor to simulate the view commonly used on TV news shows.

7. Select an overlay size from the Zoom ratio drop-down menu. Pick 50% or another size that best suits your effect.

8. Select the degree of transparency desired and enter it in the field labeled Transparency. A 0 setting corresponds to a fully opaque overlay without any transparency at all.

9. Click Apply to commit your changes.

Figure 7.13

VideoStudio 6 allows you to lay titles and video clips over your movie. This video still shows a "Happy Birthday" message as well as an overlaid clip of the earth, which is just starting to move from left to right.

Edit Titles and Overlays

After you've added a title or overlay, you can modify, remove, move, lengthen, or shorten it. Use the following techniques to edit your titles and overlays:

Change a title or overlay To change the title or overlay already applied to a clip, switch to timeline mode and double-click the item you wish to change. Use the controls in the options panel to make your changes. Click Apply to commit your changes.

Remove a title or overlay To remove a title or overlay from a clip, switch to timeline mode, select the item you want to delete, and press the Delete key.

Move a title or overlay You can drag a title or overlay to any position on the timeline.

Lengthen or shorten a title or overlay You can expand or contract the time associated with a title or overlay. Switch to timeline mode and select the title or overlay. Then drag the yellow handles at the clip edges to lengthen or shorten the clip. Click Apply to commit your changes.

Create Your Movie

VideoStudio 6 supports a number of output formats, including DV, Video CD (VCD), DVD, MPEG-1, MPEG-2, RealVideo, and Windows Media. The Finish step offers all of the controls related to producing your movie.

To produce a movie, follow these steps:

1. Click the Finish step in the main menu.
2. Save your project by clicking the Save button on the right below the playback window.
3. In the options panel, locate the drop-down menu to the left of Create Vidoe File. Click this drop down menu triangle to open the hidden menu.
4. Choose an output format.
5. Navigate to where you wish to store your video.
6. Enter a title for your movie.
7. Click Save. Wait for VideoStudio to render your movie. This step may take several minutes.

Did you create MPEG footage? After rendering your movie, you can use the Create DVD, Create VCD, or Create SVCD steps to build video discs, complete with menus and other interactive features. An easy-to-use wizard guides you through the process. See Chapter 8, "Burn Your Videos to DVD and VCD," for details.

In This Chapter...

This chapter introduced many of the most common editing tasks that you can accomplish in Ulead VideoStudio 6. In VideoStudio 5, you needed to buy the DVD and VCD production tools separately. With VideoStudio 6, they're bundled in. These tools alone are worth a good portion of the purchase price for the software. To learn more about VideoStudio, read through the manual included with the software and visit the Ulead Web site for customer service, technical support and a user-to-user Web board.

Here are a few key points to keep in mind when you work with VideoStudio:

- Work with the steps. The VideoStudio interface was designed to move you from start to finish as effectively as possible. Let the step menu guide you through this process.

- Make a habit of glancing at the options panel whenever you start a new task. You'll likely find some controls that will make your editing life easier.

- Don't forget the Apply button. Most of your edits will not take effect until you apply them.

- If your computer is powerful enough, use the Instant Preview option to save time and see your results right away. If the results do not provide enough video and audio quality for you, choose High Quality Preview instead. Be prepared, however, to wait significant lengths of time between performing your edits and seeing the results.

Burn Your Movies to DVD and VCD

DVD and Video-on-CD technology offer some of the most exciting ways to distribute and enjoy your digital video movies. They use lightweight, compact, and portable media that you can play back on both computers and home DVD players. And, surprisingly enough, this technology is now affordable, within the reach of many consumers. Recordable DVD drives sell for as little as $250, and DVD blank discs cost as little as 60 or 70 cents each. Prices continue to drop.

If you're concerned about others being able to view your work, consider that DVD player sales have soared. More people own home DVD units than ever before, and many of these players can play back both DVD and Video-on-CD discs. Now, more than ever, it makes sense to consider discs as a new and innovative way to distribute your digital video creations.

This chapter covers the following topics:

- **DVD and Video-on-CD technology**

- **Burn your video to DVD and VCD**

- **VCD compatibility issues**

- **Produce DVDs and VCDs with Ulead VideoStudio 6**

- **Create DVDs with iDVD**

- **Create VCDs with Nero 5.5 and TMPGEnc**

- **Create VCDs with Toast Titanium**

DVD and Video-on-CD Technologies

DVD and Video-on-CD technologies offer an attractive alternative to VHS tapes and VCRs. Video on CD includes VCD, SVCD, XVCD, and miniDVD formats, which are commonly collectively referred to as *VCD*. (See Chapter 3, "Video Tech Talk," for technical details on the DVD and VCD technologies.)

DVD players continue to be one of the hottest selling consumer items on the market. Many players now support both DVD and VCD formats. Also, many new computers arrive equipped with DVD drives. This market penetration provides a larger and ever-growing audience for disc-based digital movies.

Discs have other advantages. The media are durable—they can last for years (some say 20 to 30 years, up to a century or more)—and are resistant to moisture, (gentle) handling, and dust. Also, you can store your movies in minimal space—DVDs and CDs take up far less room than bulky VHS tapes. Their picture quality is superb, and you can make copies in far less time than with tape.

Which technology you should use depends on how your computer is equipped, what playback equipment you own, and how much money you're willing to invest. Table 8.1 provides a quick summary of the differences between the two technologies.

Table 8.1

A Comparison of DVD and VCD Technologies

TECHNOLOGY	CREATION DEVICE	MEDIA	COST	PLAYBACK DEVICE
Video-on-CD (VCD, SVCD, XVCD, miniDVD)	CD-R or CD-RW drive	CD-R or CD-RW blank	Less than $100 for the drive and 50 cents for the media	Computers, VCD players (primarily in Asia), many DVD players
Recordable DVD	DVD-R, DVD-RW, or DVD+RW drives	DVD-R, DVD-RW, or DVD+RW blank	About $300 for the drive and $1 for the media	Most DVD players

COMPETING DVD RECORDING STANDARDS

The DVD-R(W) and DVD+RW notations represent two competing technology standards. DVD-R and DVD-RW represent the more popular standard introduced by the DVD Forum (www.dvdforum.org), an international organization of hardware and software manufacturers, including Panasonic (Matsushita), Mitsubishi, Pioneer, Sony, and others. The competing DVD+RW Alliance (www.dvdrw.com) was formed from companies such as Hewlett-Packard, Philips, and Sony. Like Sony, several corporations belong to both organizations.

While both groups claim great things for their particular standards, it all boils down to this: Both standards play about equally well in today's DVD home players. DVD-R and DVD-RW drives and blank discs cost less than DVD+RW items and are more widely available. I personally own and use DVD-R(W) equipment because of its availability and lower price.

VCDs

VCDs offer a way to store and play movies on standard CDs. To create VCD movies, you need a CD-R or CD-RW drive. The prices of these drives have plummeted over the past few years. They are standard equipment on most (if not all) new computers.

Price and convenience helps motivate the popularity of the VCD standard. CD-R and CD-RW blanks cost well under a dollar—sometimes as little as five or ten cents each. CDs allow you to store your movies at very low cost on durable, portable media. The VCD standard stores a special data track that tells your player how to locate and play the data stored on your disk. SVCD and XVCD provide minor variations on VCD technology.

You can play VCD movies on all computers. PCs and Macintoshes easily play VCD movies using a variety of freeware and shareware players, notably Apple's free QuickTime player (`www.apple.com/quicktime`) and Microsoft's Windows Media Player (`www.windowsmedia.com`). You can find QuickTime on this book's CD, and Media Player is bundled with Windows. Whether you can play your VCD movie in your DVD player depends on the player's brand and model; some DVD players work with VCD, and some do not. See the "VCD Compatibility Issues" section later in this part for some tips on figuring out if your DVD player plays VCD movies.

Recordable DVDs

Recordable DVD drives are newer and a bit more expensive than CD-R and CD-RW drives. In 2001, Pioneer introduced a consumer line of DVD-R recorders selling under $1,000. Soon, other manufacturers followed with their offerings. By 2002, recordable DVD drive prices had fallen into the $300 to $500 range, with special deals dipping as low as $200 to $250. Prices continue dropping as the technology makes inroads into the consumer market.

Like recordable CDs, computer-based recordable DVD drives allow you to archive data as well as video and music, making them attractive outside the digital-video market. Most recording DVD drives allow you to store about ten times as much data as you can on a CD and five times as much as the new double-density CDs being introduced by Sony. And that's just on the basic 4.7-gigabyte blanks. Double-sided and multi-tracked DVDs offer even higher capacities.

Stand-alone recording DVD drives, introduced in 2001, allow you to burn production-quality DVD-R(W) and DVD+RW in real time. Hook one up to your TV, and you can throw away your VCR. Connect a DVD recorder to your analog or digital video camera, insert a blank disc, and you can instantly produce DVDs from your raw footage. Hook it up to your computer through a converter box (most of these recorders currently accept only analog input), and you can output your movies directly to DVD. These recorders are discussed in detail in Chapter 10, "Export Your Movies to TV, Tape, and More."

In 2000, DVD blanks, particularly DVD-R blanks, cost about $30 or more. By 2001, the price had dropped to about $10 each. In 2002, they cost under $1, with bulk prices dipping toward 60 or 70 cents each by the end of the year. The media prices for other standards have dropped, too. DVD+RW blanks cost a bit over $2 in bulk, contrasted with $1.00 to $1.50 for DVD-RW blanks. (Curiously, DVD+R discs do not exist and are not supported by current DVD+RW technology.)

Unlike VCD technology, recordable DVD technology allows you to create movies that play in nearly all modern DVD players.

Burn a DVD or VCD

Burning is the act of writing your digital data—that is, your video—to disc in a recording CD or DVD drive. (The term refers to the use of a laser beam to etch, or burn, the data into the physical medium.) Recording drives include your computer's CD-RW and DVD drive, as well as stand-alone recording units that work like disc-burning VCRs.

> Once CD-R or DVD-R discs are burned, you cannot change them. They support only write-once media. In contrast, you can write and rewrite CD-RW, DVD-RW, and DVD+RW discs, reburning them as needed.

To copy to a VHS tape, you must play back your video in real time. In contrast, burning DVD and CD copies can take mere minutes. This does not include all the work that goes into editing and, eventually, compressing your video. Be aware that compressing your movies to the MPEG format can take a long while—sometimes as much as four to ten hours of compression per hour of video.

For those with extra money, hardware converters allow you to create your first MPEG copy in real time. In 2001, the Dazzle Digital Video Creator II (DVC-II), which currently retails for approximately $200 (`www.dazzle.com`), offered this real-time MPEG compression. Throughout 2002, numerous vendors joined Dazzle in providing real-time MPEG-1 and MPEG-2 encoding solutions.

Basic Steps

Creating your own DVDs and VCD movies can prove surprisingly easy. Software and hardware manufacturers have gone out of their way to simplify and expedite this process. For the most part, the following are the basic steps you must follow to create these discs on your own:

1. Create and save your movie, using video-editing software (as discussed in the previous chapters).

2. Export your movie to a compliant format. For example, choose MPEG-1 for VCD and MPEG-2 for DVD. Use your editor's export feature or converter software such as Discreet

Cleaner (`www.discreet.com`) or Tsunami TMPGEnc (`www.tmpgenc.net/e_main.html`).
(Cleaner is discussed in Chapter 9, "Share Your Movies with Streaming Video," and TMP-
GEnc is covered later in this chapter, in the "Focus on: Nero 5.5 and TMPGEnc" section.)

3. Fire up your burning program. Various software tools are available for burning discs, and
you'll learn about several of them in the second half of this chapter. Programs are available
for both Mac and Windows platforms, ranging widely in both price and ease of use. Trial
versions of several programs that can burn discs can be found on the accompanying CD.

4. Follow directions to create a backsplash, menus, and so on.

5. Initiate the burning process.

This sequence will vary somewhat with the equipment and software you use. Some pro-
grams allow you to create complex and involved menus with introductory video sequences.
Other programs stick to just the basics.

Burning Issues

Burning CDs and DVDs—and failing by producing a dud—can prove to be an expensive way
to make homemade coasters. Take a few precautions before you burn, particularly if you are
using an older CD-R or CD-RW burner.

Know your burner Before you burn, learn about your burner's quirks and foibles. For exam-
ple, find out if your CD-R burner prefers certain brands of CD blanks. If so, make sure to sup-
ply it with those discs.

Lower the speed If your burner is subject to buffer underruns, make sure to lower your record
speed to 4x or less. Buffer underruns occur when your computer cannot supply a steady enough
stream of data for your drive as it burns your disc. The disc-writing operation fails when the
drive looks for new data in its buffer and cannot find it (hence the term *underrun*). When this
happens, the drive's laser stops writing and cannot be restarted, unless you own a *burn proof*-
capable drive. Burn proof drives allow your computer to restart the writing process after
interruptions, avoiding buffer underrun errors and the useless discs they produce. If you can,
upgrade to better-quality equipment that supports burn-proof writing.

Turn off your screensaver When using older (1998 or earlier) CD-R and CD-RW technology,
make sure to turn off your screensaver and as many background programs as possible. These
earlier systems are extremely sensitive to system interruptions.

> In Windows, you can turn off the screensaver by right-clicking the Desktop, choosing Proper-
> ties → Screen Saver, and choosing None from the drop-down list. Background programs such
> as antivirus software usually appear as icons on the system tray and can be turned off from
> there. Macintosh users can use the System settings panels to deactivate the screen saver and
> other background processes.

Treat your recordable DVD, CD-R, and CD-RW discs with care Avoid subjecting your discs to excessive heat, humidity, and direct sunlight. And above all, don't scratch the top surface!

Sometimes, no matter how hard you try, you still end up with a bad disc. Over the years, people have suggested all sorts of ways to use these wasted CDs in a positive manner. Creating coasters is the most popular (albeit sarcastic and lore-based) use for bad discs. Glue a thin cork backing to your discs to catch condensation from your coastered drinks and protect your furniture. To make a spectacular looking—and sounding—wind chime, buy small bells at your local hobby store. Without bells, your CD chimes will produce only a gentle, thudding noise. Use a good, thick rope and tie a knot above and below your CDs to hold them in place. A silver or gold spray-painted Frisbee adds a particularly charming top to your chime.

VCD Compatibility Issues

One of the most frequently asked questions about VCD technology is this: Will my VCD/SVCD/XVCD/miniDVD play back correctly in my DVD player? For this question, I have a quick and ready answer: It depends. This answer is both frustrating and true.

Playback capabilities are determined by two factors: format and media type. Of these two, format is the easiest to predict. It's on the box. If it says "VCD support," your player probably has it. Media type is another story. Discovering the type that your DVD player supports is often a matter of trial and error.

One of the easiest and best ways to play back VCDs is on your computer. Both Windows PCs and Macintoshes offer simple playback solutions. On a Windows-based computer, use the Windows Media Player to play the AVSEQ files in the MPEGAV directory on your VCD. Macintosh users should use their QuickTime player instead.

What Formats Does Your Player Support?

As mentioned, the easiest way to predict whether or not your DVD player supports a particular format, such as VCD or SVCD, is to read the box. Manufacturers specify clearly and in large lettering all of the formats that their product supports. Several Web sites offer compatibility lists, search engines, and reviews. A popular favorite is VCD Help (www.vcdhelp.com/dvdplayers.php). Before you buy a player, stop by a Web site and search for models that support the movie formats you want to play. In fall 2002, several DVD manufacturers including Apex (www.apexdigitalinc.com) announced that they would be dropping VCD support on their set-top DVD units for licensing reasons. This decision should not affect MPEG-2 SVCD

support. Negative consumer reaction may force these manufacturers to reconsider their decision. VCD support remains a popular reason for buying certain brands of DVD players. Table 8.2 provides a quick summary of formats and their characteristics.

FORMAT	ENCRYPTION	PLAYBACK LENGTH	PICTURE QUALITY	WILL IT PLAY BACK ON YOUR DVD PLAYER?
VCD	MPEG-1	1 hour	Near-VHS quality (1150Kbps video, 224Kbps audio)	Wide support
SVCD	MPEG-1 or MPEG-2	1/2 hour	VHS quality or better (up to 2600Kbps video, 224Kbps audio)	Good support
XVCD	MPEG-1 or MPEG-2	Varies	VHS quality or better (any nonstandard bit rate)	Some support
MiniDVD (cDVD)	MPEG-2	10 to 20 minutes	Full DVD quality	Rare support, although growing rapidly
DVD-R, DVD-RW, DVD+RW	MPEG-2	1 to 2 hours	Full DVD quality	Wide support

Table 8.2

DVD Player Formats

Bit rate specifies the amount of audio and video data that is read and played back per second, expressed as kilobits per second (Kbps). As these numbers rise, so does the quality associated with sound and picture. Video-on-CD standards specify bit rates for each type of VCD.

Playing your miniDVD movies may prove to be a challenge. MiniDVDs use DVD compression but are burned on CD media. This causes two problems:

MiniDVD software compatibility Many DVD players load software according to disc type. When they detect a CD or CD-RW disc, they load VCD drivers. These drivers are generally not compatible with miniDVD.

MiniDVD playback speed MiniDVDs use a very high bit rate. Few DVD players can spin CDs fast enough to accommodate the speed necessary to allow real-time miniDVD playback. However, more and more DVD players are incorporating this capability, in response to the consumer demand for the high quality and ease of creation that miniDVD offers.

What Media Does Your Player Support?

A DVD player uses red 635 or 650 nanometer (nm) lasers to play back movies. It shines its laser at the DVD disc. The information that reflects back is decoded to create the picture that you see on your TV. CD-R and CD-RW weren't designed for lasers of these frequencies. CD drives on your computer use a 780nm infrared laser. The organic CD-R dyes and CD-RW compounds, designed to reflect 780nm light, might not reflect sufficient 635nm or 650nm light to create a clear signal. To fix this, some DVD players use two lasers to support both DVD and VCD.

If you've used CD-R technology, you're sure to have run into a variety of colors and styles. You may have seen green/gold, gold/gold, blue/silver, and silver/silver varieties, among others. This diversity arises from the types of materials and reflective layers used to manufacture your disc. CD-Rs and CD-RWs use two types of reflective layers. The silver color you see on many blank discs comes from a proprietary technology; it is not, in fact, real silver. Gold discs, in contrast, use real 24-karat gold in their reflective layers. The combination of reflective layer and dye used produces the color seen on the opposite side of the disc. (Many DVD blanks are silver or white on top and a light violet on the bottom.)

As far as DVD-player compatibility goes, dye and compound count more than reflective layers. CD-Rs use three types of organic dye polymers. CD-RWs use a crystalline compound formed from silver, indium, tellurium, and antimony. Each of these materials provides a slightly different reflective profile. Table 8.3 summarizes the components of CD-R and CD-RW discs.

	DISC	COMPONENT	COLOR	DURATION AFTER RECORDING
Table 8.3 **CD-R and CD-RW Disc Components**	CD-R	Cyanine dye	Blue-green	75 years
	CD-R	Phtalocyanine dye	Light aqua	100 years (200 for advanced dye in "platinum" discs)
	CD-R	Metalized azo dye	Dark blue	100 years
	CD-RW	Silver/indium/tellurium/ antimony compound	Slate gray	20+ years

Here are a few rules of thumb for media compatibility:

CD-RWs work best More DVD players support CD-RW playback, rather than CD-R playback, because they reflect back more 635nm or 650nm light. Some CD-R discs cannot be detected by DVD players, producing the much dreaded "No Disc" message upon insertion. CD-RW blanks cost more than CD-R blanks but can be reused.

Check the Internet As with format support, media compatibility has been widely researched by hobbyists. Stop by www.vcdhelp.com and see what results people have found for your particular DVD player.

Match the make Wherever possible, purchase blank discs produced by the DVD player's manufacturer. Manufacturers streamline their media to work well in their own product line. For example, when using a Sony DVD player, consider purchasing Sony CD-R blanks.

Focus on DVD and VCD Production with Ulead VideoStudio 6

Ulead VideoStudio 6 (a trial version is found on the CD that accompanies this book) includes everything the Windows user needs to create DVD and VCD but the burner. In addition to

the suite of editing tools discussed in Chapter 7, "VideoStudio Skills," VideoStudio can compress, author, and direct your CD and DVD drives to burn your video discs. It's a snap to use, because a step-by-step wizard walks you through the entire creation process. This section will show you how to author and burn a disc of the video you've shot, edited, and saved. (In fact, you can also record and then burn shows for your personal viewing. Record your favorite TV show with your converter box, such as the Dazzle DVC-II, import the video into VideoStudio, and burn.)

> *Authoring* refers to the way you design the behavior of your VCD or DVD. Authoring steps include preparing your discs with menus, scene selections (also called chapter points), and so forth. These design tools use interactive computer software and are not currently available on stand-alone disc-recording units.

One of the great features of the Ulead approach is the ease with which you can create chapters for your DVDs and VCDs. Just select the start of a scene with the playhead and click a button.

Record a Movie to Disc

Whether you want to record your own creations or TV shows (for personal use!), you'll find the VideoStudio authoring approach easy to use. Alternatively, if you're using another program to edit your video, you can purchase Ulead DVD MovieFactory for about $50 (visit www.ulead.com for details). This software title includes all the same disc-authoring functionality you find in VideoStudio, but without the editing software. (For higher-end and more professional results with DVD authoring, Ulead offers the $300 DVD Workshop.)

The following steps describe how to record a movie to disc with Ulead VideoStudio or DVD MovieFactory. You'll find trial copies of both VideoStudio 6 and DVD MovieFactory on the CD that accompanies this book.

Figure 8.1

Click the icon that matches your project type.

1. In VideoStudio, select the Finish step and save your work. (See Chapter 7 for details on using VideoStudio).

2. Click the icon that best describes your project (Create DVD, Create VCD, or Create SVCD), as shown in Figure 8.1.

3. The Create Video File dialog box appears. Navigate to where you wish to save your file, enter a name, and click Save.

4. Wait while your movie is created. MPEG-1 and MPEG-2 compression both consume significant amounts of time.

5. When VideoStudio finishes compressing your movie, you're ready to design the interface for your disc. By default, the Ulead DVD Plug-in screen shown in Figure 8.2 appears. If, however, you've installed Ulead's DVD MovieFactory on your system, the screen shown in Figure 8.3 appears instead. Note that the interfaces for the DVD Plug-in and the DVD MovieFactory are nearly identical, except for the window titles.

6. Ensure that the Create Scene Selection Menu check box is checked and click Next.

7. Use the playhead and the scrubber bar to locate the start of each section of your video. Click Add to add that scene to the menu for your disc, as shown in Figure 8.4.

8. After you've finished adding scenes, click Next. The wizard will help you organize those scenes onto menus.

9. To design your menus, you need to select an interface style. The Project Templates drop-down menu offers a range of preset template styles, including Classic, Cool, and Travel (DVD Plug-in) and Business, Baby, and Romance (DVD MovieFactory). Choose a style and double-click a template to select it from the scrolling list.

10. At this point, each item on your menu will be subtitled "Enter text here...." Double-click each in turn and edit the text associated with the picture, as shown in Figure 8.5. If your disc will have more than one page of menu items, be sure to click the Next Menu button (it appears at the bottom-right side of the preview window) and edit the text on every page.

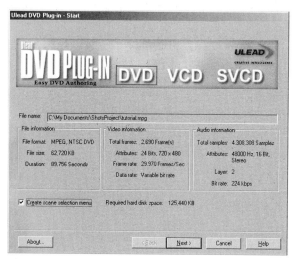

Figure 8.2

The Ulead DVD Plug-in guides you through the DVD or VCD authoring process.

Figure 8.3

The Ulead DVD MovieFactory interface allows you to design the way your DVD or VCD will look and behave.

11. Optionally, you can change the template background. To do so, click Background (DVD Plug-in) or Background Image (DVD MovieFactory) and load your own picture. Make sure to use a 3:2 (width to height) ratio image. Pictures can be in any standard graphic format, such as JPEG or GIF, and practically any size (they will be resized to fit).

> If you're changing the template background, choose an uncluttered picture, so that the text and chapter icons will appear clearly on top of it. Loading a background picture does not change the text color, icon location, action buttons, or frames of the template. Always consider the color of the text as it overlays the background.

12. After updating the titles for each scene, click Next.

13. The Playback Simulation screen, shown in Figure 8.6, allows you to test your project as played on a stand-alone system. Use the remote control to run your movie, just as you would on a real player. If necessary, return to previous steps (by clicking the Back button) to correct any mistakes. Otherwise, continue by clicking Next.

14. Set your record options (typically, the defaults work fine). When you're ready, click Next.

Figure 8.4

Add the first frame of each section of your video to your disc's main menu.

Figure 8.5

Add text captions for each scene on your disc menu.

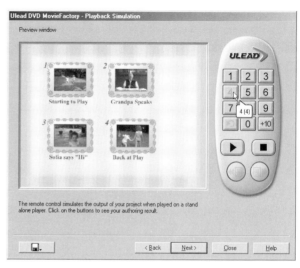

Figure 8.6

Use the playback simulation remote control to test your disc before you burn it. Although the remote controls look a bit different in the DVD Plug-in (left) and the DVD MovieFactory (right), they operate identically.

15. Click the Create DVD (or Create VCD) button and wait for your disc to burn. (If you wish to create a miniDVD (cDVD) instead of a DVD, insert a blank CD into your writer and select your CD burner rather than your DVD burner.)

16. Optionally, record more copies by clicking Create.

17. Choose Close to finish.

> When playing back a DVD in your home player, the menu will automatically appear after you load your disc. With VCDs, you must press Play on your remote control to see the menu.

Quick Burn an iMovie with VideoStudio

I've always been a big fan of Rube Goldberg. If you're not familiar with the great man, he used to draw cartoons about the most absurd ways to put together time-saving devices. A coffee-making machine might well involve a falling sandwich, a fat man, an inflatable pillow, and a fan that runs the coffee grinder. My favorite way, diagrammed in Figure 8.7, to prepare my videos for VCD involves a setup that Rube Goldberg would have loved. This setup compresses videos to MPEG in real-time, avoiding hours and hours of software-based conversion.

Here's how the procedure illustrated in Figure 8.7, steps A through F work: First, I compose my video in iMovie on the Macintosh (A). (Two Windows-based computers will work as well; just use VideoStudio or another video-editing program to export your video.) Next, I export it through the 1394 port to a Miglia Director's Cut converter box (B). I use the audio/video-out

connectors to export analog video to the Dazzle DVC-II unit (C). This unit connects to the Dazzle DVC-II board in my PC, where it performs real-time conversion to MPEG and saves the file on my PC (D). I import the MPEG file into VideoStudio (E) and, using the Ulead DVD Plug-in or DVD MovieFactory, quickly burn it to a CD-R (F). In this manner, I create a VCD in nearly real time.

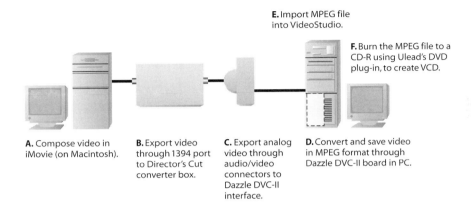

E. Import MPEG file into VideoStudio.

F. Burn the MPEG file to a CD-R using Ulead's DVD plug-in, to create VCD.

Figure 8.7

The Rube Goldberg method of exporting an iMovie video to VCD

A. Compose video in iMovie (on Macintosh).

B. Export video through 1394 port to Director's Cut converter box.

C. Export analog video through audio/video connectors to Dazzle DVC-II interface.

D. Convert and save video in MPEG format through Dazzle DVC-II board in PC.

> If you would also like to be inspired by Rube Goldberg, stop by www.rube-goldberg.com/ html/bio.htm and http://cartoon.org/goldberg.htm to read more biographical informa-tion and view some great cartoons.

Burn Easily with MPEG

When you've created DVD, VCD, or miniDVD-compliant MPEG in advance, by using the method described in the previous section or some other process, you can easily burn it in VideoStudio with the DVD Plug-in. Here are the steps:

1. Fire up Ulead VideoStudio and create a new, blank project using the appropriate (DVD, VCD, or SVCD) template.
2. Click the Storyboard step.
3. Click the Insert Media Files button, just to the lower left of the storyboard. Then click Add Video.
4. Navigate to your MPEG file and click Open.
5. Click the Create DVD (or VCD or SVCD) icon and proceed as described earlier in the "Record a Movie to Disc" section, starting at step 3.

Many other editing suites, notably SonicFoundry's popular Vegas Video 3 (www.sonicfoundry
.com), now offer MPEG support. With Vegas Video, you can purchase a standard ($30) or profes-
sional ($100) MPEG plug-in that allows you to export your edited videos directly to MPEG-2.

Focus on Nero 5.5 and TMPGEnc

If you're looking for a flexible, low-cost solution for MPEG and VCD creation, look no further
than Tsunami/Pegasus TMPGEnc and Ahead Nero 5.5. Unlike the Ulead DVD Plug-in, these
Windows PC programs do not hold your hand. They assume that you have a certain level of
technical sophistication and can hold your own in a not particularly user-friendly environ-
ment. The instructions in this section focus on VCD creation, using TMPGEnc for encoding
and then Nero for burning (Nero does not yet fully and reliably support DVD authoring).
You'll find demo versions of both software titles on this book's CD.

As for price, you cannot beat TMPGEnc (www.tmpgenc.net/e_main.html)—it's free.
Nero 5.5 (www.nero.com) costs only $49 for download and $78 for a shipped version (the
price includes shipping and handling charges). These packages offer you a great value for
their cost. The one downside is that neither package inherently supports MPEG-2, because
this compression scheme requires a separate licensing agreement with the creators of the
MPEG-2 algorithm. Ahead offers an MPEG-2 plug-in for $31 ($40 with shipping) for a CD ver-
sion or $16 for a download version. You can purchase the Tsunami/Pegasus TMPGEnc Plus
version for $48 (online only, includes an MPEG-2 encoding license) at www.pegasys-inc.com/
e_main2.html. If you want to try before you buy, the free version of TMPGEnc offers a 30-
day MPEG-2 trial. (As this book neared completion, the latest free version of TMPGEnc
was 2.58.)

Here's the basic procedure for creating a VCD with TMPGEnc and Nero 5.5:

- Create your movie in some video-editing program. TMPGEnc supports AVI, MPG, Quick-
 Time, and ASF files.
- Use TMPGEnc to encode your movie in MPEG-1 format.
- Let Nero's interactive wizard guide you through the VCD creation process.

The following sections explain how to use these two programs to produce your movies.

Encode with TMPGEnc

TMPGEnc offers both wizard-based and direct approaches to encoding your movie. The
wizard is easy to use, and the direct method offers control over parameters for more profes-
sional users.

Wizard Approach

These steps describe the process of using the TMPGEnc Project Wizard.

1. Fire up TMPGEnc. If the Project Wizard does not automatically appear, choose File → Project Wizard (or press Ctrl+W).

2. TMPGEnc prompts you for a project type. Choices include VCD, SVCD, and DVD, as shown in Figure 8.8. Select VCD and click Next.

3. The second page of the wizard, shown in Figure 8.9, allows you to set your source video file and, optionally, a source audio file. Click the Browse button next to the Video File text box, navigate to your video, and click Open. If your audio is in a separate file, click the Browse button next to the Audio File text box and open your audio file. Then click Next.

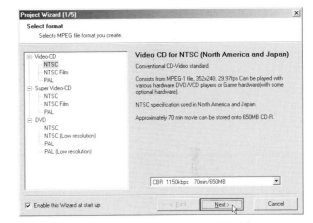

Figure 8.8

The TMPGEnc Project Wizard instructs you to select your project type from the list.

4. The next wizard screen, shown in Figure 8.10, offers a variety of filter settings. Unless you're familiar with the specifics of these settings, simply click Next to accept the defaults.

5. The fourth screen sets the bit rate for your project. When creating VCDs, TMPGEnc automatically sets this to 1150Kbps. This provides the standard VCD bit rate and should not be changed. Just click Next to continue.

Figure 8.9

Choose your source video (and, optionally, audio file) from the second page of the Project Wizard.

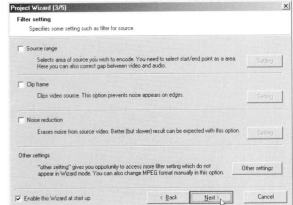

Figure 8.10

The filter settings allow you to set start and end points, frame clipping parameters, and noise reduction.

6. Examine the output filename on the final wizard screen. If you wish to save to a different location or to a different .mpg file, click Browse and navigate to the proper location or file.

7. Click OK to finish the wizard.

8. To finish, skip to step 5 in the following "Direct Approach" section.

Direct Approach

If you prefer to have more control over the settings for encoding your video, you can use the direct approach. VCDhelp (www.vcdhelp.com/tmpgencexplained.htm) offers an excellent overview of the settings available in TMPGEnc. Follow these steps to specify your TMPGEnc parameters directly.

1. Fire up TMPGEnc. First, you need to specify your source video. Click the Browse button to the right of the Video Source text box (at the bottom of the window shown in Figure 8.11).

2. Navigate to your source video and click Open.

3. Click the Setting button on the lower-right side of the TMPGenc window. The MPEG Setting dialog box appears, as shown in Figure 8.12.

Figure 8.11

Click the Browse button at the bottom left of the main TMPGEnc window to select your video source.

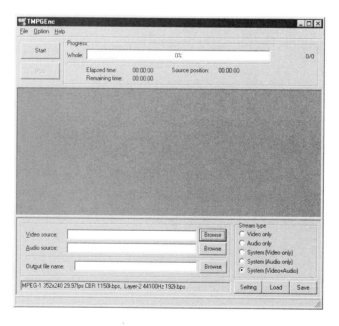

4. Set any options you need. These will vary by project type. For this VCD example, set your stream type to MPEG-1 Video, Constant Bitrate (CBR), 1150Kbps. Then click OK.

5. Click the Start button in the upper-left corner of the main window.

6. Wait while your video is converted. This may take a while. TMPGEnc provides excellent time estimates. Look at the progress bar in the top-right corner of the window (Figure 8.13) to see the elapsed and remaining time. A frame count appears to the right of the progress bar.

By following the above steps, you will have created your own VCD-compliant MPEG-1 file with TMPGEnc.

Burn with Nero 5.5

After creating an MPEG-1 file, you're ready to use Nero 5.5 to create and burn your VCD. These steps will guide you through the process.

1. Start Nero 5.5. The Nero Wizard welcomes you, asking you to choose the kind of medium (CD, DVD, and so on) that you would like to write with your recorder. Select CD and click Next.

2. When asked "How would you like to continue?" choose Compile a New CD and click Next.

3. To begin specifying your VCD, select Other CD Formats, as shown in Figure 8.14. Then click Next.

4. The next screen offers more format choices, as shown in Figure 8.15. Select Video CD and click Next.

Figure 8.12

The MPEG Setting dialog box allows you to specify your project settings directly.

Figure 8.13

TMPGEnc offers visual feedback on the progress of your encoding.

Figure 8.14

Choose Other CD Formats to author VCDs.

Figure 8.15

Nero's other CD formats include Audio + Data mixed, Video CD, and Create a CD from an image file.

5. The wizard gives you final instructions, as shown in Figure 8.16. Click Finish.

6. Drag your compliant MPEG files to the compilation window, as shown in Figure 8.17. A file browser appears on the right half of the screen. Use this to navigate to and bring in your movie files. A blue space-occupied bar appears at the bottom of the window and reflects the amount of room you've used so far. You can preview your movies by selecting them from the compilation window and clicking the Play button (on the bottom left, below the track list).

Figure 8.16

The Nero Wizard's finish screen offers final instructions about what's coming next.

7. To create your VCD, click the Burn button in the toolbar at the top of the window, beneath the menu bar. This button is the eighth from the left and has an icon that looks like a disc on fire.

8. Select whether you want to test, test and burn, or simply burn (Figure 8.18). Select your write speed from the drop-down menu. (On older drives, you might not want to burn faster than 4x to avoid buffer underruns, as explained in the "Burning Issues" section earlier in this chapter.) Select Create Image if you wish to create a disk image before you burn.

Figure 8.17

Drag your MPEG files to the bottom-left portion of the compilation window.

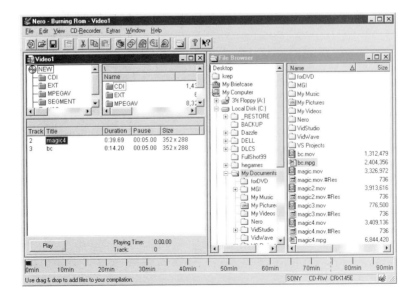

9. Insert a blank CD-R or CD-RW into your drive and wait for the drive to become ready.

10. Click Burn, and wait for your VCD to burn.

After following these directions, you will have created your VCD by first encoding with TMPGEnc and then burning with Nero. Although you use two separate software packages, they provide a single convenient path for getting the job done.

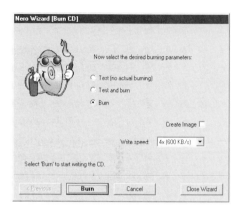

Focus on iDVD

Apple's iDVD software offers simple and intuitive DVD authoring. It provides an elegant and easy-to-use interface. This allows you to focus your energies on designing your DVD while iDVD hides unnecessary technical details. Thus, iDVD places you where you want to be—in the authoring seat, not the technician's chair.

Here are the basic steps for creating a DVD with iDVD:

- Create your movie in iMovie.

- Export your movie to the iDVD format.

- Import your movie into iDVD.

- Create a theme, folders, and the layout for your DVD.

- Burn your DVD.

Figure 8.18

The Burn Wizard allows you to set your write speed before burning your VCD.

Chapter 6, "iMovie Simplified," covered creating movies in iMovie. The remaining steps for creating a DVD are described here.

As of the time of writing this book, iDVD was available in two flavors. The original iDVD runs on Mac OS 9 and offers up to 1 hour of video per disc. iDVD 2 (and iDVD 2.1) runs on Mac OS X and provides up to 90 minutes of video. Other than iDVD 2's motion menus, the programs are virtually identical. For more information about iDVD, visit www.apple.com/idvd.

Figure 8.19

The iDVD introductory splash allows you to create a new project, open an existing one, or work through the iDVD tutorial.

Bring Your Movie into iDVD

To begin the DVD authoring process, you must start by saving your iMovie files in the correct format. Here's how:

1. Save your work in iMovie.

2. In iMovie, select File → Export Movie (or press Command+E). Choose For iDVD from the drop-down menu and click Export. Navigate to the location where you wish to save your movie, enter a name, and click Save.

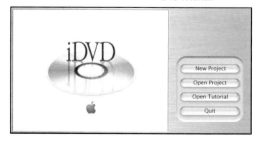

Figure 8.20

The iDVD project workspace contains the tools you need to author your DVD.

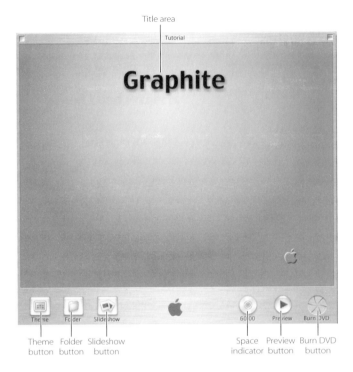

Title area

Tutorial

Graphite

Theme button Folder button Slideshow button Space indicator Preview button Burn DVD button

3. iDVD welcomes you with the introductory splash screen, as shown in Figure 8.19. Click New Project.

4. Navigate to where you wish to save your new project. Name the project and click Save. Your new project workspace will look something like the screen shown in Figure 8.20.

Take a few seconds to locate the following items:

- The DVD title appears in bold letters at the top of the screen. The default title is Graphite, because that is the name of the default theme.

- The Theme, Folder, and Slideshow buttons are on the lower-left side of the screen. These buttons offer one-click access to the most commonly used layout items.

- The disk space used/free indicator, Preview button, and Burn button are on the lower-right corner of the screen. These items let you plan, test, and burn your DVD.

Set Your Theme

The Theme button, in the lower-left corner of the screen, offers one-click access to a variety of prebuilt and custom themes. Themes set the mood and look of your DVD menus and provide an introduction to your work. Click the button to see the range of built-in themes available. Figure 8.21 shows just a sampling.

Figure 8.21

iDVD themes allow you to choose the overall look and style of your DVD interface.

Figure 8.22

The custom theme interface provides an easy way to pick and choose the elements that make up your iDVD menus.

Use the scroll bar to browse through the standard offerings. You may choose any selection by clicking it. The background will update automatically.

It's very easy to customize these standard themes. You can customize the default Graphite theme or any other theme you've chosen. Select Custom from the drop-down menu to view the range of options, as shown in Figure 8.22.

These options allow you a surprising amount of control over your presentation:

- The Background section shows the current background. Click the Import button to load a background from disk.

- The Title section lets you choose the alignment, font, color, and size for your title.

- The Button Label section lets you choose the vertical alignment, font, color, and size for your button labels. These labels can appear above, below, or on top of your buttons.

- The Button Shape section lets you select a button shape or use the default shape from the theme.

- Click the Save in Favorites button to save your changes as a new Favorites theme.

Figure 8.23 shows an example of a custom design that started with the Photo Album theme. To achieve this result, I made three simple changes: changed the title color to orange, selected the slide-shaped button, and imported a still. These small modifications made a big change in the theme's look and feel.

Figure 8.23

Specialize your iDVD interface with a custom background and coordinating colors.

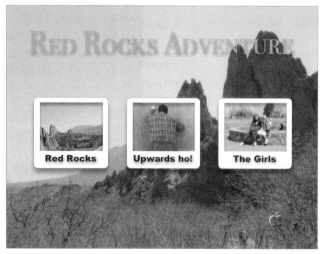

When you create a theme you really like, make sure to click the Save in Favorites button. This allows you to create a new theme from your settings that you can reuse.

Add and Edit Your Materials

iDVD supports two basic types of materials: videos and slide shows. To your DVD's audience, these are indistinguishable—you view a slide show in the same way that you view a video segment. As menus go, there is no visual distinction between the two. Adding the materials to your project, however, requires slightly different methods.

Add a Video

To add a video to your project, select File → Import Video or drag your video file from the Finder onto your iDVD screen. Click the title to edit your video's name.

> iDVD does not support "chapters" in the sense of continuous play. Each video plays separately. There is no "first play" video that starts when you insert the DVD. Instead, your viewers select each video from the main menu. When that video ends, the viewer returns to the menu.

Create a Slide Show and Add Pictures

To add a slide show, you must first create the slide show container and then add pictures. Here are the steps:

1. Click the Slideshow button to add a new slide show to your project.

2. Click the title to edit your slide show's name.

3. Double-click the new slide show to open the list view, as shown in Figure 8.24.

4. Select File → Import Image or drag your pictures from the Finder onto the list. To remove a slide from your show, select it and press the Delete key. To reorder a slide, drag it to its new position.

5. Set the slide-display duration. Valid durations include 1, 3, 5, and 10 seconds. You may choose Manual instead. This allows your viewers to move along at their own pace. If you do choose this option, make sure to turn on the arrows (check Display < > on Image) to offer a visual reinforcement of manual control.

6. After adding and editing your pictures, click the Return to Menu button, at the lower-right corner of the window.

Add a Folder

iDVD allows you to place up to six elements on any menu. To accommodate more complex interfaces, use folders. Folders allow you to store six more items in a submenu. These six items can include videos, slide shows, and more folders.

To add a folder to your menu, click the Folder button. As with other materials, you can click the title and edit it as needed.

> Unlike with the Macintosh Finder, you cannot drag and drop to place iDVD materials within a folder. Dragging onto a folder just reorders your presentation. To add to a folder, double-click. This places you within the folder itself, where you can add your materials.

Edit Your Materials

Prepare your materials as follows:

- To edit the title associated with any material, click the existing title, edit the text, and press Return.

- To remove any item from your menu, select it and press the Delete key.

- Drag any item to a new location to rearrange your materials.

Set Thumbnails for Videos, Slide Shows, and Folders

iDVD allows you to set a custom thumbnail for all your materials. To do so, select an item. Notice the slider that appears directly over the top. Drag this slider to cycle through the images that make up that material.

- With a slide show, the bar moves through the individual pictures within the show.

- With a video, the bar moves through the frames that make up the movie.

- With a folder, the bar moves through each thumbnail of the items (up to six) contained within that folder.

Figure 8.24

The Slideshow list view shows the ordering of each slide with a thumbnail and file reference. Duration (in seconds) and navigation options appear at the bottom of the window.

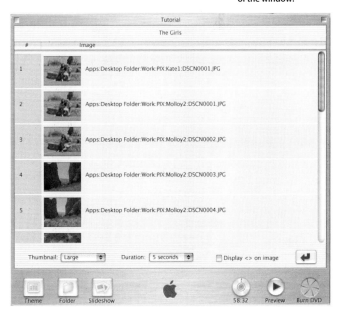

Figure 8.25

Use the slider above the Slideshow icon to set the menu thumbnail.

Figure 8.25 demonstrates how the editing process might look while working through a slide show. Notice how the slider moves from the default thumbnail (the picture of slides) to two other images at approximately one-third and three-quarters through the show.

Test Your Project

To test your iDVD project, click the Preview button (at the bottom of the screen, just to the left of the Burn button). By choosing this option, you can try out your DVD as if it were playing in a stand-alone player. iDVD provides you with a virtual remote control, as shown in Figure 8.26.

Test the interface thoroughly and make sure it matches your expectations. When you're ready to return to design mode, click the Preview button again.

Burn Your DVD

Prepare to take a long break while iDVD converts and writes your data. In fact, plan to relax for about 3 to 4 minutes for every minute you're about to burn to disc. The length of time it will take depends highly on the clock rate of your Macintosh; a 733MHz unit will compress video more slowly than a 1.25GHz unit. Do you have a 15-minute movie to burn to disc? Find something to do for the next hour or so. Are you using the whole 60 or 90 minutes on your DVD blank? Head down to your favorite coffee shop for a break. Be sure to bring enough money with you, though. Your disc might not be ready for a full four to six hours.

When you're ready to begin, click the Burn DVD icon (on the bottom-right corner of the screen). Watch it open to reveal a pulsating, yellow and black button. Click the pulsating button and wait for iDVD to compress and burn your disc.

Figure 8.26

Use the virtual remote control to preview your DVD before you burn it.

Focus on Toast Titanium

Roxio Toast Titanium (`www.roxio.com`) lets you author VCDs on your Macintosh. You can now export directly from iMovie. This lets you move seamlessly from iMovie to Toast Titanium without any unnecessary intermediary steps.

Here are the general steps for creating a VCD with Toast Titanium:

- Create your movie in iMovie.
- Export your movie to the Toast VCD format.
- Burn your disc.

The following sections describe each step in more detail.

Export from iMovie

When you install Toast Titanium, the installer automatically adds a couple of new export options to iMovie. These options allow you to export directly from iMovie to a Toast-friendly video format. Here are the steps:

1. Save your work in iMovie. (See Chapter 6 for details on using iMovie.)

2. Select File → Export Movie (or press Command+E) to display the window shown in Figure 8.27.

3. Choose Export to QuickTime from the Export drop-down menu. Select Toast Video CD from the Formats drop-down menu. Then click Export.

4. Navigate to the location where you wish to save your file, enter a name, and click Save.

5. Go get a cup of coffee. This is going to take some time.

iMovie now exports your movie using Toast's VCD standards. Toast Titanium automatically launches, creates a new video project, and adds your file to that project, as you can see in Figure 8.28.

Convert as many movies as desired. Each time, the iMovie Export function will load your movie into Toast Titanium.

Burn the VCD

Ready to record your VCD with Toast? There isn't much left to do. Here are the steps:

1. Click the round Record button in the lower-right corner of the Toast Titanium window.

2. Toast Titanium will pop open your disk drive and ask for a disc. Insert a blank CD-R.

Figure 8.27

The Toast Video CD option appears under the To QuickTime export choice.

Figure 8.28

After compression, a Toast Video CD project window appears, ready to burn.

3. Select a writing speed that matches your machine's capability, as shown in Figure 8.29.

4. Click Write Disc.

And that's all there is to it. Congratulations, you've created a VCD on your Mac.

Figure 8.29

The Record dialog box allows you to set your writing speed before you burn.

In This Chapter...

This chapter has covered many issues in regard to authoring DVDs and VCDs. Here are some key points to take away with you:

- Recordable DVDs are now an affordable and useful technology. You no longer need to approach this equipment with reverence or awe. You do need to give it practical consideration and understand the issues involved.

- Some people compare the competition between DVD+RW and DVD-RW to Betamax versus VHS. The popular and more affordable DVD-R/DVD-RW standard will most likely win the day.

- Video on CD remains a great technology to explore. Most computer owners already have all the hardware they need to get started with VCDs. Also, since you can easily play back a VCD on your computer, there's no further money to invest while trying out the technology.

- DVD (and VCD) authoring is becoming progressively easier to use and more powerful over time. Both iDVD and Ulead's DVD Plug-in and MovieFactory offer excellent and affordable ways to get started.

- Unless you own a hardware MPEG encoder, waiting is simply a natural and unavoidable part of authoring DVDs and VCDs. Learn to go with the flow and consider running your encoders overnight.

Share Your Movies with Streaming Video

Streaming allows you to share videos over the Internet by compressing them into very small files and storing them on a globally accessible site, ready to be transmitted around the corner or across the world. Your audience can watch those movies as they are downloaded, at a quality and resolution that match the bandwidth of their Internet connection. Streaming creates a handy way for people to view your digital movies on their computers, at their convenience.

In this chapter, you'll learn what streaming video involves and how you can apply this technology to your own digital creations. You'll also find some suggestions for locating a Web site to host your streaming videos.

This chapter covers the following topics:

- **Why choose streaming video?**
- **How streaming video works**
- **Streaming video considerations**
- **Create your streaming video**
- **Find a streaming host site**

Why Choose Streaming Video?

Streaming offers on-demand access to your videos. Streaming provides a way for people to view your movie, while placing few demands on their computer. Even people with relatively slow Internet connections (28.8Kbps or 56Kbps modems, for example) can watch a highly compressed streaming movie. If, instead, they had to download the movie at normal quality, it might take hours, or even days, for the movie to arrive.

Streaming is not the way to deliver high-quality video. With streaming, you sacrifice visual clarity and image size, but in return, you get a real-time result. If image fidelity is your highest goal, it probably makes better sense to send a videotape or DVD by mail rather than attempt real-time delivery over the Internet.

Streaming shines, however, when it comes to live video. When you're working with a live event such as a stockbroker's meeting or an anniversary party, streaming can bring your viewers into the event and into the moment.

This powerful technology can be employed in many ways. Here are just a few ideas:

Share family moments When you place your home movies on streaming Web sites, you allow friends and family all over the world to share your special moments. Use streaming video to document birthdays, graduations, new arrivals, and other events.

Provide tech support Place how-to videos on your site to provide off-hours technical support for your products. Other videos, such as product overviews and advertisements, can also help promote your business.

Offer online courses Include video segments as part of your online courses to help your students take the course at their own pace and on their own schedule. On-demand video allows your students to pick the time they attend a lecture. And they can view the lecture video as many times as they find necessary to understand the information.

Provide access to public events Offer online access to public gatherings. Use streaming video to provide access to recordings of city or corporate events, such as zoning board reviews or stockholder meetings.

Sell real estate A streaming video can help sell a house. Many realty sites are starting to provide full home walk-throughs to allow out-of-town buyers to see homes and neighborhoods without traveling to them.

Find a date Streaming videos are absolutely perfect for matchmaking Web sites. If ever a technology has met its ultimate match, it's streaming video and personal ads.

Streaming Basics

If you've used the World Wide Web for any length of time, chances are high that you've already encountered streaming video of some type—QuickTime, Real, or Windows Media. You

may have wondered what the differences are between these types and how they all work. Surprisingly, video delivery over the Internet is very straightforward. Even though the formats and players differ, the basic technology does not. Take a few moments now to explore how streaming works and who the major players are.

How Streaming Works

Streaming works by establishing a connection between a video server and a viewing program, called a *player*. Streaming provides controlled, on-demand delivery of both real-time (live event) and previously recorded data. The server delivers this video content at a specific rate determined by two things: the compressed video stream and the player data requests. Your player receives video content, decompresses it, and displays it for the viewer, just as it might when playing directly from a local hard disk.

The streaming rate is predetermined by the bandwidth of the Internet connection. The higher the bandwidth, the better the quality and detail of the streamed video. The most common connection rates include support for 28.8Kbps and 56Kbps modems, 100Kbps and 300Kbps broadband connections, and T-1 lines. Your streaming server may support any or all of these connection types. You can view a video meant for a 28.8Kbps connection through a T-1 line (but why would you?). The opposite is not true. In general, you simply cannot view a video meant for high bandwidth through a modem line, because you do not have the connection resources to support it.

After establishing the connection and delivery rate, the server and player begin a complicated dance of back-and-forth messaging throughout the whole playback process. For example, the player may ask the server to redeliver a certain segment. This two-way communication typifies real-time streaming and distinguishes it from a type of pseudo-streaming called *progressive download*. In this latter method, your player simply downloads a video from the Internet to a file and then plays it. With true streaming, content arrives and is played back in real-time, without being stored in a file first. This content may use any of several protocols:

User Datagram Protocol (UDP) UDP provides a real-time data-transfer protocol that receives high priority for Internet transmission. It's quick, avoiding a lot of management and overhead because it's tolerant of information loss. If data is lost or corrupted during a UDP transmission, the receiver (in this case, the player) does not request that it be re-sent.

Real-Time Streaming Protocol (RTSP) With RTSP, your player remains in constant touch with the server. It gathers, displays, and then quickly discards the video data, making it an excellent technology for viewing live events and long videos.

Hypertext Transfer Protocol (HTTP) Similar to progressive download, this method downloads the entire movie to your hard disk, allowing you to play the data as it comes from the network

or save to a file to play later. This method works best with short movies that the viewer may wish to watch multiple times. HTTP transfer lacks control uplinks—you may not be able to skip to different parts of your movies or replay a section that just downloaded until the entire file arrives on disk. Many sites also use this method to download a small redirect file that connects to a normal (UDP or RTSP) stream.

The Major Players

Three companies monopolize the world of streaming video. RealNetworks, Apple, and Microsoft have defined the most common streaming formats. You'll find streaming media players from Apple and RealNetworks on the CD that accompanies this book; if you own Windows, you already have a copy of Microsoft's Media Player.

QuickTime

Starting with QuickTime 4, Apple (`www.apple.com/quicktime`) introduced a true streaming media architecture that provides excellent online delivery capabilities. While prior versions supported only progressive downloads, QuickTime 4 and later added real-time streaming support. QuickTime 6 (the current version) introduced MPEG-4, which offers high-quality Web-based streaming video (an exciting development that's sure to be followed by the other two companies).

QuickTime actually refers to an entire family of multimedia file types. With a wide range of codecs, the QuickTime architecture supports applications as diverse as digital video, virtual reality, music, and, of course, streaming.

To create your video, you must own a video editor that supports real-time streaming output. iMovie is just one of many video editors that can produce compliant streaming Quick-Time files.

RealSystem

Developed by RealNetworks (`www.real.com`), RealSystem offers a real-time streaming media architecture. The Real standard was designed specifically for online purposes. A RealSystem media file is small and targeted at quick Internet transmission. Real media files are not meant to be edited or compressed any further after encoding. This keeps your Real files lean and mean.

The Real standard, currently version 9, supports SMIL (Synchronized Multimedia Integration Language). This is truly one of Real's nicest features. It allows you to fully integrate your video within a Web page, offering buttons, background pictures, hyperlinks, and so forth. The other outstanding RealSystem element is called SureStream. This feature allows you to create separate tracks within the same file for the most common user connections, such as 28.8Kbps modem, 56Kbps modem, and broadband.

In 2002, RealNetworks developers redesigned their core encoding and delivery technology, renaming their production tools from RealProducer to HelixProducer. The new Helix

technology offers encoding from a larger set of file types and hardware, as well as more reliable and robust broadcast methods for your videos. You can now encode directly from most digital video cameras. RealNetworks claims a 30 percent improvement in video quality for the same bit rate with the new Helix tools. A free Windows-only encoder, called Helix-Producer Basic, is available.

Unfortunately, RealNetworks dropped support for its Macintosh-based RealProducer, without replacing it with a Mac version of HelixProducer. However, the company intends to release an open-source software development kit (SDK) and allow Mac enthusiasts to build their own tools.

Windows Media

Microsoft's Windows Media (`www.microsoft.com/windows/windowsmedia`) provides a real-time streaming architecture for multimedia delivery. Like RealSystem's SureStream, Windows Media's Intelligent Streaming offers scalable bandwidth. Intelligent Streaming allows you to create a single file with separate tracks for common connections.

To create a Windows Media file, you can use the free Windows Media encoder (PC only).

> While working with Windows streaming media, you may run across either Windows Media Format (WMF) or Advanced Streaming Format (ASF) files. ASF files are designed as containers for WMF media. The Windows Media Player supports both formats.

Streaming Video Considerations

Streaming works best when you shoot your videos with the intent to stream. Several factors distinguish streaming video from normal movie production. It helps to keep these factors in mind when you plan your video, before you begin to shoot your scenes. By knowing which features enhance and enable good streaming quality, you'll be better able to compress your movie and create a higher-quality production.

Remember that bandwidth is the single most important factor in streaming. The quality of your final movie depends highly on how much visual data you can stream per second. Both connection speed and image size determine this quality. When you plan to stream to modem and broadband connections, you must understand that you're going to deal with low bandwidth and small images. You can, however, optimize your pictures for low bandwidth and small images if you keep the following considerations in mind:

Emphasize sound When you must sacrifice image quality for bandwidth, you can make it up, in part, by providing clear and helpful sound. Keep your sound quality high and relevant.

Keep things simple Put one thing on the screen at a time. Never use complex images when working with small pictures. Place your focus on a single item.

Emphasize a face People make the best subjects for streaming video. The human mind is so expert at understanding and making guesses about faces that even low-quality images can provide satisfying viewing. Don't be shy. Get up close with your camera and fill your picture with a face.

Keep it plain Dress your subjects and your set in very plain, solid colors. The more patterns you include in your video, the harder your compressor must work to create a small image. Increase quality by decreasing patterns.

Avoid text Text looks absolutely awful in streaming video. When possible, avoid it entirely. Instead, use voice-overs and helpful commentary. If you absolutely must use text, keep it very short and very big. For the most part, however, assume that any text you add to your video will be completely unreadable. Figure 9.1 demonstrates how poorly even crisp, white text on a black background appears. This figure shows a real screenshot from a RealSystem video, created from a high-quality digital video clip. Do not expect your results to be any better.

Use good lighting Good lighting can minimize ambient visual noise—random, unwanted pixels—and provide better compression. Remember, noise hurts compression. Your goal involves creating a small movie with minimal noise and the best detail possible. Good lighting can help that.

Figure 9.1

Text proves to be particularly problematic when compressing video for streaming. If possible, avoid or minimize text use. Expect the text you do use to degrade significantly in the final product.

Create Streaming Video

Streaming video is easy to create. You upload a streaming movie in the same way that you would upload a picture or Web page. Software, stored on your server's site, will stream your movie, creating a real-time presentation of your video.

Here are the simple steps you follow to create your own streaming movies:

1. Create your movies in your favorite editor.

2. Either export the movies directly to streaming format or use software to convert to the correct format.

3. Upload to the World Wide Web.

Chances are that your video-editing program can create streaming output for you. The big issue is not, generally, *how* to create streaming files but *which* streaming files to create.

Pick a Format and Creation Tool

Find out which formats your streaming host supports and choose one. Each format has certain advantages. Real is quick, small, and well distributed. QuickTime offers good-looking results. Windows Media is widely supported by hosting sites. Determine the format you'll use and proceed from there. Table 9.1 provides a summary of some of the tools you can use for each streaming format.

MEDIA	COMMON TOOLS	
Real	HelixProducer/RealProducer, Ulead VideoStudio, Sonic Foundry Vegas Video, Discreet Cleaner	Table 9.1
Windows Media	Windows Media Encoder, Ulead VideoStudio, Sonic Foundry Vegas Video, Discreet Cleaner	**Streaming Formats and Creation Tools**
QuickTime	QuickTime Pro, iMovie, Discreet Cleaner	

Once you know which format you need to produce, evaluate your tools. Your video-editing program may already support that format. Sonic Foundry Vegas Video (`www.sonicfoundry .com/products/home.asp`) and Ulead VideoStudio (`www.ulead.com`), for example, will create both Real and Windows Media files. (VideoStudio is on the CD that accompanies this book and covered in Chapter 7, "VideoStudio Skills.") iMovie (`www.apple.com/imovie`) and QuickTime Pro (`www.apple.com/quicktime`) make creating QuickTime streams a snap. (Using iMovie is covered in Chapter 6, "iMovie Simplified.")

But suppose that you're using iMovie and wish to create a RealSystem file. What do you do? With the new Windows-only HelixProducer replacing older products, you'll need to hunt around for a free copy of RealProducer Basic to convert your video as needed. You may still be able to purchase RealProducer Plus for Macintosh (`www.realnetworks.com/products/ producer/producer85.html`), a $200 investment. Alternatively, you can investigate the superior but expensive Discreet Cleaner (`www.discreet.com`). It costs about $600, but if you can afford it, this product can totally transform your streaming life. If you produce streaming content on a regular basis—for education, small business, or another function—Discreet Cleaner is a tool you cannot live without.

> With RealNetwork's release of a Helix Software Development Kit, expect third-party free or inexpensive encoding tools for Macintosh OS X to arrive in 2003.

Discreet Cleaner offers a single package that integrates every part of streaming creation. It allows you to choose and preview your encoding settings and optimize your source as you compress. With Cleaner, you can enhance your image contrast and brightness, remove audio background noise, and add video watermarking (like that logo you see at the bottom corner of the screen during many TV shows). And that's just a subset of the features available. Although not for the casual user, Cleaner can certainly streamline and enhance your streaming production. Figure 9.2 shows about a dozen QuickTime movies ready to be batch converted to RealSystem format. This summary page

Figure 9.2

Discreet Cleaner offers the definitive format-conversion and video-preparation tool for Windows and Macintosh users.

describing the enhancements about to happen includes resizing, noise reduction, and increased contrast. If this looks complicated, fear not. Cleaner provides a friendly, interactive wizard that walks you through each step of the process.

Streaming Tips

No matter which tool you use, there are a number of streaming issues to consider, particularly for creating videos for low-bandwidth connections. Think about these before starting the compression process. You probably will be prompted by your software to answer questions related to these matters.

Video/audio importance Determine in advance which feature—audio or video—is more important to you and set a relative weight to that importance. You may wish to maximize audio quality at the expense of video or vice versa.

Speech or music Decide whether to optimize your streaming media for speech or for music. Each has different properties, and your compressor may need to make trade-offs when producing your output.

Image quality Place a value on the quality of the image in your video. Streams can optimize image excellence (generally at the cost of frame rate), allowing you to offer better pictures. This proves important when, for example, you want to show off a product or sell a house. Create some test footage before you commit to a full production. Compress it, play it back, and determine what quality you really need.

Image size Determine how small you can let your video play back and how big it must be. Image size greatly affects bandwidth, so be willing to make adjustments.

Motion quality When dealing with moving objects or people, you may want to emphasize smooth motion within your video. This is especially important for subjects such as sporting events, plays, and so forth.

Find a Streaming Host Site

On the Internet, video can be a tough product to turn into a profit. Advertising revenue models have gone the way of the dinosaurs. And there aren't obvious secondary products that can provide steady revenue. Many streaming sites continue to appear on the scene and just as soon disappear.

Video streaming requires investment in storage, computers, and bandwidth, not to mention personnel and the simple cost of doing business. In response to these demands, some streaming video providers have pulled away from consumer solutions, focusing instead on providing streaming services for businesses.

A year or two ago, there were numerous approaches to finding sites to host your streaming videos, but most of these solutions failed and the host sites went out of business. Here are the remaining options:

ISPs Check with your Internet service provider (ISP) to see whether it offers video streaming and streaming with your current account. Many ISPs do, and some charge only a small additional monthly fee.

Commercial streaming services Many streaming providers, notably Spotlife (`www.spotlife.com`) and Playstream (`www.playstream.com`), have made their services available to consumers as well as to businesses. For reasonably low fees, consumers can access the same powerful servers that businesses do. On the plus side, these providers have solid business models. On the negative side, some of these companies expect a certain level of customer sophistication with regard to technical matters.

Product tie-ins Some manufacturers continue to bundle streaming solutions with their products, although this approach seems to be failing rapidly. Buy a Web cam, video-editing software, or a FireWire card, and you may find yourself entitled to a free basic video account on a branded site. You can, in theory, upgrade to a more powerful account, buying bandwidth or disk space as needed. Sites provide bandwidth-on-demand for special occasions such as stockholder meetings, commencement exercises, baby's first birthday, and so on. Your fees relate to the number of viewers expected for any broadcast. On the whole, with this business model quickly disappearing, you're probably better off going to a nonbranded commercial streaming site to get started.

> The basic problem I find with the product tie-in approach is that neither the product manufacturer whose name is used nor the backbone video provider has dedicated itself to providing consumer support—at least for video. The manufacturer is busy building and supporting its product. The provider spends its time providing smooth and dependable service, not customer handholding.

Free hosting There aren't a lot of them out there, but some sites continue to allow you to share your videos for free. Chief among these is SingleReel (`www.singlereel.com`), which went out of business and was resurrected in 2002. Expect free hosting sites to place restrictions on the material you may store, and be sure to read the user agreements carefully. Make sure you continue to own your own digital material after publishing it on free sites.

Streaming provider companies are striving to make video upload and streaming easier and more consumer-friendly. Here are a few things to expect from your streaming site:

- Consumers must feel comfortable paying for this extra service, preferably in monthly fees.

- The solution provider must be able to collect these fees in an organized and familiar way.

- The solution provider must provide a strong customer-support infrastructure.

To look for a hosting site, use your favorite Internet search engine, such as Google (`www.google.com`). Enter "video hosting streaming," and you'll find hundreds, if not thousands, of results. When hunting for a provider, make sure to do some research on the reputation and history of the companies you're considering.

In This Chapter...

This chapter discussed the technology and implementations that drive streaming video. Here are a few key points to think about:

- Streaming video provides a great compromise between quality and bandwidth. When you stream your videos, you allow more people to view your work. Even those people with dial-up modem connections can connect to and watch your videos in a reasonable amount of time.

- Streaming is not for sharing high-quality video. Instead, it's a way to deliver video quickly and effectively. If you want to produce superior-looking results, consider burning your movies to disc or DVD instead.

- There's no "best" choice when it comes to the three major players in streaming. Whether you use Real, Windows Media, or QuickTime, you're probably going to succeed in getting your video out there and seen. Use the solution that's most convenient.

Export Your Movies to TV, Tape, and More

When you're ready to share your video work with others, consider using traditional media. VHS tapes provide the easiest way to share your videos. VCRs are ubiquitous, making playback easy, and blank tapes are inexpensive (about $1 each). By transferring your movie to videotape, you'll be able to distribute your work to a wide audience. You can easily record your movies on VHS tapes in a several ways. In this chapter, you'll learn about a few approaches. One of these should work for you with the equipment and budget you have available.

In addition to the VCR approach, devices employing several new recordable technologies have just hit the market, expanding the way you can export your movies to TV. These stand-alone, set-top units work just like VCRs, but they record to alternative media such as VCDs and DVDs. This chapter provides a short introduction to these new recording devices.

This chapter covers the following topics:

- **Export via the camera**
- **Export via a converter box**
- **Record via a video card's TV-out port**
- **Save to alternative media**
- **PAL versus NTSC video format**

Export through Your Camera

One way to transfer edited movies to your TV involves using your camera as an intermediate storage device. Most digital video cameras allow you to export your finished video from your computer back to the camera through an IEEE 1394 connection. Once the movie resides on your camera, you can play it back directly to a TV or VCR. This method produces high-quality output. Your video will appear crisp and clear on your TV.

> Some cameras allow you to play through directly, without needing to first save your video to tape. Consult your manual for details to see if it supports this kind of playback mode.

Here are the steps for exporting your video to your camera and then recording it on a VHS tape in your VCR. By starting with Step 5, you can also use this method to transfer unedited footage from your camera to a VCR or other recording device:

1. Connect your computer to your digital camera with a 1394 cable. Make sure to use the correct cable type. Insert the plugs gently but firmly in each socket, without forcing them.

2. Power on your camera and set it to the mode recommended in the user manual, so it can capture video from the computer.

3. Export your movie from your video editor to the camera. Consult your software and camera manuals for specific details on how to do this. Your software will automatically control the camera through the 1394 interface, handling all record and stop commands as needed.

4. Disconnect the 1394 cable and put it away.

5. Rewind the tape so that your camera is cued to the start of your movie.

6. Connect your VCR and camera using the audio/video output cables that shipped with your camera.

7. Place a fresh tape in your VCR and set the VCR to the appropriate record mode. Most VCRs support both short play (SP, also called standard play) and extended play (EP, also called Super Long Play, or SLP). The former provides higher-quality playback but for a shorter recording duration. Since this shorter duration generally lasts a full 2 hours, you should select short play for your video transfers.

8. Press Record on the VCR. Let the VCR record a few seconds before proceeding.

9. Begin playback on your camera.

10. Wait for your movie to play, as the VCR records.

11. When the movie finishes, press the Stop buttons on both your camera and VCR. The order does not really matter, unless you plan to add more movies to your videotape. In that case, press the Pause or Stop button on the VCR, and prepare your camera to play back the next movie.

VCR RECORDING SPEEDS

Standard VCRs provide a number of recording speeds. These include the following:

SP Short Play/Standard Play gives the best quality recording speed available. This speed uses the most tape but with the best results in terms of preserving video and audio fidelity to the original.

LP Long Play offers good quality recording with slightly more noise and less clarity than SP.

EP/SLP Extended Play/Super Long Play provides the longest recording possible for your tape, but at a cost of video quality. Because this mode compresses the video the most, your video signal will degrade noticeably and your playback will not appear as crisp or clear as with the other standards.

After following these steps, you will have transferred your movie to the video camera and then copied it to your VCR.

Export through a Converter Box

Converter boxes, which cost about $200 and up, provide the same high-quality output that you get by exporting to or through your camera. A converter box digitizes analog video for importing into your computer, and converts digital video transmitted from the computer using an IEEE-1394 connection to analog, for use with your TV or VCR. These units make importing from and exporting to analog video so easy that their use becomes second nature (making it easy to forget how wide the gulf between analog and digital video production used to be). With a converter box, your VCR, TV, and personal TV recorders (such as TiVo and ReplayTV units) become direct accessories to your computer.

There are a number of excellent converter boxes on the market. Some popular ones are produced by ForMac (www.formac.com), Sony (www.sony.com), and Canopus (www.canopus.com). As mentioned in Chapter 4, "Transfer Video to Your Computer," two popular boxes are Dazzle Hollywood DV-Bridge (www.dazzle.com) and Miglia Director's Cut (www.miglia.com). Figure 10.1 shows a Director's Cut model. Here are some of its helpful features:

- Its flat geometry makes it very stable when you lay it down on a table.
- It offers NTSC/PAL output, headphone jacks, and double video-output jacks (two each of S-Video and RCA).
- It derives its power from the 1394 connection, so there's no need to plug it in. That means that you have only one series of wires to worry about.

Figure 10.1

A converter box, attached to your computer using an IEEE-1394 connection, allows you to import video from analog sources to your computer and export video to analog media.

I've had good success with both the Dazzle Hollywood DV-Bridge and Miglia Director's Cut (www.miglia.com). For general use, I prefer the Director's Cut. My early-model (called Take 1) is not particularly pretty—it's an industrial-looking metallic box (illustrated back in Chapter 1)— but it works like a charm. Newer Miglia Take 2 units are much better looking (as you can see in Figure 10.1).

Here are the steps for exporting your video through a converter box:

1. Connect your computer to your converter box with a 1394 cable. Make sure to use the correct cable type. Insert the plugs gently but firmly in each socket, without forcing them.

2. Power on your converter.

3. Connect your converter box to your TV. For video, you can use either S-Video or RCA connections. S-Video transmits higher-quality video. Either way, you must use the white and red RCA connectors for audio.

4. Connect your VCR and camera with the audio/video output cables that shipped with your camera.

5. Place a fresh tape in your VCR and set the VCR to the appropriate record mode. Most VCRs support both short play (SP) and extended play (EP). The former provides higher-quality playback but for a shorter recording duration (usually up to 2 hours). You should select short play for your video transfers.

6. Press Record on the VCR.

7. Export your movie from your video editor to the converter box. Consult your software and converter manuals for specific details on how to do this.

8. Wait for your movie to play, as the VCR records.

9. When the movie finishes, press the Stop button on your VCR, or if you plan to add more movies to the videotape, press the Pause button.

These steps take advantage of your converter box, allowing you to send an analog signal of your video from your computer to your VCR.

Record Using TV-Out

Many newer video cards include TV-out ports. These cards allow you to use a TV as your monitor or hook up a VCR, and then record your screen. This lets you play back movies and record them without needing to use a 1394 connection. Your video card will create a TV signal, making adjustments for screen size as needed.

Video cards with TV-out ports cost about $30 or more. Stop by About.com's peripherals page (`http://peripherals.about.com`) for a good list of video-card vendors.

This simple output method will not give you the high-quality video of digital transfer. TV-out cards generally produce signals at low resolution, with somewhat iffy color-quality because of the mirroring technology. Colors will not appear as sharp and true as they will on your monitor. On the other hand, you can create your videos at a very low cost. Also, you can produce videos from non-DV-25 standard files, including AVI, ASF, and QuickTime files. For many people, sharing is what video is ultimately about, and a TV-out connection may prove to be exactly what you're looking for.

Here are the steps for using a TV-out port to record your video:

1. Connect your VCR to your TV-out port. You may use any cables supported by both your VCR and video card—coaxial cable, RCA plugs, or S-Video. The connection type varies by model. With S-Video connections, make sure to use the white and red RCA connectors for audio. S-Video does not transmit audio on its own.

2. Place a fresh tape in your VCR and set the VCR to the appropriate record mode. Most VCRs support both short play (SP) and extended play (EP). The former provides higher-quality playback but for a shorter recording duration (up to 2 hours). You should select short play for your video transfers.

3. Load your movie into your player software.

4. Before proceeding, test your playback. Most players—including the Windows Media Player, QuickTime, and nearly every video editor—allow you to play back in full-screen mode. Make sure that you know how to start full-screen playback.

If you're not careful, you may accidentally record computer artifacts, such as menus and your cursor. When you record too early, you'll capture screenshots before the playback. Instead, start recording just as full-screen playback begins.

5. Press Record on the VCR.

6. Begin playback (preferably full screen) on your computer.

7. Wait for your movie to play, as the VCR records.

8. When the movie finishes, press the Stop button on your VCR, or if you plan to add more movies to the videotape, press the Pause button.

After following these steps, you will have created an analog signal that mirrors your computer screen and captured that signal to your VCR.

In theory, you can mirror to a TV by hooking a USB-based video-out device to your computer. These devices are, however, notoriously slow and not recommended. A USB wire cannot transmit sufficient bandwidth to create good-quality video. With their higher bandwidth capacity, USB-2 devices offer far more promise.

Save to Alternative Media

Newly arrived on the market, set-top disc recording units allow you to copy your videos from computer to discs—VCDs (video compact discs, described in Chapter 3, "Video Tech Talk") or DVDs—as easily as you can copy them to VHS tape. Units are known, somewhat confusingly, as personal video recorders (PVRs) or digital video recorders (DVRs), although these same acronyms also refer to hard-drive-only solutions such as TiVo and ReplayTV.

These systems work in a similar manner to how VCRs operate. You insert a disc and press Record. The unit copies incoming video to the disc until you press Stop. Although some very pricey disc recorders accept IEEE-1394 connections, for the most part, they are designed to work with an analog signal—just like VCRs. The manufacturers have designed these recorders to function with standard analog TV signals and with VCRs.

There are, however, a few key points to keep in mind about the differences between VCRs and disc recorders:

Disc recorders use MPEG Whenever a recording device uses any sort of compression scheme, you must keep quality in mind. All the artifacts and errors associated with general MPEG compression prove relevant to disc recorders as well. The more video you need to record to a disc, the less space there is available for high-quality images. If you record 4 or 6 hours to a standard 4.7 gigabyte DVD recordable disc, the video will appear blocky and of poor quality. If you record just 1 or 2 hours instead, your video will be much better looking. This is similar to how recording videotape in short play mode, rather than extended play mode, provides higher-quality playback for a shorter recording duration.

Discs need to be finalized Unlike VHS tapes, which you can rewind and watch immediately, videos on disc must be finalized before watching. This process often takes between 2 and 4 minutes and prepares your disc for playback. This means that you cannot record any further information to the disc, even if you have not used the entire space available. For non-rewritable media (such as DVD+R, DVD-R, or CD-R), that's the end of the story for that disc; you cannot add more video to it. If you're using rewritable media (DVD+RW, DVD-RW, or CD-RW), you can add new material after you reinitialize (and erase) the disc. (For more

information more about the differences between the DVD+R/W and DVD-R/W standards, see Chapter 8, "Burn Your Movies to DVD and VCD.")

> If you're working with a disc recorder that uses DVD-RAM, you can add, delete, or change video at will. However, DVD-RAM does not play back in standard DVD players.

Pressing Record may involve slight delays Many disc recorders involve a several-seconds delay before starting to record. While this happens on VCRs as well, the delays on the disc recorders are more pronounced. If you use one of the current-generation recorders, you may want to wait 5 or 10 seconds before starting your digital video playback.

Disc recorders use analog signals Although some very pricey disc recorders accept IEEE-1394 connections, for the most part they are designed to work with an analog signal—just like a VCR. The manufacturers have designed these recorders to function with standard analog TV signals and with VCRs.

Recordable discs are not universally playable As discussed in Chapter 8, video on disc cannot be played back universally in all set-top DVD players. You can find compatibility information for your particular unit at `www.vcdhelp.com/dvdplayers`.

DVD Recorders

For about $500 and up, you can purchase a stand-alone DVD recorder from most major retail outlets. Manufacturers include Pioneer (`www.pioneerelectronics.com`), Panasonic (`www.panasonic.com`), and Philips (`www.philips.com`). These recorders are marketed primarily to the TV consumer market, not to the digital video or computer hobbyist. As you can see in Figure 10.2, these recorders look very much like standard DVD players.

To record your video to DVD, follow these steps:

1. Connect your computer or camera's output to the DVD recorder's input. Refer to the earlier sections in this chapter for details on preparing your equipment to export through your camera, through a converter box, or through a TV-out port.

2. Power on your DVD recorder.

3. Insert a fresh, recordable DVD blank into your recorder and wait for the unit to acknowledge the presence of the fresh media.

Figure 10.2

The Panasonic DMR-E30S DVD recorder looks like a standard DVD player, but it allows you to record as well as play back DVDs.

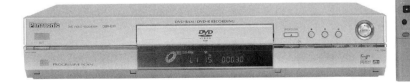

4. Select the recording speed. This will vary by manufacturer. Many recorders retain the VCR standards of short play (SP, 1 to 2 hours), long play (LP, 2 to 3 hours), and extended play (EP, 6 hours), but details are specific to each unit. Check your manufacturer-supplied user manual.

5. Queue but do not start your movie on the computer or camera.

6. Press the Record button on your DVD recorder and wait a second or so for the unit to catch up and begin recording.

7. Start the playback of your movie on your computer or camera.

8. Wait for the movie to play through completely.

9. Press the Stop button on your DVD recorder. It may take a second or two for the machine to finish recording after you press the button.

10. Stop playback of your movie on your computer or camera. Power off your camera if you wish to save batteries.

11. Depending on the make and model of your DVD recorder, you may be able to add further video segments to your DVD by repeating Steps 5 through 10. Keep in mind the maximum storage allowed by the disc size and by the recording speed you chose in Step 4.

12. When you're finished adding video to your DVD disc, follow the instructions provided by the manufacturer to finalize your disc.

After following the above instructions, you will have recorded a copy of your video from your computer or video camera to a recordable DVD disc. Once finalized, you should be able to play back your disc on your computer's DVD drive and in a large number of stand-alone set-top DVD players.

VCD Recorders

Stand-alone VCD recorders allow you to save video to standard CD blanks, in the same way that DVD recorders save to DVD. Although these units cost slightly less than DVD recorders, the price gap has narrowed considerably over the past year. You can occasionally find discount units at substantial reductions, but the manufacturer-suggested retail prices remain high.

It's likely that DVD recorders will displace these older VCD units over the next year or two. (Interestingly enough, vcdhelp.com, the center of the do-it-yourself VCD world, closed its stand-alone VCD recorder section shortly before the publication of this book.) However, VCD recorders are still available and being used by significant numbers of people. Figure 10.3 shows an example of a VCD recorder.

As you might expect, recorded VCD quality lags far behind that of recorded DVD. The VCD standard uses MPEG-1, with its low fixed bitrate and small image size. On the upside, blank CDs cost

Figure 10.3

The Terapin CD Video Recorder provides an easy way to record movies to CD blanks.

less than DVDs, and they play back on many recent DVD players. In the fall of 2002, however, several DVD manufacturers (notably Apex, `www.apexdigitalinc.com`) announced that they would be dropping VCD playback support from their set-top DVD units.

> While preparing this book, I was able to test the Terapin CD Video Recorder (`www.terapin-tech.com`) and was pleasantly surprised at the quality of the videos it produced. Although the results were clearly VCD and not DVD, they regularly matched and occasionally exceeded the level produced by the methods described in Chapter 8.

Like DVD recorders, recording VCD units work much like VCRs. You just insert your disc, hook up your video, and press Record to start the process.

PAL Format versus NTSC Format

When you're making your videotapes, don't forget about the different TV standards. As explained in Chapter 3, different country systems define video standards for TV signals used around the world. The NTSC standard is used throughout the Western Hemisphere and wherever U.S. influence has been strong, such as in South Korea and Taiwan. PAL is the video standard for TV signals used in Western Europe, Australia, Japan, and many other countries that do not specifically support the NTSC standard. France uses a PAL derivative called SECAM.

Video Format Conversion

Even though PAL and NTSC VCRs use identical types of tapes, they employ two separate standards for playback on very different types of TVs. They differ remarkably in terms of screen size and frame rate. Sending an unconverted NTSC tape to a friend in a PAL country generally proves fruitless.

A number of video-conversion services exist. For about $15 (or more) plus postage, a mail-order service will convert your video from PAL to NTSC or NTSC to PAL. It's easy to find these services. Just pop over to your favorite search engine and look for "NTSC PAL conversion." Dozens, if not hundreds, of services will pop up.

> I generally prefer to use a local service bureau to perform this conversion. I hate sending precious videos in the mail to people I do not know, hoping that they will convert and return the tapes to me in a reasonable amount of time.

Multistandard VCRs

If you're a foreign movie buff or have friends and family overseas, you may want to invest in a multistandard VCR. For about $300 and up (prices vary a lot), you can purchase a VCR that reads multiple standards, including NTSC, PAL, and SECAM.

Some multistandard VCRs produce the output format you select (typically PAL or NTSC), so you don't need to buy a multistandard TV. If the VCR's packaging or advertising says "Worldwide Video," the VCR can play back either NTSC or PAL format on any TV. Otherwise, the VCR may play PAL and NTSC tapes, but only on PAL and NTSC TVs, respectively.

You can find dozens of online stores that sell these players. Go to your favorite search engine and look up "multistandard VCR." Take care though. Many of these shops operate overseas, where consumer protections are virtually nonexistent. Others inhabit a rather gray-market part of the consumer-goods industry. Many people purchase these machines to bypass copy protection and create illegal copies.

As an example of a multistandard VCR purchase, my friend bought her Samsung SV-5000W (www.samsung.com) model for $450, although she has since found better prices elsewhere. She needed to work hard on her purchase, making follow-up calls and threatening to involve her credit card company. She sent a final e-mail stating that she would cancel her order if she did not receive shipping confirmation by 5 p.m. Eastern Standard Time the next day. (She strongly recommends being quite specific when issuing threats.) The vendor was located in Illinois, so she did have some bargaining power. The order miraculously shipped the next day, and she is quite pleased with her multistandard VCR.

In This Chapter…

This chapter focused on ways you can export your video from your computer to more convenient media. Here are some thoughts to take away with you:

- VHS tapes are practically universal. You'll find VCRs in more homes than you will DVD players. High-tech is all well and good, but a VHS tape is easily shared.

- To export your digital movie to VHS, you'll need to figure out a way to convert the digital video into an analog signal that your VCR can understand. The easiest way to accomplish this is to use your digital video camera as an intermediary. Converter boxes and TV-out ports offer reasonably convenient alternatives.

- DVD player prices continue to drop. Their introduction into homes around the world is accelerating. Within a few years, DVDs may replace VHS tapes as the sharing medium of choice. If you have friends or business contacts who are already DVD-ready, and you have a few bucks to splurge on a set-top recorder, consider distributing your videos on DVD-recordable media.

- Always keep country-specific standards in mind. If you want to send videos to another country, make sure your recipients use the same TV standard that you do. And if they do not, convert your videos before sending them. Nothing is more annoying than receiving a video that you cannot play and must be converted before you can watch it. When you take the time to do the conversion on the sending end, your recipient will be able to enjoy your movie right away.

Digital Video Fun

With digital video, the fun shouldn't stop after you shout, "Cut!" Today's video-editing suites offer unlimited possibilities. You can introduce some fabulous special effects and add a dash of movie magic to your work.

This chapter is packed with ideas for projects that go beyond the ordinary. These video projects do not involve high art or intense meaningful narrative. Instead, they offer a way for you to goof off and enjoy your video equipment a little. You'll have some fun practicing the basic shooting and editing techniques that you've learned in earlier chapters. In addition, you'll be able to involve family and friends so you can hone the more subtle skills involved in directing people.

You don't need special equipment or software to create these little videos; any video camera and video-editing software will do the job. Each project includes a basic description, a list of shots, and general instructions on how to achieve the effect described. And along with reading about the video projects, you can also watch them. You'll find versions of them on the CD–ROM accompanying this book.

This chapter covers the following topics:

- Make people "appear" and "disappear" (thanks to a little splicing)
- Cross-dissolve between shots
- Stop-motion and other animation
- Reverse video
- Work with zoom and rack focus
- Add sound effects

Stage a Disappearing Act

Have you ever wished someone would just disappear? Did you watch Samantha blink Darren away in "Bewitched" and wonder if you could do the same? You're in luck! The power to zap a person to another dimension lies now in your hands.

Translocation proves to be one of the simplest of all special effects to create with your video-editing software. First, shoot your scene with the subject in place. Next, shoot some more footage after your subject leaves the shot. Splice the footage together in your favorite video editor, and you're set. Your subject magically disappears.

You need a fixed camera and an unchanging backdrop to set up this scene. You cannot create this effect without a tripod. The challenge is to maintain the same features in the before and after shots. Only your subject will move, and he or she will do so carefully, so as not to disturb the scene. You don't want to change anything—the lighting, the position of the props, or any other elements. Avoid windows, corridors, or any other surroundings that may introduce change. After all, a cloud may pass by in a window, or a co-worker might walk down a hallway. Steer clear of these hazards to ensure a smooth visual transition.

Once you've found a good location and are ready to shoot, follow these steps to record your footage:

1. Create your set and place your subject.

2. Work through the beginning sequence until the "disappearance." When you're working with a single subject, direct the person to leave the set without disturbance. If you're working with multiple subjects, cue them to freeze in place while the primary subject leaves.

3. If applicable, cue the remaining subjects to continue their sequence, perhaps incorporating surprise at the disappearance. Otherwise, simply shoot footage of the empty set.

Once you have the footage, you're ready to edit it for the disappearance. Connect your camera to your computer and import the footage. Carefully splice together the "before" and "after" shots. Edit out voice cues, shots of the subject sneaking away, or any other bits that might give away the trick. Figure 11.1 shows an example. Play back the footage to ensure that you've achieved a smooth transition. You'll find that it's pretty easy to stage a disappearance.

Figure 11.1

Edit out the middle footage where the person leaves the scene, and your subject will seem to "disappear."

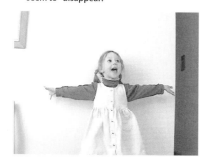

Figure 11.2

Cut between scenes with an empty box and a toy in the box to create a magic trick effect.

You can adapt the "disappearing act" special effect to create different results:

Sudden appearance Instead of having your subject disappear, reverse the effect to have the person arrive instead.

Science fiction Add appropriate out-of-this-world sound effects to introduce a space-age feel.

Magic trick Switch the focus from people to things. Introduce a magician who can summon and dismiss various props.

For example, for a magic show, consider those effects involved in lighting and extinguishing a candle, making a person appear and disappear from a large box, or even summoning a bouquet out of thin air. For this latter effect, ask your subject to maintain his or her position while waving an arm through a set trajectory—first with, and then later without, the bouquet. With luck, you can add the bouquet mid-motion. Of course, you will need a magician who "freezes" well.

No matter which variation you choose, keep the basic principles in mind. These tricks depend on introducing a single sudden change into an otherwise stable, continuous shot. Make sure to limit your transition to the magic taking place. Don't be afraid to reshoot as needed. It may take a few tries until you get everything just right.

The next sections provide specific instructions for a couple of "now you see it… now you don't" projects that you might want to try.

Produce a Magic Show

The "Emma the Magician" video (which you can find on this book's accompanying CD–ROM) demonstrates the simplest of the appearance/disappearance effects. In this sequence, Emma disappears and reappears from in front of a blank wall. Later, a teddy bear appears magically in her box, as shown in Figure 11.2. Because the special effects are so simple, you can easily complete this project with a child.

Plan the Magic Show

This project is straightforward, requiring no special scenery and little in the way of supplies. You can shoot with your subject in front of a plain, blank wall. Your supplies are simply a box and a stuffed animal (or another toy).

Here are the frame sequences in the "Emma the Magician" video:

SEQUENCE 1

1	Title card	Text says "Emma the Magician will disappear."
2	Long shot of child	Child: "Abracadabra!"
3	Long shot of wall	Same as #2, but without subject.
4	Long shot of child	Same as #2. Child: "Ta da!"

SEQUENCE 2

1	Title card	Text says "Emma conjures a bear."
2	Long shot of child	Assistant hands box to child: "Is there anything in the box? Is it empty? Are you sure? Okay! Say 'Abracadabra.'" Child: "Abracadabra!"
3	Long shot of child holding box with bear (or other toy)	Child: "It's Ojo!" (the name of the stuffed animal). Assistant: "Show me." Child takes the animal out of the box.
4	Close-up of child	Child: "Ta da!"

Shoot Your Footage

To create this project, you must use a tripod. A tripod keeps the camera steady and avoids scenery changes from shot to shot. Just set up the camera and shoot. Other than the last close-up, shoot your footage from a comfortable distance. You don't need to change any camera settings between shots.

Make sure to keep the camera rolling. Don't stop the camera as the child leaves and reenters the scene for the first sequence, and while you place the toy in the box for the second sequence. You'll edit the footage later.

The only tricky part while shooting this project involves the appearance of the bear in the box. After the child says "Abracadabra," instruct her to freeze. As long as you pause before speaking, you don't need to worry about your voice intruding on the video. You'll be able to remove these voice-overs in editing. As you place the toy, keep talking to the child, instructing, "Stay still! Stay still!" Once you've backed out of camera range, restart the dialogue by asking, "What's in the box?" The child's response (such as "It's Ojo!") will provide an excellent reentry point for your video.

When possible, use manual focus rather than automatic. This helps avoid automatic refocusing issues if your child happens to step out of the frame. You can see an example of this in the sample video: When Emma reaches down to pick up her bear, she moves out of the frame.

Edit Your Footage

To edit your footage for this project, you'll cut away everything that does not contribute to the story. This includes any footage of the child entering or leaving the scene for the "disappearance/appearance" and any footage of you placing the toy in the box. By removing this material, you introduce the magic. Things will appear to change without cause—even though you know better.

Here are the steps for editing your magic show:

1. Cut away all footage between the first "Abracadabra" and the blank wall. Make sure to leave a small pause after the child speaks, so the transition does not appear too abrupt.

2. Excise any footage where the child reenters the scene and regains her place. Leave any material where the child says "Ta da!"

3. Remove any footage between the second "Abracadabra" and the child responding to "What's in the box?" Leave in any response such as "It's Ojo!" With luck, the box position will not have changed much.

4. Add titles. For example, insert "*Name* the Magician" at the very beginning and place "*Name* Conjures a Bear" after the first effect and before the second.

5. Sound effects help highlight changes. Add pops, clicks, or beeps to accentuate the magic effects. Pick sounds that are short, quiet, and fairly subtle. Don't overdo the sounds, or you risk drawing attention away from your main subject.

6. Add a musical soundtrack to unify the presentation and provide continuity.

Teleport a Friend

The "Teleporting Brad" video (which you can find on this book's accompanying CD–ROM), while nearly identical in staging to "Emma the Magician," demonstrates how to introduce a dissolve technique to provide smoother transitions. Nearly every video-editing program offers dissolve transition effects, allowing you to incrementally blend footage from two clips until one transforms into the other. One shot literally dissolves over the other with increasing transparency, until the first shot is hidden and the second is fully revealed. The most common name for this transition is the *cross-dissolve* effect. Figure 11.3 illustrates this effect.

Plan the Show

As with "Emma the Magician," this project requires no special scenery and few supplies. Your backdrop is a plain, blank wall. A TV remote-control can serve as a high-tech "communications device."

Figure 11.3

Dissolves allow you to add a "teleport" effect to your movies.

Here is the frame sequence in the "Teleporting Brad" video:

1	Title card	Text says "Teleporting Brad"
2	Long shot of subject	Subject: "Beam me up"
3	Long shot	Same as #2, without subject
4	Long shot of subject	Same as #2, with subject, who then walks away

Shoot Your Footage

It's best to shoot this project in one take. Start with your subject in place. Instruct him as follows:

- Look upward to "disappear."

- Wait a few seconds.

- Look back down to "reappear."

- Then walk away.

Continue shooting to capture the background for later editing.

Do encourage your subject to ham it up. The more he does, the better this effect will turn out. (Rumor has it that the best actors for this project come from Canada and have some Shakespearean training.)

Edit Your Footage

To edit your footage for this project, follow these steps:

1. Trim away some "blank wall" footage (the footage where your subject does not appear). Insert this between the "disappear" and "appear" sequences. Depending on your video program, you may need as much as 5 seconds or more of this intermediate footage. The cross-dissolve effect you will use later needs a certain amount of raw video to introduce the visual transition, varying by software package.

2. Remove any remaining excess blank wall footage from the end of the video.

3. Apply your video-editing program's cross-dissolve transition to both the disappearance and the reappearance. (If you are using iMovie or VideoStudio, you can find specific instructions for applying this transition in Chapter 6, "iMovie Simplified," or Chapter 7, "VideoStudio Skills.")

4. Add sound effects to the two transitions. Something mechanical or bell-like works well. (The sample video uses the sound of a vacuum cleaner.)

5. If desired, add a title, such as "Teleporting *Name*," to the start of the video and a musical soundtrack to the background.

With this effect, as with any other that uses a fixed tripod and changing subject matter, carefully control your settings. Try to use manual focus, gain and white balance rather than automatic. If you watch the teleport movie carefully, you'll see that the overall brightness increases slightly when the subject is in place and decreases for the "empty curtain" portion.

Create a Montage

Cross-dissolves do not begin and end with wacky science-fiction effects. They can help you create some pretty effective montages, too. The montage technique involves stringing together a series of related shots. Often, there is no natural flow between those shots. By introducing cross-dissolves, you can move smoothly between one shot and the next, producing a more pleasing montage.

To create this effect, follow these steps:

1. Import your footage into your video-editing program as usual, and lay out your basic sequence.

2. Insert a short cross-dissolve transition between each pair of clips.

3. If desired, add a fade-in and fade-out to the first and last clips in the series. Keep these fades approximately the same length as the dissolves.

Montages help bring diverse footage together in an interesting and coherent manner. Consider using montages as a mainstay for your home video clips. As you can see in the sample montage video (which is on this book's accompanying CD–ROM), cross-dissolve transitions provide a smooth flow to a series of unstaged clips.

Create Animations

Have you ever wanted to dabble in animation, but felt that you lack the skill, patience, or talent? Digital video may offer you an opportunity to explore this neglected part of your artistic side. With digital video, you can create simple but effective animations with relatively little effort. Photograph yourself moving objects around, and then edit out your hands. Consider these ideas:

- A bouquet of flowers arranges itself in a vase for Mother's day, a birthday, or an anniversary.

- Magnetic letters move into position to deliver a special greeting.

- Your latest do-it-yourself project magically assembles itself.

- Your neat and ordered desk senses you coming and immediately transforms into disarray until you leave the scene. Then it cleans itself up again.

If you can see it, touch it, and move it, you can probably use it in an animation. Just manipulate common everyday items in a novel and amusing fashion to create some stunning videos. Here's how:

1. Lay out your objects in their starting position.

2. Attach your video camera to a tripod and set your focus and camera angle. Maintain these settings throughout.

3. Start shooting your video.

4. Make a small change to the objects, and then move yourself and your hands out of the scene. It's vital that you create a "clean" shot without you in it for each change you make.

Pay attention to how much you move items from shot to shot. If you want your motion to appear fluid, at a consistent speed, you'll need to move the items the same distance each time. In the final video, make each shot last the same number of frames.

5. Wait. You'll want a couple of seconds of video between each change. When you edit your video, these intervals will allow you to slow down or speed up your animation, without needing to loop overly short segments.

6. Repeat steps 4 and 5 until you've finished "animating" your scene.

7. Connect your video camera to your computer and transfer the sequence into your editing program.

8. Remove any frames containing your hands, body, and so on.

9. If necessary, trim down your shots to speed up the video.

10. Optionally, add sound cues to the audio track to emphasize particular changes, such as the placement of a flower or magnetic letter.

Avoid shadows! Think about your light sources as you move your hands and body out of the shot, and don't block the light when shooting.

The following projects will give you an idea of how to create animated video.

An Animated Love Letter

This project "animates" magnetic letters to send a special message (as you can see in the "A Special Message" video on this book's accompanying CD–ROM). Most of the work for this project occurs during the editing process. It's an easy way to create a video greeting card. You could also use this project to introduce a live-action, special-occasion video. This might involve your family singing "Happy Birthday" to a loved one or reciting a romantic Valentine's Day poem. Let your imagination soar.

Plan the Animation

All you really need is a refrigerator and magnetic letters spelling out "I LOVE YOU." You can also add a picture of a loved one in a magnetic picture frame.

Here is the frame sequence in the "A Special Message" video:

1	Title card	Text says "A Special Message"
2	Medium shot	Side of refrigerator, with letters in a clump
3	Medium shot	Same as #2, with the letter *I*
4	Medium shot	Same as #2, with the letters *I L*
5	Medium shot	Same as #2, with the letters *I LO*
6	Medium shot	Same as #2, with the letters *I LOV*

7	Medium shot	Same as #2, with the letters *I LOVE*
8	Medium shot	Same as #2, with the letters *I LOVE Y*
9	Medium shot	Same as #2, with the letters *I LOVE YO*
10	Medium shot	Same as #2, with the letters *I LOVE YOU*

Shoot Your Footage

Be sure to shoot this project in one take. Start with all of the letters in a clump. Then one by one, move them into place. Make sure your hand, body, and shadows are out of the shot, and then wait a second or two before moving the next letter into place. Figure 11.4 shows some of the footage.

Don't worry if you make a few mistakes. It's the message that counts. The sample video shows both the edited clip and the original footage used to create it. In the original version, you can see where I dropped the *Y* and where I took the *O* out of turn. As long as the letters show up in order, you'll be fine. Do it over as many times as you need to get it right.

Edit Your Footage

You'll need some patience for the editing part of this project. It can get a bit tedious as you deal with a lot of tiny little clips and sound effects. To edit your footage for this project, follow these steps:

1. After importing your footage onto the computer, cut each shot away from the rest: Create a segment with the letter clump, then with the clump and the letter *I*, then with the letters *I L*, and so on. Make sure to keep about a half second of footage for each time a letter appears.

2. Put all the shots in order.

3. Test to make sure it looks right when animated. If necessary, lengthen or shorten the letter duration to make the video flow better.

4. Add sounds to the appearance of each letter. Pick something simple and short, like a click. In the sample video, you'll hear a dull, metallic sound. Make sure to keep the volume low. Given that it will repeat no fewer than eight times, a loud or unpleasant sound can prove irritating.

Figure 11.4

Add letters one at a time to create an "animated" message.

5. Add a title, such as "A Special Message," to the start of the video.

6. Add a musical soundtrack to the background.

An Animated Conversation

This project demonstrates a variation on video animation. In the "The Conversation" video (which you can find on this book's accompanying CD–ROM), the subjects "talk" and "think" with standard comic-book dialogue bubbles. Each time they speak, a word bubble appears at their mouth. When they think, a thought bubble hovers overhead. You achieve this effect, illustrated in Figure 11.5, by mixing live video with edited stills.

As with the animated magnetic letters project, the key to this video lies in patient editing. While the shooting involves little technique, the editing requires meticulous attention. Also, you'll need to use an image-editing program to create the word and thought bubbles.

Plan the Animation

To produce this effect, you'll need two volunteers and an image-editing program. Any image editor will do. You probably already own one. Check the disks that came with your digital video camera. Many units ship with free image-editing software.

Some popular image editors include Adobe Photoshop Elements (www.adobe.com), Jasc Paint Shop Pro (www.jasc.com), and Lemke Software GraphicConverter (www.lemkesoft.com).

Before you begin, encourage your subjects to brainstorm about the conversation:

- Decide what they're talking about. For the sample video, I let each girl pick a topic. Erin chose the Girl Scouts, and Jamie chose poodles. We mixed these together for the final production.

- Write down a simple script. Keep the phrases short and to the point.

- Be flexible. Since the actual filming may not match your script, prepare to adapt the script *after* taping.

Figure 11.5

Comic-book dialogue bubbles add an animated flair to your videos.

Here is the frame sequence in the "The Conversation" video:

1	Title card	Text says "The Conversation."
2	Long shot of both subjects	Two subjects alternate puffing at each other. Let them puff back and forth two to three times. The last puff should be a "question." After each puff or question, a dialogue bubble appears.
3	Long shot of one subject	One subject thinks for a second, and then puffs a response. After the thought and the puff, dialogue bubbles appear.
4	Long shot of both subjects	The subjects continue puffing at each other to finish the conversation for one or two more rounds. Dialogue bubbles appear for each puff.

Shoot Your Footage

Before you begin to shoot, allow your subjects to practice their conversation. It takes time to learn how to respond without overlapping with the other subject's puffs. In normal conversation, we often overlap each other's utterances. In this project, you must allow a pause between each person's "speech" and "thoughts." Deliberately slow down the pace. Encourage the subjects to be aware of each other and respect each other's timing.

Once you've ironed out the technique, go ahead and shoot. Since this footage runs continuously, without any cutaways, you need flawless runs. Don't let your subjects leave without capturing at least two good takes (record your footage at least twice).

Don't worry about sound. Since this video has no traditional dialogue, you can offer directions in your normal speaking voice. You'll remove this commentary during editing.

Make sure you instruct your subjects to look at each other and *not* at you, especially as you finish taping. Looking at the camera breaks the mood and can confuse the viewer.

Edit Your Footage

This project takes a lot of editing to get it to look right. To make this video, you'll slice apart the conversation, create the dialogue stills, and reinsert them in place.

1. Import your footage into your editor and divide the "conversation" into clips. Move the playhead along your footage until you find the places where the puff or thought occurs.

2. Cut the clips after each puff or thought.

3. After cutting the clips, you should end up with one or two dozen individual clips, depending on how you've structured your discussion. Review these clips for accuracy.

4. Create a still from the last frame of each clip. Save each still to your hard drive. Use sensible names such as "6 – Jamie Puffs" or "10 – Erin Thinks." This will help you to reassemble the video.

5. Import your stills into your favorite image editor and add dialogue and/or thought bubbles.

 - To create a word bubble, draw a white oval and add a triangular pointer to the edge. This indicates who is talking.

- If you can, outline the bubble with a dark circle. In Photoshop Elements, for example, use the Stroke command.

- For thoughts, use a series of circles originating from the thinker.

- Select a large, bold font for your text. Black text on a white background works best.

- Optionally, create a series of stills showing thoughts appearing a little at a time, as shown in Figure 11.6.

You can see the "developing thought" effect in action in the "Animation" section of the sample video (on this book's accompanying CD-ROM). Each animation still lasts half a second.

6. Import the finished pictures back into your video-editing program. You can create a good effect by using 3-second still clips. This amount of time seems about right for simple utterances and thoughts.

7. Place your video and still clips in order. Since you derived the stills directly from the ends of the video clips, they should fit smoothly into the sequence, without jumps or hesitations.

8. Add a title to the beginning of your movie.

9. If desired, you can add a pop or click sound effect before each still. Anticipate the still a bit so the sound introduces the still. Keep the sounds short and soft.

10. Add a musical soundtrack to unify the presentation and provide continuity. In a "silent" feature like this one, a good soundtrack can help move things along.

Shake, Rattle, and Roll—Create Your Own Earthquake

Earthquakes can be fun when you make them yourself. Here are the basic steps:

1. Place your intrepid subject on a movable platform.

2. Start shooting your video.

3. Shake the platform, to simulate an earthquake, as your subject quakes in fear.

4. Add appropriate earthquake sound effects to your footage.

Figure 11.6

Sequentially add circles to animate a "developing thought."

 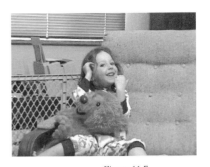

Figure 11.7

An off-screen assistant shakes a chair to simulate an earthquake.

The "Emma's Earthquake" video (which is on this book's accompanying CD–ROM) demonstrates a very simple earthquake sequence. In this project, you seat your subject in a sturdy, balanced, but shakable chair. An assistant moves the chair as you film. Figure 11.7 illustrates this effect.

Plan Your "Natural" Disaster

This project works best with a blank wall behind the subject. Rattling your subject when objects in the background are not moving can prove a bit disconcerting. All you need is a safe and sturdy platform (a chair in this example), an assistant to shake it, and a courageous volunteer.

Here is the frame sequence in the "Emma's Earthquake" video:

1	Title card	Text says "Emma's Earthquake."
2	Long shot of subject in chair	Subject: "Oh no! It's an earthquake!" (Alternatively, for adult subjects, you can ask them to talk as if they were in an interview before being interrupted by the earthquake.)
3	Long shot of subject in chair	Same as #2, with massive shaking. Subject looks terrified.

Shoot Your Footage

This is a one-take project, with almost no editing required. Make sure to follow common-sense rules for safety! Don't take risks. Use a stable platform and be careful.

To shoot, simply aim and focus your video camera, cue your assistant, and prepare to let your subject ham it up. Start with minor shaking and then build up. Vary the tempo of the shaking to make it look more natural. If you want to get clever, hang a picture behind the subject and attach dental floss to it, so you can shake it, too.

If you want, and are willing to take the risk, you can shake your camera a little. Don't shake it a lot, mind you—this is a multi-hundred-dollar piece of equipment!—just enough to add some extra wobbliness to your footage. You'll get more wobble for your effort by moving away from your subject and using your highest telephoto setting. Telephoto proves much more sensitive to small movements, but you'll need to pay more attention to keeping the focus correct. This is one of the few projects where it pays to skip the tripod and use hand-held footage.

The sample video demonstrates the simplest of earthquake effects without any camera shaking. You'll notice that all of the office supplies in the background remain fixed throughout the video—a distraction from the video's supposed story. However, this video was a lot of fun to shoot, especially for Emma, who loved "the ride."

Edit Your Footage

To edit your footage for the project, follow these steps:

1. Find a nice, rumbly earthquake sound. Look around the Internet to find some royalty-free sound clips.

2. Add this sound to your footage, just starting as your "victim" becomes aware of the earthquake.

3. You might want to add small crashing sounds, such as glass breaking. Keep these sounds quiet and subtle. Introduce them to coincide with particularly dramatic moments. In the sample video, notice the "glass" breaks just as the shaking picks up. (You'll probably find that a music soundtrack doesn't work well with the movie, but you can experiment with one.)

4. Trim away any excess footage from before and after the earthquake.

5. Add a title to the start of the video.

Create Time-Reverse Effects

Time-reversed video can create unusual and interesting special effects. It "undoes" what has occurred. Fallen blocks reassemble. A candle unsnuffs. A window pane unbreaks. This effect is really quite simple to add to your videos. Just import your footage onto your computer, trim down your clip, and reverse the clip. We'll work through two examples of this technique here.

Magical Reassembly

Figure 11.8

Reversed footage provides the key to making blocks magically reassemble.

In the "Reverse It!" video (which you can find on this book's accompanying CD–ROM), Jamie knocks down a tower of bricks, and then magically reassembles them using reversed footage.

Plan Your Reversed Video

For this project, you'll need to knock down something that both collapses and reassembles easily. For example, wooden blocks are ideal. Items like stacking cups and cardboard bricks don't work well. Be creative and experiment with various objects. Knock them down a few times. Develop some technique. When you find the right setup, you'll know it.

Keep things simple. While filming this video, I needed to reassemble the blocks about a half dozen times. By choosing an uncomplicated tower, I was able to keep rebuilding without introducing visual discontinuity. Design a configuration that you know you can restore easily.

Keep the scenery as simple as possible. This is particularly helpful if you rebuild your construction in slightly different locations. For the show, you'll need your collapsible item (a tower of blocks in this example), a magic wand (in this case, a wooden spoon from the kitchen), and a volunteer magician.

Here is the frame sequence in the "Reverse It!" video:

1	Title card	Text says "Reverse It!"
2	Medium shot, subject with "wand"	Subject: "I am Jamie the Magician. I will perform a wonderful trick."
3	Close-up of tower	Voice-over: "Behold!" as subject points to tower. Hand enters and leaves cleanly.
4	Long shot of subject and tower	Subject: "I shall knock this tower down!" Subject begins to knock down the tower.
5	Cutaway to close-up of tower, being hit	Continue the audio track from #4 as the tower collapses.
6	Medium shot of subject (tower not shown)	Subject: "And now I will wave my magic wand…"
7	Close-up of subject (tower not shown)	Subject: "Abracadabra, I command you to reassemble."
8	Long shot of subject reassembling tower	Reversed shot of subject knocking down tower.
9	Long shot of subject and tower	Subject: "Ta da!" Applause. (Keep this shot as similar to the previous one as possible.)

Shoot Your Footage

It helps to shoot this footage out of sequence. Later, in the editing process, you'll reorder the shots into the logical sequence from your script. In this example, separate the tower shots from the subject-only shots. And, of course, use good lighting and a tripod.

> Shooting your footage for simplicity rather than trying to maintain the final movie sequence is a good rule of thumb for creating videos. Often, you can simplify the videotaping progress by reordering your shots to create an effective shooting schedule. Then you can edit your footage to put the shots into a logical sequence.

Start with shots 2, 6, and 7, which are two medium shots and a close-up. These shots provide important exposition without any special technique. In them, your subject talks to the camera. Once filmed, you're ready to deal with the tower.

Next, film shot 3. In this close-up shot, the magician's hand points to the tower. In the sample video, I forgot to ask Jamie to say "Behold." We added this later as a voice-over. If you can, ask your subject to speak the line while pointing. Make sure to use a clean entrance and exit while the magician is pointing. Keep this camera angle while shooting shot 5. Rebuild the tower and knock it down again as needed.

Compose a nice long shot for shots 4, 8, and 9, as you film more knockdowns. The trick to shots 8 and 9 is to film them in backward order. Have your subject say "Ta da!" and celebrate *before* knocking the tower down. This keeps the tower in the right position for both shots. As long as your subject keeps in place, not moving, you can swap the later knockdown with the earlier "Ta da." (Observe this in the sample video.)

Edit Your Footage

This project is relatively easy to edit, with two exceptions. First you must reverse clip 8. Second, you'll use clip 4's audio for part of clip 5. Refer to the sample video to see how the cutaway between clips 4 and 5 occurs. See Chapters 6 and 7 for details on extracting and locking audio clips in iMovie and VideoStudio.

Follow these steps to edit your footage:

1. Import your video and trim your clips.

2. Place your clips in order.

3. Reverse clip 8. If necessary, render this effect. This varies by video editor. Some will render the effect automatically; others require you to enter a command. Rendering the reversed clip creates a new clip with all the frames rebuilt in the proper order.

4. Extract the audio from clip 4. This separates the clip 4 audio from the clip 4 video.

5. Lock this audio at the start of clip 4. Now, when you trim the video from clip 4, you won't remove any of the original audio.

6. Remove the second half of clip 4's video, replacing it with clip 5's video.

7. Turn off any video associated with clip 5.

8. Trim clip 5's video to fit. Don't make clip 5 extend past clip 4's audio.

9. If you've done these steps correctly, your video will now cut away from clip 4 to clip 5, while retaining clip 4's soundtrack.

10. Add a title to the start of the video.

11. Add a suitable soundtrack.

You can create similar effects by reversing all sorts of video. The next project shows how you can use the same techniques to have a candle light itself.

Figure 11.9

An extinguished candle appears to relight itself.

A Self-Igniting Candle

A self-igniting candle can introduce a nice special effect, as shown in Figure 11.9. For example, you might consider using this effect when filming a birthday video, a magic show, or a special event like a housewarming. You can see this effect in the "Candle" video on this book's accompanying CD–ROM.

Plan Your Reversed Video

This project requires little planning. Simply blow out a candle and then run the footage backwards.

Pick scenery that adds to your story. For example, for a birthday, use a well laid out birthday table. For a romantic dinner, add roses and wineglasses. The only item you'll need is a lit candle. If you like, you can add a magician and a "magic wand."

Here are the three frames in the "Candle" video sequence:

1	Title card	Text says "Candle"
2	Medium shot, subject with magic wand	Subject: "Abracadabra!" (skip this if you're not doing a magic show)
3	Close-up of candle	Candle ignites itself from smoke to flame

Shoot Your Footage

While shooting this video, be careful of your white balance. It's a good idea to set the white balance with the burning candle. Make sure to use manual video camera settings. Otherwise, when you blow out the candle, the camera will readjust and introduce a dramatic (and unwanted) contrast adjustment as the light from the candle disappears.

Make sure to keep shooting until the last of the smoke disappears. If desired, you can later edit out some of the streaming smoke and start with a nonsmoking candle. In any case, it's better to have the footage on hand and not use it than it is to wish for it later.

Edit Your Footage

Follow these steps to edit your video:

1. Import your video and trim your clips to a reasonable length. It can take a long time for that smoke to disappear. Just keep the length you want.

2. Reverse the candle clip. If needed, render this effect. This varies by video editor. Some will render the clip automatically; others require you to enter a command. Rendering the reversed clip creates a new clip with all the frames rebuilt in the proper order.

3. Place your clips in sequence.

4. Add a title to the start of the video.

5. Add an appropriate soundtrack.

In the sample video, you'll see the self-igniting candle clip is repeated several times to better demonstrate the effect.

Produce Mind Teasers

Your video camera lets you play tricks with people's minds as easily as you play tricks with their eyes. Not all special effects involve special editing techniques. The projects presented here let you produce mind-bending footage with few or no edits required.

A Friend Behind Bars

A brick wall and an oven rack are all it takes to stick a loved one in jail. With just a little planning, you can incarcerate your nearest and dearest. (Just be sure to let them out after filming, okay?) You can see this effect in the "Jail Time!" video on this book's accompanying CD-ROM. Figure 11.10 illustrates the concept.

Plan Your Prison Flick

Keep an eye open for the perfect spot. Cinderblock, bricks, or concrete walls work best for this project. If you can, try to work out a way to hold the oven rack in place without forcing your subject to hold it. As you can see in the sample video, no matter how hard one tries, it's nearly impossible to act "entrapped" and keep the rack steady at the same time. (Although, frankly, Jim deserves an Oscar nomination for this one.)

Here are the three frames in the "Jail Time!" sequence:

1	Title card	Text says "Jail Time."
2	Medium-close shot of subject in "jail"	Subject: "Hey! Let me out of here, huh? What's up? I mean, you put me in jail. You take my car. And I didn't do anything. I was even going the speed limit ..."
3	Zoom out to reveal trick	Subject continues to protest innocence.

Figure 11.10

A few simple props create the illusion of a jail cell.

Shoot Your Footage

While good lighting and a tripod are always important, so is a steady oven rack. Again, try to find a better solution than making your prisoner hold it up.

Make sure to move your victim away from the wall, to provide a sense of depth in the "jail cell." If he is too close to the background, the shot won't look right.

Frame the subject so that his hands and head are well within the center of the rack. Compose your shot so that you hide all of the rack edges. Finally, practice your zoom before you shoot it.

Edit Your Footage

There's not much editing involved here. Just import your video and trim your clips. Add a title, such as "Jail Time," to the start of the video. Finally, add a suitable music track.

Rock Climbing Made Easy

Consider the grit, sweat, and exertion expended while mastering a particularly difficult feat, such as rock climbing. Think of the challenge and the danger. Nothing speaks more to the outdoor enthusiast's heart. If the hills call your friend's name, but he is out-of-shape, middle-aged, and worn out from lifting a beer can, you can still help him achieve his dreams—at least on video.

With a little planning and some clever editing, you can provide proof of your friend's nonexistent mountaineering prowess, as in Figure 11.11. Of course, this also works on your spouse, sister, father, or anyone else willing to play the role of a climber.

Here's the trick: Attach your camera to a tripod so that it looks straight down at the ground and tape your subject as he "climbs" along the ground, shooting from above his back. Back in your digital studio, edit this footage by interspersing real shots of mountains and rock climbers with your subject's valiant efforts. Before you know it, you'll have created a stunning outdoors masterpiece. "The Climb" video on this book's accompanying CD–ROM shows an example of using this technique.

Figure 11.11

"Climb a mountain"
with camera
redirection and an
enthusiastic actor.

Plan Your Outdoor Sporting Video

Pick a natural-looking concrete surface to "climb" on. You'll also need a few real establishing shots of mountains and rock climbers. I shot my mountain and rock climber footage at the marvelous Garden of the Gods Park in Colorado Springs.

Here are the frames in the "The Climb" video sequence:

1	Title card	Text says "The Climb"
2	Long, establishing shot of mountains	
3	Long, establishing shot of rock climber	In background, include some "grunt-overs" to create the mood
4	Medium shot of subject "climbing" the concrete ground	Encourage climber to ham it up with grunts and heavy breathing as he climbs
5	Medium-long shot of rock climber, photographically altered to match your climber	

Shoot Your Footage

Use good daylight to illuminate your shots. You are, after all, shooting an outdoor sporting video.

Attach your camera to the tripod and adjust it so that it points down at the ground. Make sure to fully extend the tripod's legs to the longest settings your tripod will allow. Set the tripod directly over the subject, keeping the extra leg pointing away.

As long as you've got a good actor down there on the ground, shooting should progress smoothly and quickly. Still, be prepared to shoot several takes until you gain that sense of authentic climbing. In the sample video, you'll notice how Jim struggles hard to move up that sidewalk. I've included a "reality" shot at the end of the video to add a little perspective to the exercise.

Edit Your Footage

Follow these steps to edit your video:

1. Import your video and trim your clips.

2. If desired, import your still into Photoshop Elements or some other image editor and alter the photograph to match your subject. In the sample video, I painted over the rock climber's hat, pale pants, and shirt to match Jim's hair and outfit.

3. Add the establishing shots before and after your clip.

4. Add any voice-over grunts to the establishing shots.

5. Add a title to the start of the video.

6. Add an appropriate soundtrack.

> Establishing shots, fake or otherwise, help set the mood or setting for any number of video projects. A restaurant exterior can serve to introduce a dining sketch. A business sign might introduce a public meeting. See Chapter 2, " Compose, Light, and Shoot," for details on establishing shots and an example.

Mirror Tricks

Mirrors offer yet another way to change your perspective. Sometimes it can be fun to pull away from a picture, just to discover that you were looking in a mirror. While not a complicated trick, it can sometimes prove to be a startling one. Figure 11.12 illustrates this idea.

All you need for this project is a room with a mirror somewhere. Here are the frames in the sample "Mirror, Mirror" video (on this book's accompanying CD–ROM):

1	Title card	Text says "Mirror Mirror"
2	Long shot of subject in mirror	No special dialogue
3	Zoom out of mirror	No special dialogue
4	Turn camera to create long shot of subject in real life	No special dialogue

The key to shooting a mirror sequence involves setting your focus correctly. Be sure to adjust for the extra distance that the mirror introduces. The mirror can double the focusing length.

There are no special editing steps for this project. Just import your video and trim your clips. Then you can add a title and music track.

Figure 11.12

Startle your viewers by changing perspective from "reality" to a reflection. To accomplish this effect, pay special attention to focus.

Use Focus Effects

Proper focus is, of course, a major production goal for video production. Did you know that it could also introduce some interesting effects, as well? Here are two standout ways in which focus can play a role in advancing your video's story: rack focus and focus to zoom.

Rack Focus

Rack focus refers to an old technique that still proves fresh for video. In this method, you force your viewer to change attention by shifting focus from one object or subject in a scene to another. It's simple, dramatic, and effective. Figure 11.13 shows an example in which the viewer's eyes are forced from the candle in the foreground to the oranges in the background.

Rack focus depends strictly on setting your objects at different distances so that only one can remain in focus at any time. Here is the sequence I used for the "Rack Focus" sample video (which you can find on this book's accompanying CD–ROM):

1	Title card	Text says "Rack Focus"
2	Medium shot of objects	Focus on first object
3	Medium shot of objects	Focus changes to second object

To keep your objects from occupying the same focus settings, make sure to set them a fair distance apart. Using telephoto or zoom will help. The depth of field for telephoto proves to be far less than for regular or wide-angle shots. There's a drawback, however. When you use a telephoto setting, your camera becomes much more sensitive to small movements. You can see this in the sample video. Keep an eye out for the unsteady camera work as I very gently adjusted the focus wheel.

Focus to Zoom

Another focus technique involves zooming in from an unfocused scene onto an object, fully in focus. As with rack focus, this technique can produce a dramatic transition. Figure 11.14 shows an example.

Figure 11.13

Rack focus directs your viewer from one subject to another by changing focus settings.

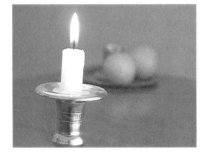 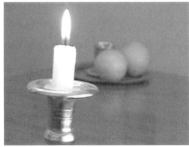 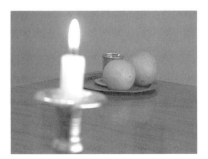

 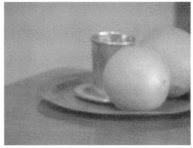 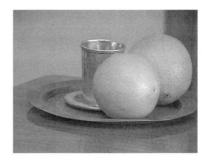

Figure 11.14

A rapid zoom onto a fully focused subject adds a dramatic touch to your video footage.

To create this zoom effect, you must prefocus your camera on the target object before filming your shot. Here is the sequence I used for the "Focus to Zoom" sample video (which you can watch on this book's accompanying CD–ROM):

1	Title card	Text says "Focus to Zoom"
2	Long shot of objects	Out of focus
3	Close-up of objects	In focus on object

Follow these steps to shoot your footage:

1. Set your camera to its furthest telephoto settings.

2. Turn off automatic focus and turn on manual focus.

3. Frame your close-up shot and focus it. Remember to use good composition in your shot.

4. Zoom away to create the long shot.

5. Begin to record your sequence.

6. Pause for a second or two and then start to zoom in. Zoom steadily and in one pass.

7. After you've fully zoomed, you should end up with the in-focus shot you established in step 3.

8. Finish your shot and stop recording.

The sample video includes both incorrect and correct versions. Compare them to better understand why preparation is so integral to this effect.

Use Sound Creatively

Sound can add interest, drama, or comedy. It depends on how you use it. The projects described here use sound to add humor and to create an illusion.

Add Humor with Sounds

Incorrect or inappropriate sounds create some of the silliest moments and lowest humor in videos.

For the sample "Wrong Sounds" video (which you will find on this book's accompanying CD–ROM), I used a hammer, a paper cup, a teakettle, and a happy baby. I also drew from my public domain and/or royalty-free collection of sounds. Here are the frames in the "Wrong Sounds" sequence:

1	Title card	Text says "Wrong Sounds"
2	Title card	Text says "Hammer"
3	Medium shot of hammer	Sawing sounds
4	Title card	Text says "Cup"
5	Medium shot of hand crushing paper cup	Glass breaking sounds
6	Title card	Text says "Kettle"
7	Medium shot of teakettle (preferably boiling, but not necessarily)	Choo-choo train sounds
8	Title card	Text says "Baby"
9	Medium shot of happy baby	Crying baby sounds

After you shoot your footage and import it into your video-editing program, you're ready to replace the right sounds with the wrong ones. For each clip, you will remove the original sound-track and replace it with a sound from your public domain/royalty-free library. Here's how:

1. Import your video and trim your clips.

2. Place the clips in order.

3. Turn the volume control for each clip to zero; that is, turn off the sound.

4. Add title cards before each video clip.

5. Import the sound effects for each video, making sure to trim their length to match the clip.

6. Add a title to the start of the video.

7. Add a soundtrack at a fairly low volume.

Who's in the Box?

Did you ever wish you could magically transport a friend, acquaintance, or sibling into a box, and then do with them as you will? Now you can. With this handy-dandy project, you'll stick your nearest and dearest into a small, confined enclosure, as you subject them to heat, cold, and the knife.

Careful attention to sounds brings this project to life. After all, it's just a box you're filming. But with proper editing and creative sound use, you'll create an entire illusion. Do it right, and you'll convince your audience that there is really someone in the box. Watch "The Box" video on this book's accompanying CD–ROM to see an example. Figure 11.15 shows some highlights from the video.

This can be a whole-family project. Everyone can lend a hand. Your family members can enjoy themselves, and, at the same time, you can sublimate some of those sibling rivalry issues. Family fun and family therapy—what could be better?

Plan the Video

For this project, you'll need a box, a knife, a candle, a refrigerator, a "magic wand," a magician, and a cooperative assistant. Here are the frames in the "The Box" video sequence:

1	Title card	Text says "The Box."
2	Medium-close shot of adult	Adult: "Hey kids! These are special magic effects. Please do not attempt to reproduce these at home without proper adult supervision. Thanks!"
3	Title card	Text says "Let's go!"
4	Medium-close shot of magician	Magician: "Hi! I'm Erin."
5	Medium-long shot of magician and assistant	Magician: "This is my assistant, Jamie."
6	Medium-close shot of magician	Magician: "I'm going to make my assistant disappear."
7	Long shot of magician holding box and assistant	Magician: "Jamie, I'm going to put you in this box."
8	Close-up of assistant	Assistant: "Okay!"
9	Medium-long shot of magician holding wand	Magician: "Abracadabra!"
10	Long shot, just of assistant and hand of magician with wand	Magician is off-screen. Her hand, holding the wand, taps assistant (gently!) on the head three times, and then is removed from the scene. The assistant then fades away. (This is the same effect as the cross-dissolve described in the "Transport a Friend" section earlier in this chapter.)
11	Long shot of magician, knocking on box	Magician: "Are you in there, Jamie?" Magician does the first five beats of "shave and a haircut." Pause (generally called a beat in scripts). Off camera, the assistant knocks back "two bits."
12	Medium shot of magician with box	Magician gives thumbs up, saying: "Great!"
13	Title card	Text says "Heat!"
14	Long shot of magician heating box over candle flame	A long pause. Assistant: "Hey! It's hot in here!" Optional: applause.
15	Title card	Text says "Cold!"
16	Medium-long shot of magician and refrigerator	Magician places box in freezer and gives the camera a smile. Cue a nice cold breeze sound effect.
17	Long shot of refrigerator	Assistant: "Please! Someone turn down the air conditioning!" Optional: applause.
18	Title card	Text says "The Knife!"
19	Medium shot of magician holding knife	Magician: "And now… the knife!" Cue dramatic danger sound.
20	Long shot of magician holding box	Magician: "Jamie, get to the left side of the box." The left side of the box drops down. Magician: "No! Your left!" The right side of the box drops down. Magician: "That's better."
21	Close-up of magician	Just a mug to the camera with a raised eyebrow.
22	Medium shot of hand holding knife and box	Magician inserts knife in box. Assistant: "Ow!" Wait a beat. Assistant: "Just kidding!"
23	Long shot of magician with box and knife	Magician removes knife from box. Magician: "Ta da!" Optional: applause.
24	Close-up of magician	Magician: "And now, I will restore my assistant."
25	Close-up of box	From off camera, the magic wand taps the box three times. Magician: "Abracadabra."
26	Long shot of box	Assistant "teleports" back (using a cross-dissolve effect).
27	Long shot of magician and assistant	Magician and assistant take a bow. Both: "Ta da!" Lots of applause.

Figure 11.15

Sound effects bring the box to life, as a subject is "transported" into a box and subjected to fire and even a knife.

Shoot Your Footage

Other than two cross-dissolves for the "teleports," there are no special shooting techniques required for this project. Shooting this project demands organization and forethought rather than technical sophistication. To accomplish this, create a shooting schedule. Shoot your video out of sequence, grouping similar shots on your schedule.

When we filmed the sample video, we started by shooting all of Erin's solo shots, followed by the shots of Erin with the box. Only then did we add in Jamie. I shot the refrigerator scene last, moving the lights and camera into the kitchen after we had fully finished in the dining room.

By approaching the video in this way—filming similar shots together rather than following the script order—we saved a huge amount of time and effort. Grouping my shots allowed me to set up once and film several sequences rather than needing to keep rearranging, shooting, and framing for each shot.

Don't forget to follow the shooting advice in the "Stage a Disappearing Act" section earlier in this chapter. Use a tripod, keep the camera rolling, and above all else, don't move the camera as the subject steps in and out of the scene.

Edit Your Footage

Follow these steps to assemble your footage:

1. Import your video and trim your clips.

2. Create your title clips.

3. Place the clips in order, according to the script, including titles.

4. Insert cross-dissolves to create the two teleport effects. Add appropriate sounds to accentuate the disappearance and reappearance.

5. Add a "boiling" sound effect to the candle sequence.

6. Add a "chill" sound effect to the refrigerator sequence.

CREATE YOUR OWN WEATHER

Create your own weather effects and have some fun. If you're of a meteorological bent and want to play with nature, these tricks might be right for you. Give them a try.

Rain If you have a hose, an umbrella, and a colander, you've got rain! To create rain, shoot your water through the colander to disperse it and create a nifty rain effect. It helps to aim your water at a 45-degree angle and place your subject fairly far away. The colander diffuses the water and creates "drops" of rain.

Thunder The old way to create thunder involved rattling a large sheet of metal. With today's public-domain sound libraries, all you need to do is pick a dramatic prerecorded sound effect and edit it into your video.

Autumn If you're looking for that autumnal feeling, just grab some leaves and a small fan. Throw the leaves in front of the fan, and you're set. The wind from the fan will give life to the leaves and muss your subjects' hair.

Reflections off water To create the illusion of the seashore, place a shallow pan of water next to your subject. Reflect the light off the water and instant-presto, you've got it!

Fog Where would any magician be without some good fog? You can rent a fog machine (usually for $50 or less). Many party-supply stores offer these rentals. You'll need to buy some dry ice to go with it, too. Check around your local grocery stores to see who carries dry ice.

7. Add a "thunk" to the knife insertion. Meatier is better.

8. Add any voice-overs you missed during filming. In the sample video, we added all of Jamie's "in the box" sounds during editing. If possible, add an echo sound to each line while she is in the box. (This effect may be available in your video-editing software.)

9. Import and place additional sound effects to help round out the story. Applause, thumps, and magic bells can enhance your video.

10. Add a soundtrack at a fairly low volume.

In This Chapter...

In this chapter, you've seen how to incorporate a number of special effects into your digital films. Here are a few points to keep in mind.

- Low tech is big fun when it comes to digital video. You can accomplish all the effects in this chapter with the most basic video cameras (analog as well as digital) and software available on the market.

- Know your camera's settings. In many filming situations, including several of these projects, manual focus, white balance, and other settings prove superior to the automatic kind. Take some time to learn how to use these features, and you'll improve your digital videos enormously.

- Planning helps. The more you think and plan before you film, the better your shoots will run. Scripts, even the rough ones described in this chapter, will smooth the production your video projects.

- Don't be afraid to shoot your videos out of sequence. Make a plan that accommodates more effective scene orders and shoot them in that sequence. There's no rule that you must shoot the beginning first, then the middle, and then the end. Shoot in the order that works best for you.

- Get wacky. There's no reason that you shouldn't use your video equipment for the sheer fun of making creative little films.

Glossary

4:1:1 color A reduced color sampling method employed by the DV-25 compression standard for YCC (a TV transmission standard) data. The human eye is much more sensitive to accurate luminance (light levels) than chrominance (colors). This method stores only a quarter as much color information as luminance information.

4:2:0 color A reduced color sampling method, used primarily in MPEG compression and PAL video recorders. Superficially similar to 4:1:1 color, this method stores only a quarter as much color information as luminance information. This method splits the two color components, storing only one component at a time.

4:2:2 color A reduced color sampling method. This method stores half as much color information as luminance information. Digital video cameras use the 4:1:1 color method, which stores even less information than 4:2:2 color.

4:4:4 color An uncompressed, full-color sampling method that stores equal luminance (light levels) and chrominance (colors).

AC adapter An adapter that allows you to plug your camera into a wall outlet. (AC stands for alternating current.) Most camcorders arrive with a bundled adapter. However, if yours did not, your camera's manufacturer can usually provide one at an additional cost.

ADC See *analog-to-digital converter*.

Advanced Streaming Format (ASF) A type of Microsoft Windows streaming media file format designed as a container for Windows Media Format (WFM) media and now mostly superseded in use by plain WMF files.

after image The continuing perception of an image after the actual stimulus has ceased.

ambient (sound) The existing background noise (from sources both near and far away) at the location where you shoot your video footage.

analog Data in the form of continuous waveform information. Analog data must be digitized to be used and understood by a computer. Analog video signals are more subject to noise than digital video signals.

analog-to-digital converter (ADC) A device that translates analog data (typically voltage data) to digital values that may be used by a computer. Charge couple devices (CCDs) are ADCs that translate light signals to image data. Other ADCs allow you to convert the output from your analog camcorder to a digital form your computer will understand.

anamorphic A special type of lens that changes the aspect ratio of the image you are shooting. Traditionally, anamorphic lenses allowed film production crews to shoot wide-screen films on less elongated film stock.

aperture The size of the camera's lens opening. A small aperture provides a larger depth of field while letting in less light. A large aperture lets in more light at the cost of a narrower range of focus.

artifact An unintentional image element produced in error by an imaging device or as a byproduct of inaccurate software.

ASF See *Advanced Streaming Format.*

aspect ratio The proportionality between the width and the height of the pictures that make up a movie.

Audio Video Interleave (AVI) Microsoft's Video for Windows standard format.

author To design the behavior of a video CD or DVD. Authoring steps include preparing your discs with menus, scene selections, and so forth. These design tools use interactive computer software.

auto-focus lens A camera lens that automatically chooses the proper settings to create a sharp picture.

available-light filming A method in which you use only the light available; that is, without any additional artificial light sources.

AVI See *Audio Video Interleave.*

axis of action An imaginary line that defines the direction people and things face from the camera's point of view. The axis of action helps distinguish screen-left from screen-right.

baby spot A 500 or 750 watt lamp used to light individual subjects.

backing Large backdrops that provide a fake "scene" behind your subject. Many news programs use this technique to provide a city setting for interviews or reports taking place within a studio building. Strictly speaking, backings refer to painted or photographic surfaces hung to create scenery. You may occasionally find these backings referred to as *cycloramas* or *cycs*.

backlighting Light emanating from behind your subject and pointed toward the camera. This phenomenon often causes your subjects to appear darkened or in silhouette.

banding, color The "layered" effect produced in images when smooth gradients are displayed or printed with a smaller number of hues than demanded by the image. Similar hues are used with different colors because they fall to either side of a threshold and produce a visual discontinuity.

banding, video A striped image on the screen, resulting from one of the two recorder heads in a digital video camera becoming clogged and failing to read data. When banding occurs, you'll see 10 bands (or 12 bands outside the U.S.) across your screen. Every other band will show a live picture.

bandwidth The amount of information that can be transmitted across any digital connection in a given period of time. The higher the bandwidth, the more the information that may be transmitted.

barn doors Metallic plates attached to a lamp. By opening and closing these doors, you regulate the direction and the amount of light produced by that lamp. Also used as the name of a popular wipe technique where the new footage slides in symmetrically from the right and left sides of the screen.

barrel distortion Image distortion that spreads the center of the image.

binary Information made up of one of two discrete values, either on (one) or off (zero). Binary representation allows computers to store digital data.

bit rate The amount of information transferred per unit time, usually expressed in kilobits per second (Kbps). High bit rates demand higher bandwidth.

bitmap Strictly speaking, a black-and-white image constructed of arrays of black-and-white pixels. However, in common usage, the term bitmap (incorrectly) refers to arrays of pixels of any colors.

blooming Image distortion caused by overexposing a CCD camera to light. A white area will appear to bleed from light sources such as a window or lamp.

blue screen A method that allows you to overlay footage shot against a solid-colored background over another video. With the solid background hidden, the underlying video shows through. Virtually every weather broadcast uses this effect to place announcers in front of maps and satellite images. Curiously enough, most blue screens are now actually green.

blurring A loss of image detail caused by incorrect focus or camera motion. Blurry pictures can be partially corrected with sharpening filters and "deconvolution" techniques.

boom A type of large microphone, usually hung over a set on a mobile trolley.

bounce light A light aimed toward a reflective surface such as a white wall or ceiling or a silver-coated cloth.

breakaway A prop designed to break in a particular way without causing injury. Typical breakaway props include beer bottles and chairs used in staging saloon fights. Because these props have been specially prepared, they appear to be dangerous but are actually quite harmless.

brightness The amount of light detected at each picture element by the camera's CCD.

broad light A light that provides diffuse, soft lighting over a wide area.

brute light A light that provides bright, fake sunlight for interior sets. Also called *arc light*.

burn To write digital data, such as video, to disc in a recording CD or DVD drive. The term refers to the use of a laser beam to etch, or burn, the data into the physical medium.

call sheet A record stating which people will be needed for each period of filming. By preparing a call sheet in advance, you allow your subjects the luxury of showing up only when they are needed.

camera angle The camera position and the field of view used. Typical angles such as high and low refer to how the camera position relates to a camera placed on a shoulder of an average-height man. Wide angles and narrow angles describe the field of view.

camera-left/camera-right When asking a subject to move in a certain way, the directions are from the camera's, and the filmmaker's, point of view. This is often reversed from your subject's orientation. Therefore, by specifying "move a foot to camera-left," you make it clear which direction you wish your subject to move.

canned music Music that you can purchase to edit into your video. Make sure to check the royalty agreements before making your purchase. Royalty-free music can be used without paying additional fees beyond the original license.

capture To acquire digital data through a camera or other scanning device.

CCD See *charge couple device*.

CD-R/RW A type of drive that allows users to author compact discs (CDs).

cDVD See *miniDVD*.

CFF See *critical fusion frequency*.

charge couple device (CCD) A light sensor used in digital cameras to sample light intensity for gathering image data. CCD sensors produce more accurate images than CMOS sensors. A CCD array consists of a series of CCD sensors arranged in the digital camera to capture many points of light at once.

"Cheat the look" This direction instructs your subject to turn, a little unnaturally, toward your camera and allow you to film more of his or her face. This means that dialogue between your subjects may occur without them looking at each other in a normal fashion.

choke A piece of equipment specially designed to block electrical noise at radio frequencies. Chokes are built from coils or wire wrapped around ferrite cores, and they attenuate 60Hz alternating current (AC) noise by resisting rapid changes in current flow while letting direct current (DC) pass freely. Ferrite-core chokes create inductance, which causes fluctuating magnetic fields that, in turn, generate electric fields. The electric fields help counter electric noise emission.

chromakey A TV process that uses blue screen techniques. See *blue screen*.

chromaticity The way any image represents color as mathematically defined points within a color space.

clapper board The zebra-striped chalkboard you see in old movies. They allowed old-fashioned filmmakers to synchronize the soundtrack to the action. Clapper boards are totally unnecessary for video production, although they're fun to play with.

clean entrance A shot at the beginning of a scene that does not show any part of your subject, your subject's shadow, possessions, and so on. This allows your subject to "cleanly" enter into the scene during the filming.

clean exit A shot at the end of a scene that does not show any part of your subject, your subject's shadow, possessions, and so on. This allows your subject to "cleanly" leave the scene before the shot ends.

close-up A shot with limited spatial scope. In the case of people, a close-up is a shot in which your subject's face fills the field of view.

CMOS See *complementary metal-oxide semiconductor*.

codec A piece of software implementing a compression algorithm. Popular codecs include MPEG-1, MPEG-2, MJPEG, DV, and D1.

color sampling A compression method. Color sampling saves space by discarding some color data while retaining all brightness information.

color space A systematic representation of color using geometric coordinates. Common color spaces include RGB, CMYK, YIQ, and YUV.

color temperature The temperature, in Kelvin, of a light source. The lower the temperature, the redder the light. The higher the temperature, the more blue. Candlelight clocks in at about 2,000° Kelvin and sunset at 3,000° Kelvin. Daylight and flash photography both register at about 5,000° Kelvin.

complementary metal-oxide semiconductor (CMOS) A light sensor used in digital cameras to sample light intensity for gathering image data. CMOS sensors produce images with more noise and errors than do CCD sensors. However, CMOS sensors are available at a lower price than CCD sensors.

component video An analog video connection in which each element is transmitted along a separate wire and a standard in which each value is stored as a separate value. Component connections include individual cables for luminance and the two color components. These connections produce the highest quality analog connections. The BetaSP standard uses a component video format and is widely found in industrial video and network broadcasts.

composite video A simple analog video connection that combines luminance values with a color component and then transmits them along a single wire. Also a standard that combines these component values and stores them together. Composite video connections provide the lowest quality analog connections. The VHS standard uses a composite video format.

compression A technique used to store image data in the smallest amount of space. See also *spatial compression* and *temporal compression*.

cone light A lamp used to create general diffuse lighting.

continuous tones Arbitrary image tones. Digital cameras cannot produce continuous tone because they must approximate colors and shades within fixed-byte values.

contrast The ratio in brightness between the darkest and lightest elements of an image. Natural scenes should contain moderate contrast, unlike printed text, which should be highly contrasted.

converter See *analog-to digital converter*.

cookie A prop placed in front of a light to cast shadows simulating light through leaves.

country code See *region code*.

covering A mistake in which a subject blocks either your camera or a lighting fixture while you attempt to film another subject.

critical fusion frequency (CFF) The frame rate at which the human mind begins to interpret a series of pictures as a moving continuity, which is approximately ten frames per second.

cross-dissolve A transition, or *wipe*, in which one scene dissolves into the next. Editing software titles create this effect by compositing two sets of frames, incrementally applying translucency to the first scene until it is replaced by the second.

cross light Lighting that is placed to illuminate the sides of your subject.

crossing the line An error in which you change screen direction, confusing your viewers and mistaking screen left for screen right. See also *axis of action*.

cue cards Cards used to remind your subjects of their lines.

cue light A visual signal that cues your subject. You might cue to begin dialogue or to look in a different direction. Cue lights are placed behind or to the side of the camera so they will not interfere with filming.

cut A visual transition between two shots.

"Cut!" A traditional direction that ends the filming of a scene.

"Cut and hold…!" A direction that instructs your subjects to stay still as you stop filming and set up your next scene.

cutaway To change from one scene to another without an intermediate transition between the two shots. Also refers to a reaction or insert shot that allows you to seamlessly edit bits out of an overlong narrative.

cutback To change from one scene to another that has been previously viewed without a transition effect.

cutting on the action Having your subject make a large movement, typically with his or her head or arm, as a prelude to cutting away. When movements begin in one shot and finish in the next, your eyes naturally follow the action.

cyclorama See *backing*.

cyclical noise A noise component with an exact frequency consisting of a repeating patterns such as 60 Hz hums, fans, engines, or motors.

D1 codec A spatially compressed codec that uses 720×486-pixel images. It produces a huge, uncompressed data rate of 25 megabytes per second and is primarily used for TV broadcast.

data rate The rate at which a video can be transmitted to a computer. This rate depends on the user's connection speed, the size of the image to transmit, and the speed of the machine receiving the data, especially if the image must be uncompressed upon receipt.

day for night A technique in which a filter is placed over the video lens to simulate nighttime, although filming occurs during the day. This is usually done to save production costs.

delta frame A frame used in temporal compression that stores only that information that has changed since the last key frame. Also called a *difference frame*.

depth of field The area within which all objects placed at varying distances from the camera remain in focus.

dialogue Any spoken elements used within your video. Dialogue can be adlibbed or scripted.

difference frame See *delta frame*.

diffuser Any material placed in front of a light in order to soften or diffuse the lighting.

digital Data that is made up of binary information, readable by a computer.

digital accuracy How close pixel values match the colors and shades of the physical qualities of the item being imaged.

digital camcorder/digital video camera A film-free camcorder that uses a CCD array or CMOS sensors to capture images in digital form.

Digital8 A DV-25 variation that accommodates analog Hi8 movies. Digital8 systems store DV-25 data on Hi8 tapes and allow consumers to play and digitize their analog Hi8 videos in the same camera.

digital video (DV) Video stored as digital data, which can be read by a computer.

digital video disc (DVD) A consumer product that stores movies at a very high quality. DVDs have excellent storage capacity compared to video CDs and super video CDs. DVDs are also known, more correctly, as Digital Versatile Discs.

digital videotape A tape used to record digital video, commonly called *DV tape*. The MiniDV standard is the most widely used variety of digital videotapes.

digital zoom Magnification of an image by means of software within a digital video camera. Digital zoom does not increase resolution and creates a lower-quality image by interpolating between pixel values.

digitization Converting analog "real-world" data into digital form.

Direct-X Microsoft's graphics hardware application programming interface (API).

dissolve A visual transition between shots in which one shot slowly fades into the other. Also called a *cross-dissolve*.

dolly A wheeled camera mount.

dollying To move the camera while shooting.

dot crawl A video effect that looks like little moving dots, most apparent near the sharp edges of text, along natural diagonal lines, and other edges. This effect is caused by compression and is most visible when you place white lettering on a blue background.

dressing the set To place objects around your set to lend it a more natural and real appearance.

drifting A bad habit of many subjects, who unconsciously move from their marks and wander off position while they are being filmed.

dropped frame A lost video frame that should have been captured. Dropped frames can introduce unwanted gaps or hesitations into your digitized video.

DTV Digital television. As new broadcasting standards are established, DTV services are becoming available to consumers.

dubbing To add a voice track to a sequence that has already been filmed.

dulling spray A spray applied to overly shiny surfaces to reduce glare.

DV See *digital video*.

DV-25 A digital video compression standard that stores 25 megabits per second on a digital videotape or hard drive. This standard uses a 5:1 compression ratio and 4:1:1 color sampling. It transmits at 3.6 megabytes per second. One hour of DV-25 video stores roughly 13 gigabytes of data.

DV-50 A digital video compression standard that stores 50 megabits per second on a digital videotape or hard drive. DV-50 uses 3:3:1 compression and 4:2:2 color sampling to produce a much higher quality, less compressed video stream than does DV-25. The DV-50 standard is aimed at the professional broadcast market.

DV-100 A digital video compression standard that will store 100 megabits per second on a digital videotape or hard drive. Although not yet in use, it will be used with HDTV recording.

DV codec A spatially compressed codec that uses 720×480-pixel images. It produces a lightly compressed data rate of approximately 3.5 megabytes per second and is primarily used for TV broadcast.

DV tape See *digital videotape*.

DVC Consortium A consortium of electronic companies that joined together to form a standards committee for consumer-grade digital video. This group includes many high-profile companies such as Sony, Philips, Panasonic, Hitachi, and Sharp. As of today, more than 60 companies have joined.

DVCAM A professional variant of digital videotape created by Sony. This standard reduces noise by storing less information on a tape. By separating the digital video samples physically, DVCAM creates less interference between the magnetic tape elements. This produces a higher quality, less noisy, and more stable recording.

DVCPRO A professional variation of digital videotape, similar to DVCAM.

DVD See *digital video disc*.

DVD recorder A standalone unit that works like a VCR but records to DVD discs instead of VHS tapes.

DVD regional coding See *region code*.

DVD-R/RW, DVD+RW A type of drive that allows users to author DVDs.

dynamic range The difference between the darkest and brightest light that a digital camera can capture and reproduce.

editing The process of assembling raw video into a finished production.

electron gun A component at the back of a TV set. An electron gun produces a stream of electrons that hit the front of a TV picture tube, excite the molecules there, and produce the light you see.

establishing shot A long shot, often exterior, that sets the location of a movie scene.

exposure compensation The mechanism that overrides a camera's automatic exposure sensors to manually select a longer or slower exposure.

exposure meter The system that measures light in order to set the speed and aperture of a camera. Using the segment metering system, the image is divided into segments, each of which is evaluated by the camera's light meter. With the center-weighted metering system, the meter gives greater importance to the light values at the center of the image.

exterior(s) Any video shot outside.

Extra VCD (XVCD) A video-on-CD format that uses nonstandard bit rates, up to 3.5 megabits per second. This standard is fairly new and not widely supported.

extreme close-up A very close shot, typically of the face of a subject.

fade in/fade out A dissolve from or to blackness.

false move An actor's blunder; the physical equivalent of a *flub*.

fast motion An effect in which you shoot fewer frames per second. When viewed at normal rates, subjects appear to move unnaturally fast.

feathering A video effect that looks like small lines extruding from a main block of color, most apparent near the sharp edges of text, along natural diagonal lines, and other edges. This effect is caused by compression and is most visible when you place white lettering on a blue background.

feedback An effect produced by pointing your video camera at a monitor or TV and sending the signal that you are taping to that device. Video feedback is analogous to audio feedback.

fields The two passes used by an interlaced display, made up of either the odd lines (the "upper" field) or the even lines (the "lower" field). Both fields together make up a single frame. A TV that displays 30 frames per second must draw 60 fields per second.

fifty-fifty shot A camera angle that shows two subjects equally at once. Also called a two-shot.

fill light A soft light used to provide ambient lighting in a scene.

filter A camcorder accessory that allows you to customize the light entering your video camera, found primarily on high-end models. In video-editing software, a feature that allows you to alter image quality. Software filters can produce artistic, distorted, blurred, sharper, and many other versions of an image.

FireWire Apple's implementation of the IEEE 1394 standard.

fish eye An extreme wide-angle lens, often used by security camcorders, that produces a distinctive distorted view. Elements at the center of a fisheye view occupy proportionately greater space than elements that lie towards its edges.

flub A verbal blunder made by your subject during filming.

focal length The distance between the lens and the point where light rays focus behind the lens when light enters the lens in parallel lines. The longer the focal length, the greater the magnification that the lens will provide.

focus The quality of sharpness produced by light streaming through a lens and converging correctly on your camera's sensors.

fog making A visual effect, usually created by dumping dry ice in water.

follow shot A shot in which you make the camera follow the action. You see this a lot on reality TV shows.

fps (frames per second) See *frame rate*.

frame rate The number of frames shown per second. The human eye perceives "smooth motion" at about 10 frames per second (fps) because of a phenomenon known as *after image*, but more commonly, and incorrectly,

referred to as *persistence of vision*. Modern cinemas project frames at a rate of 24fps, and American TV uses a 30fps standard.

framing a shot Adjusting the camera to set the composition of a shot.

"Freeze!" An instruction that tells your subjects to stop talking and/or acting but hold their positions.

freeze frame Creating the appearance of stopped time by repeating a single frame. Also called a *stop frame*.

"From the top!" Instructions to your subjects to restart the scene from the beginning.

front lighting Lighting from behind the camera, illuminating your subjects. This is the primary means of lighting used during video production.

generation loss The accumulation of noise and signal degradation as copies of analog tapes are copied again. Each copy of a copy incurs a generation loss of signal quality.

"Give me a level" An instruction that tells your subjects to talk in a natural tone of voice so you can adjust the sound levels before filming.

hand cue A quiet means of cueing your subjects by waving at them with your hand.

HDTV High-definition TV, a TV format that uses a 16:9 wide-screen display format.

hertz (Hz) A unit of measurement for frequency, equal to one cycle per second.

high shot A camera angle in which the camera looks down on the subjects.

horizontal resolution The greatest possible number of pixels that your video camera can produce along the width of an image.

idiot cards A derogatory synonym for cue cards.

IEEE 1394 A cable connection standard that offers fast data transfer, particularly for digital video applications. Connections can transmit data at 400 megabits per second. This standard can transmit video, audio, time codes, device controls, and other data. The device controls allow you to control your digital video camera directly from your computer.

I-LINK Sony's implementation of the IEEE 1394 (FireWire) standard.

infrared-block filter A type of camera filter that reduces some of the infrared light entering your camera, while allowing regular visible light to pass through.

insert shot A filmmaker's device to help add to the narrative. For example, you might insert pictures of a clock, a calendar, or a newspaper to show how time has passed or events have occurred.

intercutting An editing technique in which the action rapidly changes back and forth between two scenes.

interframe compression See *temporal compression*.

interior(s) Any video shot inside.

interlacing A technique in which half the lines of an image are displayed at a time. Most TV broadcasts display a picture's odd-numbered lines before drawing the even-numbered ones. This technique produces an evenly lit screen. It ensures that the bits of phosphor that light up to create your TV picture do not begin to fade at the top before the bottom is fully drawn by the electron beam that projects the image.

intraframe compression See *spatial compression*.

IR-block filter See *infrared-block filter*.

iris The part of your video camera that admits light. By opening or closing the iris, you can control how much light reaches the camera's sensors.

Joint Photographic Experts Group (JPEG) An image format for digital pictures. JPEG pictures use efficient compression algorithms and averaging techniques to minimize image size at a slight accuracy cost.

jump cut To cut between two shots, usually a long shot and a close-up, without a change in camera angle. This creates the illusion that the camera has jumped closer or farther away.

junior spot A 1000 or 2000 watt lamp.

Kelvin A temperature measurement system used for light sources. See also *color temperature*.

key frame A frame used in temporal compression as the base to which all other frames are compared. Also called a *reference frame*. See also *delta frame*.

key frame frequency The rate at which key frames appear in a compressed video.

key light A lamp used to illuminate a particular subject. Key lights are usually placed to the side of the camera and about 45 degrees above the subject. Because of their brightness, you may need to soften the key lighting with fill lights.

lavolier microphone A small, hands-free microphone, generally attached with a clip to a tie.

LCD See *liquid crystal display*.

lip synching A technique in which you dub audio from one subject onto the video from another.

liquid crystal display (LCD) The screen on the back or side of your digital camcorder, often flipping out or up, that allows you to preview and review your digital images. LCDs consume a large percentage of your battery's power. New advances in LCD technology, particularly in passive-matrix LCD displays known as DSTN (Double-layer Super-Twist Nematic, also known as dual-scan LCDs), produce brighter screens with sharper colors. Many cameras support two types of LCD displays: one icon/character-based for displaying camera status and one pixel-based for use as a viewfinder.

live streaming Technique in which video streams continuously over an Internet or intranet connection. Live streaming provides excellent coverage for live events. See also *progressive download*.

long shot A shot in which the subject is far away from the camera. Often called a *wide shot*.

lossless compression Any compression scheme that produces decompressed images identical to those it compressed.

lossy compression Any compression scheme that produces decompressed images that are not identical to those it compressed. Usually, colors have been blended, averaged, or estimated in the decompressed version.

low key lighting A lighting technique in which subjects are dimly illuminated.

low shot A camera angle that looks up toward your subjects.

luminance The brightness (as opposed to the color) of a pixel.

marks Locations, usually marked by small bits of tape on the floor, that guide your subjects to their correct positions during filming.

matte An effect that places an imported image (such as a picture or title) over your video, using transparency and translucency to allow portions of your video to show through.

medium close shot A shot that falls somewhere between a close-up and a medium shot. Usually refers to a shot from the waist up.

medium long shot A shot that falls between a long shot and a medium shot. Usually refers to a shot showing a person at full height.

medium shot A shot showing a person at nearly full height.

microphone shadow A type of flub created by allowing the microphone to cast a shadow onto your scene.

miniatures Small-scale figurines used to create the illusion of large-scale scenes. For example, you might push a toy car off a curb to create the illusion of a fiery car accident.

MiniDV A physically small tape format (about a third the size of an audio cassette tape) that stores digital video. This is the most popular tape standard used by consumer-grade digital video cameras.

miniDVD A Video-on-CD format that stores DVD-style MPEG-2 data on a CD blank, also sometimes called cDVD. This format is gaining acceptance, and more commercial DVD players are starting to support miniDVDs. MiniDVDs can store approximately 15 to 20 minutes of high-quality footage.

mixing A technique that blends dialogue, music, and sound effects.

MJPEG A spatially compressed codec that uses 720×486-pixel images. It produces a data rate between 0.5 and 25 megabytes per second.

mock-up A life-sized facsimile of any large-scaled object, such as a house, car, or plane.

moiré A photo artifact consisting of bands of diagonal distortions.

montage A technique in which a series of related shots are strung together. Montages usually simulate the passage of time.

motion blocking A compression artifact caused by fast motion where fine detail is lost. Fast motion may cause dissimilar fields and prevent normal intraframe (spatial) compression.

Motion Picture Association of America (MPAA) An association that forms the voice of and offers advocacy for the American motion picture industry.

moving shot Any filming done from a moving vehicle.

MPEG-1 Motion Picture Experts Group standard version 1. A spatially compressed codec that uses 352×240-pixel images. It produces a highly compressed data rate between 0.01 and 0.06 megabytes per second and is widely used to create video CDs and Web broadcasts.

MPEG-2 Motion Picture Experts Group standard version 2. A codec that uses both spatial and temporal compression for 720×480-pixel images. It produces a compressed data rate ranging between 0.01 and 2 megabytes per second and is primarily used on DVDs and for satellite broadcasts.

MPEG-4 Motion Picture Experts Group standard, version 4. A codec used to produce high-quality streaming video over the World Wide Web.

multicam Video production that uses more than one camera at a time.

multistandard VCR A VCR that plays back two or more country systems, including NTSC, PAL, SECAM, and variants.

narration A voice track dubbed over your video.

National Television Standards Committee (NTSC) Refers to the video standard for TV signals used in the U.S., American Samoa, Barbados, Bermuda, Bolivia, Canada, Chile, Columbia, Costa Rica, Cuba, Democratic People's Republic of Korea, Dominica, El Salvador, Ecuador, Guam, Guatemala, Haiti, Honduras, Mexico, Micronesia, Myanmar, Nicaragua, Panama, Peru, Philippines, Puerto Rico, Suriname, Taiwan, Trinidad, Tobago, and Venezuela. NTSC video is made up of 525 lines transmitted at 29.97 frames per second.

neutral shot An intermediate shot that allows you to change camera angles. Neutral shots have no screen direction.

nickel-cadmium (NiCd) battery A type of rechargeable battery that provides excellent camera operation. Because NiCds (pronounced "nigh-cads") contain the heavy metal cadmium, they promote concerns about proper disposal.

nickel-metal-hydride (NiMH) battery A type of rechargeable battery that provides excellent camera operation, long effective life, and fewer environmental concerns than alkaline or NiCd batteries. NiMHs (pronounced "nimms") also have fewer "memory effects" than NiCd batteries do. You do not need to drain them each time before recharging.

noise Random, unintended image values added to and distributed across a digital picture. See also *artifact*.

noise-removal package A software tool that allows you to remove noise from your video's soundtrack.

noninterlaced A display that draws all lines of a frame in sequence, regardless of whether they fall on an even or odd line. The best-quality digital video uses noninterlaced frames.

nonlinear editing A technique in which you edit film and video on the desktop, rather than using the traditional tape-to-tape method.

NTSC See *National Television Standards Committee*.

off screen Sound that occurs out of camera range.

omnidirectional microphone Microphones that provide nondirectional pickup, allowing recording from all directions.

on location Filming outside a studio.

optical zoom Magnification of an image by means of an optical zoom lens. Optical zoom does not lower resolution and creates the same quality image as an image taken without optical zoom.

outtakes Flawed scenes retained for archival purposes.

over-the-shoulder shot A shot that uses one subject's back, head, and shoulder to frame the shot of another subject.

overlap A technique in which one subject starts talking before the other has finished.

overlay To place an imported image (such as a picture or title) above your video, using transparency and translucency to allow portions of your video to show through.

overscan The tendency for a TV to lose picture information off the top, bottom and sides of the picture tube.

PAL See *Phase Alternation Line*.

pan Horizontal camera movement. (Not to be confused with a bad film review.)

parallax The difference between what an observer off to the side sees and what the filmmaker sees through the viewfinder. If you do not operate the camera yourself, be sure to stand right next to the videographer when framing your shots.

Peripheral Component Interconnect (PCI) A standard that allows you to add third-party hardware solutions to slots in your computer.

persistence of vision A human phenomenon more correctly labeled as an *after image*. It refers to the way that you can continue to see a picture even after the original picture is no longer displayed.

Phase Alternation Line (PAL) The video standard for TV signals used in Western Europe, Australia, Japan, and many other countries that do not specifically support the NTSC standard. PAL video is made up of 625 lines transmitted at 25 frames per second.

phosphor A chemical that emits light after being energized by an electron gun.

"Pick it up!" An instruction that tells your subjects to repeat the scene at a faster rate.

pickup A camera shot that continues from the end of the last filming sequence using the same camera angle.

picture-in-picture A technique that allows you to place video clips and still images above portions of your video.

pin-cushioning A distortion effect caused by extreme wide-angle lenses. A pin-cushioned image appears rounded near the edges.

pixel A picture element. A pixel is the smallest part of an image, which when placed into a two-dimensional array with other pixels forms a picture.

playhead An interactive element of a video-editing interface that points to the current frame of your video.

point-of-view (POV) shot A shot taken from the point of view of the subject, as the subject would see it.

polarizing filter A type of camera filter that uses circular polarization to allow or deny access to certain types of light.

progressive download Transmission technique in which your computer buffers parts of the video stream, playing it as it downloads the next segment. This technique allows you to cache a video and replay it.

progressive scan A high-quality display that does not use interlacing.

prosumer A grade of equipment that falls between professional and consumer.

push-over wipe A wipe technique that moves an image horizontally across the screen while cutting from one shot to the next.

QuickTime format Refers to Apple's family of multimedia file types. With a wide range of codecs, the QuickTime architecture supports applications as diverse as digital video, virtual reality, music, and video streaming.

rack focus A video technique in which one quickly switches the camera's focal mechanism between two focal points. In this way, you force your viewer to change attention by shifting focus from one object or subject in a scene to another.

RCE See *Regional Code Enhancement*.

reaction shot A shot showing how a second subject reacts to the ongoing action. Reaction shots are essential for editing interviews. Common reaction shots for interviews include a listener nodding her head, tapping her notebook with a pen, and carefully furrowing her brows. For horror films, a reaction shot might show a person gasping in terror.

Real format A real-time streaming media architecture developed by RealNetworks. Also called RealSystem, this standard was designed specifically for online purposes, with small media files targeted at quick Internet transmission. RealNetworks offers the HelixProducer (formerly Real-Producer) encoder to compress video into Real format.

reflector A coated surface used to reflect light and provide overall softer ambient lighting.

refresh rate The number of times a screen is redrawn per second.

region code A number assigned to different geographical regions by the MPAA, to protect theatrical distribution markets. Motion pictures are released at different times in different international markets. Region codes prevent DVDs from being imported into markets in which the theatrical runs have not completed.

Regional Code Enhancement (RCE) A new level of technology that checks to see if a player is set to region 0. If so, the DVD will refuse to play.

resolution The degree to which your video camera can record fine detail, often based on a pixel count.

retake Shooting a scene over.

RGB The standard set of colors used by computer monitors to create images on your screen. RGB stands for red (R), green (G), and blue (B).

rippling water A technique that reflects light of a moving pan of water to create rippling shadows on your subjects' faces, emulating sitting next to water.

rock-in/rock-out How an actor can move into and out of the shot by shifting his weight from one leg to another.

rough cut A first pass at assembling the component shots of a video into a whole movie.

run-through A rehearsal.

safe zones The areas of a screen that are unlikely to be cropped by over-scanning. You may encounter two types of safe zones: action safe zones and the smaller (since cropped titles are more immediately noticeable) title safe zones.

scene detection A feature found in many video-editing programs to detect the start of scenes. It typically works by checking for discontinuities in the recorded time code, reflecting when you pressed the record button.

screen direction The relative placement of people and things when viewed through the camera. Screen direction emulates the way an individual would define left and right regarding the placement of on-screen elements.

screen left/screen right See *screen direction*.

scrim Translucent material that partially cuts off and diffuses light.

SECAM A video broadcast standard used in France, the Middle East, and Africa. SECAM video is made up of 625 lines transmitted at 25 frames per second. Since SECAM is a broadcast-only standard, countries that employ it use PAL technology to record and play back their videotapes.

senior spot A 5000 watt lamp.

sequence An entire scene in a video.

set Furnishings, walls, and other elements that create the illusion of a location in a video.

shot A single sequence filmed without stopping the camera.

"Sit into the shot" An instruction that tells the subject to sit down into the starting position after the shot begins.

sky pan A lamp used to illuminate a backing. Also called a *scoop*.

slow motion An effect in which you shoot more frames per second. When viewed at normal rates, subjects appear to move slowly.

soft focus An out-of-focus technique used to flatter your subject.

soft light A lamp with a built-in reflective surface. A soft light lamp bounces its light off an attached umbrella to create soft, diffuse lighting.

sound effects Sounds added during editing to provide realism, drama, humor, or other audio effects in your video.

soundtrack Sound that accompanies a video.

spatial compression A technique that compresses each frame of video based on such elements as blocks of similar colors or patterns. Spatial compression does not use information from other frames. Also called *intraframe compression*.

special effects Any filming or editing technique that creates an illusion.

split (clips) To segment video footage into individual clips.

split-screen effect A technique that merges two video sources, usually side by side, to form a single screen. For example, this effect is used widely in movies where one actor plays himself and his own twin.

still A single video frame saved to an image file.

stop frame Creating the appearance of stopped time by repeating a single frame. Also called a *freeze frame*.

storyboard (editing program) A film-strip-like layout, in which clip thumbnails are viewed in a sequential line.

storyboarding A planning technique that specifies camera angles for individual shots.

streaming media Highly compressed video transmitted over the Internet or an intranet.

streaming media player A software program that receives and decompresses streaming video for viewing.

subtitles Words overlaid at the bottom of the video, usually providing translations.

superimpose To place one image over another, usually for titling.

Super VCD (SVCD) A video-on-CD format that provides approximately one half hour of good-quality video on an average CD.

S-Video A connection that transmits luminance and color component information along two separate wires. This provides a better-quality transmission than the single-wire composite connections do. Also a standard used by SVHS and Hi8 videos to store high-quality video for prosumer use.

swish pan Rapid side-to-side panning, simulating eye movement.

take Each filmed shot. Traditionally, the director numbers takes for later editing.

telephoto A zoomed shot that shows a smaller-than-normal area at the cost of some depth of field. See also *telephoto lens*.

telephoto lens A magnifying lens with a very high focal length. The opposite of wide-angle lenses, telephoto lenses provide images with a narrow angle of view. Telephoto lenses take pictures of a smaller area of the scene. Use a telephoto lens when you cannot get close to your subject, such as in wildlife photography.

temporal compression A compression technique that compares differences between frames to store only the data that has changed. Also called *interframe compression*. See also *key frame* and *delta frame*.

tethered microphone A microphone with a cord attached.

tie-clip microphone See *lavolier microphone*.

tilt A vertical camera move.

timeline (editing program) An editing layout that shows video and audio clip duration over time.

title cards A title technique in the style of old-fashioned silent films, typically using white text on a black background. Also called *title boards*.

titles Text added to video footage.

top lighting Lighting that shines down onto your subjects from above.

transition effects An editing technique in which one shot replaces another in a variety of fashions until the first shot is totally covered.

trim (clips) To shorten video clips.

tripod A three-legged stand for your camera. Tripods are steadying devices that allow you to capture stable images.

TV-out port A port found on some video cards, allowing users to replace their monitors with a standard TV or mirror the monitor out to a TV or VCR.

two-shot A camera angle that shows two subjects equally at once. Also called a *fifty-fifty shot*.

unidirectional microphone A one-person microphone with specific directional pickup.

Universal Serial Bus (USB) A cable connection standard that provides quick and efficient data transfer. Most newer computers provide USB ports. USB-2 introduces even higher speed and more reliable communication.

vertical resolution The greatest possible number of pixels that a digital camera can produce across the height of an image.

video-capture device A device that employs analog-to-digital converter technology to convert analog signals to digital streams that your computer can store and edit.

video compact disc (VCD) A standard that stores video on a compact disc. A VCD will store about one hour of fair-quality video on a CD.

videographer A person who uses a video camera to shoot videos. Analogous to the still-image photographer.

visuals The image components of your video, as distinct from the sound components.

voice cue A cueing technique in which you simply use your voice.

voice-over Voices from off camera, either recorded during filming or added during editing.

wardrobe Any costuming needed for your video.

white balance A feature that allows you to manually adjust how your camera reacts to light sources with differing color temperatures. When a camera is balanced for one temperature of light and used to photograph another temperature, it creates colors that are not true.

wide-angle lens A lens that allows your camera to capture a wider image. The opposite of telephoto lenses, wide-angle lenses provide greater depth of field. Wide-angle lenses take pictures of a larger part of the scene.

wide-angle shot A shot that includes a larger-than-normal area. Wide-angle shots have good depth of field.

Windows Media Format Microsoft's streaming architecture for real-time multimedia delivery.

windscreen A soft cover that shields a microphone from wind noise.

wipe An editing technique in which one shot replaces another by following an imaginary line until the first shot is totally covered.

WMF See *Windows Media Format*.

XVCD See *Extra VCD*.

YCC A transmission standard used in TV. Instead of broadcasting individual RGB values for pixels, this standard sends a luminance (brightness) value Y, followed by a color component made up of two values that combine to create a particular hue. This allows TV signals to be understood equally well by black-and-white and color TVs. YCC signals are also called composite. YCC variations include YIQ, YUV, and YcrCb.

zoom Video technique in which the lens deforms to magnify objects at a distance.

zoom lens A lens that provides a magnification effect by changing your camera's focal length.

Index

Note to the Reader: Throughout this index **boldfaced** page numbers indicate primary discussions of a topic. *Italicized* page numbers indicate illustrations.

A

AC adapters, 233
AC power interference, 50–51
action safe zones, 64
ADCs (analog-to-digital converters), 162, 233
 with analog camcorders, 3
 exporting with, 197–198, *197*
 for FireWire, 7
 non-1394, 90–93, *91*
 for transferring video, 86–90, *87, 89, 93*
Advanced Streaming Format (ASF), 189, 233
ADVC-100 converter, 7
ADVC-1000 converter, 86
after images, 233
aliasing, 38
ambient sound
 background noise for, 50
 defined, 233
analog data and sources, 233
 camcorders, 2–4, *2*
 setup for, 7–8, *7*
 transferring video from, 85–86
 camera preparation for, 89–90
 connections for, 88
 converter boxes for, 88–89, *89*
 with non-1394 digitizers, 90–93, *91*
 supplies for, 86–88, *87*
 VCR preparation for, 90
analog-to-digital converters. *See* ADCs (analog-to-digital converters)
anamorphic lenses, 233
Anandtech Web site, 83
angle shots, 27–29, *27–29*
animations, 211–212
 conversations, 214–216, *214, 216*

 love letters, 212–214, *213*
 in VideoStudio, 155
apertures, 17, *19*, 233
Apex, VCD support by, 164
artifacts
 compression, 70
 defined, 233
ASF (Advanced Streaming Format), 189, 233
aspect ratio, 14, 233
assembling clips
 in iMovie, 128–129
 for rough cuts, 102–105, *104*
 in VideoStudio, 151
asymmetric codecs, 71
ATI converters, 92
atmosphere for filming people, **44**
Audio Video Interleave (AVI) format, 233
audio/video-out ports, 88
authoring DVDs, 167, 233
auto-focus lenses, 233
automatic scene detection, 93, 101, 126
autumn, simulating, 231
available-light filming, 233
AVI (Audio Video Interleave) format, 233
axis of action, 35, *35*, 233

B

B (bidirectional) frames, 72
baby spots, 233
background noise, 50, 112–113
background processes, 95
background sound, 50
backgrounds
 simplifying, 39–40, *39–40*
 in VideoStudio, 169
backing, 233
backlight, 52–53, *52*, 233
backward transitions, 132
banding, 76, 234

bandwidth, 234
 in streaming video, 187
 in video quality, 68–69
barn doors, 135, 234
barrel distortion, 234
basic camera shots, 24–25, *25–26*
Batch Capture feature, 149
bidirectional (B) frames, 72
binary data, 234
bit rate, 68, 234
bitmaps, 234
blemishes, 46
blend shots, 50
blinds, 135
blooming, 234
blue screens, 135, 234
blurring, 234
booms, 234
bounce lights, 234
box trick, 228–231, *230*
Bravo plug-in, 135
breakaways, 234
brightness, 63, 234
broad lights, 234
brute lights, 234
buffer underruns, 163
built-in microphones, 47–48
built-in special effects, 15
burn proof-capable drives, 163
burning to DVDs and VCDs, 159, 162, 234
 compatibility in, 164–166
 iDVD for, 177–182, *177–179, 181–182*
 issues in, 163–164
 in Nero 5.5, 175–177, *175–177*
 steps in, 162–163
 TMPGEnc for, 172–175, *173–175*
 Toast Titanium for, 182–184, *183–184*
 in VideoStudio, 166–172, *167–171*

C

cables, 65, 81–82, 87–88
call sheets, 234
camcorders. *See* cameras
camera angles, 234
camera-left/camera-right direction, 234
camera moves, 35–38, *36–37*
camera shots, 24, 242
 angle, 27–29, *27–29*
 basic, 24–25, *25–26*
 for editing, 29–32, *29–31*, *33*
 POV, 26–27, *26*
cameras
 connections to, 92
 digital vs. analog, 2–4, *2*
 operation of, 73–74
 transferring video from. *See* transferring video
candles, self-igniting, 221–222, *221*
canned music, 234
capturing video, 148–149, *149*, 234
CCDs (charge couple devices), 73–74, 234
CD-insertion notification, 95
CD-R/RW drives, 234
CD-ROM Movie, Medium option, 140
cDVD (miniDVD) format, 77–78, 165, 239
CFF (critical fusion frequency), 68, 235
changing pictures, 103–104, *104*
charge couple devices (CCDs), 73–74, 234
"Cheat the look" direction, 235
children, filming, 46–47
chins, 45
chokes, 51, 235
chromakey process, 235
chromaticity, 64, 235
clapper boards, 235
clarity of microphones, 47
clean entrances and exits, 32, *33*, 235
clean sets, 58
Climb video, 223–225, *224*
Clip Info dialog box, 131, *131*
clip viewer, 124, *124*
clips
 in iMovie, 127–129
 in rough cuts, 100–105, *100*, *104*
 in VideoStudio, 150–151, *150*
Clips Shelf, 124
close-up shots, 24, *25*, 235

CMOS (complementary metal-oxide semiconductor) sensors, 235
coasters, CDs for, 164
coaxial cable, 65
codecs, 70–71
 defined, 235
 with non-1394 digitizers, 91
coding regions, 66–67, 241
Color Effects plug-in, 136
color for DVDs, 166
color sampling, 235
color space, 63–65, *63*, *65*, 235
color temperature, 20, 235
compatibility issues in DVD burning, 164–166
complementary metal-oxide semiconductor (CMOS) sensors, 235
component video, 65, *66*, 235
composite video, 65, *66*, 235
composition, 38
 backgrounds, 39–40, *39–40*
 details, 40–42, *40–41*
 distance to subjects, 43
 facing subjects, 44, *44*
 framing subjects, 42–43, *42–43*
 rule of thirds, 39, *39*
compression, 69–70, *70*, 235
 codecs for, 70–71
 MPEG-2, 72, *72–73*
 types of, 71
cone lights, 235
connections for video transfer
 analog, 88
 locating, 83–84
 non-1394 digitizers, 92–93
Content Scrambling System (CSS), 67
continuous tones, 235
contrast, 107, *107*, 235
conversations, animating, 214–216, *214*, *216*
converter boxes. *See* ADCs (analog-to-digital converters)
converting video formats, 203
cookies, 235
Cool Edit Pro editor, 112
cordless tie-clip microphones, 49
costs of analog camcorders, 3
costuming, 46
country TV systems, 66–67
courses, streaming video for, 186
covering errors, 235
Create Video File dialog box, 167

credits in VideoStudio, 155
critical fusion frequency (CFF), 68, 235
cropping in iMovie, 128
Crops & Zooms plug-in, 137
cross-dissolve effects, 111, 209, *209*, 211, 235
cross light, 236
crossing the line, 236
CSS (Content Scrambling System), 67
cue cards, 57, 236
cue lights, 236
"Cut!" direction, 236
"Cut and hold...!" direction, 236
cutaway shots, 31, *31*
 defined, 236
 in editing, 105–106, *106*
cutbacks, 236
cuts, 236
cutting on the action, 34, *34*, 236
cyclical noise, 112, 236

D

D1 codec, 236
dark pictures, 55–56
data rates, 236
dating, streaming video for, 186
day for night technique, 236
DC 1000 converter, 86
declick and dehiss plug-in, 112
DeCSS descrambler, 67
defragmenting disks, 96
Deinterlacer utility, 63
delta frames, 236
depth of field, 16–19, *17–19*, 236
desktop video, 4–5, *4*
details in composition, 40–42, *40–41*
dialogue, 236
Diamond Cut Millennium plug-in, 112
difference frames, 236
diffusers, 236
digital accuracy, 236
digital camcorders, 2–3, *2*, 236
digital data, 236
Digital Learning Center, 20
digital television (DTV), 237
digital video (DV), 236
 camera operation in, 73–74
 disadvantages in, 75–76
 videotape standards in, 74–75

digital video discs. *See* DVDs (digital video discs)
digital video recorders (DVRs), 200
digital videotape, 236
digital zooms, 236
Digital8 standard, 75, 236
digitization, 236
digitizers. *See* ADCs (analog-to-digital converters)
DINR plug-ins, 112
Direct Memory Access (DMA), 95
Direct-X application, 236
Director's Cut converter, 7, *7*, 86, 197–198
disappearing acts, 206–207, *206–207*
disassociating sounds in iMovie, 130
Discreet Cleaner converter, 162–163, 191, *191*
disk storage
 in low-budget setup, 9
 in medium to high-end setup, 6
 VCDs for, 78
 for video transfer, 96
dissolves, 236
distance drop-off with microphones, 47
distances
 in jump cuts, 33, *34*
 to subjects, 43
divine ratio, 39
DMA (Direct Memory Access), 95
DMR-E20 recorder, 77
DNoise plug-in, 112
dollies, 36, 236
dollying, 236
dot crawl, 75, 236
double chins, 45
downward shots, 28, *29*
dress, 46
dressing sets, 58, 236
drifting, 236
drives
 in low-budget setup, 9
 in medium to high-end setup, 6
 VCDs for, 78
 for video transfer, 96
dropped frames, 237
 in video transfer, 94–96
 in VideoStudio, 149
DTV (digital television), 237
dubbing, 237
dulling spray, 237
duplicating clips
 in iMovie, 128

in VideoStudio, 151
DV (digital video), 236
 camera operation in, 73–74
 disadvantages in, 75–76
 videotape standards in, 74–75
DV-25 compression, 126, 237
DV-50 compression, 237
DV-100 compression, 237
DV-Bridge converter, 86, 198
DV codecs, 237
DVC Consortium, 74–75, 237
DVC-II converter, 91–92, 162
DVCAM standard, 237
DVCPRO standard, 237
DVD Forum, 160
DVD MovieFactory, 167–170, *168–170*
DVD-R(W) drives, 160, 237
DVD-RW drives, 160, 237
DVD+RW drives, 160, 237
DVD+RW Alliance, 160
DVDs (digital video discs), 160, 236
 burning to. *See* burning to DVDs and VCDs
 coding regions for, 66–67, 241
 exporting to, 200–203, *201*
 recorders for, 161–162, 201–202, *201*, 237
 recording standards for, 160
 as storage media, 76–77, *77*
 in VideoStudio, 157
DVR-1000 recorder, 77
DVRs (digital video recorders), 200
DVStorm converter, 86
dynamic range, 55, 237

E

earthquakes, 216–218, *217*
Echo plug-in, 136
editing, 99, 128, 237
 background noise, 112–113
 camera shots for, 29–32, *29–31, 33*
 effects in, 107–111, *107–109, 111*
 in iDVD, 181
 overlays, 157
 for rough cuts, 102–106, *104–106*
 sound
 in iMovie, 130, *130*
 in VideoStudio, 153
 soundtracks in, 114–118, *115–117*

splitting and trimming clips, 100–101, *100*
 titles
 in iMovie, 138
 in VideoStudio, 157
effects
 in iMovie, 131–137, *132–133*
 sound, 109–110
 titles, 108–109, *108–109*
 transitions, 110–111, *111*
 in VideoStudio, 152–155, *154–155*
 visual, 107–108, *107*
El Gato converters, 92
electron guns, 62, *62*, 237
Elements editor, 214
Email Movie, Small option, 139
Emma the Magician video, 207–209
Emma's Earthquake video, 216–218, *217*
entrance shots, 32, *33*
EP (Extended Play) in VCRs, 197
equipment, 5
 for analog setup, 7–8, *7*
 for home studios, 56
 for low-budget setup, 8–9
 for medium to high-end setup, 5–7
Eskape converters, 92
establishing shots, 29–30, *29–30*, 105, 237
event structure, 12
exit shots, 32, *33*
Export Movie dialog box, 139–140, *139–140*
exporting
 to discs, 200–203, *201*
 from iMovie, 139–140, *139–140*, 183
 PAL vs. NTSC in, 203–204
 to Toast Titanium, 183
 to VCRs, 195
 with cameras, 196–197
 with converter boxes, 197–198, *197*
 with TV out, 198–200
exposure compensation, 237
exposure meters, 237
extension cords for microphones, 49
exteriors, 237
external microphones, 48–50
Extra VCD (XVCD) format, 165, 237
extracting sound, 153

extreme close-ups, 237
eyeglasses, 45–46
EyeTV converter, 92
eZeClip plug-in, 136
eZedia plug-ins, 136
eZeMatte plug-in, 136
eZeScreen plug-in, 136

F

faces
 flattering, 45–46, *45*
 in streaming video, 190
facing subjects, 44, *44*
fade in and fade out effects, 111
 defined, 237
 in VideoStudio, 153
false moves, 237
fast motion, 237
feathering, 75, 237
feedback, 237
fields, 63, 237
fifty-fifty shots, 25, *26*, 238
fill lights, 238
filters
 defined, 238
 in VideoStudio, 154–155, *155*
finalizing DVDs, 200
FireWire standard. *See* IEEE 1394
 standard
fish eye lenses, 238
flattering subjects, 45–46, *45*
flubs, 238
focal length, 238
focus, 15–16, 238
 depth of field in, 16–19, *17–19*
 tips for, 20
focus detection zone, 15
focus effects
 focus to zoom, 226–227, *227*
 rack focus, 20, 226, *226*
focusing attention, camera moves
 for, 37
fog, simulating, 231, 238
folders in iDVD, 181
Foley technicians, 109
follow shots, 26, 238
fonts for text, 109, *109*
formats and standards, 74–75
 for DVDs, 164–165
 for iDVD, 177–178, *177–178*
 for streaming video, 190–192, *191*
 for TV, 14
 in VideoStudio, 148, 157

forward transitions, 132
4:1:1 color sampling, 65, 233
4:2:0 color sampling, 65, 233
4:2:2 color sampling, 65, 233
4:4:4 color sampling, 64, 233
frame rate, 238
 in TV standards, 66
 in video quality, 68–69, *69*
frames
 in MPEG-2 compression, 72,
 72–73
 in TVs, 63
framing shots, 238
framing subjects, 42–43, *42–43*
Freeplay Music, 118
"Freeze!" direction, 238
freeze frames, 238
friend behind bars effect, 222–223,
 223
"From the top!" direction, 238
front lighting, 238
Full Quality, Large option, 140
full-stereo sound with microphones,
 48

G

GeeThree plug-ins, 134
generation effects, 3, 74, 238
"Give me a level" direction, 238
Glows & Blurs plug-in, 137
gold DVDs, 166
golden ratio, 39
GraphicConverter editor, 214
grooming, 46

H

hair, 46
hand cues, 238
Hauppauge converters, 92
HDTV (high-definition TV), 238
HelixProducer tool, 188–189, 191
hertz (Hz), 238
high-angle shots, 27, *28*, 238
Hollywood DV-Bridge converter, 7
home studios
 equipment for, 56
 setting up, 57
 tips for, 57–58
horizontal resolution, 69, 238
host sites for streaming video,
 192–194
hot swapping, 82

HTTP (Hypertext Transfer
 Protocol), 187–188
humbuckers, 51
humor, sound for, 227–228
Hz (hertz), 238

I

I (intraframe) frames, 72
I-LINK. *See* IEEE 1394 standard
I values in TV color, 63–64
idiot cards, 238
iDVD, 177
 adding material in, 180–181, *181*
 editing in, 181
 exporting movies to, 140, *140*
 formats for, 177–178, *177–178*
 themes in, 178–180, *179*
 thumbnails in, 181–182, *182*
IEEE 1394 standard, 238
 converter boxes for, 7
 in digital camcorders, 2
 in medium to high-end setup, 5–6
 for transferring video, 82–84,
 87–88
illusions for sets, 58
image overlays, 156–157, *156*
iMovie plug-in page, 134
iMovie program, 121
 automatic scene detection in,
 101, 126
 burning movies in, 170–171, *171*
 clip management in, 127–129
 clip viewer in, 124, *124*
 effects in, 131–137, *132–133*
 exporting from, 139–140,
 139–140, 183
 importing into, 125–127,
 125–126, 129
 interface for, 122–125, *122*, *124*
 palettes in, 124–125, *124–125*
 projects in, 125
 sound in, 129–131, *129–131*
 for streaming video, 191
 timeline in, 123, *124*
 titles in, 137–138, *137*
 for transferring video, 82
importing
 into iMovie
 sound, 129
 video, 125–127, *125–126*
 into VideoStudio
 sound, 152
 video, 147–150, *148–149*

indirect lighting, 53, *54*
infrared-block filters, 238
insert shots, 31–32, 238
Intelligent Streaming, 189
intercutting, 238
interference with microphones,
 50–51
interfield compression, 75
interframe compression, 71–72,
 72–73
interiors, 238
interlacing, 63, *63*, 238
Internet, 185
Internet service providers (ISPs),
 193
interval drives, 96
intraframe compression, 71, 75
intraframe (I) frames, 72
iris, 239
ISPs (Internet service providers),
 193

J

Jail Time! video, 222–223, *223*
JPEG (Joint Photographic Experts
 Group), 239
jump cuts, 33, *34*, 239
junior spots, 239

K

Kelvin measurement, 239
key frame frequency, 239
key frames, 239
key lights, 239

L

lasers for DVDs, 165
lavolier microphones, 239
LCD (liquid crystal display)
 screens, 239
leading looks, 44
letterbox format, 14
libraries of sound effects, 110
lighting, 51
 backlight, 52–53, *52*
 indirect, 53, *54*
 low-light, 54–56
 in streaming video, 190
 time of day, 53–54
 window, 54, *55*

line
 crossing, 236
 in shooting, 35, *35*
 working with, 103
lip synching, 239
liquid crystal display (LCD)
 screens, 239
live streaming, 239
live video, 186
locations
 angle shots for, 28–29, *29*
 planning, 12
long shots, 239
lossless compression, 239
lossy compression, 70, 239
love letters, animated, 212–214, *213*
low-angle shots, 27, *27*, 239
low-budget setup, 8–9
low key lighting, 239
low-light filming, 54–56
LP (Long Play) in VCRs, 197
luminance, 63, 239

M

machine noise with microphones,
 48
Maestro tool, 116–117, *116–117*
magic shows, 207–209
magical reassembly, 218–220, *218*
makeup, 46
manual focus, 16
marks, 239
matchmaking Web sites, 186
mattes, 135, 239
Media folder in iMovie, 125
media types with DVDs, 164
MediaStudio Pro, 143
medium shots, 25, *26*, 239
medium close shots, 239
medium long shots, 239
medium to high-end setup, 5–7
memory
 in low-budget setup, 9
 in medium to high-end setup, 6
 virtual, 95
Microeditor editor, 112
microphone shadow, 239
microphones
 AC power interference with,
 50–51
 built-in, 47–48
 external, 48–50
 selecting, 15

mind teasers
 friend behind bars, 222–223, *223*
 mirror tricks, 225, *225*
 rock climbing, 223–225, *224*
miniatures, 239
MiniDV format, 75, 239
miniDVD (cDVD) format, 77–78,
 165, 239
mirror tricks, 225, *225*
mixing, 239
Mixman Studio, 114–115, *115*
MJPEG standard, 239
mock-ups, 239
moire artifacts, 240
Monitor in iMovie, 122
montages, 211, 240
mood-rendering effects, 108, *108*
motion blocking, 75, 240
Motion Picture Association of
 America (MPAA), 240
motion quality in streaming video,
 192
MovieStar program, 91
MovieWorks converters, 91
moving shots, 27, 240
MPAA (Motion Picture Association
 of America), 240
MPEG Setting dialog box, 174, *175*
MPEG standards
 burning movies in, 171–172
 for DVDs, 200
 MPEG-1, 240
 MPEG-2, 72, *72–73*, 240
 MPEG-4, 240
multicams, 240
multistandard VCRs, 203–204, 240
music
 in iMovie, 130
 in soundtracks, 118
 in streaming video, 192
Music Bakery, 118
MyTV converter, 91–92

N

narration, 240
National Television Standards
 Committee (NTSC) standard, 66,
 203–204, 240
natural frames, 42, *42*
Nero 5.5 program, 172, 175–177,
 175–177
neutral shots, 28, *28*, 240
New project dialog box, 146, *147*

nickel-cadmium (NiCd) batteries, 240
nickel-metal-hydride (NiMH) batteries, 240
noise, 240
 in analog signals, 3, 74
 background, 112–113
 with microphones, 48
 in videos, 55
Noise Reduction plug-in, 112
noise-removal packages, 240
non-1394 digitizers, transferring video with, 90–93, *91*
noninterlaced displays, 240
nonlinear editing, 240
NoNOISE plug-in, 112
noses, 45
NTSC (National Television Standards Committee) standard, 66, 203–204, 240

O

off screen sounds, 240
omnidirectional microphones, 50, 240
on-demand access, 186
on location filming, 240
online courses, 186
opening projects
 in iMovie, 125
 in VideoStudio, **147**
optical zooms, 240
outtakes, 240
over-the-shoulder shots, 27, 240
overexposed footage, 107, *107*
overlap, 240
overlays, 135, **156–157**, *156*, 240
overscanning, 240

P

P (predictive) frames, 72
Paint Shop Pro editor, 214
PAL (Phase Alternation Line) standard, 66, 203–204, 241
palettes in iMovie, **124–125**, *124–125*
Pan & Scan plug-in, 136
panning, 36, *36*, 240
parallax, 241
parallel port video-capture devices, 8

partitions, 96
PCI (Peripheral Component Interconnect) standard, 241
peels, 135
people
 atmosphere for, 44
 flattering, 45–46, *45*
 makeup for, 46
Peripheral Component Interconnect (PCI) standard, 241
persistence of vision, 68, 241
personal video recorders (PVRs), 200
Phase Alternation Line (PAL) standard, 66, 203–204, 241
Phi ratio, 39
phosphors, 62, *62*, 241
"Pick it up!" direction, 241
pickup shots, 32, 241
picture-in-picture effects, 135, 241
pictures, importing, 127, **147–150**, *148–149*
pin-cushioning, 241
pixels, 69, 241
planning, 9–10
 event structure in, 12
 locations, 12
 scripts and storyboards for, 10–12, *11*
playback capabilities with DVDs, 164
Playback Simulation screen, 169, *170*
players in streaming video, 187
playheads, 241
Playstream streaming service, 193
polarizing filters, 241
pop filters, 49
POV (point of view) shots, 26–27, *26*, 241
power interference, 50–51
predictive (P) frames, 72
Product tie-ins for streaming video, 193
progressive downloads, 187, 241
progressive scans, 63, 241
Project Wizard, 173–174, *173*
projects
 in iMovie, **125**
 in VideoStudio, 145–147, *147*
prosumer equipment, 241
public events, streaming video for, 186

push-over wipes, 241
PVRs (personal video recorders), 200

Q

Q values in TV color, 63–64
quality, video, 67–68
 bandwidth resolution in, 69
 compression in, 69–72, *70*, *72–73*
 frame rate in, 68–69, *69*
 with non-1394 digitizers, 91
QuickTime format, 79, 241
 exporting movies to, 139–140, *139–140*
 for streaming video, 188
QuickTime player, 161
QuickTime Pro program
 for streaming video, 191
 video formats in, 126
QuickTime Settings dialog box, 140

R

rack focus, 20, **226**, *226*, 241
rain, simulating, 231
RAM
 in low-budget setup, 9
 in medium to high-end setup, 6
random background noise, 112
range finders, 15
RCE (Regional Code Enhancement), 241
reaction shots, 31, *31*, 241
real estate, streaming video for, 186
Real format, 241
Real-Time Streaming Protocol (RTSP), 187
RealNetworks standard, 79
RealProducer program, 191
RealSystem format, 188–189
reassembly, magical, 218–220, *218*
recordable DVDs, 76–77, *77*, 161–162
recorded music in iMovie, 130
recorders
 for DVDs, 161–162, 201–202, *201*, 237
 for VCDs, 202–203, *202*
recording voice-overs, 152
reflections
 from eyeglass lenses, 46
 off water, 231

reflectors, 241
refresh rate, 62, 241
region coding, 66–67, 241
Regional Code Enhancement (RCE), 241
resolution, 241
 in digital camcorders, 3
 in low-budget setup, 9
 in video quality, 69
retakes, 241
revealing information, camera moves for, 37
Reverse It video, 218–220, *218*
reversing clips, 218
 in iMovie, 128
 for reassembly effect, 218–220, *218*
 self-igniting candles, 221–222, *221*
RGB standard, 63, 241
rippling water, 241
rock climbing effect, 223–225, *224*
rock-ins/rock-outs, 242
rough cuts, 102, 242
 analyzing video for, 106
 assembling clips for, 102–105, *104*
 cutaways for, 105–106, *106*
 reviewing footage for, 102
royalty-free soundtracks, 118
RT2000 converter, 86
RTSP (Real-Time Streaming Protocol), 187
Rube Goldberg DVD burning method, 170–171, *171*
rule of thirds, 39, *39*
run-throughs, 242

S

S-Video, 65, *66*, 87, 242
safe zones, 64, 242
sampling, color, 64–65, *65*, 235
saving projects
 in iMovie, 125
 in VideoStudio, 146, *147*
scene detection, 93, 101, 126, 242
screen direction, 242
screen formats, **14**
screensavers, 95, 163
scrims, 242
scripts, 10–11
seashore, simulating, 231
SECAM standard, 66, 242
selecting clips, 127–128

self-igniting candles, 221–222, *221*
senior spots, 242
sequences, 242
servers in streaming media, 79
set-top disc recording units, 200
sets
 defined, 242
 dressing, 58, 236
 in streaming video, 190
sharing movies with streaming video. *See* streaming video
shine, 46
shooting video, 13
 camera moves in, 35–38, *36–37*
 cutting on the action, 34, *34*
 jump cuts, 33, *34*
 line in, 35, *35*
 screen formats in, 14
 supplies for, 13
 tips for, 14–15
 tripod for, 13–14
shore, simulating, 231
shots, camera, 24, 242
 angle, 27–29, *27–29*
 basic, 24–25, *25–26*
 for editing, 29–32, *29–31, 33*
 POV, 26–27, *26*
signals, 55
silver DVDs, 166
simplicity
 of effects, 107
 of sets, 58
 for streaming video, 189–190
SingleReel site, 193
"Sit into the shot" direction, 242
16x9 Converter, 136
size
 in digital camcorders, 3
 of selections, 128
 in streaming video, 192
 of text, 109
sky pans, 242
Slick Transitions and Effects plug-ins, 134–135
slide shows, 180, *181*
slow motion, 242
slowing down clips, 128
SLP (Super Long Play) in VCRs, 197
SMIL (Synchronized Multimedia Integration Language), 188
soft focus, 242
soft lights, 242

Sonicfire Pro, 116–117, *116–117*
sound
 background, 50
 in digital camcorders, 3
 for humor, 227–228
 in iMovie, 129–131, *129–131*
 quality setting for, 15
 in streaming video, 189, 192
 in video transfer, 85
 in VideoStudio, 152–153, *152*
sound effects, 109–110
 defined, 242
 in iMovie, 129, *129*
Sound Forge editor, 112
sound start and end points
 in iMovie, 130
 in VideoStudio, 153
soundtracks, 114, 242
 from Freeplay Music, 118
 Mixman Studio for, 114–115, *115*
 from Music Bakery, 118
 Sonicfire Pro for, 116–117, *116–117*
SP (Short Play) in VCRs, 197
spatial compression, 71, 242
special effects, 242
 built-in, 15
 in VideoStudio, 153–155, *154–155*
Spectra plug-in, 135
Spectrum Analysis tool, 113
speech in streaming video, 192
speed in DVD burning, 163
speeding up clips, 128
spins, 135
split-screen effects, 135, 242
splitting clips, 100–101, *100*, 242
 in iMovie, 127
 in VideoStudio, 150, *150*
Spotlife streaming service, 193
stand-alone recording DVD drives, 161
standard TV format, 14
standards. *See* formats and standards
start and end points in sound
 in iMovie, 130
 in VideoStudio, 153
stereo sound with microphones, 48
stills, 242
 in iMovie, 128
 in VideoStudio, 151

stop frames, 242
storage media
　DVDs, 76–77, *77*
　streaming, 79
　VCDs, 78
　videotape, 76
storage space in video quality, 68
storyboarding,, 242
storyboards, 242
　in editing, 102–103
　in planning, 11–12, *11*
　in VideoStudio, 145, *145*
streaming media, 242
streaming media players, 242
streaming video, 79, 185
　benefits of, 186
　considerations for, 189–190, *190*
　formats and tools for, 190–192,
　　191
　host sites for, 192–194
　operation of, 186–188
　QuickTime for, 188
　RealSystem for, 188–189
　tips for, 192
　Windows Media for, 189
Streaming Web Movie, Small option,
　140
strobe effects, 38
Stupendous Software plug-ins, 136
subtitles
　defined, 242
　in VideoStudio, 155
sunlight, 53–54
superimposing, 242
SuperVCD (SVCD) standard, 165,
　242
supplementary lights, 53
supplies
　for shooting video, 13
　for transferring video, 86–88, *87*
SVCD (SuperVCD) standard, 165,
　242
swish panning, 242
Synchronized Multimedia
　Integration Language (SMIL),
　188

telephoto lenses
　defined, 242
　depth of field with, 16
telephoto shots, 242
teleportation, 209–210, *209*
television
　color space in, 63–65, *63*, *65*
　country systems for, 66–67
　operation of, 62–63, *62*
template backgrounds in
　VideoStudio, 169
temporal compression, 71, 242
temporary files, 95
testing projects, 182
tethered microphones, 49, 243
text
　in streaming video, 190, *190*
　in titles, 109, *109*
　in VideoStudio, 155
text safe zones, 64
themes in iDVD, 178–180, *179*
360-degree pickup microphones, 50
thumbnails in iDVD, 181–182, *182*
thunder, simulating, 231
tie-clip microphones, 49–50
tilting, 36, *37*, 243
Time Effects plug-in, 137
time of day in lighting, 53–54
time-reverse effects, 218
　reassembly, 218–220, *218*
　self-igniting candles, 221–222,
　　221
timelines, 243
　in editing, 102–103
　in iMovie, 123, *124*
　in VideoStudio, 145, *145*
title cards
　defined, 243
　in VideoStudio, 155
titles, 108–109, *108–109*, 243
　in iMovie, 137–138, *137*
　in VideoStudio, 155, 157
TMPGEnc program, 163, 172–175,
　173–175
Toast Titanium, 182–184, *183–184*
top lighting, 243
transferring video, 81
　from analog sources, 85–86
　　camera preparation for,
　　　89–90
　　connections for, 88
　　converter boxes for, 88–89,
　　　89

　　with non-1394 digitizers,
　　　90–93, *91*
　　supplies for, 86–88, *87*
　　VCR preparation for, 90
　camera preparation for, 82–85,
　　82, *84*
　dropped frames in, 94–96
　exporting movies. *See* exporting
　　process, 93–94
　quality in, 2
transitions, 110–111, *111*, 243
　in iMovie, 131–135, *132–133*
　in VideoStudio, 153–154, *154*
translocation, 206–207, *206–207*
trimming clips, 100–101, *100*
　defined, 243
　in VideoStudio, 151
tripods, 243
　for camera moves, 38
　for disappearing acts, 206
　for magic shows, 208
　setting up, 13–14
TV-out ports, 243
　defined, 243
　recording with, 198–200
TV tuner cards, 8–9
TV viewing, 4
TVs
　color space in, 63–65, *63*, *65*
　country systems for, 66–67
　operation of, 62–63, *62*
two-shot angles, 25, 243
two-way transitions, 132
tying down sounds, 130

T

Take 2 units, 198
takes, 242
tech support, streaming video for,
　186

U

UDP (User Datagram Protocol), 187
underruns in DVD burning, 163
unidirectional microphones, 243
upward shots, 28, *29*
USB (Universal Serial Bus) devices
　defined, 243
　in low-budget setup, 8
User Datagram Protocol (UDP), 187

V

VCD Help site, 164, 166, 174
VCDs (video compact discs),
　160–161, 165, 243
　burning to. *See* burning to DVDs
　　and VCDs

compatibility issues in, 164–166
recorders for, 202–203, *202*
as storage media, 78
Toast Titanium for, 182–184,
183–184
VCRs
exporting to, 195
with cameras, 196–197
with converter boxes,
197–198, *197*
with TV out, 198–200
multistandard, 203–204
transferring video from, 90, 93
Vegas Video program, 172, 191
vertical resolution, 69, 243
video
digital, 236
camera operation in, 73–74
disadvantages in, 75–76
videotape standards in,
74–75
importing
into iMovie, 125–126,
125–126
in VideoStudio, 147–150,
148–149
quality of, 67–68
bandwidth resolution in, 69
compression in, 69–72, *70,
72–73*
frame rate in, 68–69, *69*
with non-1394 digitizers, 91
streaming. *See* streaming video
transferring. *See* transferring
video
video-capable computers, 6
video-capture devices, 8, 243
video cards for exporting to VCRs,
198–199
video compact discs. *See* VCDs
(video compact discs)
video overlays, 156, *156*
videographers, 243
VideoStudio program, 143
assembling video in, 151
automatic scene detection in, 101
burning DVDs in, 166–172,
167–171

clip preparation in, 150–151, *150*
importing in, 147–150, *148–149*,
152
interface in, 144–145, *144*
output in, 157
project management in,
145–147, *147*
sound in, 152–153, *152*
special effects in, 153–155,
154–155
storyboards in, 145, *145*
for streaming video, 191
text in, 155
timelines in, 145, *145*
for transferring video, 82
videotape
for analog camcorders, 3
in digital video, 74–75
as storage media, 76
VideoWave program, scene
detection in, 101
Virtix plug-ins, 135–136
virtual memory, 95
virus scanners, 95
visual effects, 107–108, *107*
in iMovie, 133–134, *133*
in VideoStudio, 153–155,
154–155
visuals, 243
voice clips, 129
voice cues, 243
voice-overs, 110
defined, 243
in VideoStudio, 152
volume, sound
in iMovie, 131, *131*
in VideoStudio, 153

Web Movie, Small option, 139
white balance, 20, 243
white noise, 112
wide-angle lenses, 243
wide-screen format, 14
wide shots, 25, *25*
defined, 243
depth of field with, 16, *18*
wind chimes, CDs for, 164
wind sensitivity with microphones,
48
window for lighting, 54, *55*
Windows Media Format (WMF),
189
defined, 243
for streaming video, 189
Windows Media Player, 161
Windows Media standard, 79
windscreens, 48, 243
wipes, 110–111, *111*, 243
in iMovie, 131–135, *132–133*
in VideoStudio, 153–154, *154*
wireless microphones, 51
WMF (Windows Media Format), 189
defined, 243
for streaming video, 189
wrinkles, 45

X

XVCD (Extra VCD) format, 165,
237

Y

Y values in TV color, 63–64
YCC standard, 243

W

wardrobes, 243
wasted CDs, 164
water
reflections off, 231
rippling, 241
WaveHammer tool, 112
weak chins, 45
weather simulations, 231

Z

zoom
depth of field with, 16
focus to, 226–227, *227*
focusing with, 20
zoom lenses, 243
Zoom plug-in, 136
zooming, 36, *36*, 243